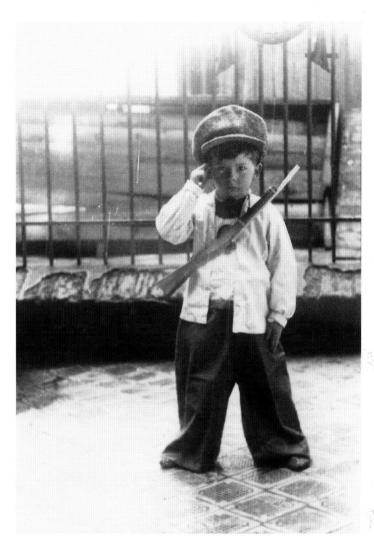

"For as far back as I can remember,
the line between fantasy and reality
has been hopelessly blurred."

Roman
Polanski
A Retrospective

James Greenberg
Foreword by Roman Polanski

Abrams, New York

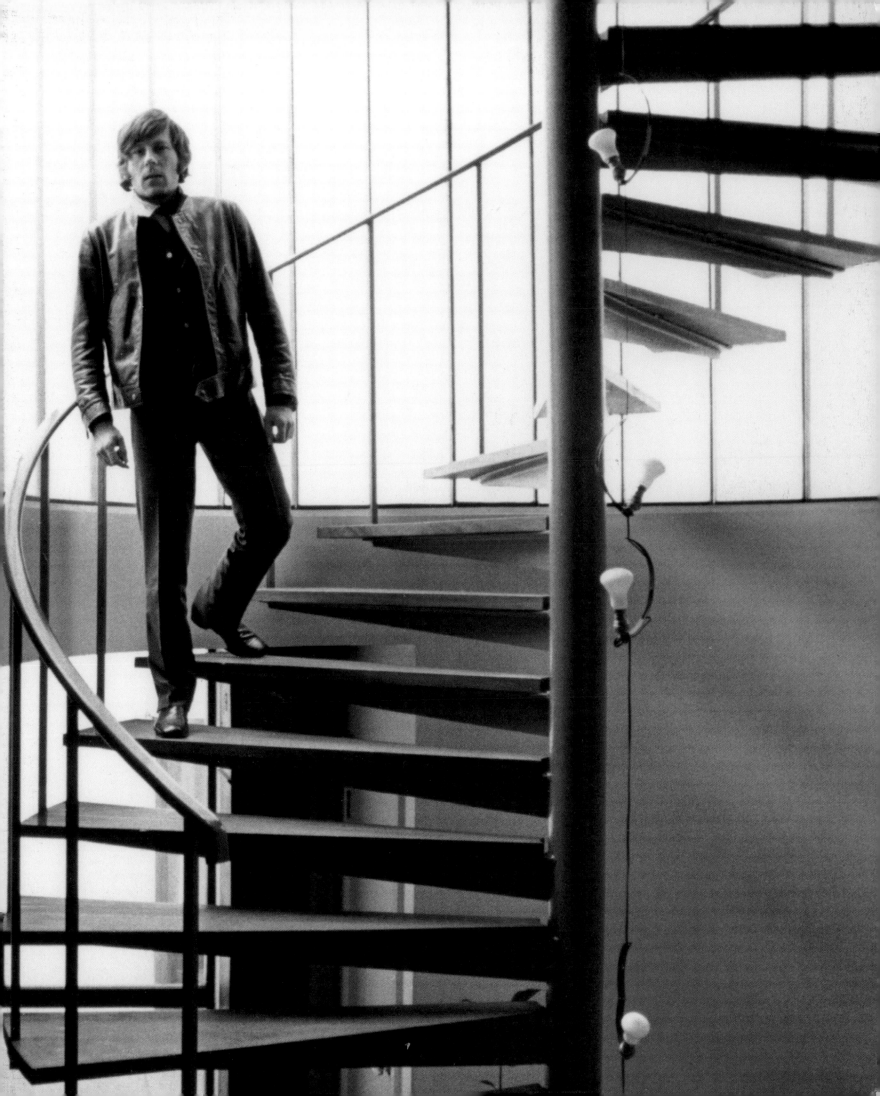

Text © 2013 James Greenberg
Foreword © 2013 Roman Polanski

Cataloging-in-Publication Data has been applied for and may be obtained from the Library of Congress.

ISBN: 978-1-4197-0721-6

Created and produced by:
Palazzo Editions Ltd
2 Wood Street, Bath, BA1 2JQ, UK
www.palazzoeditions.com
Publisher: Colin Webb
Design: Mark Thomson/Rob Payne
Editorial: Judy Barratt/James Hodgson
Picture research: Emma O'Neill
Please see picture credits on page 285 for image copyright information.

Printed and bound in China by Imago.

10 9 8 7 6 5 4 3 2 1

Endpapers: Polanski's trusty viewfinder, which he has used throughout his career.

Page 1: Aged five, with early ambitions to be a performer.

Title page: At home in Los Angeles, 1969.

ABRAMS
THE ART OF BOOKS SINCE 1949

115 West 18th Street
New York, NY 10011
www.abramsbooks.com

Contents

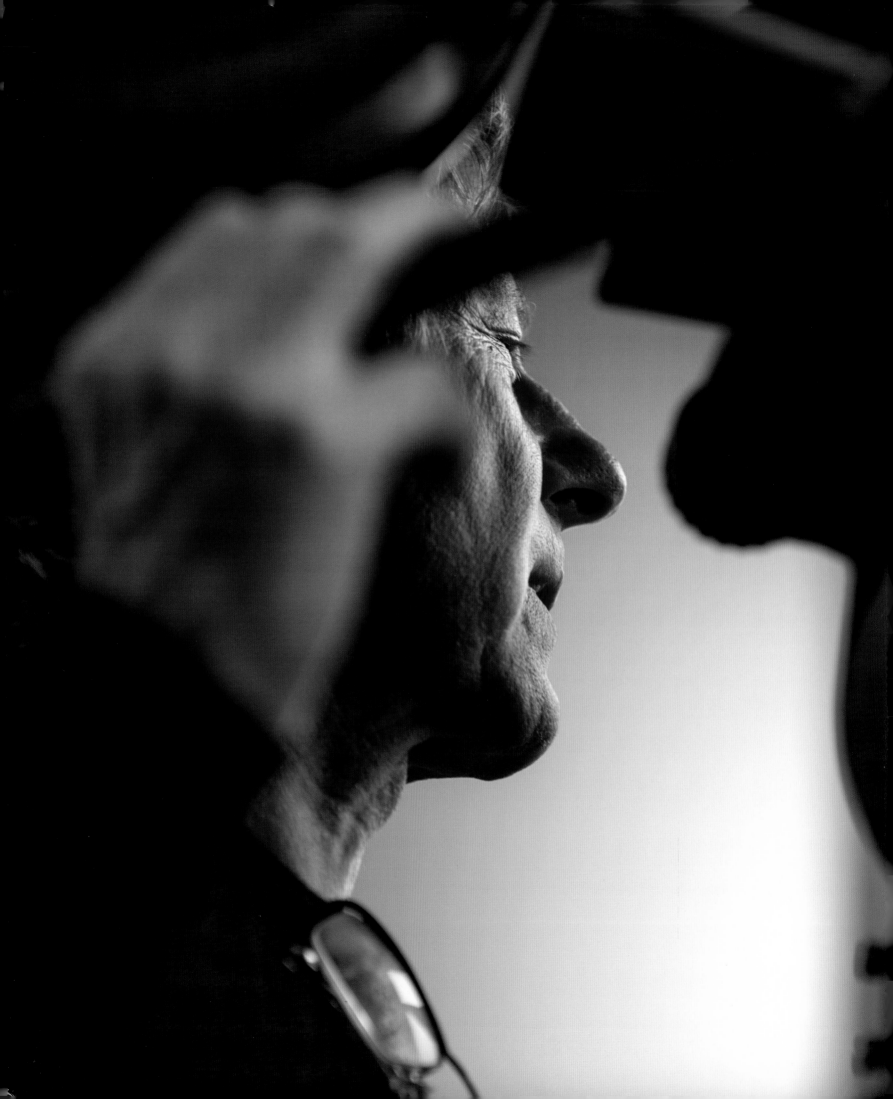

Foreword by Roman Polanski

WHEN James Greenberg kindly asked me to write the preface to his book—the first of its kind that I have collaborated with—I was in the middle of a tight shooting schedule for *Venus in Fur*. I was planning to start shooting *D*—my take on the Dreyfus affair—immediately after that: the first back-to-back movies I will have done since early in my career. So, regrettably, I didn't have a second to sit down and write anything thoughtful or explanatory about this book, but in any case the movies have always spoken for themselves and don't need, I hope, further embellishment in words.

The book may trigger for you some memories of films made over a career that has largely been unbroken—despite the earthquakes in my own life—since I made *Knife in the Water*, my first international success, in 1962. I hope it gets across the simple fact that movies have been my passion ever since I was a small boy in Kraków and how, from those first fearsome and troubled times, the making of movies has sustained me through my life. I never stopped making films—they are my lifeblood. When I was at film school in Lodz, where I learned my trade in highly supported and privileged circumstances, despite a Communist regime, I was so certain of my career that I had a vision of it that almost became the reality. I don't know whether this was pretentious or precocious or just advanced dreaming. But clearly almost from when I was conscious, I knew this was what I wanted to do—and then gradually found out how it could be done.

It has been pleasurable, and in some ways regretful too, remembering my films through people and places I've known along the road. It made me wonder who was still around, of those I hadn't seen for years. I've worked with so many great collaborators, especially my team of loyal friends, some of whom have been making movies with me for almost forty years. Primary among them was my close friend Gérard Brach. We wrote nine scripts together for films I directed, and for some that never got made.

I realized long ago that the best moments for me are when I'm on the set, where I feel happy in spite of the aggravation. And that can be bad; sometimes hellish. I had moments when I pondered changing professions. There were times when I've looked at the rushes for what turned out to be a good movie and contemplated shooting myself. And there probably *are* easier ways to make a living than directing films.

Much of the time, not just for me but for most directors, our energy is soaked up in all kinds of problems that have nothing to do with filming. I seemed to run into a lot of bad weather—figuratively and literally. A frigid winter on *Tess*, melting snow on *Fearless Vampire Killers*, a tropical storm on *Pirates* and the sunniest weather for the rainiest picture, *The Ghost Writer*. But nothing ever managed to dim, for more than those moments, the early enthusiasm I had for making movies.

Some things have changed, though. I remember the butterflies in the stomach when I was directing my first short, *The Bicycle*. How excited and terrified I was the night before. I couldn't sleep. Years later, when I came to work in Hollywood on *Rosemary's Baby*, I drove through the famous Bronson Gate to the Paramount Studios that first morning, but the butterflies were gone. Nothing could match the thrill of that first time.

Why do I go on doing it? Simply because I enjoy it, and because I'm still learning about directing. I wish I could have done some of the effects available with today's technology on some of my earlier films. You can now put on the screen, almost instantly, anything that comes into your head. Before, certain things were just impossible. My only regret is that I didn't make more films. Maybe I hesitated too much, stumbled on various projects I wanted to make. Maybe I strived for too much integrity? It was easier to decide what to do next when I was young. Now I take a long time to think about it. But whatever does come my way, I plan to keep going for as long as I can and for as long as it's still fun. In the meantime, I hope that this retrospective captures some of the pleasure I've had so far.

This page and previous page:
On the set of *The Ghost Writer*, 2009.
Portraits by Guy Ferrandis.

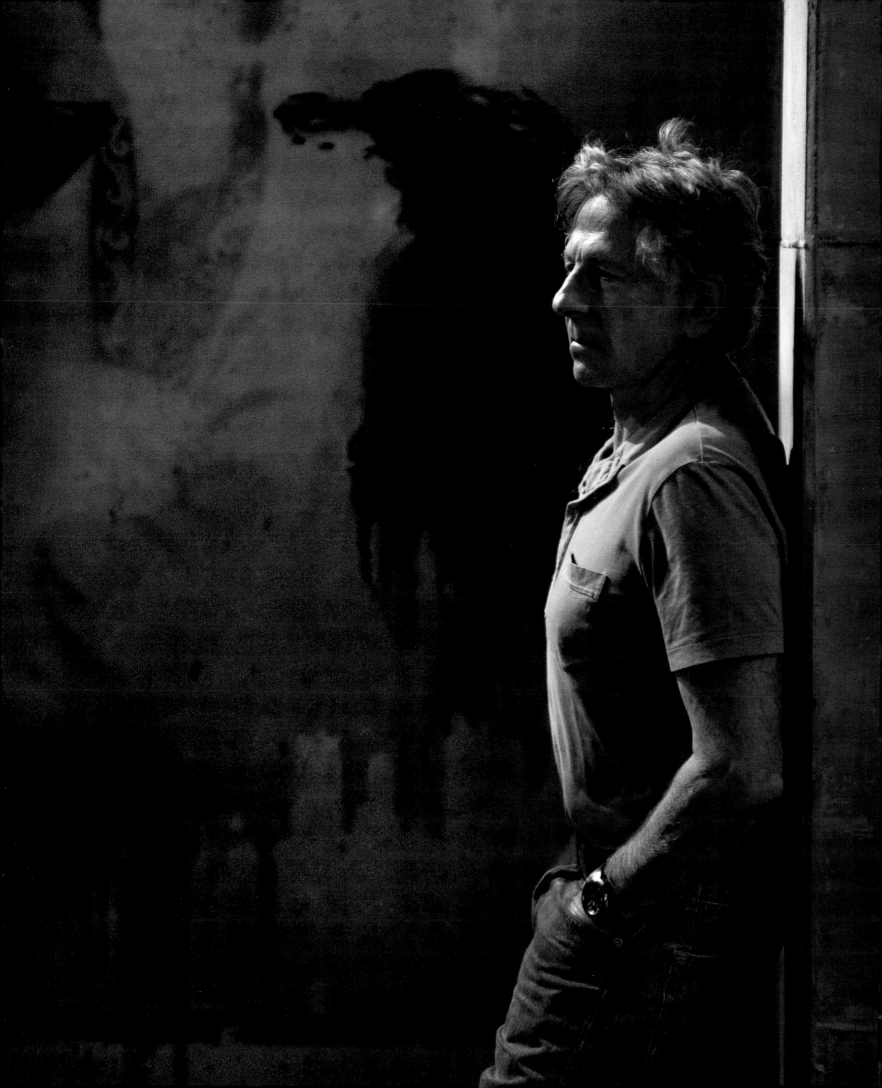

The Early Years

"Only swine go to the movies."

That was the graffiti Roman Polanski saw scribbled outside movie theaters in Nazi-occupied Kraków during World War II. He didn't care. He sold newspapers to make a few pennies and went to see anything he could. He knew every seat in every theater in the city. Movies became his passion, an escape from the despair and depression that surrounded him.

"I was completely in love with all of it. With the room, the seats, the atmosphere, the smell, the beam of the projector and, principally, with what was on the screen," said Polanski.

And he's still in love with it. "I feel happiest on the set," he said. "Those are the best moments for me." So as he turns eighty and celebrates fifty years of making films, he keeps working. Operating out of his office on avenue Montaigne in Paris's posh eighth arrondissement, where he has lived and worked for almost forty years, he appears to be ageless. His full head of tousled hair and readiness to tell a joke are intact. He seems content.

Polanski is surely one of the most famous directors in the world, but the fame he has achieved has not always been for the right reasons. He acknowledged in his 1984 autobiography that some people think of him as "an evil, profligate dwarf." Mention his name to someone who has never even seen one of his movies and they will know who he is. His life has had as much tragedy as a Shakespeare play: The death of his pregnant mother in Auschwitz, the murder in 1969 of his pregnant wife Sharon Tate by the Manson Family, and his arrest in 1977 for sexually assaulting a thirteen-year-old girl have become public knowledge. After agreeing to a plea bargain in which he admitted having unlawful sexual intercourse with a minor, he fulfilled about half of a ninety-day court order for psychiatric evaluation and expected to be released on probation. However, when the judge made it clear he would seek additional prison time, Polanski fled America. He's lived in Paris ever since and can't return to the United States for fear of being imprisoned. He was, in fact, arrested in Switzerland in 2010 at the request of the Los Angeles district attorney, but after two months in jail and eight months under house arrest, the Swiss government turned down the request for extradition.

It is indeed a remarkable story, but these aspects of his life will not be detailed here. There are many other sources for that. This book is a retrospective of Roman Polanski's abundantly creative, complex, and resourceful career as a director. There are instances where the events of his life have influenced his work, as they would any artist, and I've not hesitated to make those connections. But too often Polanski's notoriety has overshadowed the fact that he is simply one of the world's great filmmakers with a vision that is darkly humorous, deeply disturbing, and uniquely his own.

The tantalizing question about Polanski, of course, is, "what if?" What would his career have been like if he hadn't been forced to work outside the United States? I raised the subject with him once some years ago and with the slightest bit of defensiveness, he noted that *Tess* was the first film he made after his arrest and it was one of his most acclaimed pictures. End of conversation. The question is unanswerable and the circumstances can't be changed, so Polanski doesn't waste any time thinking about it. That's the way he is. He has still created an incredible body of work, and it's possible he wouldn't

Still from *The Enchanted Bicycle*, 1955.

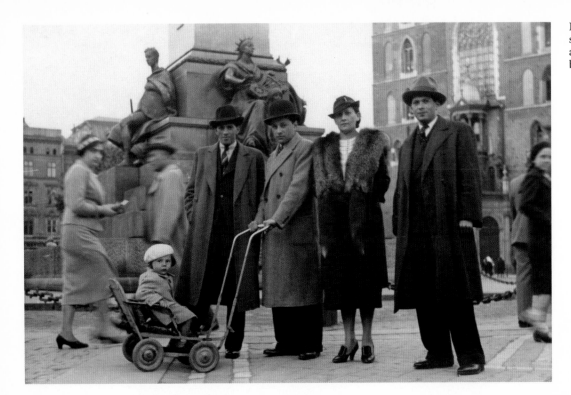

In Kraków, aged about four, shortly after his parents, Ryszard and Bula, had decided to move back to Poland from France.

have been able to do that if he had stayed in Hollywood. He does acknowledge one drawback of not being able to work there.

"What it limits is direct contact with people involved in the industry," he said. "A lot of things happen in restaurants and cafeterias, a lot of ideas, a lot of projects, a lot of friendships. I am cut off from that. But I have other things to compensate."

Polanski was born in Paris in 1933, the same year Hitler came to power in Germany. His father, Ryszard, a Polish émigré from Kraków, had moved to France with dreams of being a painter. His mother, Bula, was a beautiful Russian divorcée from a well-to-do family. Polanski would later say he inherited his obstinacy and resilience from her. Even at a young age, Romek, as he was affectionately known to family and friends, had an artistic temperament and in his autobiography admitted he was a "demanding, difficult, and petulant child with a tendency to sulk and throw tantrums—a spoiled brat."

Feeling out of place in Paris, Polanski's parents made the unfortunate decision to return to Poland in 1936 with their three-year-old son and his older half-sister, Annette. Their middle-class life in Kraków was disrupted by the growing Nazi presence, and young Romek became so anxious he would squeeze his fists so tightly that he developed calluses on his palms. After continued crackdowns in which the Jewish population was gradually starved, assigned to forced labor, and shipped to death camps, first Bula, then Annette, and finally in 1943 Ryszard were sent to concentration camps. Anticipating

such a turn of events early in the war, Ryszard had provided for his son, paying his life savings to a family who would find a hideout for Romek, eventually placing him with a dirt-poor Catholic family in rural Poland. He remained there until returning to Kraków shortly before the Russians liberated the country in 1945.

Who could have imagined that this nine-year-old boy hiding out with farmers in the Polish countryside, where Nazi soldiers took potshots at him just for sport, would grow up to be an important artist? Perhaps only Polanski himself.

While working with him on *Bitter Moon* in 1991, Peter Coyote, who starred in the film, observed that, "Sometimes you see Roman on the set and he's operating at such a fevered pitch of anxiety, I can't help but think that at one time this was a child whose life was worth less than dust. Now he's created a universe in which he's the central figure, nothing happens without him and, at least poetically, I sense a connection between the two. I think of him as a child living with Polish pig farmers. He couldn't cry, he couldn't whine, he couldn't be needy, he couldn't express any of the terrors that must have been in his nine-year-old heart. And I see that in him sometimes when he's directing. I see that he's focused all these deep feelings on his work."

If anything, Polanski's experiences during the war had perhaps given him the one thing he's needed the most in life—survival skills. He was an undersized kid who by necessity developed an oversized sense of confidence. Polanski considers himself an optimist, otherwise, he says, how could he keep going? "Roman is more geared to the future than the past because he's had some terrible things

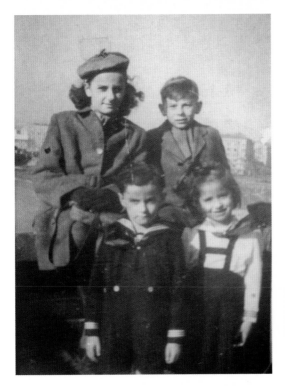

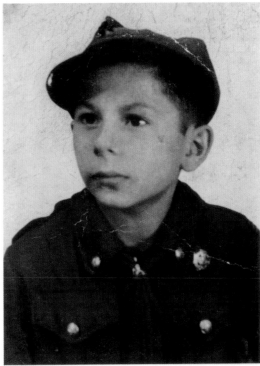

happen in his life," his longtime writing partner Gérard Brach once told me. That might explain why Polanski is not given to introspection or self-analysis, at least publicly, and is apt to deflect attempts to get him to go there with humor. When Charlie Rose said in a television interview in 2000 that he was interested in what makes him tick, Polanski responded, "I know you are. But I'm not."

Even as a child Polanski had a vision for his life. "Art and poetry, the land of the imagination, always seemed more real to me, as a boy growing up in Communist Poland, than the narrow confines of my environment," he wrote in his autobiography. "From an early age, I realized that I was not like those around me: I inhabited a separate, make-believe world of my own."

He was an indifferent student—until Jews were not allowed to go to school at all. The first inklings of his visual imagination came when an epidiascope, a device for projecting pictures onto a screen, was introduced into his class. Polanski wasn't interested in what the image was but was fascinated with how the mechanism worked, constantly examining the lens and mirror. After the war he would trade plastic Disney figurines he found while rummaging in a deserted garret to a toy store for an epidiascope of his own. He played with it constantly. No one could understand the attraction.

Polanski's first movie memory was seeing Jeanette MacDonald descending a staircase singing in a white chiffon gown in *Sweethearts* (1938). His sister had taken him to the theater just before the war, but not wanting to miss a second of the film, refused to take him to the rest room and told him to urinate under his seat. An inauspicious start perhaps.

Before his parents were sent to concentration camps and he escaped the Kraków ghetto, Polanski would catch glimpses of propaganda newsreels projected on a marketplace wall on the Gentile side. He would press his nose against the barbed-wire fence. "From time to time there would be a card on the screen that read: JEWS = TYPHUS; JEWS = LICE."

After the war, Polanski's father returned from the concentration camp and had an emotional reunion with his son. But Ryszard soon had a new girlfriend whom he eventually married, and rather than tame the wild child, he found a place for him to live and supported him. So by the time Polanski was in his early teens, he was pretty much on his own. When most of his friends, even the tough guys, had to go home to their families, Polanski would go with one of his buddies to a food bar for their favorite dinner of beans in tomato sauce. Though they were the only kids in the place, no one ever thought to throw them out.

Life was bleak as the country tried to dig out of the ruins and Russia tightened its grip. One bright spot was the foreign films that started pouring into Poland. In this burnt-out landscape, imagine the transformative power on Polanski's miserable life of the swashbuckling *Adventures of Robin Hood* in brilliant Technicolor. "I was just the right age and for a kid who had only seen German movies before, it was fabulous," said Polanski. "I saw the film with my friends probably twenty times. It was like the dawn of something new."

Polanski would have a lifelong affection for that kind of unabashed adventure movie and would later try to replicate it in his own film *Pirates*, but in 1945 he was still

"What if I had had a marvellous childhood, with rows of lackeys and nannies bringing me hot chocolate, and chauffeurs driving me to the cinema? Then you would say I am that way because I had such a luxurious childhood. But the truth is I just am this way."

a few years away from thinking seriously about films. When he was a little older, two pictures that came out around the same time would have a lasting and significant impact on his cinematic sensibility. The first was Carol Reed's *Odd Man Out* in 1947. A suspenseful film noir about a wounded rebel leader (James Mason) hiding out from the police in the back alleys of Belfast after a botched holdup, it immediately grabbed Polanski's attention. In the mid-1960s, when he was in London working on *Repulsion*, he went to see it again—with great trepidation lest it not live up to the memory—and figured out why it had made such an impression on him.

"The whole atmosphere strangely resembles my childhood in Kraków, with a change in seasons that can happen in a day," explained Polanski. "I was seduced by the atmosphere, the acting, and the photography. It was the first film that had a great impact on me and has stayed with me until today. I feel I'm always trying to copy *Odd Man Out*."

But there was something beyond it being a well-made movie. "Much later I realized there was something deeper. It was a story about a guy who is a fugitive. And, you know, I was a fugitive from the ghetto."

The other film he saw a year or so later that had a lasting influence on his life was Laurence Olivier's *Hamlet* (1948). Olivier's fluid camera crawling through the halls of Elsinore Castle is a style that can be seen in almost every Polanski film from *The Fearless Vampire Killers* to *The Ghost Writer*. "That maze of interiors was just so different from what I had seen," said Polanski, who loved the sensation of being surrounded by the action. And when he started making his own movies, "I wanted to make the

kind of films where you feel the walls around you. I much prefer a film that gives me the feeling that I'm in it rather than watching a cavalry chasing across a battlefield, not knowing who they're fighting."

This set Polanski off on a Shakespeare kick, reading all his plays and amusing his friends by delivering Hamlet's "To be or not to be" soliloquy. Forging his identity was indeed the question for Polanski. Rebelling against the iron hand of Stalinism spreading in the country, Polanski and his pals, referred to officially as hooligans but known as "pheasants" by the conservative citizenry, took to wearing black leather toe-cap shoes, ankle-tight pants, corduroy jackets, and shirts with a shallow, wide-angled collar to effect the style of an Edwardian rake. And to top off a look that must have cut quite a figure in Kraków, Polanski swept his hair up and brushed it back into a duck's ass topped by a cloth cap worn at a jaunty angle. What Polanski lacked in size he made up for in attitude.

At the same time, Polanski was an avid cyclist, and, as incongruous as it may seem, a proud member of the Boy Scouts. He loved hiking with the troop and best of all got to go to summer camp for his first real holiday, during which he accidentally found his calling in life. He already had a reputation among his rag-tag group of friends for practical jokes and entertained them by imitating characters from films. After seeing *The Hunchback of Notre Dame*, he would become Quasimodo; after *Ivan the Terrible*, he became the evil tsar. One night at a campfire Polanski got past his shyness and put his skill at improvisation and his hours at the movies to use. His comic story about an old peasant and the calamities that befall him was greeted with laughs of approval.

Making his breakthrough as an actor in the lead role in V.P. Kataev's stage play *Son of the Regiment*, 1947.

"There were times when the obstacles in my path were such that I needed all the fantasy I could muster, just to survive."

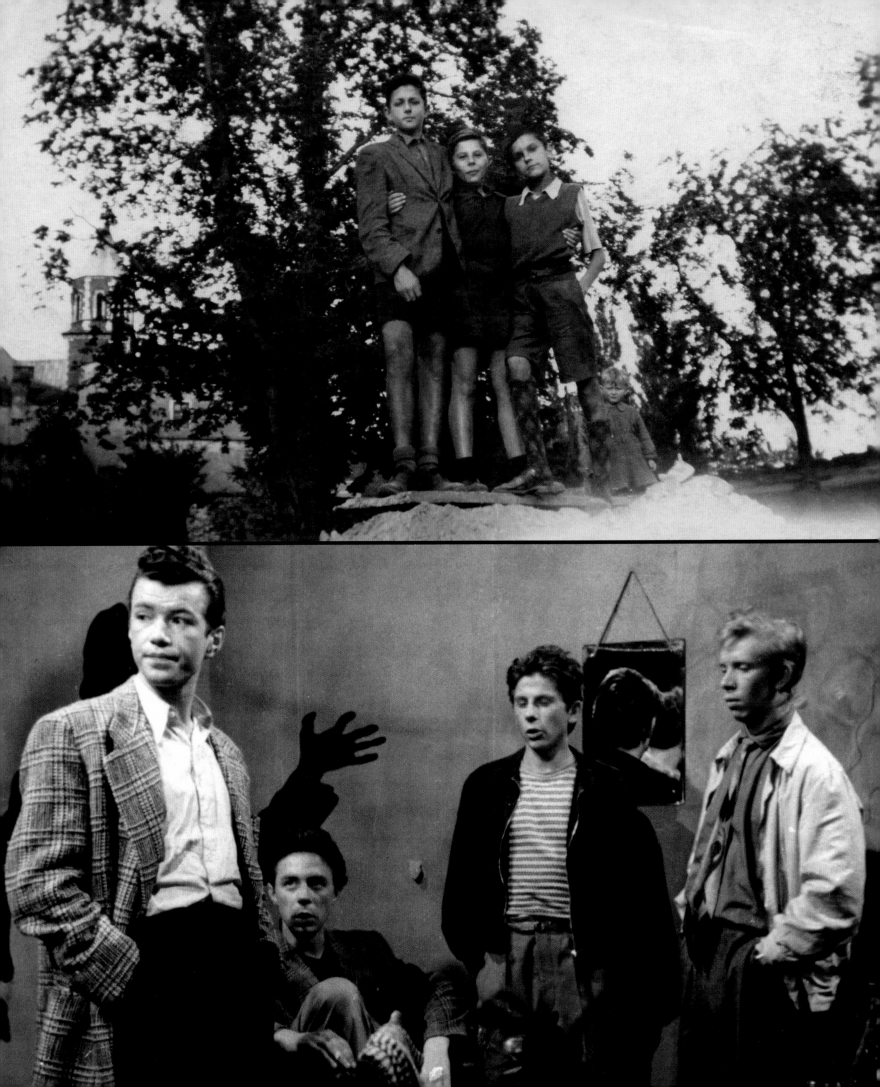

Top: Out and about in Kraków (Polanski is in the center), circa 1950.

Bottom: On screen as "little one" (second from right) in *End of the Night*, 1957. With his boyish stature and features, Polanski often found himself cast in roles much younger than his age.

"If there is any gothic tendency in my cinema, it is rather nostalgia for things that gave me so much pleasure as a child, such as *Snow White and the Seven Dwarfs*."

For the first time, he realized he had a talent to give an audience pleasure, and he was hooked. "It was a once-in-a-lifetime sensation …," he said in his autobiography. "I had discovered my vocation."

Polanski started his professional career as a radio actor in typical fashion. When a bi-weekly Communist-leaning children's show produced by a group called The Merry Gang invited listeners to the station, he turned up and told the head of the company that "the show stinks." She asked if he could do better, and immediately he delivered one of his monologues; he was hired on the spot.

The woman who ran The Merry Gang, Maria Billizanka, also headed the Young Spectators' Theater, where she would occasionally use some of her radio actors. Polanski's first stage appearance was as a chorister in a vaudeville piece. It was a nothing part but Polanski was now captivated by the theater and couldn't get enough of it. He explored every corner of the auditorium and when he wasn't rehearsing, he hid in the balcony watching performances. He loved to try on costumes and experiment with makeup. But he didn't take it all so seriously that he wouldn't try one of his elaborate pranks. One day, he started moaning in the green room toilet. When an elderly actress opened the door, she was startled to see fake blood spurting from his seemingly slashed wrist. A taste of things to come from Polanski.

Then a life-changing event occurred. When he was fourteen, Polanski was cast as the lead character in V.P. Kataev's *Son of the Regiment*. It was the kind of pro-Soviet patriotic play that was popular in those days about a

Russian peasant boy, the mascot of a Red Army battalion, captured by the Germans. He refuses to reveal any information and when the Russians strike back and defeat the Germans based on information the boy gathered behind enemy lines, he becomes a hero of the Revolution. The production was a huge popular and critical success. "That put me in the category of kids who do something different from the ones more interested in football," said Polanski.

But perhaps the most profound part of the experience was the trip the company took to perform in Warsaw. The city had been absolutely ravaged by the Germans. In addition to the enormous damage that had already been done, not long before the Germans pulled out, Hitler gave orders to destroy the city. When Polanski arrived, he didn't recognize it. "Warsaw was flattened out," he recalled. "They had already rebuilt the theater where we played, and there was one hotel, which for some reason was not bombed, but everything else was just endless ruins." This image of rubble as far as the eye could see stayed with Polanski for fifty years. When he finally revisited this period in *The Pianist*, he insisted this is what the hero, Wladyslaw Szpilman, should see when he emerges from hiding.

At this point, cycling was the only thing that came close to equaling Polanski's new passion for the theater. He joined a sporting club and would sometimes travel more than a hundred miles a day. When he could, he competed in road and track races. What held him back was, as he called it, his "machine." One afternoon he met a young man who said he could get him a prewar (then the ultimate mark of quality) racing bike for a good price.

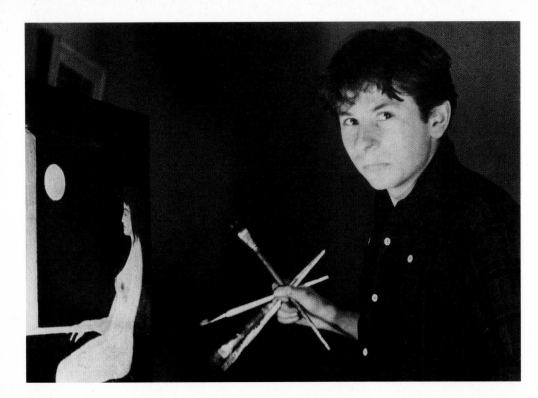

Left: At art school in the early 1950s, Polanski eagerly absorbed a wide range of aesthetic influences, from Kafka to cubism.

Opposite: Performing in *The Enchanted Bicycle*, 1955 (top), and Andrzej Wajda's *A Generation*, 1954 (bottom), which gave Polanski his first major screen role.

At fifteen, Polanski had not learned that when something sounds too good to be true, it probably is. He followed the fellow to a foul-smelling bunker the Germans had built in an outlying park. In the dark tunnel, Polanski was severely beaten on the head and robbed. When the assailant was caught, it turned out he was wanted for three murders, so Polanski figured he got off easy. And like many of the experiences of his young but eventful life, he was able to use it later, in this case in his first student film, *The Bicycle*.

Polanski was far more interested in his extracurricular activities than he was in school. He was reading a lot but his education was at best sketchy. So much so that when it was time to transfer to a preparatory school for university, his grades weren't good enough so he had to enroll in the vocational Kraków Mining Engineers' College, much to the delight of his father. But physics and chemistry proved to be "a bore," and he spent more time on his theatrical pursuits and less time in class. Polanski was disgraced when he was held back a year and not promoted to the next level, and, without a diploma, he would be unable to realize what had become his true goal—going to drama school.

This is where things took an unexpected turn. Polanski had always been good at drawing and worked on putting together a portfolio of still lifes, nudes, portraits, characters from plays, and stage designs and in 1950 was accepted to art school. Once he was there, his attitude about his studies completely changed. "A whole new world opened up to me, one that was forever to alter my perceptions and thought processes," he said. He read Kafka and discovered impressionism, which he had never heard of before, as well as cubism and surrealism. The idea that an artist could distort reality for aesthetic purposes was a novel concept to him, and one that he would take to heart in his films. His innate sense of the absurdity of life became more developed. When a friend told him his mother had just died, the two of them digested the news for a moment and then broke out laughing. "In a fair and rational world, mothers didn't die …," wrote Polanski. But of course they do. That, in essence, is the whole foundation of Polanski's work. Bad things happen, and the only thing to do about it is laugh. It is little wonder that he was later drawn to the theater of the absurd— it was already all around him.

In the middle of his last term in art school he was suddenly expelled, perhaps because of an increasingly repressive political climate where a free spirit like Polanski was a threat. The political was creeping into people's apolitical lives, just as it would in his films. There is often the pervasive sense of Big Brother or some unseen malevolent force hovering in the background of a Polanski movie. Years later he was asked in an interview if he was an anarchist. He said, sure, it's healthy to be an anarchist. But not in early-1950s Poland, it wasn't.

While he was out of school, Polanski landed his first film acting job thanks to the exposure he had gotten from *Son of the Regiment*. Polanski was nineteen, but, because of his diminutive stature, he could play a twelve-year-old boy. *Three Stories* was a typical piece of Soviet flag-waving about kids turning in spies and such, but it was important for Polanski in several ways. He was so anxious to get going he showed up before he was needed on location and was allowed to hang around on the set and observe the moviemaking process. The film was being made by seniors at the prestigious National Film School in Lodz and

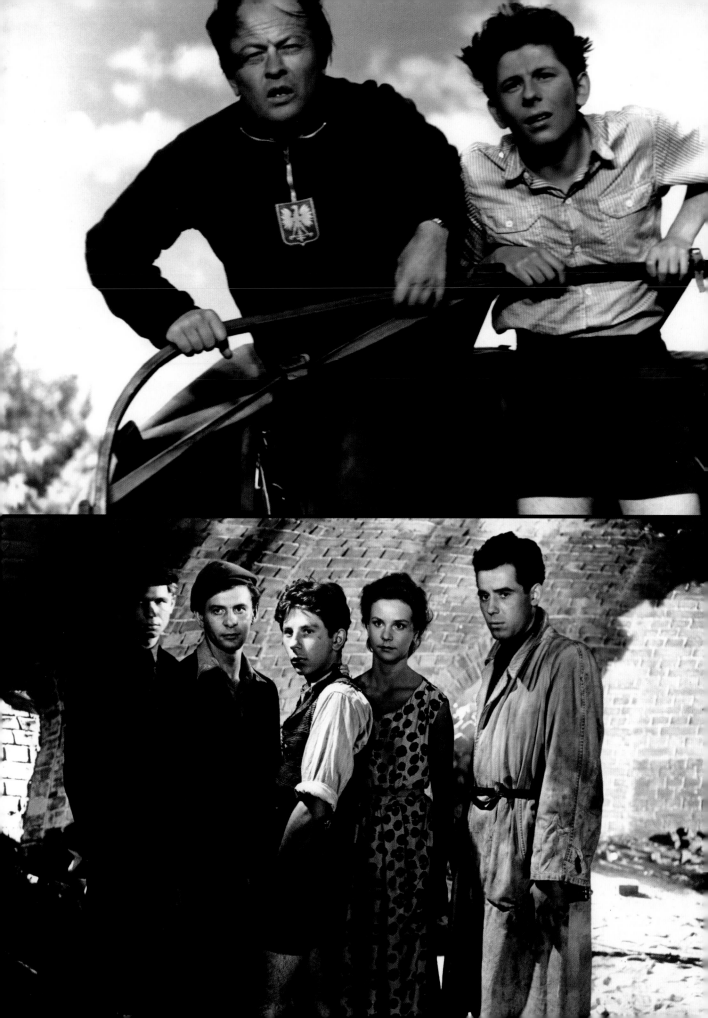

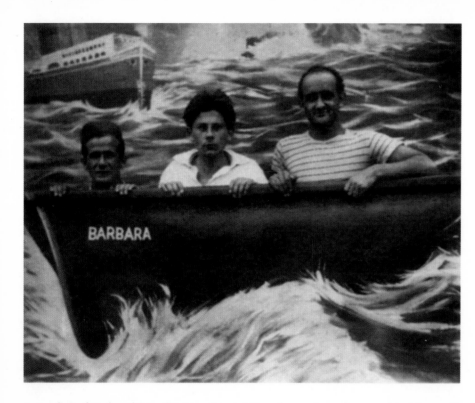

Left: Flanked by his friends Kuba Goldberg and Henryk Kluba, who played the two men of Polanski's 1958 student short *Two Men and a Wardrobe*.

Below: Wrapped up in film from an early age.

introduced Polanski to the people and the place where he would later get his training. Among the students was the cinematographer Jerzy Lipman, who would be Polanski's cameraman on *Knife in the Water*. He also met another student who would have a lasting impact on his career, Andrzej Wajda. Wajda would go on to become a celebrated director and the godfather of the New Polish Cinema, but was still two years away from directing his first feature, *A Generation* (1954), in which he would give Polanski his first important role. Working on *Three Stories* was a heady experience for the young actor who, as he recalled in his autobiography, "knew beyond a doubt these were the people I wanted to be with from now on. I wanted to lead their kind of life and talk their language."

Polanski realized he wasn't yet ready to study film in Lodz but thought he might be able to get there eventually by way of drama school, which had been his longtime dream anyway. So he decided to apply to Kraków Drama School. He prepared for the entrance auditions and became the unofficial coach for three of his friends by virtue of his stage experience. Never lacking for self-assurance, Polanski was certain he would get in. He didn't. He was told there weren't enough parts for someone his size. He was crushed.

Now desperate and afraid of being drafted, Polanski tried anything he could think of. In short order he was also rejected from the politically correct Warsaw Drama School. He then applied to the heavily Marxist-Leninist Kraków University. But without the proper proletariat credentials and a spotty school record, he was turned down from three different programs at the college. Swallowing his pride, as a last-ditch effort he applied to clown school.

On his application he wrote that he wanted to be a film director "so sooner or later I'll end up in the circus." The draft board didn't think it was funny and refused his student exemption. What is striking about this dark period in Polanski's life is his determination and refusal to give up. He may have despaired about his future, but was not deterred by rejection the way others might have been.

Polanski had started to think about how to escape the country and avoid military service (concealing himself in the roof of a railroad car was one aborted plan) when he got a call to be in Wajda's *A Generation*. At this time the entire Polish film industry was State controlled; there was no private funding for movies. What's more, not only the scripts but the final product had to be approved by Communist ministers. There was no room for originality in style or content; the correct message was all that counted. Wajda was part of the first postwar generation to come of age and was well schooled in Italian neorealism. *A Generation* was a conventional story about the wartime resistance movement, but Wajda, enlisting contributions from the entire cast and crew and filming on location outside Warsaw, turned the film into something that had never been seen before in Communist Poland. Not surprisingly, the movie encountered problems from the Ministry of Culture and was forced to cut and reshoot a number of scenes. Nonetheless, *A Generation* marked the beginning of the Polish new wave and Polanski was there from the start.

Perhaps it was the intensity of Polanski's wary yet cocky gaze that attracted Wajda. As the earnest young member of a resistance cell, he was perfectly cast. When he wasn't working, he was on the set watching. He had read

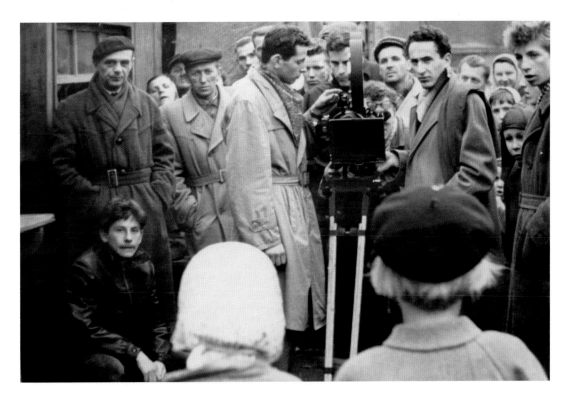

everything he could find about filmmaking and the set became a living textbook as he observed the lighting, camera work, sound recording, and special effects. Shooting interior scenes on location was unheard of at the time, but Wajda insisted on building the main character's house in the middle of an actual slum because he wanted the view of the outside world from the windows to be authentic. His attention to detail was an invaluable lesson for Polanski, who would make it a part of his filmmaking aesthetic. He saw for the first time that the creation of a particular reality on camera depended on painstaking work off camera. "Whether it's movies or any other art, particularly the performing arts," said Polanski, "a lack of attention to detail is simply sloppiness."

Not all of Polanski's early experiences as a film actor would be as inspiring. In fact, shooting *The Enchanted Bicycle* taught him another important lesson—that filming could be hell. But spending more time as part of a production convinced him that he was finally ready for film school. A professor in Lodz, Antoni Bohdziewicz, had befriended him and encouraged him to apply. Although he was deficient in Communist theory and working-class history, his practical work on stage and films as well as his time at art school were a plus. Bohdziewicz summed up the young man's qualifications to the examiners as this: "A little wild but shows promise." At the age of twenty-one, Polanski realized his dream and was admitted to the National Film School.

Polanski declared the city of Lodz to be "a dump," but he was thrilled to be there nonetheless. Because Lenin had proclaimed, "Of all the arts, cinema for us is the most important," students at Lodz enjoyed a privileged position in Polish society. However, the reason cinema was important to Lenin was not the same reason it was important to Polanski. For Lenin it was in service to the Communist State; for Polanski it was a tool for self-expression and storytelling. He had no respect for students who subverted their talents to make propaganda films with the right message.

Among resources for students was the availability of classic and current international films that were otherwise denied to the general public. Polanski, along with his fellow students, would jam into the school theater to see the latest hits. The upperclassmen were impressed with the Soviet cinema; the middle students were attracted to Italian neorealism; but Polanski and his classmates thought Orson Welles' *Citizen Kane* was "the ultimate." Gregg Toland's deep-focus cinematography, which seemed to bring the viewer inside the film, was a revolutionary technique that Polanski would later incorporate into his own work. For instance, one of his favorite setups, evident in *Rosemary's Baby* and other films, was to shoot the action through a doorway looking into the next room. The epic quality that Welles brought to the storytelling and his new cinematic language have stayed with Polanski throughout his career.

This was a crucial time in the formation of Polanski's ideas about film. In addition to *Citizen Kane*, he was impressed with Akira Kurosawa's *Rashomon*. Perhaps it validated his feelings about the relativity of truth and would push him to excavate the layers of reality in his own work. The emotionalism of Luis Buñuel's *Los Olvidados*,

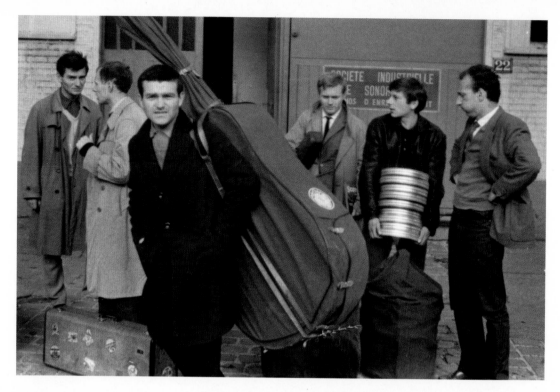

Polanski (second from right) underwent a comprehensive five-year course of studies at Lodz. His education gave him a grounding in both the technology and aesthetics of filmmaking.

with its unflinching images of juvenile delinquents in Mexico City, may have awakened Polanski's realistic approach to violence.

The course of studies at Lodz was a five-year program that required directing students to make at least two one-minute silent shorts; a ten-minute documentary; a ten- to fifteen-minute dramatized film; and a slightly longer diploma film. There were also abundant opportunities to do other films working with the cinematography students who were given film stock to practice with and always needed projects to shoot. Polanski was dying to make his first movie and fast-talked a Bulgarian senior student cameraman into using his allotted color film to shoot a short film in Kraków. This was *The Bicycle*, the aforementioned short about Polanski's bloody beating at the hands of a thief. He used his stepmother's nail polish to fashion the convincing movie blood. Polanski worked out a detailed shot list for scenes at the flea market and in the streets of Kraków. The night before, he experienced "bowel-churning terror," but also an ecstatic sense of anticipation at taking this first giant step. Once shooting started he was perfectly calm but discovered a few essential things about filmmaking: There wasn't enough light at dawn and changing locations took longer than he thought. Polanski was happy with how the production was going, but because of a mix-up when the film was sent to Russia for processing, almost nothing came back. *The Bicycle* is truly the lost Roman Polanski film.

The attitude of the school was a strange mix of adherence to strict academic requirements and permissiveness. "It was quite free, like a university,"

said Polanski. "You could skip classes without much problem, you could fail courses. But one that you could not fail was photography. If you were not good at it or you just neglected it, you would be out in no time."

Photography was considered the essential building block to making movies. As time went on students would be given more sophisticated cameras and the assignments would become more complex. "They would teach you lighting using plaster busts," said Polanski, recalling some of the drudgery of the program. "You know, lighting a plaster sculpture is extremely difficult, but you are really learning the principles of lighting a face."

The open environment suited Polanski both socially and intellectually. He was as engaged by film theory as he was by the practical side, and was not shy about expressing his opinions. One of his instructors recalled having "permanent trouble with him. He would come to exams late, during lectures he would tirelessly defend his standpoint." On one occasion, disagreeing about a film after a premiere screening, Polanski and a fellow student came to blows, slapping each other in the face in front of the screen. Passions ran high.

A hot topic of conversation was the split between film form and content. To the Communist way of thinking, formalism was heresy. Theses were written on the subject and it was endlessly debated in corridors and classrooms. But Polanski's real lesson on the controversy came outside of school. A friend of his had gotten his hands on some 16mm porno films from World War II, which they watched eagerly. They were crudely made, sometimes out of focus and badly lit, but still effective. With this, Polanski understood how content could trump form.

In 1957, Polanski finally made his first official student film, though he would probably consider it more an exercise than a film. Running a little over a minute without sound in black and white, *Murder* watches as a man in a dark coat enters a dreary room, approaches a shirtless victim sleeping on a bed, pulls out a penknife and stabs him to death, then slinks out of the room. Not to overanalyze, it is instructive to see what was on the twenty-four-year-old director's mind—murder and bloodletting. He had probably come up with a scenario set in a single room for practical reasons, but the film already shows signs of his signature claustrophobia. The creepiness of the setting and terror of the victim in the instant before he is killed is intense. It shows a darkly lit and more expressionist style (shades of Fritz Lang's *M*) than he would adopt in his features, but he already had an idea of how to create suspense by isolating on certain details: the handle of the door slowly turning, the blade of the knife, the victim's hairy chest. But the element that is most distinctive—essentially the conceit of the piece—is that the killer is seen only from the waist down, except for a brief glimpse of his face as he leaves. Polanski instinctively knew the way to create tension was to conceal information. When I asked him how he built suspense in *Rosemary's Baby*, or any of his films, he shrugged and said he just did it, he didn't think about it. This is the first example of his innate ability to make an audience squirm.

Polanski's next short, *Teeth Smile*, also silent, came with a theme assigned by his instructor, possibly voyeurism, or perhaps that's just where he went with it. A man is rushing down a flight of stairs in an apartment building when he suddenly stops and backtracks to a small crosshatched window. The actor leers at an attractive woman drying herself in a bathroom. A neighbor opens his door to put out a milk bottle and the voyeur scurries away, but the view draws him back. Unfortunately, this time he sees an unattractive man brushing his teeth who catches sight of the Peeping Tom and gives him a toothy smile. A few things stand out here: the first being Polanski's trademark subversive humor. Even in an unsavory situation, he's able to go against the grain of the material and find something to laugh about, as he often does. He is also learning to play with narrative perspective as we see what the man is looking at and also a reverse of him leering through the window. The interaction between the subject and the object is a two-way street. People spying through windows, skylights, doors, and holes in the wall, is a recurring image in Polanski's films. The creepiness of neighbors invading each other's space calls to mind *The Tenant*. It is also worth noting the sexual content and his use of frontal nudity in only his second film at a time when this was not seen in Communist films in theaters. His film-school cronies were probably too sophisticated— or trying to be—to make much of it, but Polanski would push the envelope for real and test it out on the general public a few years later with *Knife in the Water*.

After a year of hard work, Polanski needed a break. Thanks to the death of Stalin and the ascendancy of Khrushchev in the Soviet Union, conditions had thawed a bit in the Communist bloc. For the first time, people who had relatives outside the country could apply for a passport to visit them. After months of waiting, Polanski secured the cherished document and set out for Paris to visit his older sister who had survived a concentration camp and

settled in France following the war. For young people trapped behind the Iron Curtain, Paris was Mecca, the cultural capital of the world, and as he had been born there it always held a special place in his imagination. Polanski's vision of Paris was based solely on the films of French directors like Marcel Carné, Jacques Becker, and Jean Delannoy. The contrast between the drab, gray streets of Poland and the vibrant, colorful life of Paris was extreme and intoxicating for Polanski. He spent days at the Cinémathèque Française, where he was fascinated by the work of two actors still unknown in Poland: Marlon Brando and James Dean. He had been accustomed to the conventions of traditional acting; this was something completely new. What he saw on screen was the kind of naturalism he innately knew he wanted from a performance. Brando's cool and Dean's neurotic tension were so convincing, it would inform how Polanski eventually worked with actors. He was always looking for the perfect gesture or movement that was so original it made the characters seem real.

Polanski was having such a good time in Paris that he had to be summoned back to Lodz by the dean of the director's program with a gentle threat of expulsion. But before he headed back to Poland he took a detour to the Cannes Film Festival, where he tracked down Andrzej Wajda, who had a film premiering there, and announced his arrival like it was the most natural thing in the world. Wajda took him to a screening of Ingmar Bergman's symbol-laden *The Seventh Seal*, which was a long way from the verisimilitude Polanski would go on to create.

Back from Paris, Polanski was the toast of Lodz, showing off his super-pointy black shoes and modern drip-dry shirts, and doing impressions of Brando and Dean. There was a tradition at the film school of elaborate practical jokes, which Polanski did more than his share to uphold. Putting a fish in the developing tank of the basement darkroom and then listening for the shrieks of frightened female students was one of his favorites. Having to produce a documentary for his third year requirement, he came up with a project that combined his filmmaking and prankster sides. He would stage an outdoor student dance, which he often did, only this time he would invite a gang of local toughs to come by and bust up the party. The intruders were supposed to act up gradually, but once they climbed over the fence, they couldn't contain their aggression and chairs started flying and punches were thrown immediately. It seems more staged and choreographed, like a scene from one of his films, than it does a documentary. His fellow students were even more furious with him than the school administrators, who considered expulsion but let it go with a reprimand. Polanski called his test film *Breaking Up the Party*.

For his next project, Polanski again convinced a cinematography student to allow him to direct a short with his film. By this time Polanski had some definite ideas about shorts. The main problem he thought was that students would try to make them look like they were an excerpt from a feature film, rather than a self-contained entity. He saw no reason why a short couldn't have a distinct beginning and end, and noted that documentaries and cartoons accomplished this, but with actors he knew it would be different. He felt sound should be used for effect and dialogue kept to a minimum. He also believed a

realistic theme wouldn't work; he wanted to make something that was poetic and allegorical, yet totally understandable.

The short that resulted, *Two Men and a Wardrobe*, is a good example of Polanski's creative process and how his mind worked at an early stage. When he was a teenager living in Kraków, he and a friend were clowning around and had a fantasy, inspired by a Laurel and Hardy gag, about hauling his mother's prize possession, her grand piano, out to the street and leaving it there just to see what happened. A pure Dada act before he knew what surrealism was. Somehow the image had lodged in Polanski's brain and at Lodz years later he got the idea to have two men emerge from the sea carrying a piano. He eventually abandoned the idea of the piano, thinking it would suggest the wrong interpretation of artists versus philistines, and substituted it with the kind of old-fashioned wardrobe with a mirror that could be found in any cheap hotel.

Even at this point in his career, Polanski was thinking big. He presented his scenario and storyboards for every shot to his supervisor announcing that he was going to make an award-winning short, and asked if he could have the extra money to go to the seaside to shoot it. And like many of Polanski's later films, this one would go over budget. He had to start paying for meals out of his own pocket. Tension built between Polanski and his two main actors, Henryk Kluba and Kuba Goldberg, and if things weren't going well he would break the mirror and vanish for a day, Kluba recalled in a catalogue published in conjunction with an exhibition of Polanski memorabilia at the Lodz Film Museum.

Nonetheless, *Two Men and a Wardrobe* can probably be considered the first real Polanski film. It was the first work of his that was seen publicly and it did win a bronze medal at the Brussels World's Fair, as he predicted it would. Fourteen minutes long, it showed vision and direction, and the skill to execute it. The style is very much like a silent comedy but there are moments of violence, even brutality (some dished out by Polanski as a Polish street punk), much as he would introduce into his mature work. As the two men walk out of the water, they try to get on a streetcar, go into a restaurant, and check into a hotel carrying the oversized wardrobe. They're rejected everywhere because they're different, while vicious behavior all around them is ignored, which is the point of the piece. In one extraordinary shot the two men stop for lunch on what looks like a deserted pier and place the wardrobe flat on the ground reflecting the clouds above. Resting on top of the mirror is a smoked codfish, so it appears that the fish is floating in the sky. As they walk along, the two men observe the daily life around them, and at the end, they walk back into the sea where they came from.

Polanski was under the spell of surrealism, and perhaps a little bit of William Faulkner, but his use of a bouncy jazz score may have marked the biggest leap forward in his filmmaking. Jazz had been frowned on by the Communists because of its free-form individualism and association with the decadent West, and was only now moving above ground. It was the favored music for students, intellectuals, and anyone who felt rebellious against the prevailing conditions. The leading light in Polish jazz was a composer and group leader named

Opposite: Barbara Kwiatkowska
dips a toe next to her future
husband on the set of Polanski's
last student film, *When Angels
Fall*, 1959.

Right: While developing his
own directorial career, Polanski
continued to act for other
directors, including this turn
(behind the bearded rider) in
Andrzej Wajda's *Innocent
Sorcerers*, 1960.

Krzysztof Komeda. Polanski showed him a rough cut and
he agreed to do the score for the film. He would become
Polanski's close collaborator, composing the soundtracks
for *Knife in the Water*, *Cul-de-Sac*, *The Fearless Vampire
Killers*, and *Rosemary's Baby*. Polanski was devastated
when Komeda died in 1969 from a blood clot on the brain
following a fall. He visited him in the hospital and found
him bandaged from head to toe. It was a sight that would
haunt Polanski and could very well be the inspiration for
a similar mummified image in *The Tenant*.

Compared to *Two Men and a Wardrobe*, Polanski's
next short, *The Lamp*, seems little more than an effective
exercise in mood. Polanski apparently doesn't think
much of the film and does not mention it at all in his
autobiography. What's most notable about it is the eerie
undertone of impending doom, achieved through lighting,
music, and camera movement. A craftsman is working in
his shop making dolls in the late afternoon on a winter's
day in what appears to be turn-of-the-century Poland.
As the camera sweeps the space, there is something
almost sinister about the dolls on the shelves. In a real
Polanski touch, the man picks up a realistic looking pair
of eyeballs from a table of eyeballs and puts them in place
through the top of the doll's head. Other disembodied
doll parts are strewn about the room. When the place goes
up in smoke, there is the suggestion that the dolls started
an electrical fire. One thing Polanski proves here that
remained with him for the rest of his career is that what
you see all depends on how you look at it.

Polanski's last student film, *When Angels Fall*, would be
much more substantial. He got the idea from a newspaper
story about an elderly female attendant in a public rest

room who has a mystical vision. He thought, what could
be more pathetic and poignant—a life no one pays any
attention to that once had drama and passion. His vision
was to create a romantic, almost baroque style that would
capture the daydreams of the woman. Polanski enlisted the
help of an art student to create an authentic-looking art
deco set modeled after a public lavatory in one of Kraków's
famous squares. Ornate urinals were constructed out of
plaster and the roof built with frosted glass tiles through
which one could see people passing above. As the water
drips like the sands of time, the woman looks up toward
the glass and falls into reveries of happier days of her
youth, and not-so-happy days later in the city.

The filmmaking here is amazingly adventurous for a
twenty-minute student film. By this point Polanski's work
looks very professional and accomplished. The present-
day scenes are shot in black and white, switching to the
rich colors of the country when the old woman goes into
thoughts of the past. That section especially is directed in
a classical style with a real feel for nature, reminiscent of
what Polanski would do in *Tess*. There is even a battlefield
scene with explosions, which Polanski learned how to do
by watching closely when he worked on *A Generation*.
He found the eighty-year-old woman for his lead at a rest
home. She had the perfect vacant stare and remnants of
a once-attractive face. The stream of men who pass in
and out of the rest room are a parade of Polanski's friends.
In casting, appearance was more important to him than
training. The inherent believability of a character would
always take precedence over a mannered performance for
him, even later when working with seasoned professionals
and movie stars.

In Paris Polanski directed the Beckett-inspired short *The Fat and the Lean*, 1961. He also took the role of Lean; his co-star, playing Fat, was Andrzej Katelbach.

When Angels Fall was Polanski's diploma project—but he never got one. The short was accepted by the school board with mixed reviews, but he failed to write his thesis and didn't officially graduate. The only graduation he was really interested in anyway was graduating to a feature film. He got a full-time job working for Kamera, one of the few non-government production companies in Poland. The Ministry of Culture still had to approve and fund all films, but under the new, slightly relaxed conditions a company like Kamera could develop its own projects. With some encouragement, Polanski started work on the screenplay for his first feature, *Knife in the Water*. Kamera responded favorably and submitted it to the State for vetting. Preproduction was actually underway when the script was rejected; it didn't have enough social commitment, said the Ministry. Polanski was stunned.

Around the same time, in 1959, Polanski married the young Polish actress Barbara Kwiatkowska and moved to Paris for a year, where he landed a deal to direct another short. The French government, as a boost to young filmmakers, required all features to be accompanied by a short, which could wind up turning a profit. Heavily influenced by Samuel Beckett and the theater of the absurd, Polanski wrote *The Fat and the Lean* about a master–slave relationship reminiscent of Pozzo and Lucky in *Waiting for Godot*. Much later, Polanski played Lucky in a production of *Godot* for French television and toyed with the idea of turning the play into a feature. Stylistically, Polanski also shared Beckett's fondness for silent comedy and the interaction between the two characters resembles the slapstick of Laurel and Hardy by way of Buster Keaton. Polanski plays Lean, a waif in a tattered black jacket and

pants too short, and his friend Andrzej Katelbach plays Fat, a fallen aristocrat literally down on his heels. (In another indirect connection to *Godot*, Polanski and Brach would write a screenplay called *When Katelbach Comes*, in time retitled *Cul-de-Sac*.) Lean is a one-man band, playing a recorder, pounding a drum, and dancing for his master who remains seated in a broken chair outside a dilapidated house. He shaves him, feeds him, and washes his feet. He's like a court jester without benefits. All this is done without dialogue, accompanied only by Komeda's lively score. It also looks like Polanski undercranked the film so that the characters, especially Lean, who is much more animated, bounce along at a speedy pace like silent movie actors.

The Fat and the Lean is interesting not only for its stylistic experimentation but also thematically for Polanski on several levels. Lean longs to escape, and in the distance not that far away he can see a city spreading out and the skyline topped by the Eiffel Tower. It's Paris! Lean longs to escape to Paris just as Polanski did, and Fat could represent the repressive, bloated, and broken-down Polish State. To carry it a step further, Lean is the artist performing for the bourgeoisie, seeking approval that doesn't come. At the time, Polanski was strapped for money, as he often was early in his professional life. (*The Fat and the Lean* won a few awards but did nothing to help Polanski's finances or his career.) But Lean has the last laugh. He makes a bunch of artificial tulips and "plants" them around Fat, his art creating a beautiful field of flowers out of this godforsaken place.

There was still one final act remaining in Polanski's apprenticeship. He returned to Kraków for Christmas

and while visiting his film pals in Lodz, they decided to make a short. The State production company had already turned down the script. So sitting around a table at their favorite student bar, two of his friends offered to put up the money. A contract was drawn up on the spot on a napkin. Polanski with great delight commented that this must be the first private film in Poland since before the war. But there was still a major obstacle to overcome: private ownership of 35mm camera equipment and raw film stock was prohibited. The four friends lit up big cigars so they would look like producers and barged into the director's office at the film school and demanded a camera. He gave it to them! Then they bought the film stock under the table from a lab technician.

The film was called *Mammals*, and by this time Polanski was pretty much spinning his wheels. The novelty of the piece was that it brought the same master–slave relationship from *The Fat and the Lean* to a snow-swept landscape. As it starts, the screen is like a white-field abstract painting; except for a thin strip at the top, nothing else is visible. Then a speck appears on the horizon and gradually gets bigger, a similar and cruder version of what David Lean's *Lawrence of Arabia* would do in the desert. Two men come into view, one of them on a simple sled being pulled by the other. In the course of ten minutes, they fight, change places, and go through a series of sight gags right out of the Harold Lloyd playbook. The most inspired part is when one of them wraps himself in bandages and becomes indistinguishable from the snow. Finally, a sausage salesman, who hangs a few links from a pole in the middle of nowhere, steals the sled while the protagonists are off roughhousing. The pair walks off into

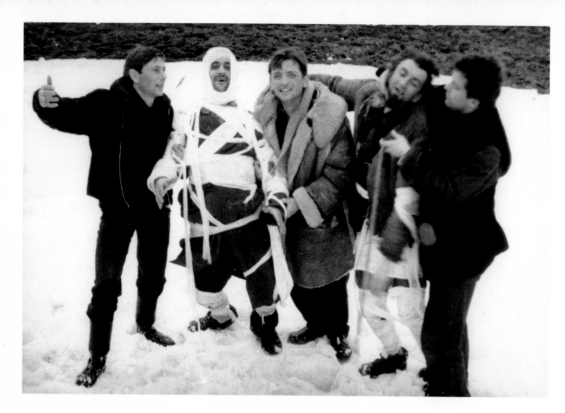

Left: Upon his return to Poland from France for Christmas 1961, Polanski made another absurdist short, *Mammals*.

Opposite: Beginning to get a taste for the high life, in the early 1960s Polanski was a man in a hurry.

the white void—not the sunset—the more domineering one trying to get the other to carry him. There is no pretense of realism here; props such as a dead chicken and a pair of crutches can just materialize out of thin air.

Form had temporarily gotten the better of content for Polanski. He admitted that when he left film school he was more concerned with the look than the story. It was fortunate that he was about to move on to *Knife in the Water* in which he was forced to have a beginning, middle, and end. He would learn that "the form has to serve something and has to be an expression of something. You can't just search for an original form if it doesn't have a reason behind it."

Polanski had been well trained by life and the National Film School to undergo his "ordeal by fire"—his first feature. In his student films, he had explored some of the themes he would continue to develop for the rest of his career: claustrophobia, loneliness, deceit, sex and violence, and the relativity of truth. By the time he made *Knife in the Water* he was already an accomplished technician.

"If he hadn't been a filmmaker he would have been a scientist, perhaps a mathematician," said Brach. "He has

an extreme rigor in his work, he takes care of all details and has the capacity to analyze in a very scientific way. He always wants to understand everything."

This was obvious when I watched Polanski at work on the set of *Bitter Moon* years later. He was like a mad scientist, frantically mixing all the ingredients. If a wire broke on the soundboard, he elbowed the technician out of the way and fixed it himself; if the lighting was a hair off, he adjusted it himself. He was constantly in motion—moving the furniture, changing the lens, arranging the extras. I assumed his ability to do any job on the set came from his training at Lodz. When I asked him about it he said, yes, but some of it was instinctive. "Some people are interested more by the physical stuff, others by the words." With his intelligence, visual sense, and appreciation for the spectacle, it was almost like filmmaking came naturally for Polanski.

Looking back at his time in Lodz, Polanski said, "When we were in school we all thought we were wasting our time. But not long after I graduated I realized how much I had really learned. And the further I am from it, the more I remember it as really the beginning of everything for me."

Overleaf: On the set of *The Pianist*, 2002, amid the discarded suitcases of families transported to Treblinka.

"Why did Hitchcock leave England? If you were a director you'd like to work in Hollywood, too. Now go ahead and ask me if I'm still Polish. You people keep asking me this question. You want Polish artists to make it in the world, but when they do, you accuse them of treason."

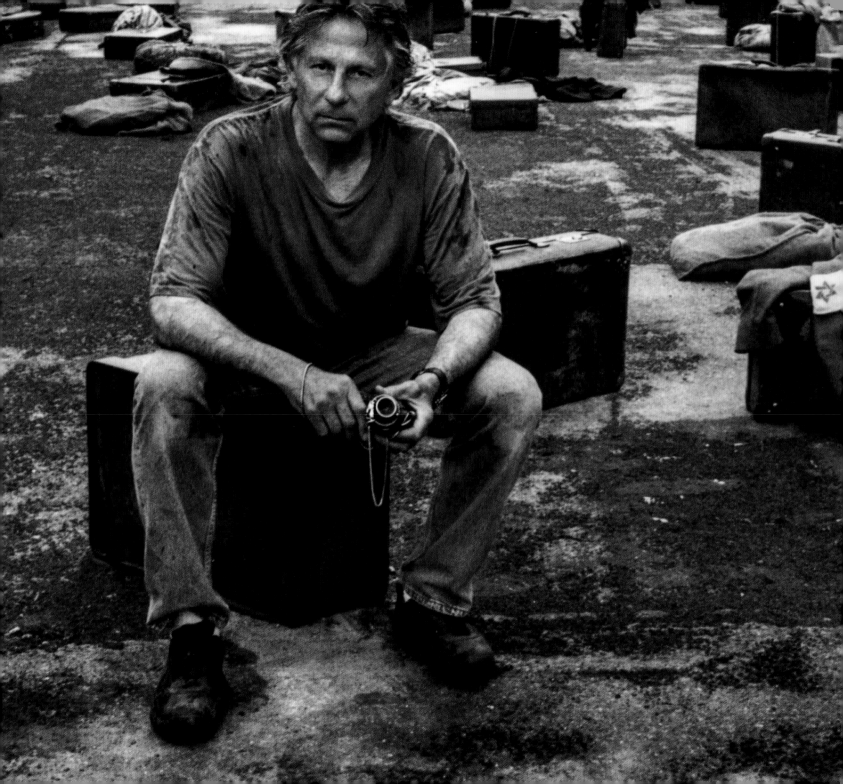

The Director

Knife in the Water 1962

"Even discounting wind, weather, and the natural hazards of filming afloat, *Knife in the Water* was a devilishly difficult picture to make."

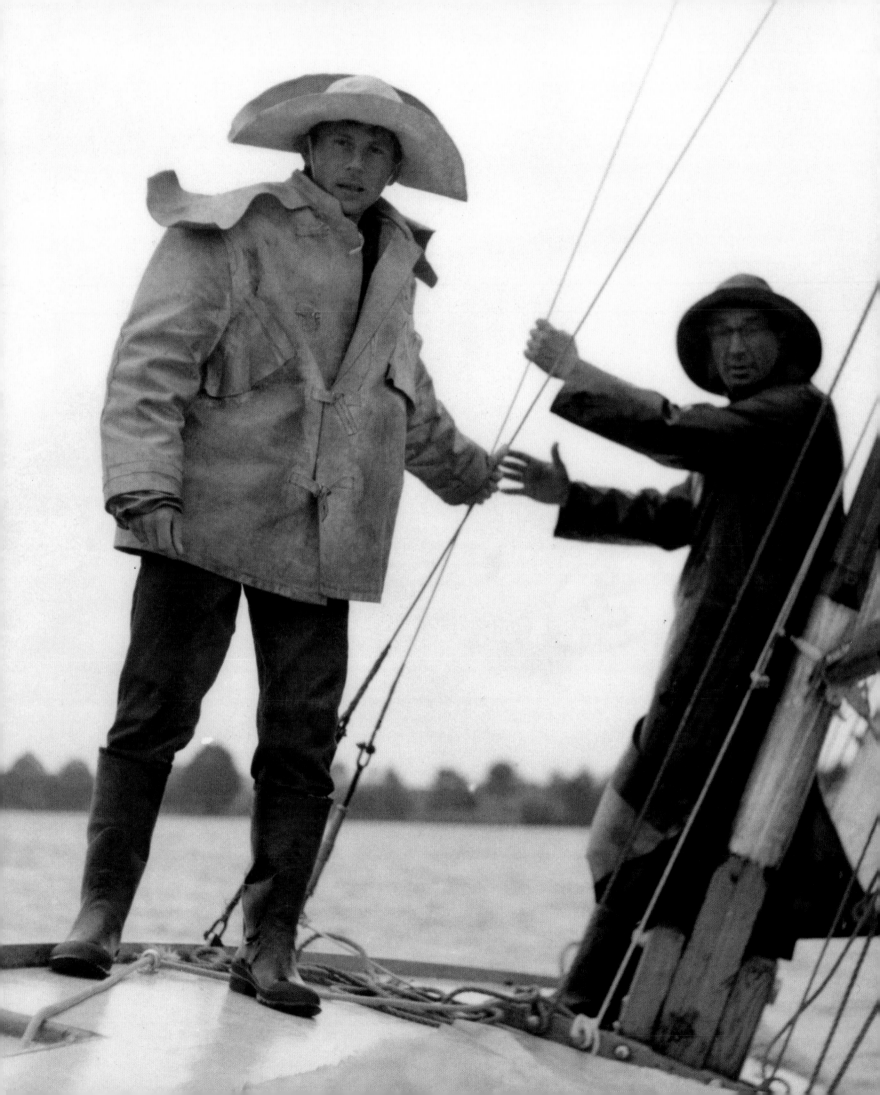

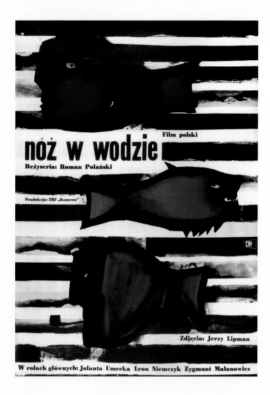

W rolach głównych: Jolanta Umecka Leon Niemczyk Zygmunt Malanowicz

To say that *Knife in the Water*, Roman Polanski's first feature and the only film he ever made in Poland, was not well received at home is like saying Stalin was not such a bad guy. Even the leader of Poland's Communist party, essentially the head of state, got into the act, declaring the film "neither typical of nor relevant to" Polish society. He hated it so much he supposedly threw an ashtray at the screen. The film critic for *Youth Flag*, the official young Communist magazine, said definitively, "the director has nothing of interest to say about contemporary man."

No one in Poland had seen anything like it—or its director—before. The iron grip of the Party had loosened enough for the film to get made in a period known as the "jazz thaw," but this was still far from an open society. Up until this point no Polish film during the Communist regime had dealt with contemporary life; productions were restricted to historical dramas or war stories approved by the State-run industry. On top of that, *Knife in the Water* employed a jazz score (by Polish composer Krzysztof Komeda), a style of music previously deemed so decadent it was restricted to secret underground clubs.

So into this bleak, depressing landscape comes Polanski—brash, ambitious, and supremely talented. Almost fifty years later, he still seems hurt that his work was rejected at home. "They said it was a criticism of a certain class of people, which in the classless society was not supposed to exist," he recalled, sounding a bit like someone having the last laugh.

After finishing up at the National Film School in Lodz and working as an assistant director, Polanski had to jump through government hoops for several years before the script for *Knife in the Water* was finally approved. His idea was to do a simple thriller, a timeless triangle of sexual tension featuring a self-satisfied, middle-aged man vying with a younger, more rebellious version of himself for the attention of his wife. When he thinks about it now it seems relatively easy, "but back then I thought it was absolutely impossible. There must have been something in me propelling me to do it."

Polanski was a keen sailor in those days and was inspired to make a movie in the Mazury Lakes region in northeast Poland. "When I started thinking of the film, I knew it had

Previous page: Extreme weather called for extreme clothing during the making of *Knife in the Water*.

to be within a certain budget and with a limited number of people. I wanted it to be original and I wanted the three unities of time, place, and action. But principally, I wanted to use this landscape that I was in love with."

His story focuses on a couple who, on their way to go sailing, pick up a hitchhiker who joins them on their boat, then falls overboard and mysteriously disappears. Even though most of the action takes place outdoors, the film feels closed in, confined by the psychology and limitations of the characters. There is almost a preordained sense that something bad is going to happen.

The game is on instantly as the hitchhiker recklessly jumps in front of the couple's car, daring the driver to stop, as his wife watches dispassionately. The husband bluffs and blusters but it's as if something in his male nature welcomes the contest. "You want to go on with this game?" asks the young man. "You're not in my class," answers the older man, inviting him on the boat so he can prove it.

The rest of the film is basically a textbook on how to build suspense with limited resources. Polanski's co-writer, the future director Jerzy Skolimowski, had wisely

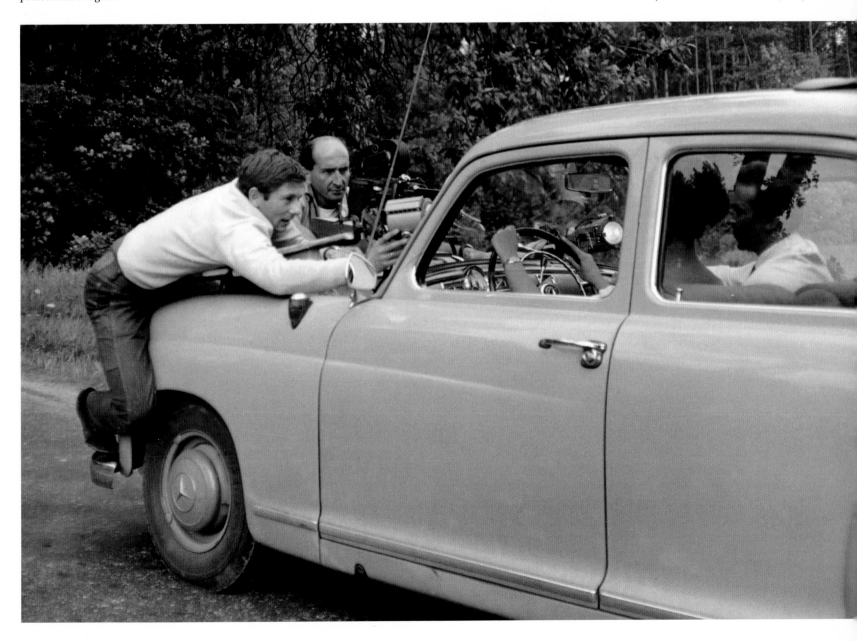

Polanski and his cameraman Jerzy Lipman perch precariously to get a shot. The film's producers later instructed Polanski to reshoot the exterior of the car, replacing the upmarket Mercedes with a more proletarian Peugeot.

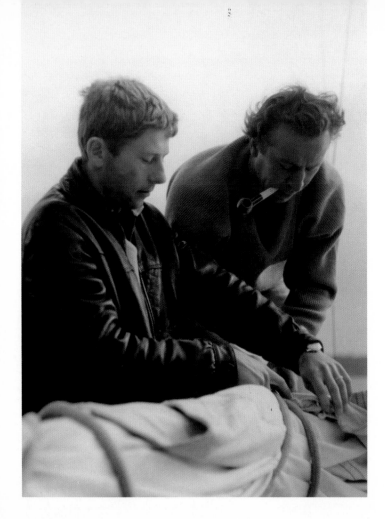

Opposite: Polanski thought about playing the role of the young hitchhiker himself, but instead cast Zygmunt Malanowicz, a young Method actor who needed the right atmosphere and motivation before every scene.

Left: He found experienced performer Leon Niemczyk much easier to deal with.

suggested that the story transpire in one day to compress the tension. What could have been stagy or static is crackling with emotion thanks to Polanski's framing and his use of lighting, camera movement, and music.

Shots are exquisitely composed, almost painterly. In one sequence that is pure cinema—the image communicating everything—the hitchhiker dangles over the edge of the speeding boat as he takes giant steps seemingly walking on water accompanied by the liberating rhythm of the jazzy score. Composing the shots himself was something Polanski felt strongly about—and still does. When I suggested that some directors leave that part of the job to their cinematographer, Polanski answered drily, "Yeah, they certainly do, but I don't."

Polanski remembers the making of *Knife in the Water* as a great adventure, working with young people on their first film, most of them camping out on a houseboat on the lake. But at the time it wasn't all fun and games for the director. For one thing, dealing with the actors proved to be a real challenge. With only three characters, casting was obviously crucial. For the husband, Andrzej, Polanski found a solid Polish stage actor with a lot of experience (Leon Niemczyk). All Polanski had to do was show him what he wanted and he did it.

Creating the character of the hitchhiker was more complicated. He's a rebellious youth, contemptuous of the State and the small bourgeois pleasures it allows to the privileged one percent. At this time in his life, this was clearly the character Polanski most identified with. In fact, he initially wanted to play the role himself but was persuaded by his producer that it would seem too egotistical for a first-time director. (When the sound recording turned out to be unusable, Polanski wound up dubbing the hitchhiker's voice.) So he hired a young Method actor (Zygmunt Malanowicz) fresh out of drama school. This meant that before every scene Polanski, who is impatient by nature, had to stop and set up the right atmosphere and motivation for him.

But the chemistry of a more authoritative, experienced actor facing off with a younger actor less sure of himself worked in the director's favor and mirrored the action of the film. The hitchhiker resents everything about the older man—his car, his sailboat, his job, and ultimately his wife. And Andrzej envies the promise of youth. The husband lectures the young man, telling him that sailing is more about brains than brawn. The hitchhiker couldn't care less, and climbs to the top of the mast just for the hell of it. Even a game of pick-up-sticks becomes a challenge to their manhood.

The knife of the title, a switchblade the young man proudly brandishes, becomes the key symbol of their power struggle. It's introduced early in the film when the

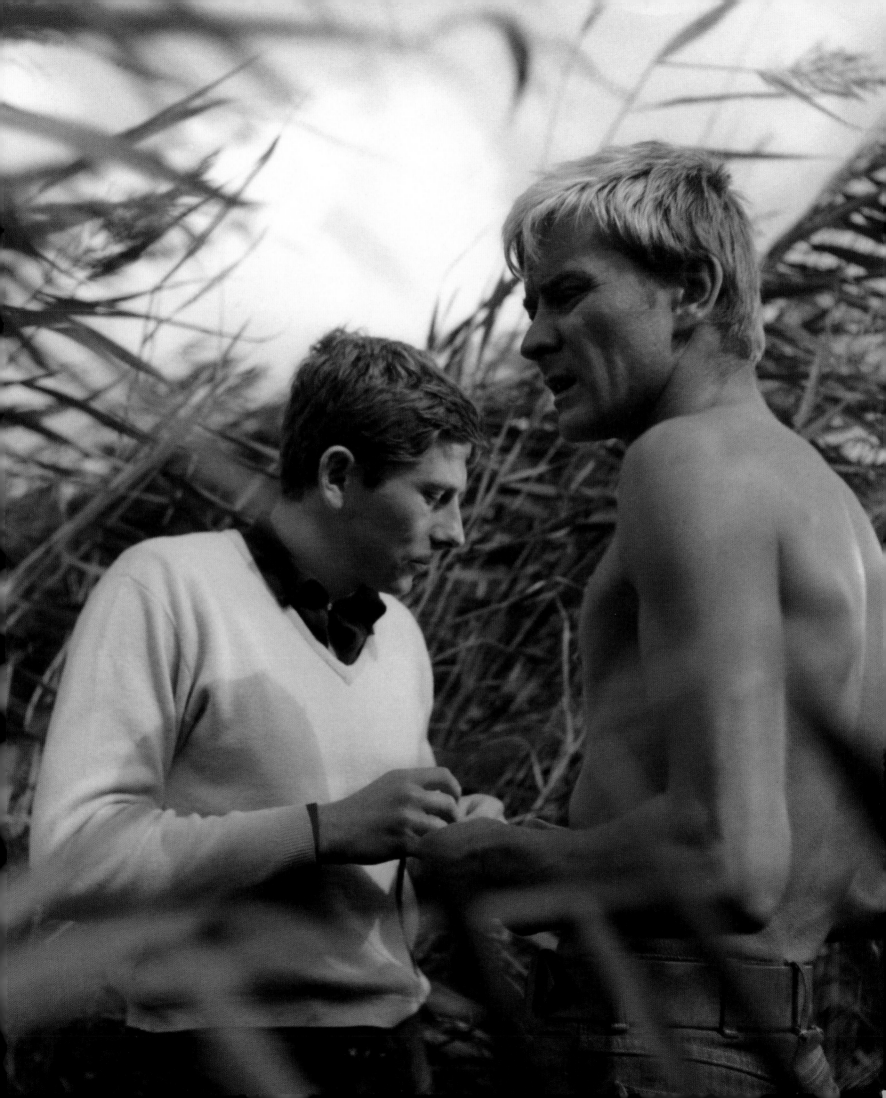

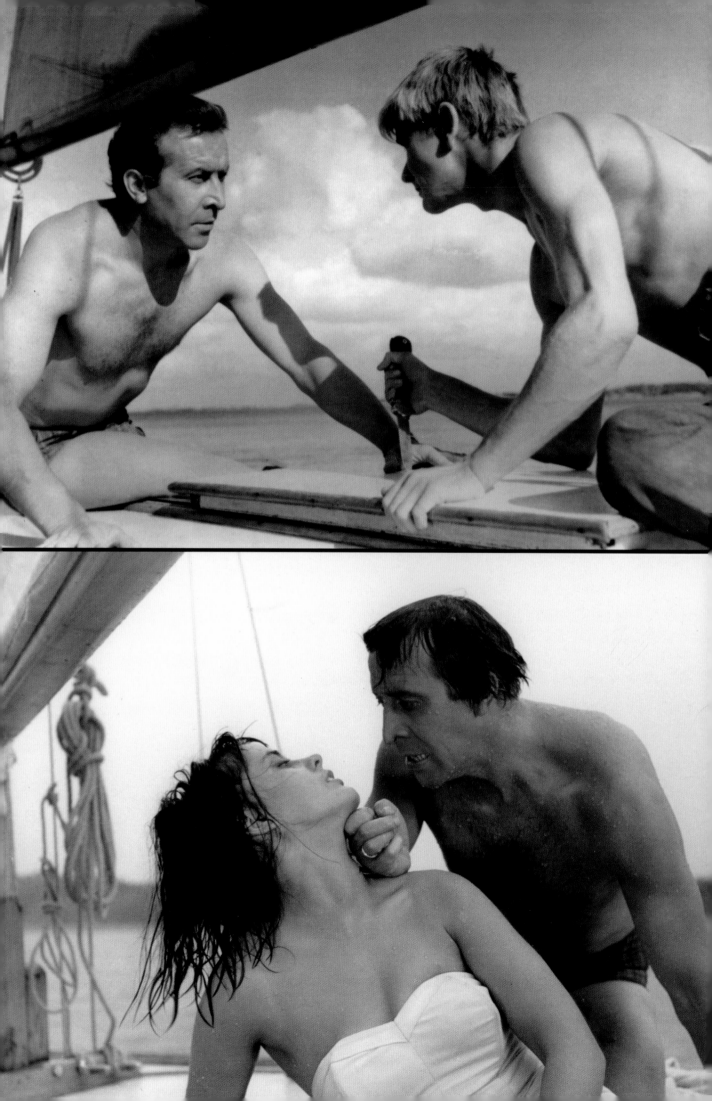

"I took three people and put them in a situation that subjected them to stress, due to their confinement on the yacht and the competition between the two males."

Breaking point: Tension builds in this claustrophobic *bateau à trois*. The two men vie with each other in a game of "five finger fillet" (opposite top); husband and wife Andrzej (Leon Niemczyk) and Krystyna (Jolanta Umecka) argue passionately (opposite bottom); and, sheltering from a downpour, the three protagonists find their proximity to each other more and more uncomfortable (above).

hitchhiker places his hand palm down on the deck and rapidly jabs the blade between his fingers in a game aptly known as "five finger fillet." The older man can't keep pace with this game. Score one for youth.

All of this preening of course is inspired by the third part of the triangle—the woman. The game is really of no consequence without her; she is the prize. For her part, she has contempt, and perhaps some feeling, for both men. In one of the key lines in the film, she tells the kid, "You're just like him, only half his age and twice as dumb."

When a flash rainstorm forces the three of them into the cabin and even closer quarters, the sexual tension becomes so thick you could cut it with the knife. And a few moments later it erupts on the deck as the men fight over the knife and the hitchhiker falls overboard. He is feared drowned, but fooling everyone he sneaks back onto the boat while the husband is out looking for him. When the woman sees him, her emotions go from surprise to anger to passion. It makes perfect sense psychologically that she would have sex with him then. It's her own reckless act of rebellion and revenge, frustrated with the boredom of her life and a failing marriage. It's the only card she can play in this game, and it excites her.

But eliciting that excitement from the actress (Jolanta Umecka) became a major problem for Polanski. She wasn't an actress, just a woman he found at a municipal swimming

"What I like is an extremely realistic setting in which something does not fit in with the real. That is what gives an atmosphere. In *Knife in the Water* ... everything is based on ambiguities, on little ironies, on a kind of cynicism in half-tone."

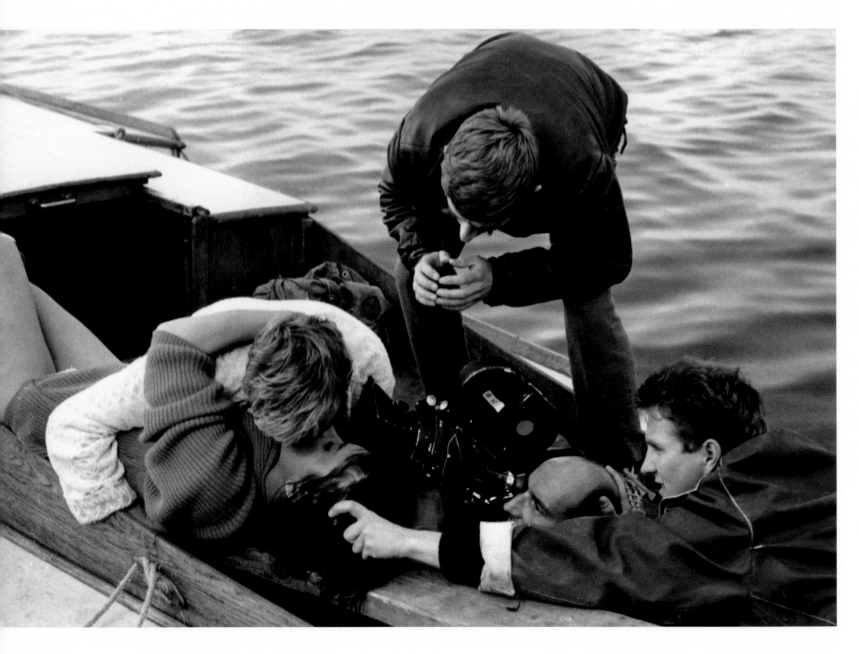

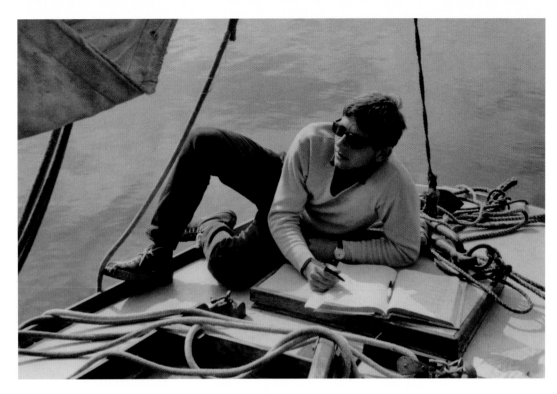

Checking the screenplay (right), and framing a close-up of Krystyna and the young man embracing (opposite).

pool and recruited because she looked like the character he had in mind. However, "the naturalness and artlessness that had so impressed me at first sight [at the pool] turned out to be manifestations of a genuinely bovine temperament," Polanski said in his autobiography. He couldn't even get a reaction from the actress for the critical scene where the missing hitchhiker returns to the boat and startles her on deck. After multiple takes, a crewmember came up with a trick that worked. Right before the youth climbed back onboard, someone fired a flare gun behind the woman and she jumped with surprise. And that's how the director got the shot he needed. (Shades of Polanski plucking a hair out of Faye Dunaway's head during the filming of *Chinatown*.)

In other respects, *Knife in the Water* was a learning experience for Polanski. For his earlier short films he had meticulously drawn storyboards (he had, after all, gone to art school) to plan all his shots, and with the complicated staging necessary for this film he started out doing the same. But he discovered that when he rehearsed with the actors they invariably came up with solutions better than anything he could have imagined. So he tossed the storyboards in the lake.

"Very soon I realized that reality is much richer than what I can actually come up with in my imagination," said Polanski. "On the encounter with the real set—in this case the sailboat—and with real actors, their way of reacting and talking was much more interesting than what I had anticipated for a particular scene. Trying to conform to my drawing of a particular shot was cramping my style."

And from this experience, Polanski distilled a style that would serve him for the rest of his career: rehearse, observe, and shape. "At the beginning I try to interfere as little as possible, and by observing I see if certain things are wrong, either too difficult to film or not interesting. So that's my job, to render it filmable. That's how I work. There are probably many other ways to skin the cat, but I feel comfortable doing it my way."

Almost all of the filming took place on the thirty-foot sailboat, too small to even set up a tripod for the camera. Working with Andrzej Wajda's great cinematographer, Jerzy Lipman, Polanski commanded a cumbersome studio on the water—a floating camera platform, an electrician's boat, and a few motorboats for towing and transportation. Lipman would sometimes strap himself high up on the mast of the sailboat to capture the moody, expressionistic shots his young director was demanding. At one point, Polanski got so excited he called up to Lipman to see how it was going. Lipman got angry and shouted down, "It's fucking beautiful," and accidentally dropped the camera into the water, never to be recovered.

The whole film was shot with a handheld Arriflex, and even though the action took place on water, Polanski was intent on keeping the camera as steady as possible to avoid displaying self-conscious artiness, a quality he remains contemptuous of to this day. "Who likes shaky?" he asked me with his typical rhetorical flourish. "Shaky is for the masturbators. When you watch life around you, is it shaky? I'm allergic to dogma that tries to impress me with technique."

Still, Polanski had a specific aesthetic strategy in mind. In those days, form meant more to him than story. "When you finish film school you want to be original and you want to be an innovator. So it seems that story is old-fashioned.

43

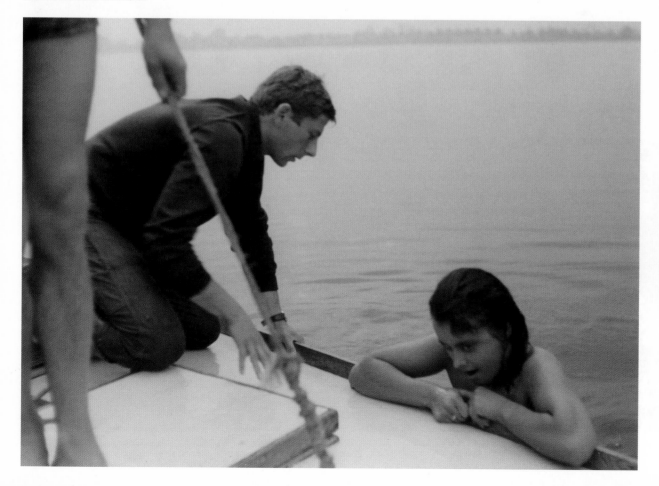

Not a professional actress, Jolanta Umecka struggled with her role. In an improvised solution to her inability to react with shock when the young man apparently returns from the dead, a crewmember fired a flare gun behind her at the precise moment that Malanowicz clambered back on board.

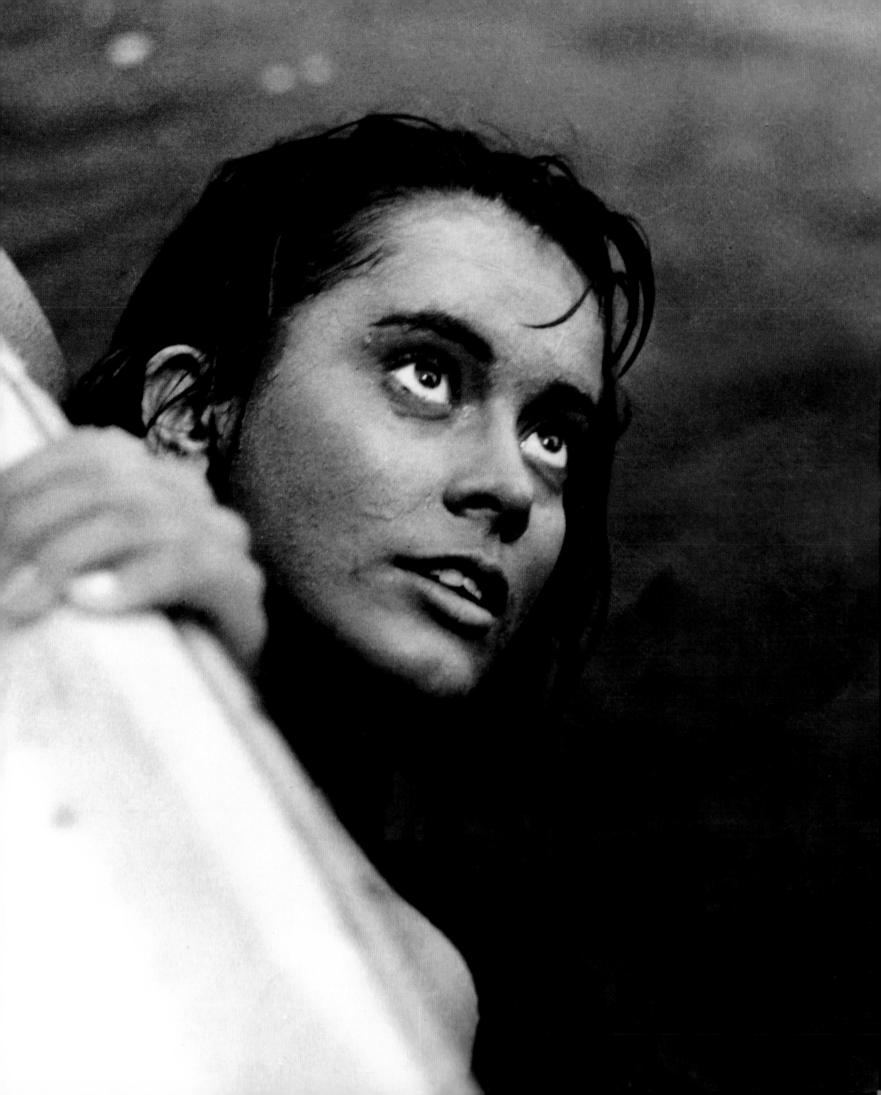

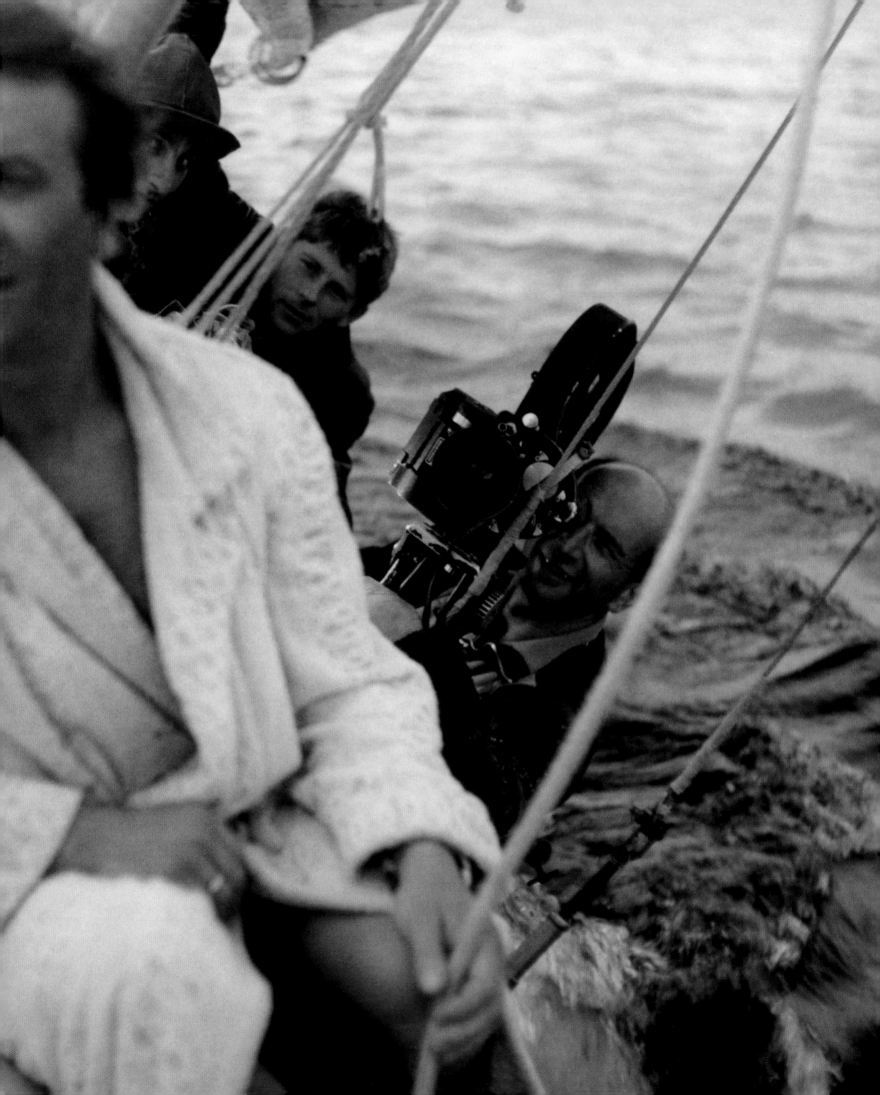

"The press showing was a disaster ...
Whether motivated by spite or political zeal,
most critics vociferously demanded to know
what the film was about."

But once you get over this exercise you realize that first you have to know what you want to say, and if you have nothing to tell, you better shut up."

The film ends on an ambiguous note, one that naturally baffled Polish leaders in a society with no room for shades of gray. Back in their car, the couple stop at a crossroads and the husband can't decide if he should go home or go to the police station to report what happened, thinking the hitchhiker is still missing. Either way, he has lost the contest. It's not a matter of right or wrong—the film isn't about that. It's about how people act in the real world. To appease officials, Polanski made a few minor trims, and the film was approved for release in Poland. But it hardly mattered. After the film was officially lambasted, no one went to see it and it was gone from theaters in two weeks.

And then a funny thing happened, as it sometimes does to deserving work. The film won the critics' prize at the 1962 Venice Film Festival, and eighteen months after opening in Poland it had its American premiere at the first New York Film Festival, climaxing with a cover story in *Time* magazine under the headline "Lovers in Polish Film."

American critics hadn't seen anything like this before either, and they embraced it. Aside from recognizing a terrifically well-made movie by an impressive new talent, for westerners it was a rare view of life behind the Iron Curtain. Much to Polanski's amusement, American reviewers seized on the knife as an obvious Freudian symbol. Polanski had read Freud, but even this early in his career he was more an instinctive artist than an analytical one. For him, capturing human behavior was simply a matter of careful observation.

In any case, Polanski's psychosexual approach was always better suited to the West. *Knife in the Water* was nominated for an Academy Award for best foreign film (losing to Fellini's *8½*). But by this time Polanski had left Poland for good. Like the hitchhiker, he had grander goals.

"Who likes shaky?" Under the watchful eye of his director, Jerzy Lipman keeps a firm hand on the Arriflex.

Repulsion 1965

"In order to justify the making of *Repulsion* to myself, I had to give it a significance that would set it head and shoulders above the average horror movie."

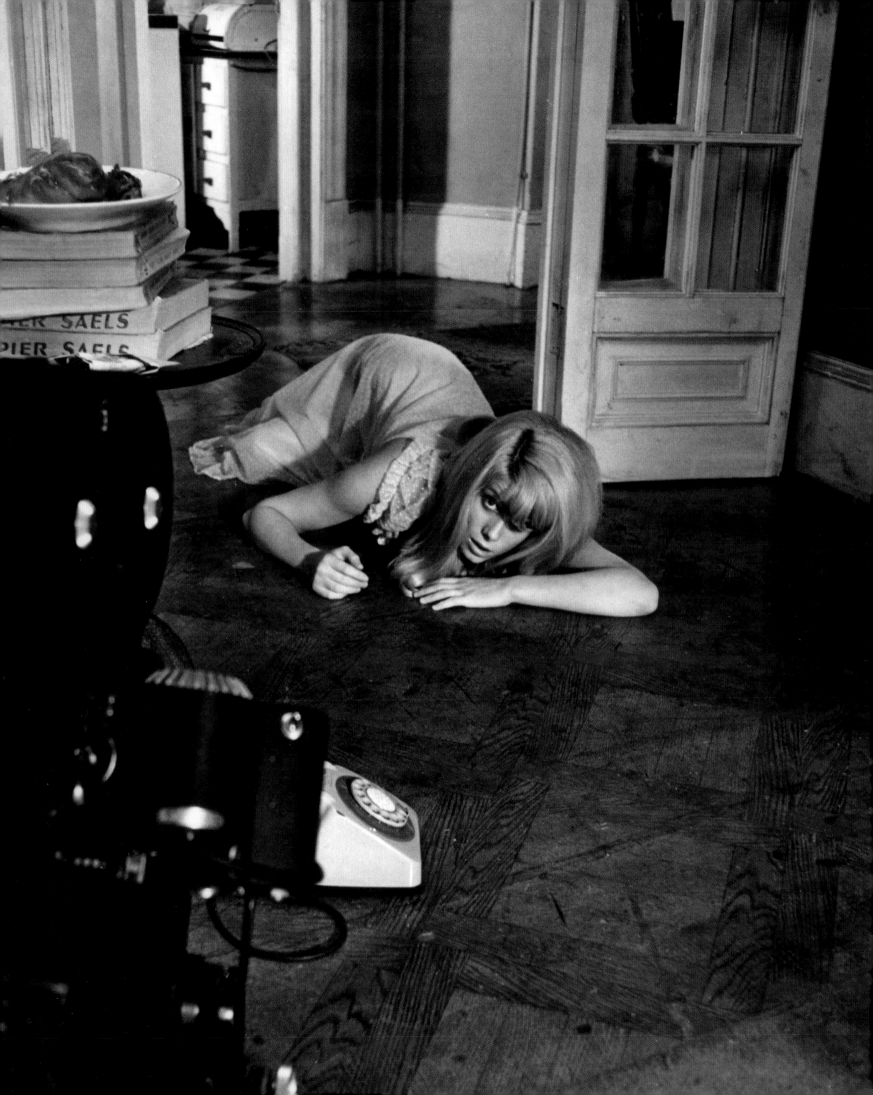

LA OBRA MAESTRA DE
ROMAN POLANSKI

Catherine Deneuve en
Repulsion

Ian Hendry · John Fraser · Patrick Wymark

Y LA PARTICIPACIÓN ESPECIAL DE
Yvonne Furneaux

Journalists, myself included, often foolishly ask directors, "What attracted you to this project?" As if they were going to tell you the truth. So when I asked Polanski what attracted him to *Repulsion*, I was more than a bit surprised when he said simply, "I needed a job."

That may not have been the only reason, but it was true, he did need a job. *Knife in the Water* might have given him cachet on the festival circuit and earned him countless meetings with would-be producers, but it didn't get him any work. He directed a segment of the compilation film *The World's Most Beautiful Swindlers* in Amsterdam in 1963 but that film died almost immediately. So after kicking around in Paris for three years, Polanski started knocking on doors in England. Having exhausted all the A, B, and C production outfits, he went to plan D and approached the Compton Group, a company that ran a "cinema club" in Soho that showed soft-core porn, some of which they produced themselves.

Compton was doing very well and its owners were anxious to move up the respectability ladder—but not too far. They were intrigued by the hot new Polish director, but had their sights on making a horror film. So Polanski and his writing partner Gérard Brach went back to Paris and wrote the screenplay for *Repulsion* in seventeen days.

The plot involved an increasingly deranged young Belgian woman who runs amok in her sister's flat in London, climaxing in two bloody killings. Compton loved it and offered Polanski, Brach, and producer Gene Gutowski the outrageously low fee of $5,000 to write, direct, and produce the picture, and fought with Polanski throughout production over the budget. But Polanski was in no position to turn it down and was in fact delighted with the opportunity to get his second film off the ground. He realized it was pulp material but was confident he could elevate it stylistically above a genre piece through lighting, composition, and mood.

Previous page: Catherine Deneuve's mesmerizing performance as Carole, a young Belgian manicurist progressively losing her mind, was anything but phoned in.

Right: Polanski gives clear direction to Catherine Deneuve and John Fraser (Carole's boyfriend, Colin) in one of the few scenes filmed outside the South Kensington apartment where Carole lives with her sister.

Below: Back in the apartment, Carole is disturbed by the sound of her sister's lovemaking.

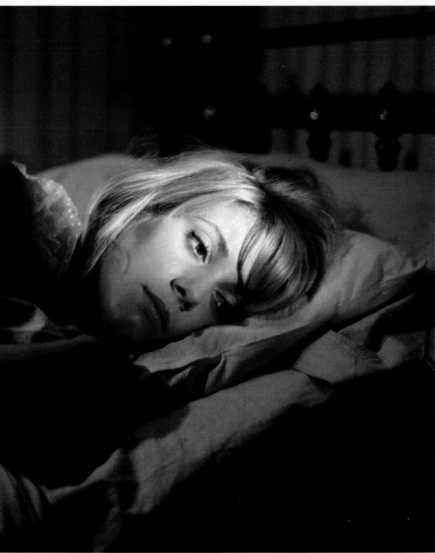

The first step was casting. Polanski wanted the little-known Catherine Deneuve, then twenty years old and breathtakingly beautiful, to play Carole, a schizophrenic and homicidal manicurist, adrift in London and lost in her own mind. As he later did with Nastassja Kinski on *Tess*, Polanski took a young, inexperienced actress and molded her, and was rewarded with one of Deneuve's best performances. He turned her into a kind of *Baby Doll* character, a mixture of perversion and innocence, attracted and repelled by sex. The mere presence of her sister's boyfriend (Ian Hendry) makes her skin crawl, and when she overhears her sister having an orgasm (the first time British censors allowed that in a film), it literally drives her up the wall.

Polanski's idea was to show Carole's deteriorating mental state by shooting from her point of view and gradually increase the use of wide-angle lenses to distort her face. The great cinematographer Gilbert Taylor, whom Polanski hired after seeing his work on *Dr. Strangelove*, contributed immensely to the film, and his shadowy black-and-white lighting made even the most banal scene seem interesting. The only thing Taylor balked at was shooting a beautiful woman like Deneuve with unflattering wide-angle lenses. Polanski, of course, prevailed. As Taylor affectionately explained years later in a documentary about the making of *Repulsion*, "Polanski wears you down and brings you to tears, and in the end you do it his way."

A lot of things came together for Polanski on *Repulsion*, not least of which was the location. After the indifference he had faced in Paris, Polanski became a minor celebrity in London just as it was starting to swing. As a foreigner in a strange country, the energy of the place was invigorating.

"Working with Catherine Deneuve was like dancing a tango with a superlatively skillful partner."

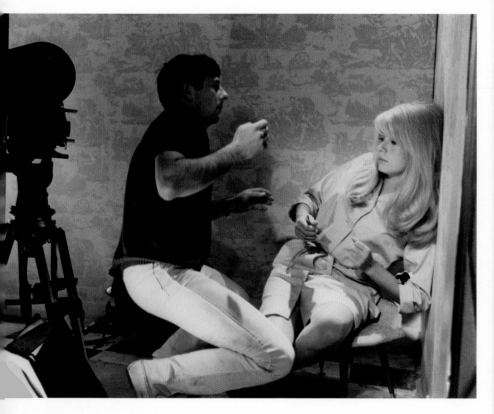

Polanski (above) and the renowned cinematographer Gilbert Taylor (right) set up another of the shadowy shots that helped to give *Repulsion* its singularly unsettling atmosphere.

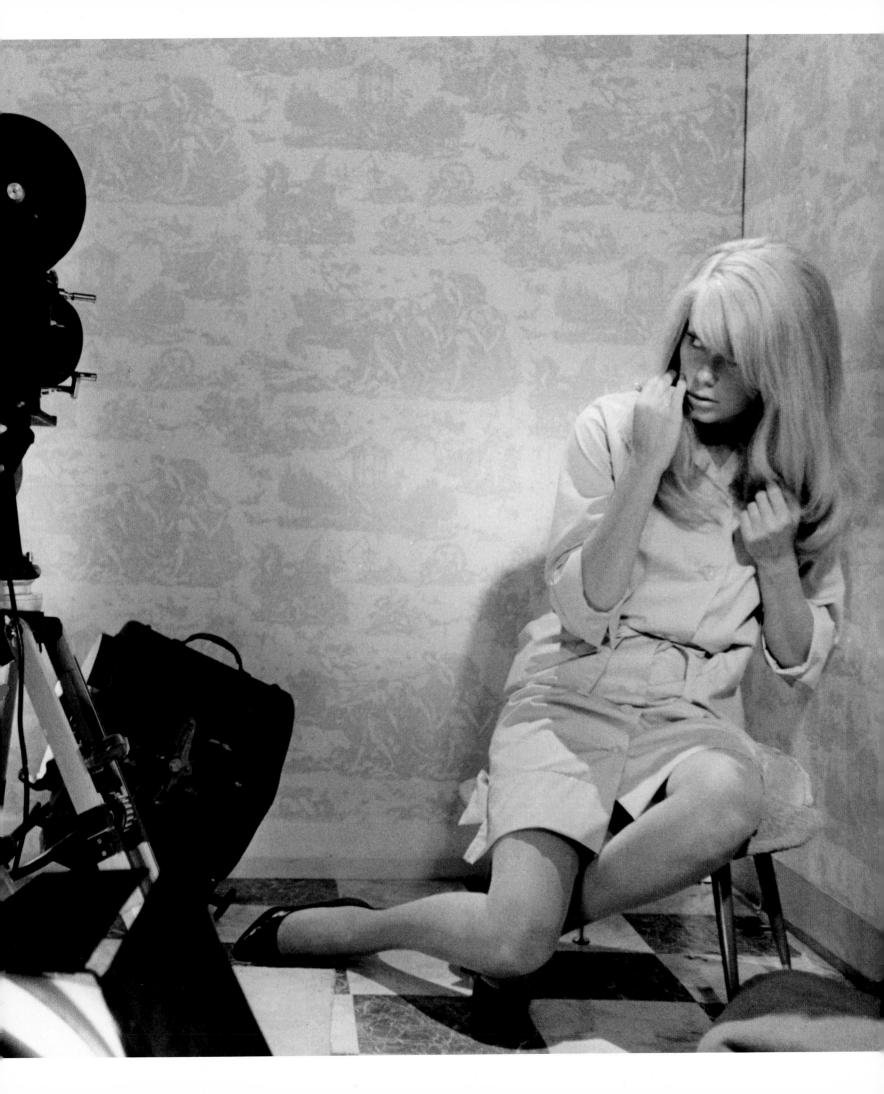

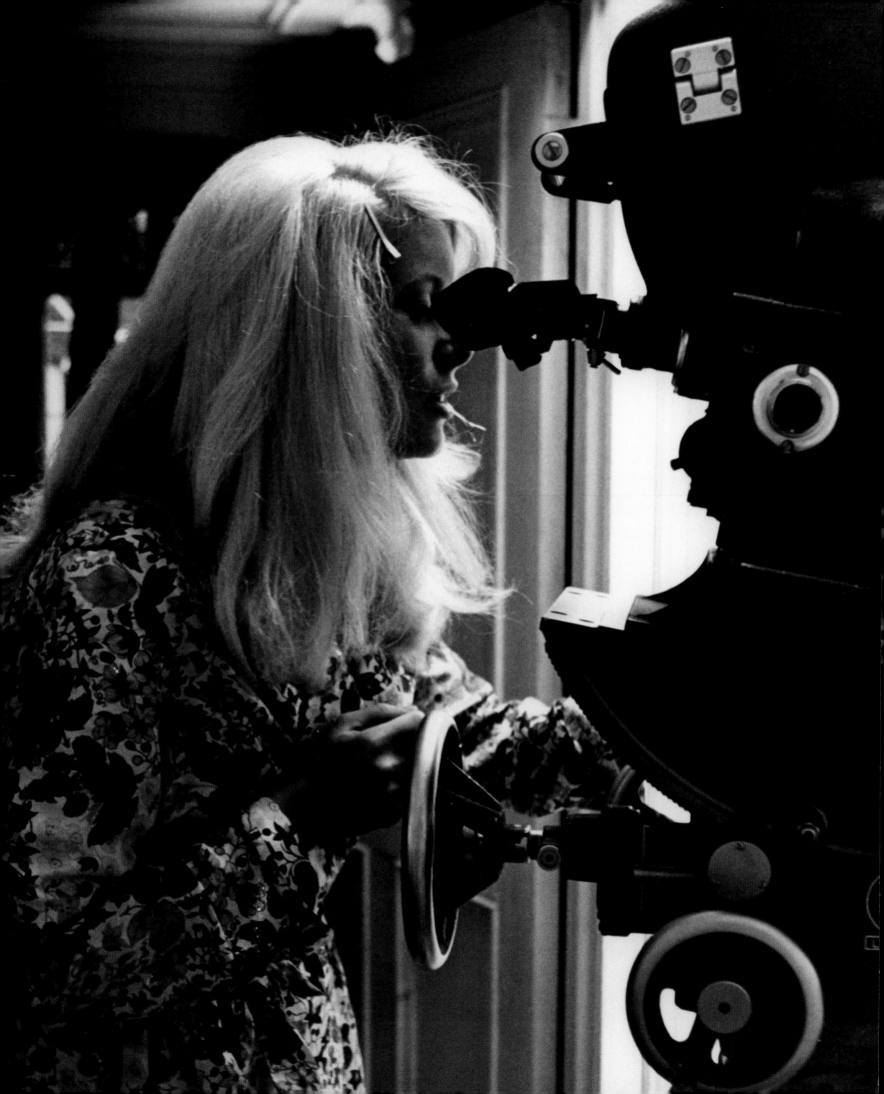

> **"You will say what you please: Everything is gross, silly, stupid, and anyone could tell the story in a grotesque manner. That is easy. Only I told it in a plausible manner, and with surprising psychological motivation. The result is that it has become true."**

It was his first film in English, though he hadn't entirely mastered the language. At thirty-two, his youthful enthusiasm allowed him to play with ideas that had been floating around in his head, many of which would form part of his mature style. Polanski now shudders at some of the showiness, but it's that exuberance that makes the film so much fun.

"*Repulsion* was my discovery of London," Polanski told me. "I'd never been in England before, and I was suddenly overwhelmed by the Anglo-Saxon world: language, objects, sets, people. It was new to me and I was tremendously inspired. It's great to be excited by a setting and to be able to use it in a picture."

Repulsion was Polanski's first great work of claustrophobia, a theme he would return to over and over again. Most of the action takes place in the South Kensington flat where Carole and her older sister Helen (Yvonne Furneaux) live. Polanski understood that the set was crucial to exploring the deeper psychological aspects of the film. With his art director Seamus Flannery, he constructed a model of the apartment on his living room floor, and came up with a plan. "As she starts more or less hallucinating," recalled Polanski, "I wanted it to have the feel of the place getting bigger and having her lost in the middle. So we decided to build the set in such a way that we could open up the walls and move the flats out."

For Polanski, the devil has always been in the details. He understands that little things can be as horrific as cutting off heads. *Repulsion* is full of these small touches that make it come to life. A fetal-looking, skinned rabbit, first in the refrigerator and then left to decay in the living room, is one of the film's haunting primal images that on one level indicates the passage of time, but also seems somehow connected to the psyche of the central character. It's unforgettably creepy.

Polanski is also masterful in his manipulation of sound. Chico Hamilton's jazzy score is used quite sparingly in order to call attention to ambient sounds. So as Carole begins to lose her mind, her senses become more acute and sounds such as dripping water, a ticking clock, and nuns playing catch in a convent yard, become exaggerated and more ominous. It's the kind of old-fashioned horror film trope Polanski delights in using to turn the screws.

By design, *Repulsion* takes its time getting to the shocking stuff. Much to his producers' chagrin, Polanski wanted to lull the audience into a sense of calm and then scare the bejesus out of them. When her sister and boyfriend go off on a holiday to Italy, Carole is at first like a wayward, disturbed child left on her own, and then gradually all hell breaks loose. It's about fifty minutes into the film before Carole swings open a closet door in her bedroom and sees a strange man reflected in the shadows. As a music cue pounces on the moment, she jumps a foot, and so does the audience.

Even the surreal moments possess their own internal logic. It makes perfect sense that the walls start to gradually crack, mirroring the fissures in Carole's psyche. But working on a tight budget without a special-effects team, Polanski had to set up everything himself. "The simplest appearance of cracks in the walls proved to be our biggest headache," he said, shaking his head even after all these years. "The walls had to be plastered and repainted for every take."

Catherine Deneuve takes
her turn behind the camera.

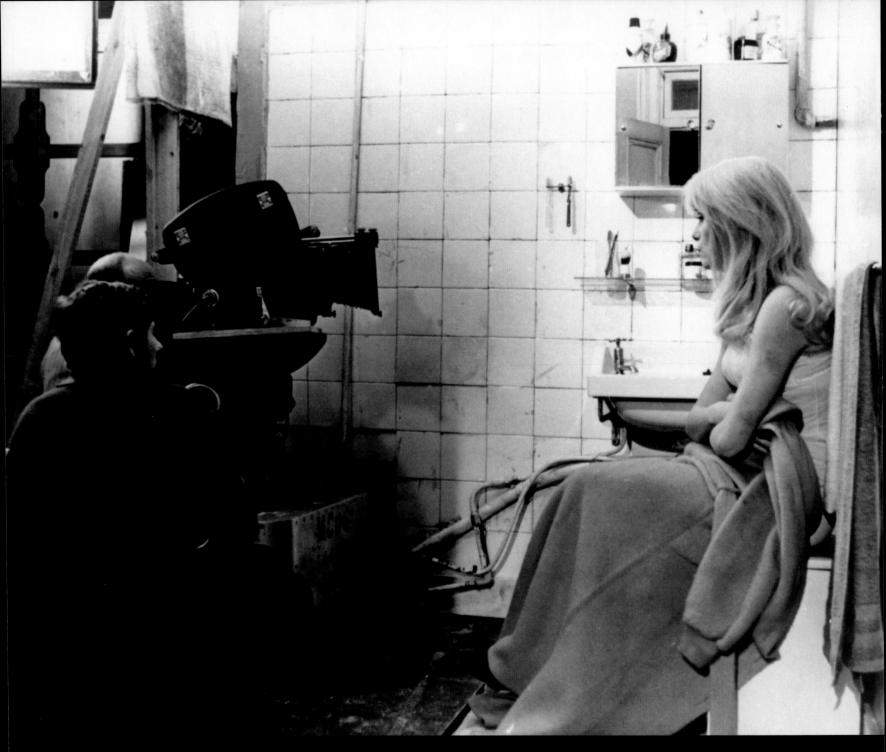

Mirror images: Carole's sister's lover, Michael (Ian Hendry), shaves himself (opposite top) with the straight razor that Carole will later put to murderous use. Throughout the film the bathroom mirror also helps to convey the young woman's increasingly troubled mental state (opposite bottom).

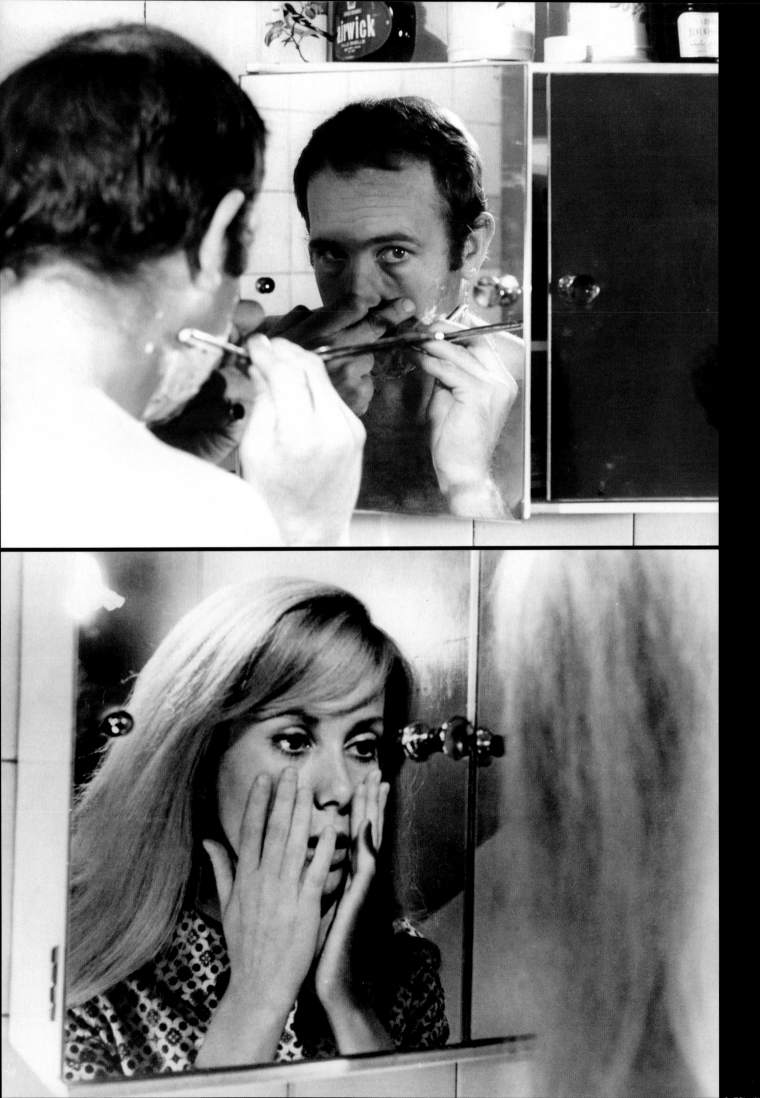

"*Repulsion* became an artistic compromise that never achieved the full quality I sought. In retrospect, the special effects strike me as sloppy, and the sets could have been more finished. Of all my films, *Repulsion* is the shoddiest—technically well below the standard I try to achieve."

Another hallucinatory effect that was difficult to set up involved a dozen or so pairs of hands popping through the wall, reaching out to grab Carole. To stage the shot, Polanski sent his production designer off to a condom factory to buy sheets of latex that were placed in the wall and painted over so the hands could burst through on cue. It was a primitive special effect to be sure, and its execution is still a sore point for Polanski.

"Oh God, how many things I could have done so much better if I had [computer-generated imagery]," laments Polanski. "For example, certain surrealistic images I had in my head in those times I could not express with the technology of that period. The hands in the wall would be so easy now."

The money shot (a term the producers no doubt would have appreciated) was a stunner at the end of the film. With the dirty work done, the apartment in havoc, two dead bodies discovered and removed, the camera crawls around looking at the remains. Coming upon a family photograph from Carole's childhood, Polanski bores in and in on it until it reveals the root of the problem. All the family members are looking toward the camera with pleased-to-be-there expressions—except Carole, who is glaring distrustfully at her father. Polanski would never say, but one can surmise what might have happened.

This is a rightfully famous and innovative shot, and I wonder whether Stanley Kubrick might have been influenced by it for the final frame of *The Shining*. Again, as Polanski recalled, it was tough to pull off. "In those days to actually execute this type of shot was very difficult. The dolly did not have the same mobility that it has now, and the zoom was hand-operated, so to get it really smooth and come in was very difficult. I had to do a lot of takes."

Although it remains powerful and leaves the audience with an appropriately unsettled feeling, Polanski was never entirely happy with the shot, or the whole movie for that matter. "It was made on such a shoestring that I feel upset seeing it because it was not as I wanted simply because we did not have enough time or money to do it to my satisfaction. So I think the film is quite shabby."

I was surprised to hear that. "Shabby but effective, or just shabby?" I asked him. "Well, apparently effective because of the reactions," he replied. "You always hope for it, but the success of the film was unexpected. But because of the reactions I can say it worked."

This scene, in which hands emerge from the wall to grab Carole, made ingenious use of latex sourced from a condom factory. But it's the kind of surreal moment that could be done much more easily today with computer-generated imagery.

Cul-de-Sac ₁₉₆₆

"Making *Repulsion* had been
a means to an end: *Cul-de-Sac.*"

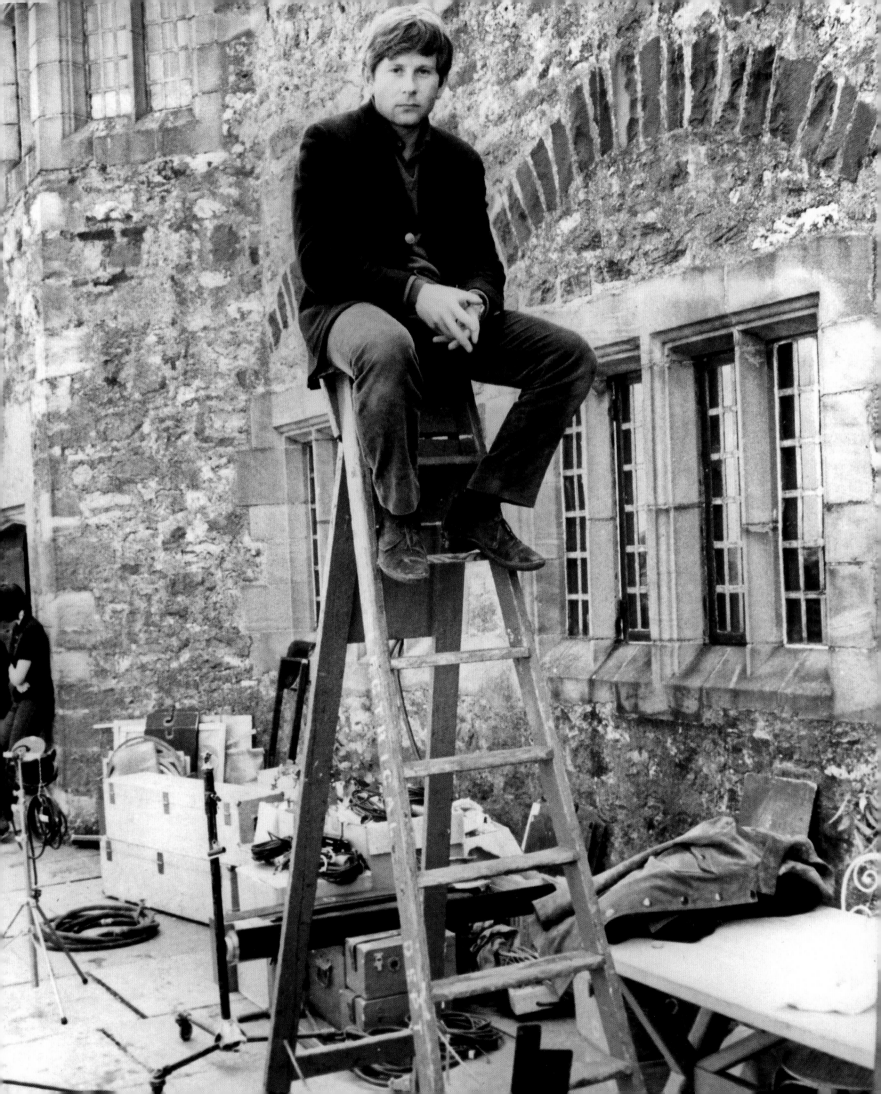

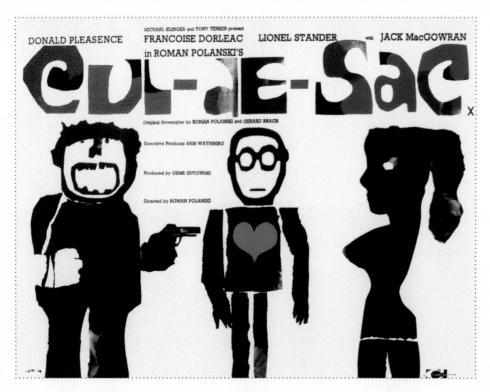

The poster text reads: DONALD PLEASENCE, FRANCOISE DORLEAC, LIONEL STANDER, with JACK MacGOWRAN, MICHAEL KLINGER and TONY TENSER present, in ROMAN POLANSKI'S Cul-de-Sac

I've seen *Cul-de-Sac* countless times and still find it hard to categorize, which I think is exactly what Polanski and his co-scenarist Gérard Brach had in mind. They wrote it before *Repulsion,* in a period when they were down and out in Paris and going to movies almost every day at tiny revival houses in the Latin Quarter. Among the films they must have seen were American gangster pictures from the thirties and forties. Filtered through their unique sensibilities, it came out as *Cul-de-Sac.*

"We were using this type of image but putting it in a different context," remembered Polanski. "And that was tremendously amusing to two young film lovers. It didn't matter what it was about or how it was organized. What mattered was that it contained the situations, scenes, and atmosphere that we wanted to create; that was the approach we took when we started working on it."

They dreamed up the story of a retired British businessman and his sexy young wife who are held captive by an American gangster on the lam. If it sounds like *Key Largo* or *High Sierra,* or a dozen others, forget it. It's more Samuel Beckett than John Huston, and is reminiscent of the experiments with surrealism and theater of the absurd Polanski had tried in his student films.

After an extensive search, Polanski found the perfect setting for this macabre tale: an isolated speck of land off the northeast coast of England called Holy Island, a place cut off from the mainland twice a day by high tide. And even better, atop a hill on the island sat a sixteenth-century castle, so Polanski and Brach revised the script to include it. This singular location is as much a part of the story as the characters. As the water ebbs and flows, engulfing vast expanses of sand, and puffy clouds float across the sky in magnificent black and white, Polanski orchestrates the power struggle between three people with their hands at each other's throats.

A man may be king of his castle, but not George. Played brilliantly by Donald Pleasence as a bag of neuroses, he's married to Teresa (Françoise Dorléac, older sister of Catherine Deneuve), a beautiful French woman of dubious morals. Married only nine months, she's already bored and as the film opens she is having

Previous page: "There were days when the whole crew were against me, when I felt totally solitary in my work."

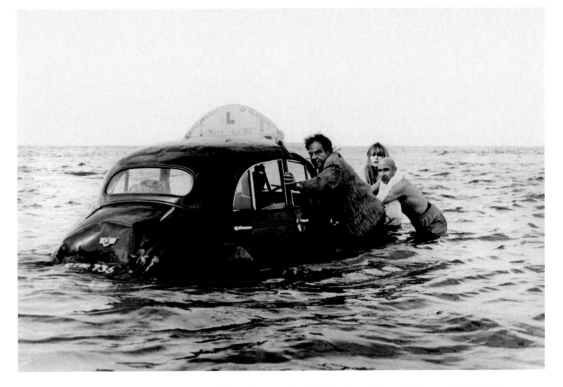

Right: Teresa (Françoise Dorléac) and her husband George (Donald Pleasence, with shaved head) help failed robber Dickie (Lionel Stander) to retrieve his getaway car, and his mortally wounded accomplice, from the rising tide.

Below: Sharing a child's scooter with Françoise Dorléac. Holy Island, the geographical cul-de-sac on which the film is set, can be seen in the background.

a roll in the sand with her boyfriend. Enter Dickie (the gravel-voiced Lionel Stander) and his dying partner Albie (Beckett stage veteran Jack MacGowran). They've both been shot fleeing a botched robbery and Dickie leaves his friend in the car to seek help. By the time he returns, the car has been nearly swallowed by the sea. Albie's head, with Coke-bottle glasses poking up above the waterline, is just one of Polanski's many darkly hilarious images.

At this point, Dickie invites himself into the castle and phones his boss Katelbach for instructions. In fact, the script was originally called *When Katelbach Comes*. But Katelbach, like Godot, isn't coming, leaving Dickie to figure it out on his own. For all his bluster, when faced with the unknown, he has no answers.

Dickie arrives at the castle just as Teresa has taken George's pants off, dressed him in a woman's nightgown, applied makeup and assumed the male role in their relationship. After some initial tough talk, she bonds with Dickie over homemade vodka as he digs a grave for his friend. Later, it's George's turn to cozy up to Dickie. Together they form a strange, almost co-dependent household, playing pranks and nearly killing each other. Polanski understands that the funny thing about power is how it can turn on a dime and confound expectations. Eventually, instead of the gangster killing George, the meek George rises up and plugs Dickie.

If this were a Hollywood movie, the intrusion of a dangerous stranger would reunite the threatened couple. But by the end Teresa despises George more than ever and George is destroyed by love. To complete this domestic picture, Polanski presents another household model when friends of George arrive for an unannounced visit.

63

Above: A bored young French woman cooped up with her neurotic husband on a remote island, Teresa seeks various distractions, including fooling around with her boyfriend in the dunes.

Opposite: Geoffrey Sumner and Renée Houston (far left and center left) play an insufferably middle-class couple on a surprise visit to George and Teresa.

"We just sat down and decided to write whatever we wanted to, just what we wanted to see on the screen; completely disconnected things, just feelings and characters."

A parody of the British middle class, they're insufferable even for George, who, in his best W.C. Fields imitation, kicks their kid and throws them all out of his "fortress." So much for the bourgeois niceties of the nuclear family.

For all of his coarseness and loutish behavior, there is something perversely endearing about Dickie. When he was casting the part, Polanski was looking for a Wallace Beery type. "It was very difficult to find somebody like that in England. And then one evening [producer] Gene Gutowski called me and said there was an American actor on a talk show and it was our Dickie. So the next day we contacted Stander and hired him immediately."

Stander had been blacklisted during the McCarthy era in America in the fifties and was living in England. He was on his best behavior at first, but the honeymoon didn't last long. "He started to become extremely lazy. Good living and good booze were much more interesting to him than the work. He was a pain in the ass. I mean, he was terrible," lamented Polanski. "But we had problems with everything, with the lighting, with the weather. Changing weather is disastrous for the filmmaker."

"There was hail, rain, a foot of snow, and I had to make it all look like August," said cinematographer Gilbert Taylor in an earlier interview.

Not surprisingly, the production quickly fell behind schedule and the budget soared. The Compton Group,

Above and opposite: Teresa assumes the dominant role in her marriage, dressing a compliant George in her negligee and applying makeup to his face—or, at other times, simply ignoring him.

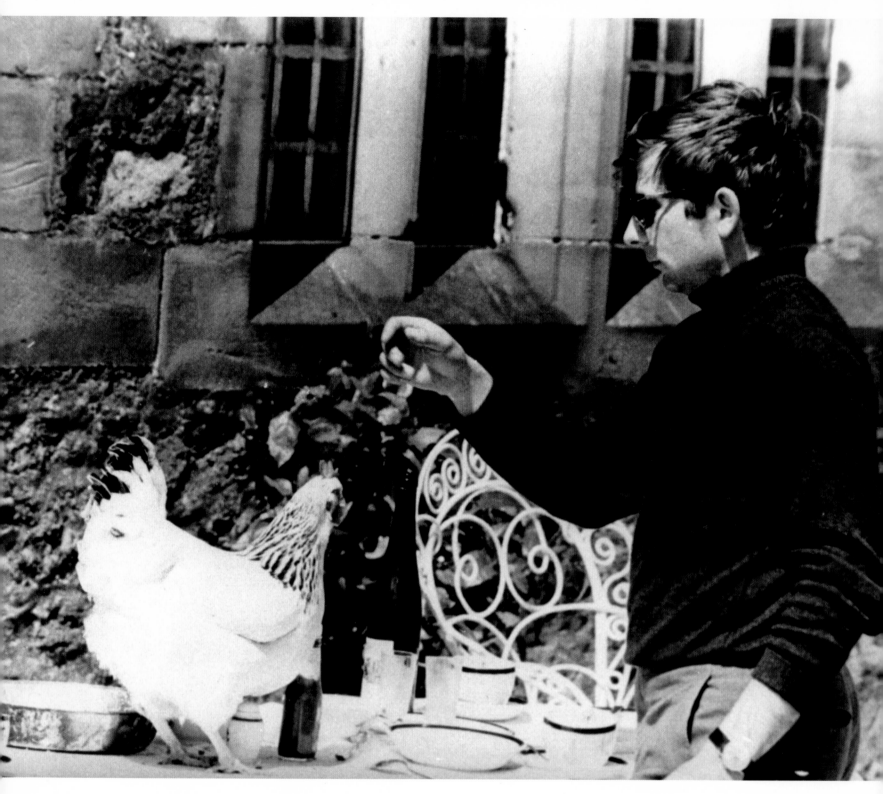

"My head tells me that *Cul-de-Sac* is my best film—it is the film that is the most self-contained. It only has meaning as a movie, as itself."

Right: The heartbreaking final scene in which George, now completely alone, sobs uncontrollably on his island within an island.

Opposite: Polanski gives the chicken its motivation.

the British former soft-core porn company that had provided the money for *Repulsion*, was squeezing Polanski again. "They left me alone as far as the artistic side of it goes but I had those guys on my back telling me about the budget. It was getting on my nerves, I was certainly tense and uptight."

To top it off, the crew and actors were disgruntled after months on the island (population 300), eating nothing but lamb, salmon, and twenty pounds of pastrami Stander had imported from the Stage Deli in New York. It all came to a head as Polanski tried to set up an ambitious shot to save time. In the scene, George is drunk on the beach, pouring his heart out to Dickie about the failure of his marriage, when Teresa walks by, drops her robe, and goes for a swim. Just then a plane flies overhead and Dickie thinks it's Katelbach coming to rescue him and starts firing his gun into the air. Even Taylor thought it would be impossible to coordinate the plane to fly overhead on cue, but Polanski pulled it off according to plan as a single eight-minute take. However, the water was so cold that in the middle of the scene Dorléac fainted from hypothermia.

"Suddenly the whole crew was against me. I was a torturer, a sadistic director who doesn't care what happens to his performers," recalled Polanski. "So, I said, 'OK, let's wrap it up and do the rest in the studio, and I'll just come back here with a camera to shoot a few details without actors.' And that's how we finished it."

Polanski says he couldn't make a film like *Cul-de-Sac* now, and doubts anyone would finance it anyway. He wouldn't have the same innocence and naïveté that allowed him to try anything. "It was almost like a teenager's movie," says Polanski with a trace of nostalgia. "But I like the film. I think it is really a *movie*—not a theater piece or a book. It could only be expressed this way, in this medium."

In *Cul-de-Sac*, perhaps more than in any of his other films, the bleakness of Polanski's vision is tempered by an almost childlike sense of fun. We're watching a skilled young director playing around with his toys. But the overriding feeling—which the movie's dramatic location makes abundantly clear—is that, in this life, there is no such thing as solid ground.

69

The Fearless Vampire Killers 1967

"I get more fond of that film every year. I suppose I am reliving my happiness at the time of making it. It was toward the end of the 1960s. Everyone was full of hope and good spirits. I was making a comedy with people I liked, and of course with Sharon."

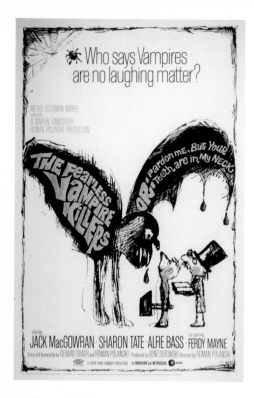

Polanski is not normally the sentimental type, but he said he gets a bit teary-eyed when he watches *The Fearless Vampire Killers*—and not just because he was starting his relationship with the film's co-star and his wife-to-be, Sharon Tate. "It's a favorite of mine because it associates with a very happy period in my life—the late sixties in London." And unlike his previous film, *Cul-de-Sac*, where no one got along on the set, this was great fun to shoot with friends in the snow in the Italian Alps.

Previous page: On set with Sharon Tate, who played the innkeeper's daughter, Sarah. They were to marry a year later.

Friends in the snow: The camaraderie Polanski found on the set of *The Fearless Vampire Killers* (right) made a welcome contrast to his previous film. This time he was acting as well as directing—in the role of Professor Abronsius's assistant, Alfred (opposite).

"It made us all feel like children," continued Polanski. "We enjoyed that shoot to the extent that it cannot compare with any other experience I had after. So, each time I see this, I recall the atmosphere on the set, what was going on around it, and the people who worked on it."

After directing *Repulsion*, Polanski and his writing partner Gérard Brach were watching a lot of the British low-budget horror movies churned out by Hammer Films. "Seeing those films, I realized that the more horrific a scene was, the more the audience laughed, and I remember saying it would be great to make a horror film which would be intentionally funny. So that's how the idea started."

A parody of vampire movies, *The Fearless Vampire Killers* is given over to the silly rather than the dark side of Polanski's sensibility. It was his first film in color and his only overt comedy. He wanted it to be entertaining for people who went to the movies just for fun. Is it? Even Polanski admits it's a matter of taste. Some may find the wall-to-wall sight gags, one-liners, and pratfalls somewhat one-note, but it does have a certain charm, and regardless of how successful it is, it's nice to see Polanski in a lighter mood.

The story follows the dotty Professor Abronsius (Jack MacGowran) and his trusted assistant Alfred (Polanski) as they travel to Transylvania in search of the undead. Checking into a local inn that looks like a delicatessen by way of Chagall (salamis and garlic hang from the rafters), the innocent Alfred is immediately smitten with Sarah (Tate), the innkeeper's young daughter—a case of art imitating life. Initially, Polanski didn't want to cast Tate because he thought she didn't look like a Jewish innkeeper's daughter. She doesn't, but who cares;

she's ravishing. Polanski had so enjoyed working with MacGowran on *Cul-de-Sac* that he wrote the role of the professor for him. With a wild mop of white hair and wire-rimmed glasses, Abronsius looks like Einstein without the brains.

After Sarah is bitten and abducted by Count von Krolock (Ferdy Mayne), Abronsius and Alfred set off to his castle in hot pursuit. The wonderful castle sets built at the MGM British Studios were created by production designer Wilfred Shingleton and allowed the camera to move up and down dark corridors, through windows, and into the claustrophobic crypt. Many of the conventions of vampire movies are employed with a wink to the genre so it all looks appropriately artificial. The matte painting of mountains behind the castle isn't meant to fool anyone. And as in all vampire pictures, the castle's first line of defense is a hulking hunchback (played by former world middleweight boxing champ Terry Downes). When the servant catches the professor and Alfred snooping around, he drags them into the ballroom to meet the count.

Channeling Christopher Lee, Mayne's count is courtly, urbane, and educated, making him the only character in the film with the slightest hint of depth. His son is another story: a gay vampire (played by Polanski crony Iain Quarrier) with a hankering for Alfred. This is one of Polanski's tweaks to the vampire canon, and the idea of a fey vampire shuffling delicately around the castle is indeed good comic fodder.

The film is infused with the Eastern European rhythms and humor Polanski grew up with. In one of the best gags, a Jewish vampire (an amusing idea in itself) is preparing to chow down on a housemaid when she pulls out a crucifix.

"Our basic aim was to parody the genre in every way possible while making a picture that would, at the same time, be witty, elegant and visually pleasing."

Above: Performing with Jack MacGowran (Professor Abronsius) and Ferdy Mayne (Count von Krolock).

Opposite: Out for the count— chief vampire hunter Abronsius is floored by a knockout blow.

Above: Count von Krolock turns in for the day.

Left: Having saved Sarah from the clutches of the vampires and expecting a kiss as his reward, Alfred is about to receive an unpleasant surprise.

Opposite top: Alfred prepares to drive a stake into the sleeping vampire, but is unable to go through with it.

Opposite bottom: This elaborately staged dance of the vampires gave the film its original title.

"What I made was a funny, spooky fairy tale, and Ransohoff turned it into a kind of Transylvanian *Beverly Hillbillies*."

He looks at it dismissively and says, "Oy, do you have the wrong vampire!"

Another piece of vampire lore that Polanski played with is the notion that vampires don't cast shadows or have reflections in mirrors. In the film's most lushly produced set piece, a midnight ball with sixty vampires dressed in formal vintage finery, the hunters and the hunted dance past a mirror, but only the professor Alfred are visible. It's a nifty trick, and when I asked Polanski how he was able to pull it off, he joked, "with mirrors." Then he explained, "It was just a cut in the wall and I had doubles on the other side."

It was always Polanski's intention to cast himself as the bumbling vampire hunter who is afraid of vampires. The part required stamina and the ability to ski, which he felt would have been hard to find in another actor, plus he would have missed out on the fun. Outfitted with a pair of old-fashioned wooden skis, he and the professor had to race down a mountainside. "We could not fix the shoes to these old skis to do what we needed. So I remember taking off my shoes and a crew member nailing them to the skis to go down the hill; we got one take," Polanski laughs thinking about it now.

He was, however, not laughing when the film came out. *The Fearless Vampire Killers* was the first film he made for an American production company, and Polanski had naïvely given the executive producer, Martin Ransohoff, final cut for the Western Hemisphere. So to sell it more as a farce, the studio cut nine minutes, added a ridiculous animated prologue, dubbed the voices, and changed the name from its original title, *Dance of the Vampires*, to *The Fearless Vampire Killers or: Pardon Me, But Your Teeth Are in My Neck*. The critical response in the United States was terrible, though it was better received in Europe and over the years has found a cult following.

"In America the film was never shown in its complete version," lamented Polanski. "The fact that it was butchered and dismissed and swept under the carpet is like a wound."

The film ends with a dark and unexpected Polanski flourish. Alfred saves Sarah from the clutches of the count and whisks her away on a sled into a seeming winter wonderland. But at the last instant, just when it looks like she is going to kiss Alfred, she flashes her newly acquired vampire fangs and sinks them into his neck. Even in a Polanski comedy, love ends badly.

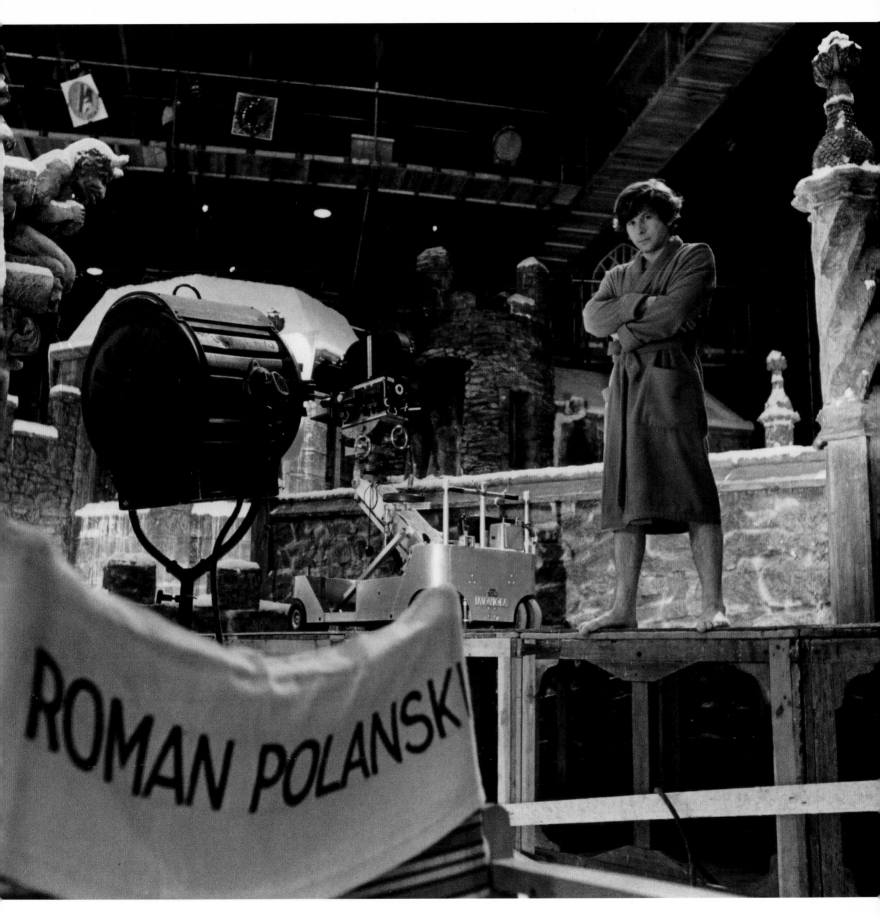

Polanski's name may have been on the director's chair, but this did not give him any influence over the final edit of the film— or its title in the United States.

Rosemary's Baby 1968

"The title was *Rosemary's Baby*. My reaction to the first few pages was, 'Hey, what is this, some kind of soap opera?'"

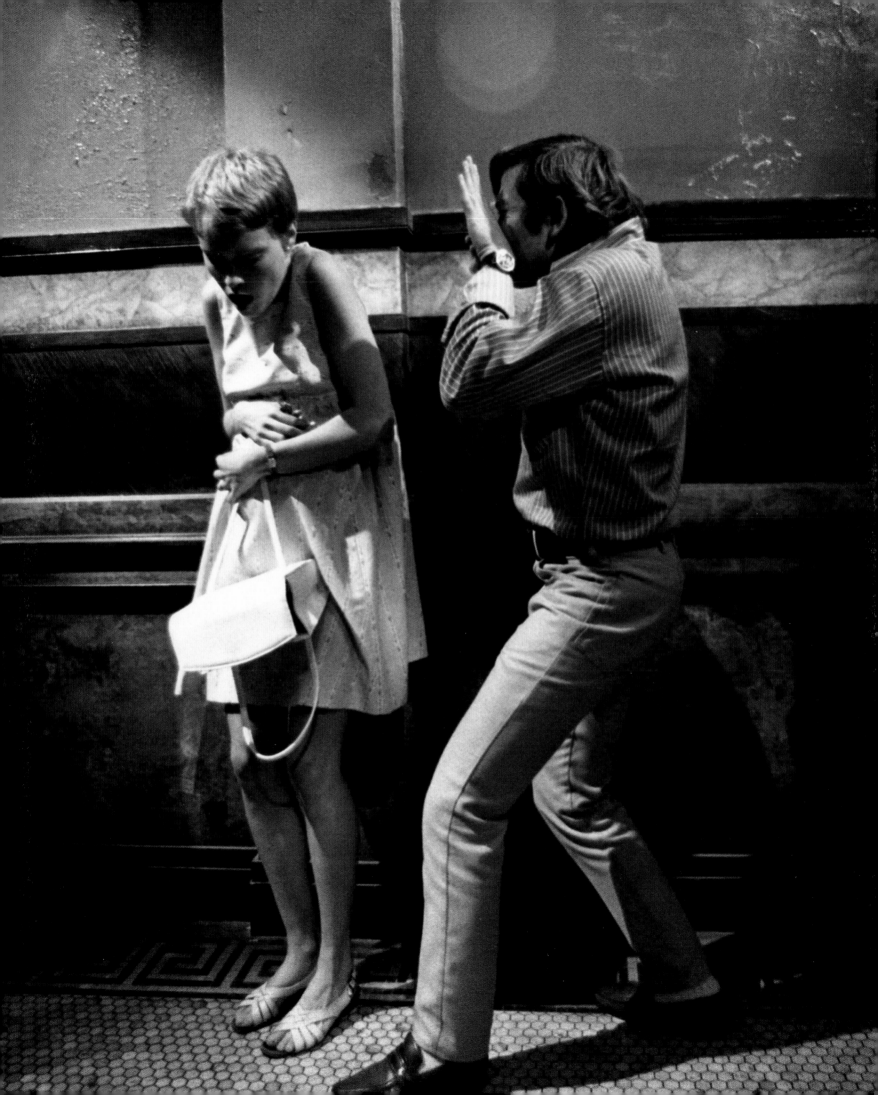

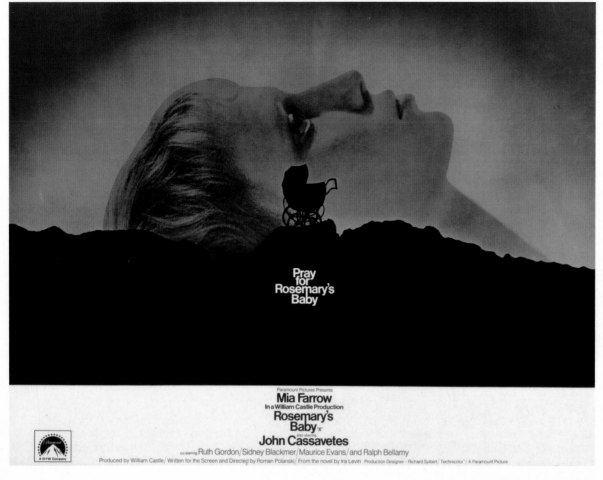

Paramount Pictures Presents
Mia Farrow
In a William Castle Production
Rosemary's Baby 'X'
also starring
John Cassavetes
co-starring Ruth Gordon / Sidney Blackmer / Maurice Evans / and Ralph Bellamy
Produced by William Castle / Written for the Screen and Directed by Roman Polanski / From the novel by Ira Levin Production Designer - Richard Sylbert / Technicolor° / A Paramount Picture

Ever since he was a teenager, Polanski imagined how he would turn a novel he was reading into a movie. With Ira Levin's supernatural potboiler *Rosemary's Baby*, he got his first chance to do so. It marked his inevitable arrival in Hollywood, and at thirty-four his coming-of-age as a world-class director. He couldn't have been happier.

Initially, however, Polanski was lured to Tinseltown under somewhat false pretenses. "Robert Evans [Paramount head of production] called me with a proposal for a skiing picture, *Downhill Racer*," Polanski remembered. "And since skiing is my sport and I've always been eager to do a film about it, I came and he handed me the script and also a bunch of long strips of pink paper which were the proofs of a book called *Rosemary's Baby*. He said, 'Read this first please.' So I went back to the Beverly Hills Hotel, where I was staying, and started reading it, and around four in the morning I was still at it. The next day I came back to the studio, and said, 'OK, I'll do it.' And that's how it happened."

Polanski immediately saw the cinematic potential of Levin's tale of a young, innocent wife in New York whose husband sells their baby to a pack of Satan worshipping witches in the next apartment. He was so excited by the project that he went back to London and in a marathon session dictated the script to his secretary in three weeks, returning to Los Angeles with a 260-page first draft.

Rosemary's Baby is still a very scary film because Polanski completely understood the book and what he needed to do with it. The originality of his concept was to present supernatural events in a real and believable way. What made the story shocking was that Rosemary was a vulnerable girl from Omaha living an everyday life in the

Previous page: Framing a close-up of Mia Farrow, who plays the film's central character, Rosemary Woodhouse.

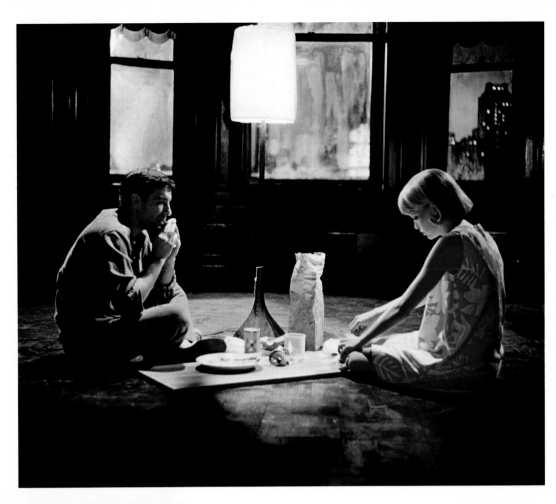

Rosemary and her infernally
ambitious husband, Guy
(John Cassavetes), settle in
to their new apartment.

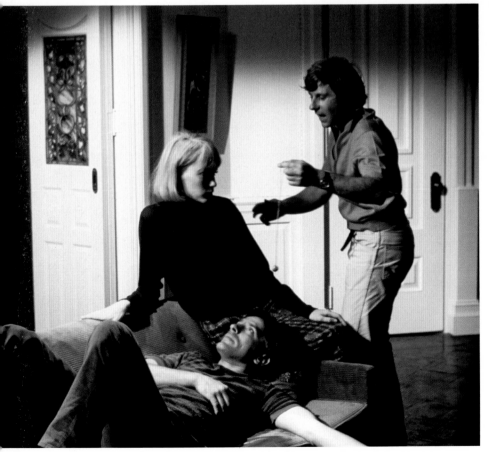

big city that little by little goes haywire. In the context
of the film, it was something that could happen to any
unsuspecting soul.

This was gold for Polanski, who in his best films
has taken ordinary people and magnified their worst
nightmares: Jake Gittes is drawn back to Chinatown
against his best judgment; with no apparent survival
skills, the hero of *The Pianist* is thrown into a war-ravaged
world and forced to survive. Just like that, life can take
a wrong turn and become dangerous. For Polanski,
existence has always carried a sense of dread. That's why
he's naturally so good at building suspense. When I asked
him how he does it, he said, "It's just there ... If I have
some kind of facility in creating suspense it comes from
life and the various things that I may have gone through
for real."

In *Rosemary's Baby*, Polanski wastes no time setting
up a disquieting tone. The credits roll with various benign
bird's-eye views of New York, but as the camera closes in
and it's time to begin the story, a conventional overhead
shot of an ornate apartment building (the Dakota on
the Upper West Side of Manhattan, called the Bramford
in the film) is slightly off kilter. It's at an odd angle, a bit
woozy and vertigo inducing. On top of that, Mia Farrow
is humming the film's haunting theme in the background,
as if casting a spell.

83

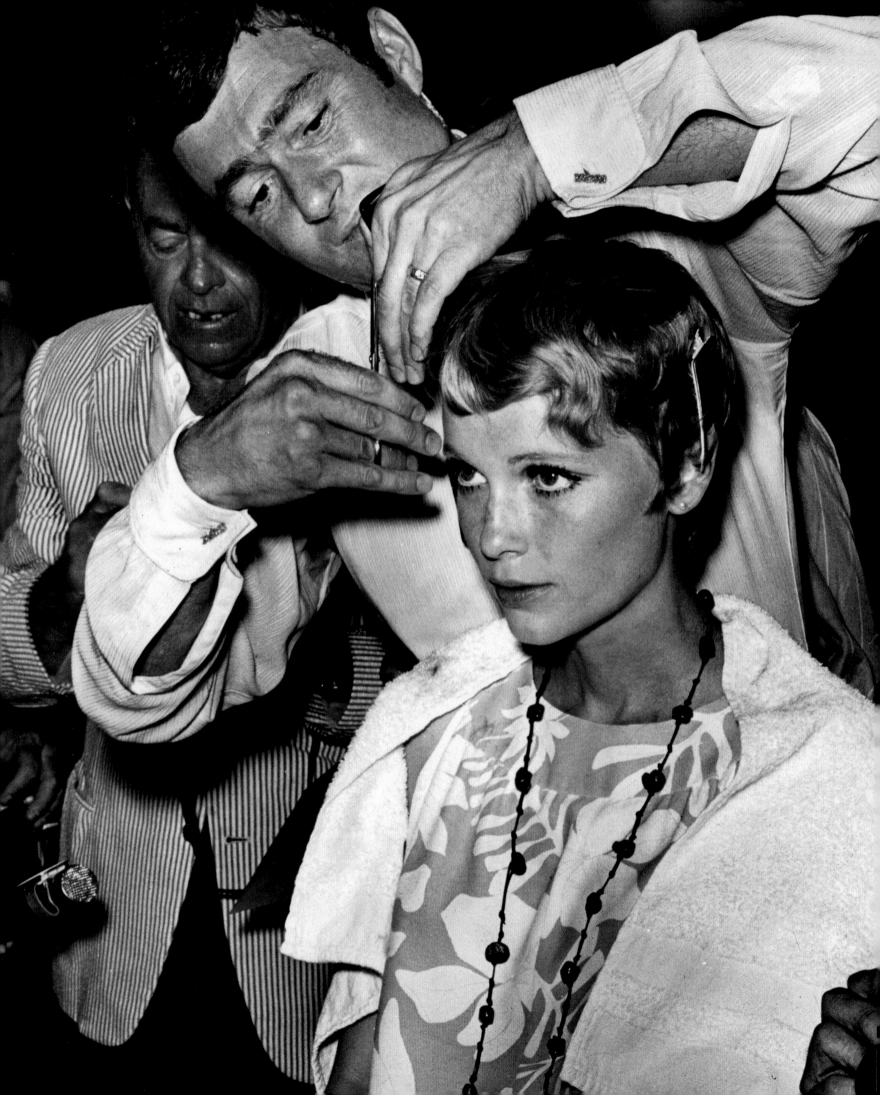

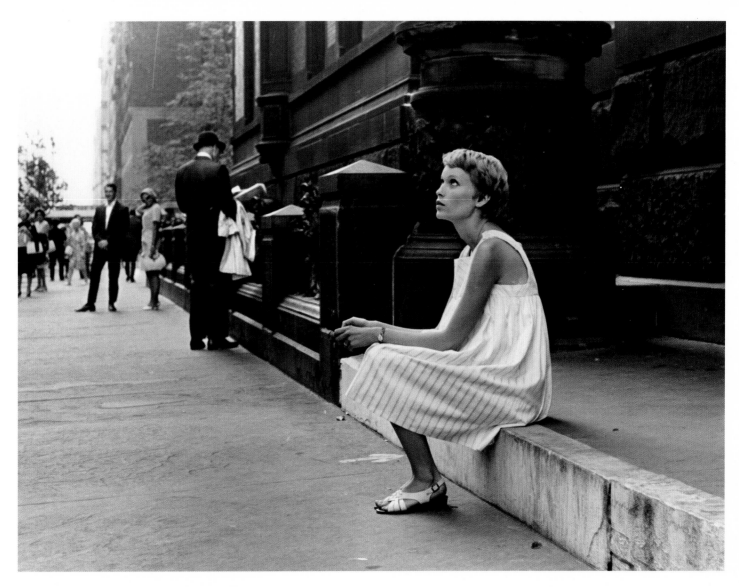

"I wanted a sort of healthier-looking young woman, like a typical milk-fed American that a couple like the Castevets would be really convinced was good material for a mother—which Mia was not necessarily. But it was a good choice. And it was a terrific time, those few months of work with Mia. She was fantastic to work with."

Even when Rosemary (Farrow) and her actor husband Guy (John Cassavetes) are happily looking at the apartment, there is an uneasy feeling. And with the great, jittery character actor Elisha Cook, Jr. (the gunsel who Bogart slaps around in *The Maltese Falcon*) as the renting agent, it's a good bet that something is wrong with the place.

But to set up the ghastly events to come, Polanski made everything around them seem normal, including the supporting cast. In those days he would sketch what the characters looked like in his mind's eye and give it to the casting people to bring in possibilities. He wound up casting a harmless-looking bunch of Hollywood old-timers who are pitch perfect. Sidney Blackmer and Ruth Gordon play the next-door neighbors, the elegant patriarch Roman Castevet and his dotty wife Minnie. Patsy Kelly is the none-too-bright upstairs neighbor Laura-Louise. And central to the plot is Ralph Bellamy, who exploits the wholesomeness he had built a career on, as the prominent New York obstetrician Dr. Sapirstein. All of them witches.

Opposite: Polanski's friend Vidal Sassoon cuts Farrow's hair as a publicity stunt for the movie.

Above and overleaf: Polanski admired the natural, unaffected quality of Mia Farrow's acting. The warmth of their working relationship can be sensed in the playful chart he kept of her daily performance.

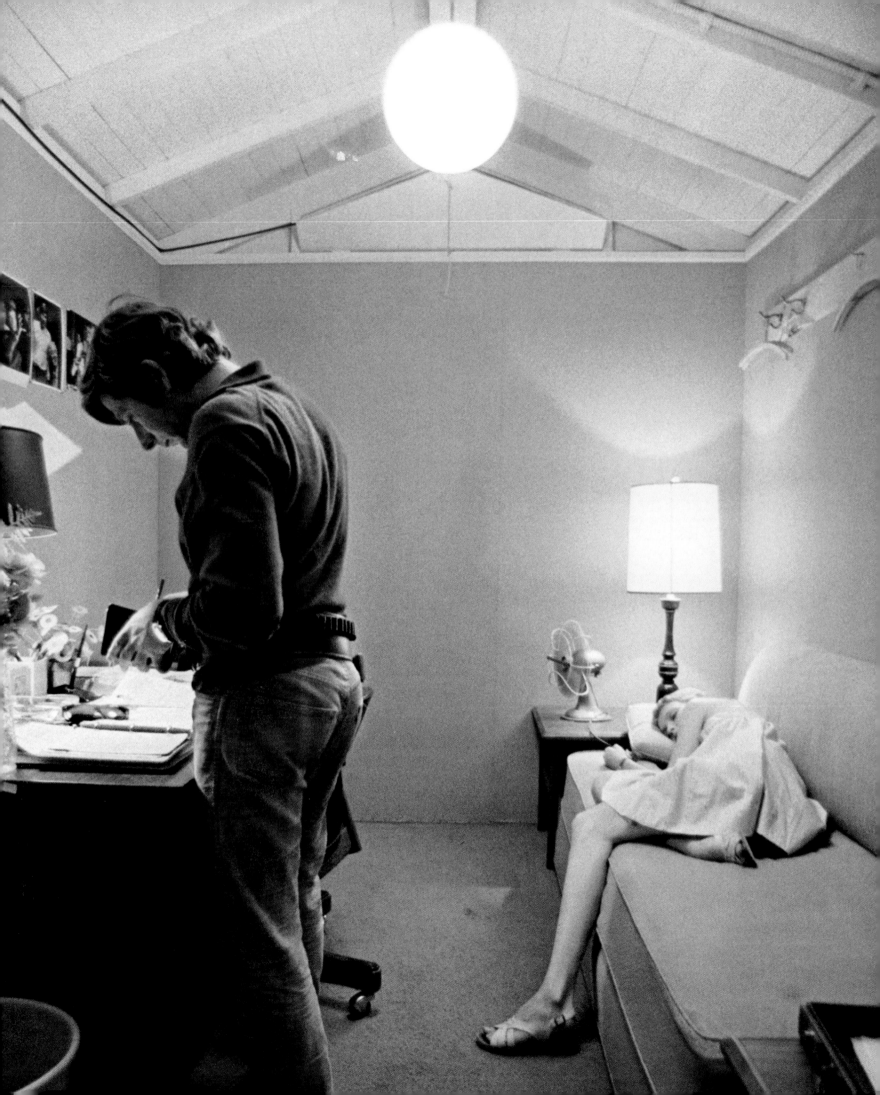

The character of Rosemary described in Levin's book was a robust, all-American girl, so Farrow was initially not even on the radar as Polanski met with every prospect on the Paramount lot. At that time, she had some notoriety as the star of TV's *Peyton Place* (and as the wife of Frank Sinatra), and when Polanski met with her he was taken with her naturalness (she painted flowers and wrote the words "peace" and "love" above her dressing room door). He liked that Farrow had none of the Method "trickiness" about her and played things straight. Her slightly spacey, helpless quality made her seem like the perfect sacrificial lamb at the altar of her husband's ambition.

For the role of Rosemary's opportunistic husband Guy, Polanski settled on the New York actor and director Cassavetes. Perhaps fittingly given the nature of the material, it was not a marriage made in heaven and ultimately these two strong-willed men of opposing sensibilities did not get along. As a director, Cassavetes was freewheeling and improvisational, where Polanski was precise and methodical; as an actor, Cassavetes was Method trained while Polanski preferred a more naturalistic style. Polanski was never entirely satisfied with Cassavetes' performance, but I think he underestimates its effectiveness.

This is a deeply despicable character. As an actor whose career is going nowhere he thinks nothing of offering his wife to the devil in exchange for success. His hunger for fame, as relevant today as it was when the film was made, is what really drives the plot. Not surprisingly, next stop for him is Hollywood. Whatever his method, Cassavetes was convincingly able to capture the character's shallowness and self-absorption.

Polanski had no trouble adapting to the Hollywood system. "I felt very much at ease and even if I had to experience a new type of work because it was a studio picture, I felt very comfortable," he recalled. "I even remember driving through the Paramount gate on the first day of shooting and thinking I don't have any of the butterflies that you usually have."

For the first time, Polanski felt that he totally knew what he was doing on the set and was in full control of the medium. He was getting paid $150,000 as the director, more than he made on all of his previous movies combined. But perhaps more importantly, he was working with a then-sizable $2.3-million budget and a crew of sixty first-rate technicians. He was intent on making the most of the resources he had at his disposal. Ever since he had seen Elia Kazan's *Baby Doll* when he was in film school, Polanski had admired Richard Sylbert's production design. The two men met in London while Polanski was making *Repulsion*, and Polanski said he hoped to work with him someday. Until *Rosemary's Baby* he could never afford his salary, but once he was in Hollywood, Sylbert was the first person he hired, even before the cast.

As an inveterate New Yorker, Sylbert was an ideal choice. "Roman didn't know New York," recalled Sylbert in a 2000 documentary about the making of the film. "I spent thirty-five years there. There's not a place in the book that I didn't know." Perhaps his greatest contribution to the film was the interior set for the Dakota apartments that he built on the Paramount lot. The mid-sixties modernism of Rosemary's apartment and the Old World Gothic of the Castevets' place next door set the perfect tone for Polanski to stage these terrifying events.

During the making of *Rosemary's Baby*, Farrow had to deal not only with her director's scrutiny but also with the breakdown of her marriage to Frank Sinatra, who served her with divorce papers while she was on set.

"In *Rosemary's Baby* I never gave any supernatural hints—it could all be interpreted, in the final analysis, as some kind of a neurosis on Rosemary's part: a figment of the imagination of a pregnant woman."

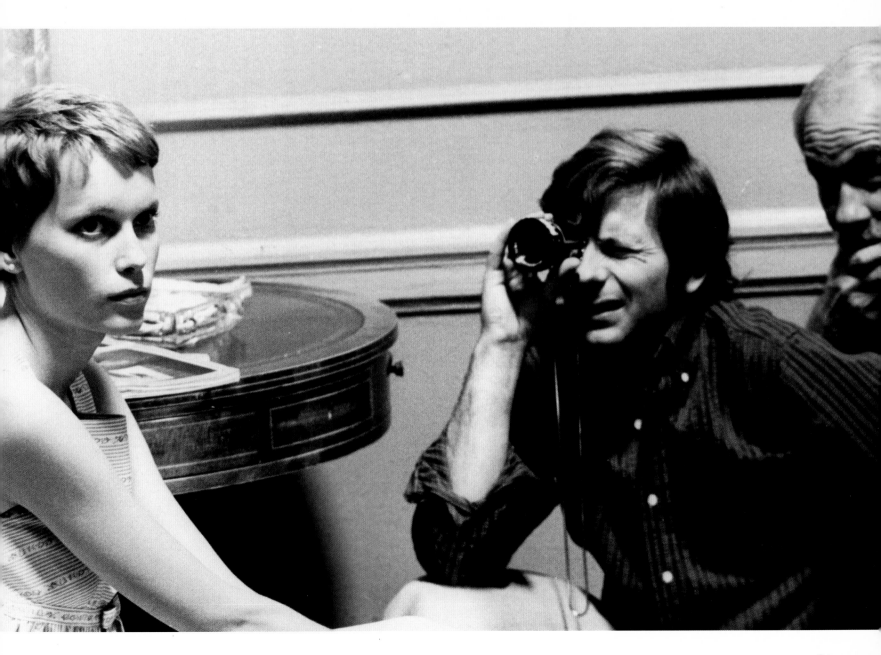

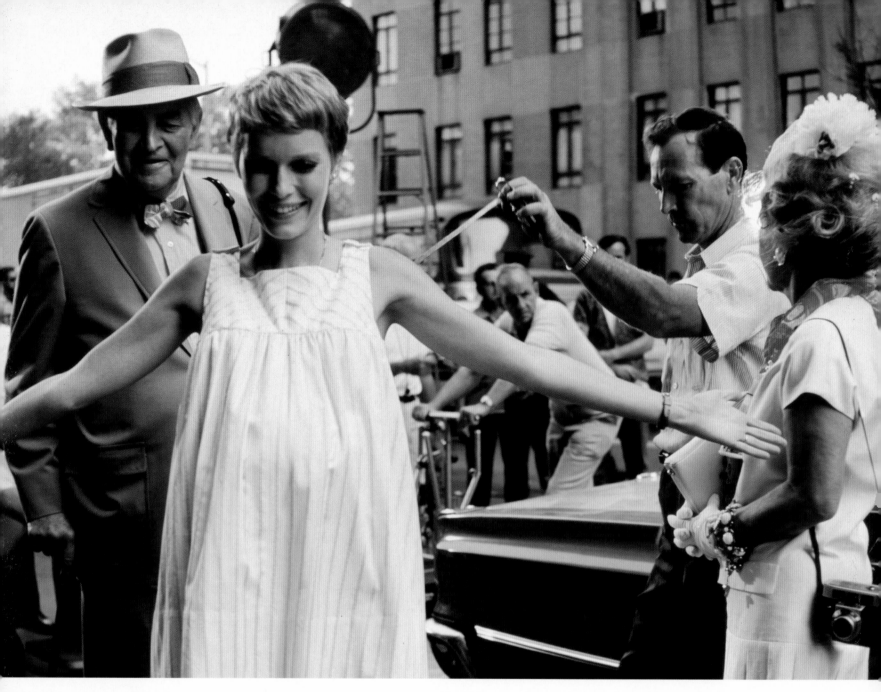

Above: Farrow prepares for a
scene with Sidney Blackmer and
Ruth Gordon as the deceptively
inoffensive looking satanists
Roman and Minnie Castevet.

Opposite: The atmosphere in
the Bradford Building becomes
terrifying as Rosemary finally
grasps the full horror of what
has been done to her.

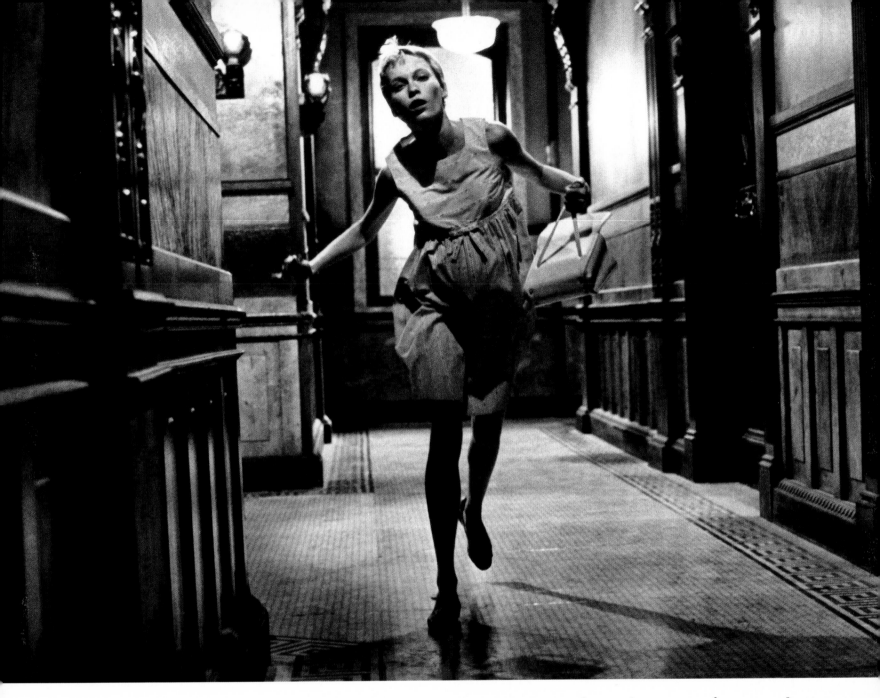

"I told them how I was going to do the film and I said that I hoped it was for this quality that they called on me and not because they thought it would be easy to change my work. And they said that was exactly why they wanted me there and left me complete freedom."

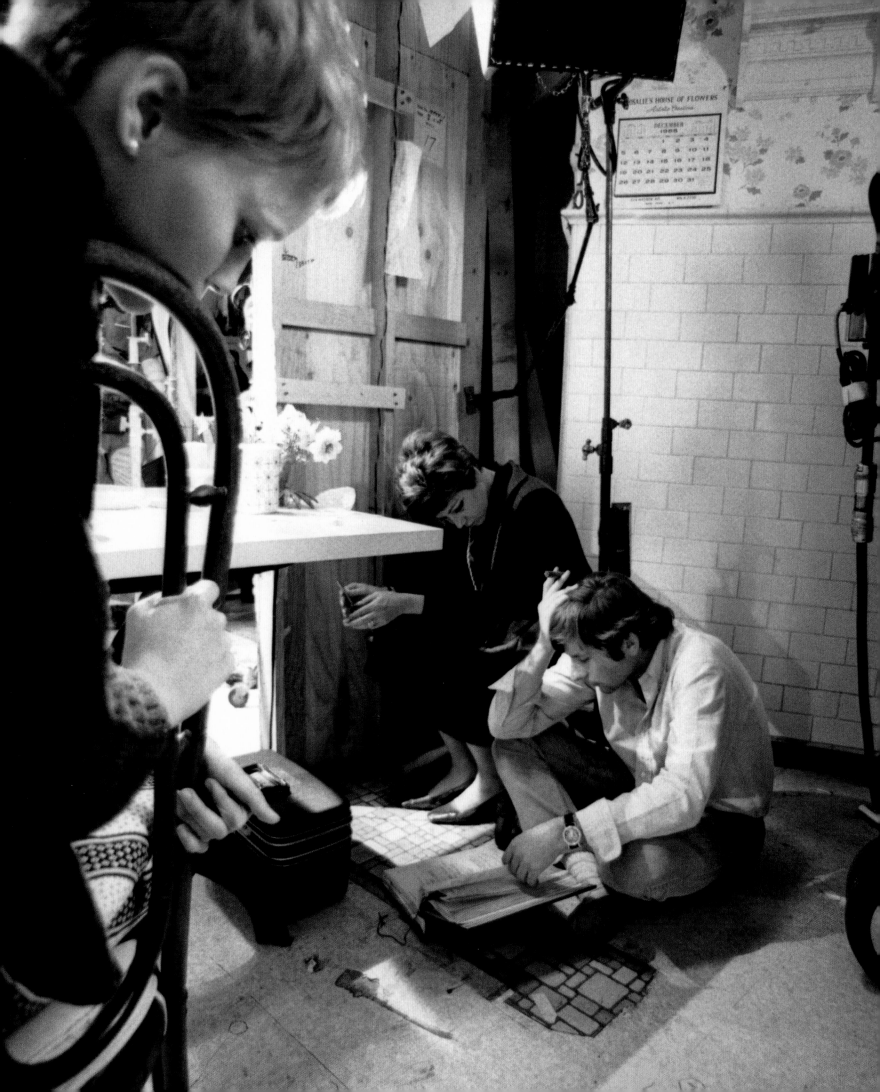

Rosemary's Baby was Polanski's first experience of adapting a novel for the screen, something he had aspired to do ever since he was a teenager in Kraków.

"For the first time ever, I didn't have to hustle for a living. The overnight success of *Rosemary's Baby* had turned me into something of a Hollywood golden boy, deluged with scripts and propositions from other studios all over town."

Sylbert said that Polanski knew more about lenses than the cameraman, but the great cinematographer William Fraker, who went on to garner five Academy Award nominations of his own, was no slouch. In an interview for the 1992 documentary *Visions of Light*, Fraker gave some insights into how Polanski worked on the set. For a shot where Ruth Gordon is seen talking on the phone in Rosemary's bedroom, Fraker set up the camera in the living room looking through the doorway (a typical Polanski set up). Fraker framed the shot so the audience could see Gordon sitting on the bed. Polanski came to the set and said, "No, no, move the camera to the left." Fraker said, "But then you won't be able to see her!" Polanski said, "Exactly." So Fraker shot it with just Gordon's back visible. Later when he saw the film with an audience in a theater he understood why. Eight hundred people tipped their heads to the side to try to see Gordon around the doorjamb. And that's how Polanski grabbed the audience and pulled them into the action.

The film is full of directorial touches like this that add to the mood and help build the suspense. One of my favorites occurs late in the film, when Rosemary has more or less figured out what's going on and she is in a phone booth on a busy street. As she frantically waits for her original, good doctor to call her back, she sees the back of a white-haired man who looks exactly like the now sinister Dr. Sapirstein

pacing outside the booth. It's a blistering hot day and there is very little happening in the frame, but the suspense is intense as Polanski makes viewers feel the stifling heat and fear. Turns out it's just a guy waiting to use the phone.

Probably the most talked-about scene and the one that sent people home with nightmares of their own was the dream sequence in which Rosemary is raped by the devil. Polanski wanted it to look the way we experience dreams in real life, not in movies. "I was trying to use the things that I remember from dreams, which is, one, that they are very quiet, almost silent, even if somebody is screaming. And, two, that people change. The person you're dreaming of is suddenly not the person you started the dream with, but has somehow evolved into somebody else. Those are elements I was trying to sell in those sequences."

The scene begins with Rosemary bobbing on a bed in a body of water, like a waterbed adrift in a lake. A clock loudly ticks off the seconds to intensify each moment. As all the neighborhood witches stand around naked muttering what sounds like dissonant Gregorian chant, Rosemary's husband mounts her. But then Polanski cuts to a pair of scaly, webbed hands dragging across her body. She looks up and sees the catlike eyes of the devil, or thinks she does. What makes it even more terrifying is that at the height of it, Rosemary wakes up and screams, "This is no dream, this is really happening!"

"I had sixty technicians at my beck and call and bore responsibility for a huge budget—at least by my previous standards—but all I could think of was the sleepless night I'd spent in Kraków, years before, on the eve of making my very first short, *The Bicycle*."

Desperately trying to get in touch with her original, trustworthy doctor, Rosemary thinks she sees the sinister Dr. Sapirstein waiting for her outside the phone booth.

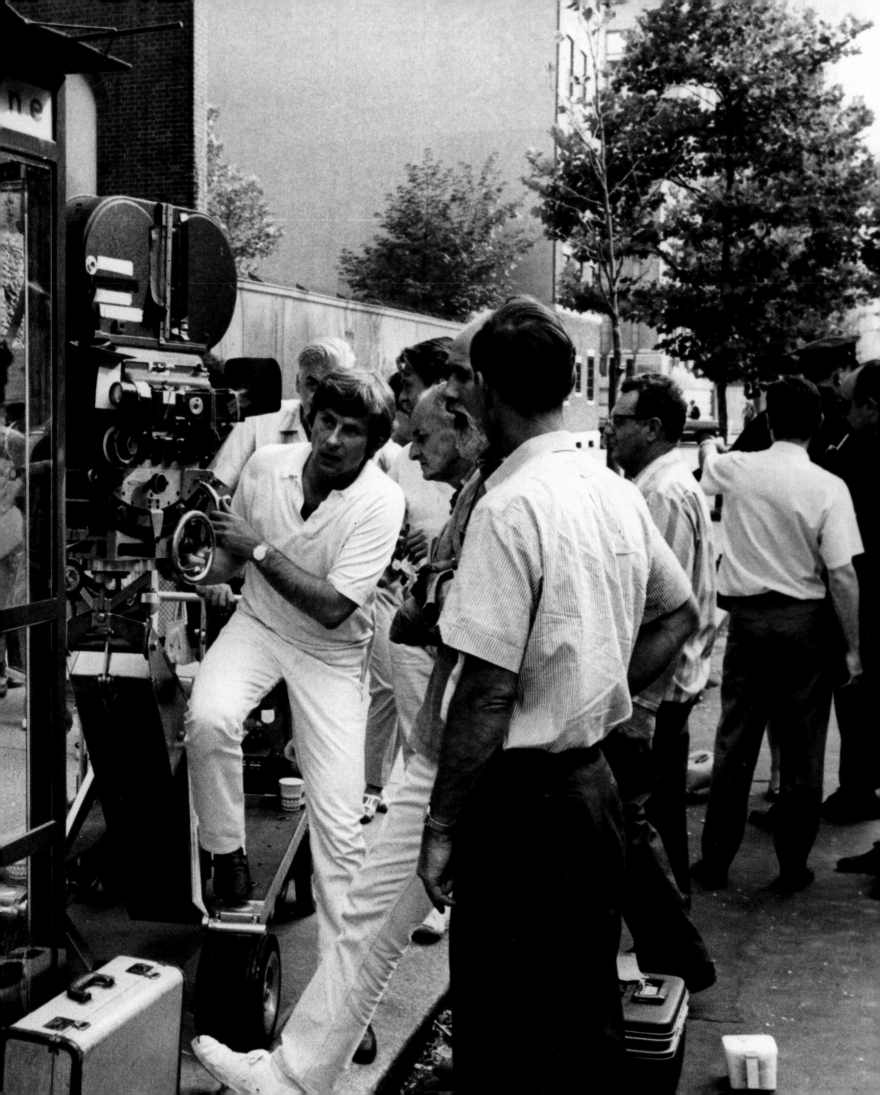

"I dreamed someone was raping me.
I think it was someone inhuman."
The horrific nocturnal vision that
Rosemary sees on top of her (opposite);
and inspecting the scars of her ordeal
the next morning (above).

Or is it? The story is told from Rosemary's point of view, but what if that's unreliable? At least, Polanski wanted it to be open to interpretation. As a confirmed agnostic, he did not believe in the devil any more than in God. "That aspect of the book disturbed me," he said. "I could not make a film that is seriously supernatural. I can treat it as a tale, but a woman raped by the devil in today's New York? No, I can't do that. So I did it with ambiguity."

For the sake of credibility—and his own worldview—there had to be the possibility that the whole thing is a figment of Rosemary's imagination. This was especially true of the ending, in which Polanski refused to show the baby, although it was described in detail in the book. "Better to leave it obscure and ambiguous," he said. "It doesn't all have to be so obvious. The obvious is boring."

When the film came out in mid-1968—it was a huge hit—people would come up to Polanski and insist they had seen the baby, cloven hoofs and all. But all that's there, and only for a split second, is a subliminal superimposition of catlike eyes. When I told him I was one of those people and for years believed I had seen the baby at the end, he seemed pleased that he had fooled me. "You thought you did? Well, that's good. It shows that you can act on the imagination of the spectator; you're creating certain illusions. In a film like this you have to be mysterious."

I don't think anyone—except for a few crazies—truly believed Rosemary had been violated by the devil. But the important thing is that for two hours Polanski made it feel like it *could* happen. And in his great films, of which this is surely one, there is always that shadow of a doubt.

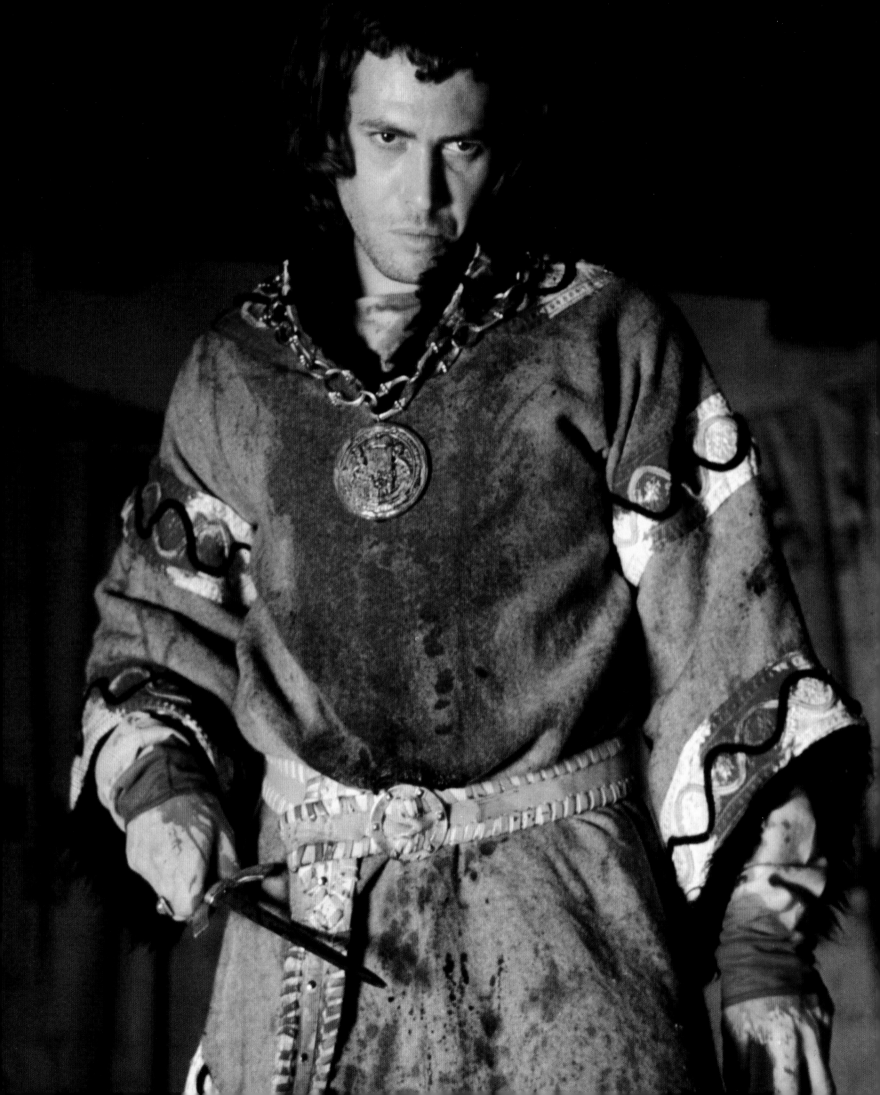

Macbeth ₁₉₇₁

"You have to show violence
the way it is. If you don't show
it realistically, that's immoral
and harmful. If you don't upset
people, that's obscenity."

"Most American critics assumed that I'd used the film for some cathartic purpose. In fact, I'd chosen to make *Macbeth* because I thought that Shakespeare, at least, would preserve my motives from suspicion."

When *Macbeth* opened in 1971, it was widely regarded in the United States as Polanski's response to the brutal murder in 1969 of his wife, Sharon Tate, by the Manson Family. Reviews commented mostly on the graphic violence of the film. One critic said it presented "a world of blood"; *Newsweek* declared that for Polanski it was "a rationalization of a psychic compulsion."

Previous page: Macbeth (Jon Finch) murders Duncan, an act that takes place offstage in Shakespeare's play but that Polanski shows in unflinching detail in his film adaptation.

It was a no-win situation for Polanski, who has always denied the claim. "After the Manson murders, it was clear that whatever kind of film I'd come out with next would have been treated the same way," Polanski said in his autobiography. "If I'd made a comedy, the charge would have been one of callousness." The unfortunate result of all this moralizing was that a very deserving and beautifully crafted film was largely swept under the rug, and it remains to this day one of Polanski's most underrated and least appreciated movies.

The idea of making a film from a Shakespeare play had long been in the back of Polanski's mind. In fact, he had been captivated by Shakespeare since seeing Laurence Olivier's version of *Hamlet* when he was fourteen. Searching for his next project after his wife's death, he decided now was the time, and chose *Macbeth* because he thought it was the one major play that had not been done successfully on film. As for the people who found it excessively gory, Polanski said, "Well, they don't know this is Shakespeare's bloodiest play. It's steeped in blood, it's a violent play."

That's not to say *Macbeth* wasn't a personal project for Polanski. The play is about things he had endured in his own life—violence, cruelty, brutality—living through the horrors of Hitler, Stalin, and Manson. The scene in which Macbeth's henchmen barge into Macduff's castle to kill his wife and children was staged the way Polanski remembered the Nazi SS bursting into his family's one-room apartment in the Kraków ghetto.

Another scene that resonated for him was when a dejected Macbeth is sitting on the throne and hears shrieks after Lady Macbeth has killed herself. Years later, Polanski remembered Macbeth's line and repeated it several times: "I have almost forgotten the taste of fear."

Polanski's *Macbeth* is not a standard reading of the text. Working on the script with the acclaimed British theater critic Kenneth Tynan, Polanski felt no need to abide by the conventions of Elizabethan drama. Their most radical innovation was portraying the Macbeths as young, sexy, and ruthlessly ambitious. Traditionally, Lady Macbeth is a middle-aged shrew who goads her husband into a plot to kill the Scottish king. That's not how Polanski saw it. "These traditions grow up with time but there is really no indication and no reason for having Lady Macbeth as an aging witch, and nothing indicates that Macbeth is one of these gangster types, which is how they're always played," said Polanski. "In fact, I think the opposite is more logical. Macbeth would probably be a fellow around thirty at the most. So his wife should be young and attractive. It makes it much more interesting."

Polanski understood that he had to take a dense text with archaic language, thin out the story and make it cinematic. This is a film that is *directed*, and by that I mean the vision, choices, and challenges are apparent. Polanski did exactly what an artist should do with an adaptation: He put his stamp on it. "The important thing was to construct a spectacular and coherent framework that would underpin and amplify the text," said Polanski.

Directing Francesca Annis (Lady Macbeth, opposite); and referring back to the original play with co-adaptor Kenneth Tynan (above).

101

"I see Macbeth as an open-faced young warrior who is gradually sucked into a whirlpool of events because of his ambition—a gambler for high stakes."

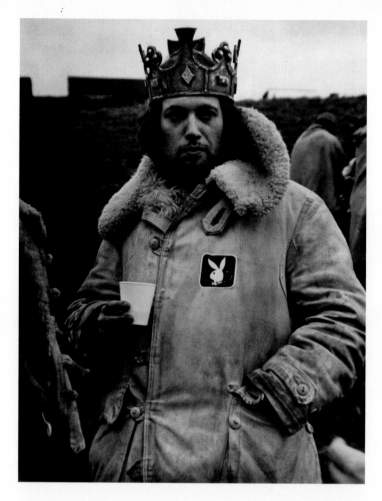

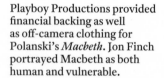

Playboy Productions provided financial backing as well as off-camera clothing for Polanski's *Macbeth*. Jon Finch portrayed Macbeth as both human and vulnerable.

Shakespeare offers only sparse stage direction in the play; a character enters, exits, is slain, usually offstage. It's up to the director to figure out what to do with it. "It's a little bit like jazz where you can improvise on the theme," said Polanski.

Polanski and Tynan decided to dramatize some major events that we don't see in the play. For instance, on the stage the news of King Duncan's death is delivered by Macbeth simply telling his wife: "I have done the deed." But Polanski shows it graphically, having Macbeth sneak into his room in the dead of night and stab the king in his bare chest, which makes it even more startling and emphasizes the physicality of the act.

The effect of showing these events is to move action that could seem distant closer to home, making it more realistic. This is the work of individuals, not the State or supernatural forces. Macbeth and his wife are flesh-and-blood characters with the failings and frailties of all people. The "dark and deep desires" Macbeth contemplates are feelings he and his wife didn't know they had that are now exposed like an open wound.

By making these scenes visible, Polanski was able to trim and rearrange the text in sequential order, simplifying the plot and giving it more immediacy and momentum. In another bold move, he and Tynan turned the thoughts of the characters, by necessity spoken as soliloquies on stage, into voiceover monologues, thereby highlighting the psychology. Macbeth's famous speech, "Tomorrow, and tomorrow, and tomorrow, creeps in this petty pace ...," becomes half internal and half recited, and more personal. "That's what a movie allows you to do," explained Polanski. "You can't do it in the theater, but if you're using this medium, why not take advantage of all the possibilities that it presents?"

This device allows the actors to tone it down a notch and be less theatrical. The fine cast, led by Jon Finch and Francesca Annis as the doomed couple, strike a conversational tone that makes the connection to the characters more intimate, as if they were confessing their deepest thoughts. Polanski wanted to make these people human and vulnerable, and to that end, in the most controversial scene in the film, he had Lady Macbeth do her sleepwalking scene nude. Reasoning that people slept without clothes in the eleventh century, Polanski thought it would be consistent with the youth of the character. Audiences had never seen anything like this before in *Macbeth* and assumed it was the influence of *Playboy* founder, Hugh Hefner, who had put up most of the money for the film after Polanski couldn't find any Shakespeare lovers in Hollywood willing to take the risk. The credit for Playboy Productions was frequently greeted with laughter at early screenings in New York and one

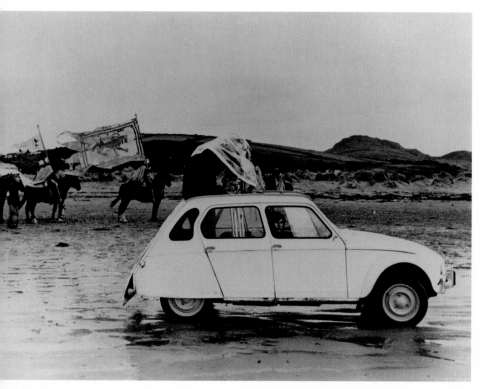

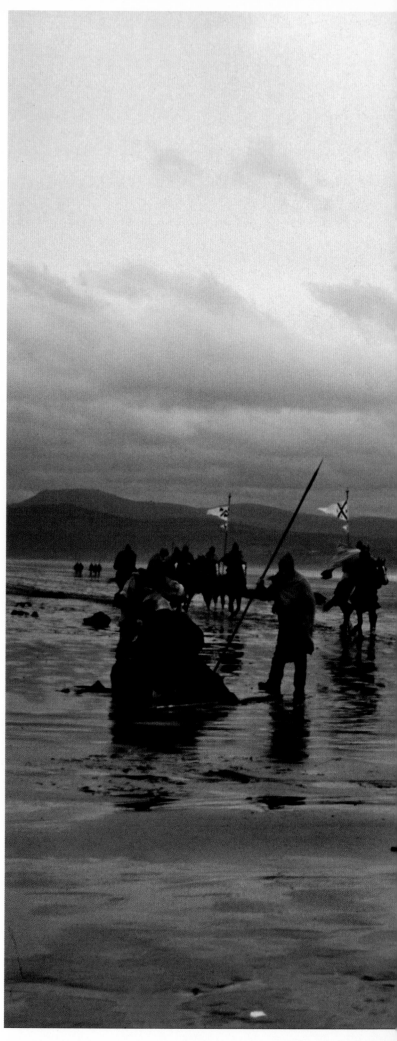

critic wondered if the film would have staple marks in the middle of the screen. But the outcry was misguided. Polanski and Tynan had made the decision about nudity at the script level. (Tuesday Weld turned down the part of Lady Macbeth for that reason.)

Directors often like to boast that every penny of their budget is up on the screen, and in this case it was true. Polanski, working again with cinematographer Gilbert Taylor and production designer Wilfred Shingleton, clearly got his money's worth for $3.5 million. Shooting in a widescreen format for six months amidst constant foul weather in Wales, at Lindisfarne Castle on Holy Island in northeast England (the same location used in *Cul-de-Sac*), and on two soundstages at Shepperton Studios, the visual imagery of the film is as powerful as the words. The gray skies, muddy beaches, and misty horizon seem to stretch out until the end of the time. It's bone chilling.

But it wasn't only stormy weather and challenging locations that made the shoot more difficult than Polanski had expected. He was trying to create a medieval spectacle involving hundreds of costumes as well as horses, battles, and action scenes. To cut costs for some crowd scenes, he placed plastic dummies in the background; on another occasion, the production rounded up an army of men from the unemployment line. When the English soldiers bring "great Birnam wood to high Dunsinane hill" in order

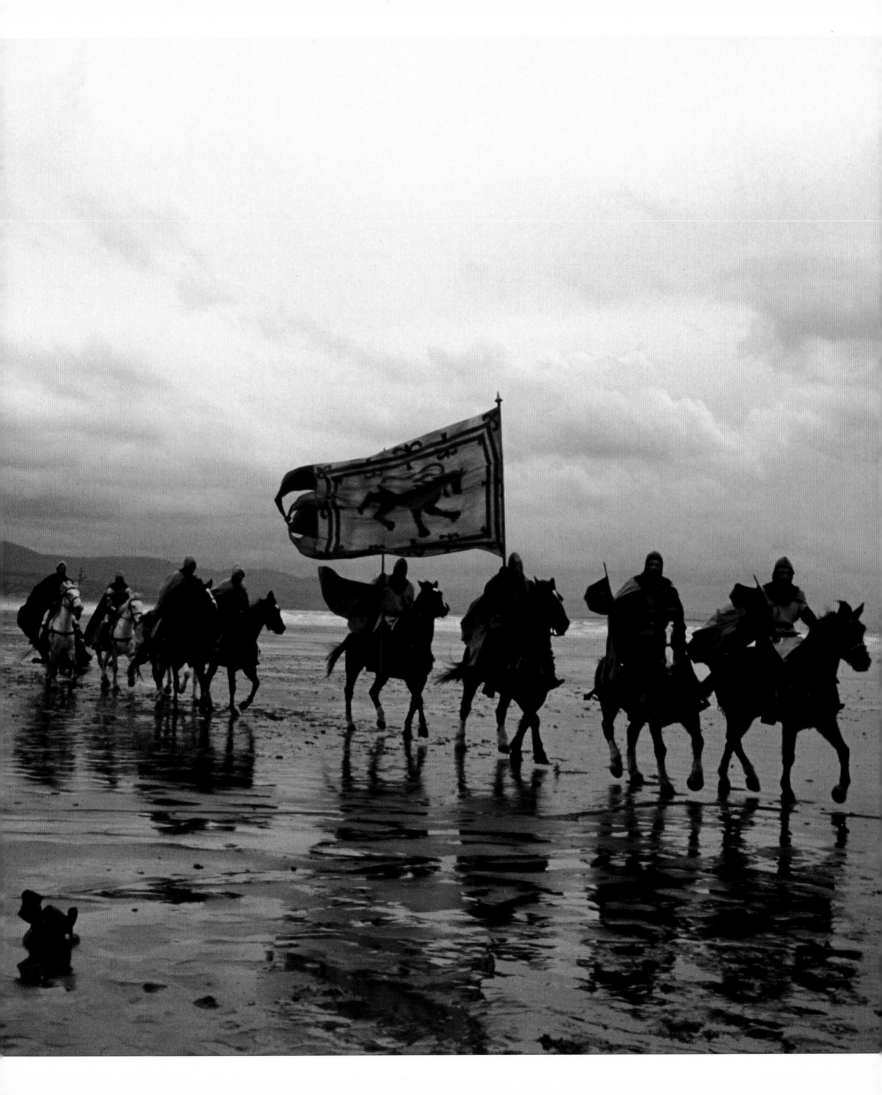

to attack Macbeth's castle, they come equipped with well-researched implements of eleventh-century warfare. However, when it came time for the catapult to launch balls of fire over the castle walls, they fell harmlessly short. "Our special-effects department did not do the best job. We called them special *de*fects," quipped Polanski.

Once the army is inside the castle, Macbeth engages in mortal combat with Macduff, but again, where Shakespeare only specified a stage direction that had them exiting and fighting, Polanski embellished. Even for a movie battle, it was not what audiences were used to. This was not the balletic swordplay of an Errol Flynn film, which had traditionally been the style of movie fighting; this was clanging, clumsy, and physical. "I wanted to do something that was more realistic and motivated by the participants' will to survive," said Polanski. "It wasn't

about how I look when I fight, but what do I have to do to kill the other guy."

It was a fight to the finish and Polanski allowed it to go on and on to show the brutality. When it's finally over, in action that takes place offstage in the play, Macduff decapitates Macbeth. The bloody head, still wearing its crown, rolls around in the courtyard and is then hoisted on a stake.

Some might see this as an excessive or gratuitous detail, but if portrayed truthfully, the horrendous acts we've witnessed call for this treatment. It is the boldness of Polanski's vision that makes these events recognizable. The evil in the hearts of men is not an abstract concept; even across the expanse of time, the extreme behavior of Macbeth and his wife seems all too human. At least to Polanski it did.

Opposite: Always a hands-on director, Polanski demonstrates his skills as a fight coordinator and a makeup artist.

Above: Macduff (Terence Bayler) deals the telling blow in his fight with Macbeth moments before beheading the usurper.

What? 1972

"Of *What?* itself, little need be said.
The picture was a success in Italy,
a modest success elsewhere in Europe,
and a flop in America."

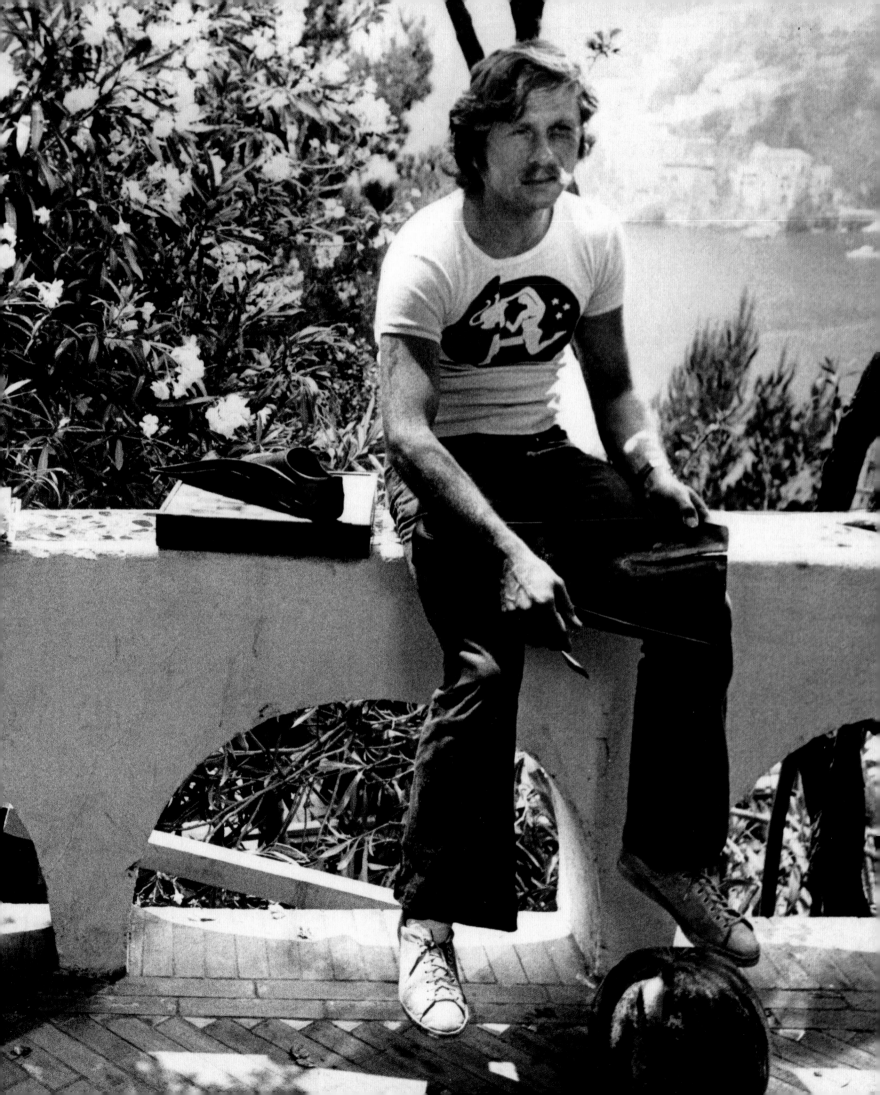

CARLO PONTI PRESENTE

UN FILM DE ROMAN POLANSKI

QUOI ?

CARLO PONTI PRESENTE — UN FILM DE ROMAN POLANSKI — AVEC MARCELLO MASTROIANNI ET SYDNE ROME

QUOI ?

AVEC HUGH GRIFFITH·ROMOLO VALLI / SCENARIO DE GERARD BRACH ET ROMAN POLANSKI

What? was Polanski's *La Dolce Vita*. He was living in a six-acre villa on the outskirts of Rome, entertaining celebrities like Andy Warhol and Warren Beatty, and displaced European royalty. The famous Italian producer Carlo Ponti (Sophia Loren's husband) befriended Polanski and subsidized the writing of the script with Gérard Brach and the financing of the film, which would be shot in Ponti's seaside mansion near Naples. After the ordeal of making *Macbeth* on the Welsh moors, Polanski just wanted to have some fun with his friends.

Previous page: As an antidote to the mud and guts of *Macbeth*, Polanski chose an Italian sex farce for his next film.

"My wish was to make a film without costumes first of all, preferably without clothes at all. And without catapults and stage fights. *Macbeth* exhausted us all to such an extent that we were truly ready to change professions," said Polanski.

So nothing like an Italian sex farce to pick up the spirits. But not surprisingly, Polanski and Brach ignored all the conventions of the genre and fashioned instead a string of surrealist episodes, closer to *Alice in Wonderland* than *Marriage Italian Style*. It kicks off when Nancy (Sydne Rome), a hitchhiking American, flees a carload of would-be rapists and stumbles into a rambling coastal estate. Wearing little more than a napkin for the entire film, she encounters a rag-tag collection of hangers-on, art dealers, tourists, and fallen aristocrats who ogle and paw her as they go about their business. She's an amusing bauble but they're all busy playing their own private games—whether it's ping-pong or admiring the art (by Francis Bacon, among others). As in life, these people are totally absorbed in their separate realities.

The ringleader (or white rabbit, if you will) is Marcello Mastroianni as Alex, a retired pimp in a hideous powder-blue suit with a taste for flagellation. His flirtation with Nancy is just so he can get her to whip him while he's dressed only in a tiger skin draped over his head. With his hair slicked down and a pencil mustache, Mastroianni is

Polanski also took on an uncredited supporting role in *What?* as the harpoon-gun-toting and flamboyantly mustachioed Mosquito.

Scantily clad ingenue Nancy (Sydne Rome) doesn't know what she's let herself in for when she wanders into a house full of libidinous misfits— but she soon finds out.

as deliberately sleazy as he usually is attractive. One can imagine his delight in parodying his stereotype as the quintessential Latin lover.

The ailing padrone of the villa is played by the great Hugh Griffith as a kind of cultured dirty old man. On his deathbed, he summons Nancy and asks her so plaintively to see what's between her legs, she can't refuse. Shot from behind by Polanski at a discreet low angle with Griffith framed by Nancy's legs towering above him, it is almost touching as the geezer gets a last look before he expires. It's probably not the kind of thing you could get away with now, but this was 1972.

"It was a product of its times," says Polanski of the film. "This was in the short period between the invention of the birth control pill and AIDS. When sex was enjoyable, not threatening."

Playing one of the residents, who carries around a harpoon gun for no particular reason other than to get a joke out of it, Polanski pokes fun at his diminutive size and reputation. "They call me Mosquito," he says, "because I sting with my big stinger." To which another character says as an explanation, "Perhaps he had a bad childhood."

Polanski clearly delights in observing these peculiar goings-on. The film is no more than a series of vignettes with no real beginning, middle, or end. Things just happen for no apparent reason without an explanation.

Above: Mosquito holds
retired pimp Alex (Marcello
Mastroianni) in his sights.

Opposite: Easy, tiger! The
sleazy Alex submits to his
animal impulses and penchant
for flagellation.

"Almost of its own accord, the screenplay turned into a ribald, Rabelaisian account of the adventures of a fey, innocent girl, wholly unaware of the company that surrounds her in a weird Riviera villa

"I had no interference at all. I did it with Ponti,
and I must say, you have no problems with him.
I saw him maybe twice during the production."

"What splendor!" Nancy grants
the dying Joseph Noblart (Hugh
Griffith) his final wish.

A priest's familiar platitude that "the Lord works in mysterious ways" is even more foolish in the face of such randomness. With stilted dialogue and a lack of connectedness, the film plays like a Pinter piece on Viagra.

Nancy roams through this Eurotrash rooming house with the optimistic innocence of an American Candide. After testing countless starlets in Paris and London, Polanski wound up casting much closer to home. He eventually discovered the novice actress Rome— originally from Sandusky, Ohio—just a few blocks from where he was living.

But even Nancy has her limits, and after two days at this place, which seems like forever as the action repeats itself in a continuous déjà vu, she runs out of the house with only her experience covering her. Polanski is fond of observing the Aristotelian unities he learned in school and frequently concludes his stories where they started. So at the end, Nancy hitches another ride, this one in the back of a truck

of farm animals—pigs squealing so loudly that when Alex calls after her to come back, she can't hear him and can only scream the film's title: "What?"

Polanski said he still finds the film pretty funny. He admits, however, "we made a lot of mistakes there, but I like it very much." He thinks the script was witty and the shortcomings were mostly in his direction. "Something was missing. It didn't quite express what we were trying to say."

That response seemed fairly universal, except in Italy, where the film had lines around the block. *What?* remains the least known of Polanski's films, and the least memorable. It was recut and released in the United States as *Diary of Forbidden Dreams* as part of a double bill at adult theaters. But Polanski's Roman holiday wasn't wasted. When he finished *What?*, he was sufficiently recharged and ready to tackle his greatest challenge to date—*Chinatown*.

Chinatown 1974

"In *Chinatown* what I was trying to create was this Philip Marlowe atmosphere, which I'd never seen in the movies the way I got it in the books of Dashiell Hammett or Raymond Chandler."

Polanski was giving me a ride back to Paris from the Boulogne-Billancourt Studios, where he was shooting *Bitter Moon* in the early 1990s. After watching him work for a few days and interviewing him a couple of times, I felt almost comfortable enough to attempt a conversation about *Chinatown*. It was a film that had entered my consciousness the first time I saw it in 1974 and never let go. So I started gushing about what a great movie it was. Polanski shrugged. As I recall, he said something to the effect of, "It's not that great." I was baffled. How could the director not love his own film as much as I did?

Previous page: Directing a scene in an orange grove with typical attention to detail.

What I realized from subsequent interviews was that he was indeed proud of it, but as one of the most celebrated films of the last half-century, *Chinatown* didn't need his affection; he was saving it for his more needy offspring. Years later he did acknowledge that *Chinatown* and *The Pianist* were his two best films.

But it is true that initially Polanski didn't want to do the film. For him, *Chinatown* was a reluctant return to the scene of the crime where, four years earlier, his wife Sharon Tate had been murdered by the Manson Family in Beverly Hills. Polanski was living happily in Rome, about to turn forty, and in no mood to go back to Los Angeles. But he was running low on funds when his old pal Jack Nicholson called and said he had finally found something they could do together. It was Robert Towne's inspired screenplay about crime and corruption in 1930s Los Angeles. When Paramount production chief Robert Evans also phoned, it was an offer Polanski could not refuse. Material this good didn't come along that often.

Towne had originally conceived of *Chinatown* as part of a trilogy chronicling the sprawl and exploitation of the Los Angeles he remembered from growing up there. Wrapped around the four basic elements of life, *Chinatown* dealt with a water scam; *The Two Jakes*, eventually directed by Nicholson in 1990, continued with fire and earth, in the form of oil; and the never-made *Gittes vs. Gittes* was going to be about the air and the advent of no-fault divorce in California. All would be seen through the eyes of private detective Jake Gittes (Nicholson) and intertwine a personal story with political intrigue. It was a detective story not just about solving a crime but with a moral and philosophical underpinning.

Right: "Hello, Claude. Where'd you get the midget?" As private eye Jake Gittes, Jack Nicholson quits his wisecracking when the midget (Polanski) pulls a knife and slits his nose.

Below: Polanski back in director mode and armed only with a viewfinder (left).

Polanski read the 180-page first draft of Towne's screenplay for *Chinatown* and came to Los Angeles to meet him at one of his favorite haunts, Nate 'n Al's deli in Beverly Hills. Over what was probably a brisket sandwich on an onion roll, he told Towne his script was too long and too convoluted, and went back to Rome. "Bob said that he would deliver a second draft very rapidly. It took months, and it was longer than the first," laughed Polanski.

After that, "Bob Evans said we won't get this script together unless you lock yourself up with Bob [Towne] and you work on it," recalled Polanski. "He found me a house in the Hills and we worked for eight weeks, eight hours a day on that thing and restructured it, shortened it, eliminated certain characters, put together others, and ended up with what we have now. More or less."

What Polanski brought to this quintessentially American material was a European sensibility and an unerring feeling for the darkness of the human soul. He also had the ability to take the ridiculous and absurd to great lengths and to find pitch-black humor, a quality not always associated with *Chinatown*. For instance, after Gittes has his nose famously sliced by a punk thug played by Polanski, Nicholson appears with either a bandage or row of stitches for most of the film. No phony movie recovery for Polanski. "No real American would ever have included the band-aid on Nicholson's nose— only a displaced European would do it," noted Polanski in a 1992 interview with *Cahiers du Cinéma*.

Probably Polanski's most significant contribution to *Chinatown*, though the movie is all of a piece, was insisting on a tragic ending, and the steps leading up to it, so that the climactic impact was devastating.

Overleaf: Filming in the water-starved San Fernando Valley north of Los Angeles (Polanski is in straw hat and shorts).

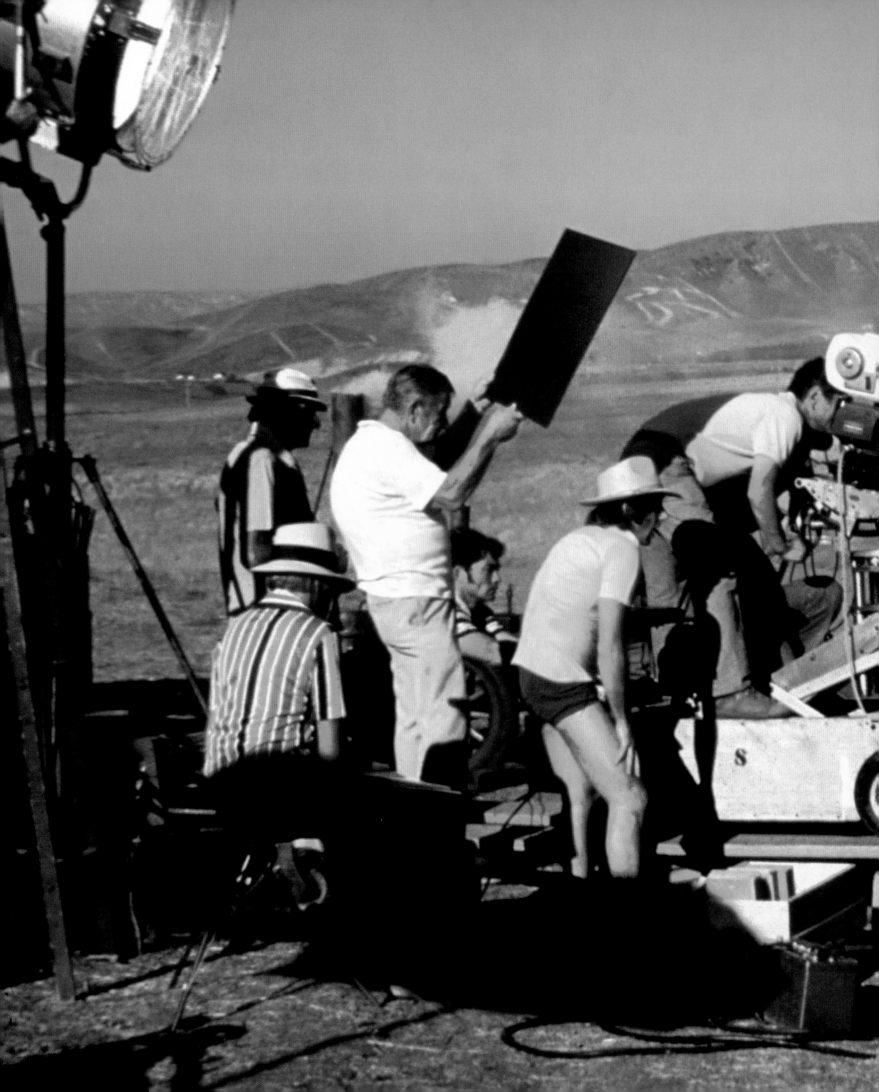

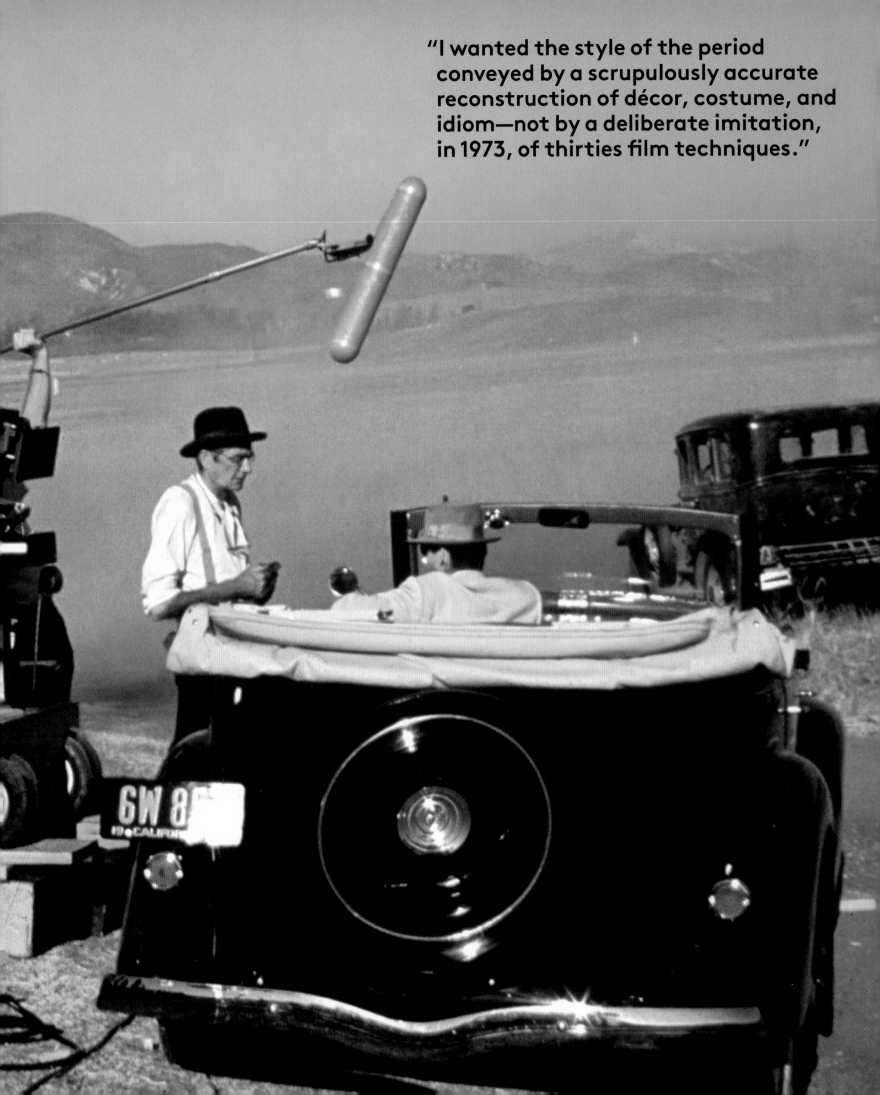

"I wanted the style of the period conveyed by a scrupulously accurate reconstruction of décor, costume, and idiom—not by a deliberate imitation, in 1973, of thirties film techniques."

"I had neither the ending nor the love scene when we started shooting. Robert Towne never wanted the main characters to go to bed, and he didn't want her to die at the end. We had a hard time agreeing about that ending."

Opposite: As the eyes and ears of the audience, Gittes gradually unravels the mystery. Here he runs into a beating from farmers who mistake him for an employee of the company that is diverting water from their land.

Below: Polanski sets up the scene.

In Towne's original screenplay, the doomed femme fatale Evelyn Mulwray (Faye Dunaway) was raped by her water tycoon father Noah Cross (John Huston) and gave birth to their daughter when she was fifteen, leading to one of the film's unforgettable lines: "She's my sister. She's my daughter. She's my sister *and* my daughter."

The way Towne had it, Evelyn would plug her father at the end of the film and get off after doing some short jail time, a relatively happy ending given the territory. Polanski wouldn't hear of it. First of all, for the ending to really sting, Polanski realized the relationship between Gittes and Evelyn had to be more than platonic, so he added a love scene. And at the end, he had Evelyn gruesomely shot in the eye by the police while her father swoops in, scoops up the daughter, and gets off scot-free for both his personal and professional transgressions. "I was always convinced that it has to end this way if you follow the logic of the piece," said Polanski. "If you want to have any feeling of injustice, you have to leave the audience with a sense of outrage."

It was a problem Towne and Polanski had not been able to solve in the script stage. When it came time to shoot the ending, Polanski was also unhappy that not a single scene in the film took place in Chinatown. The metaphorical Chinatown—a place where things went hopelessly, even tragically wrong, despite one's best intentions—was simply not as powerful without a geographic touchstone. And the glorious last line, "Forget it Jake, it's Chinatown," would not be the monument to futility it is. So Polanski had his production designer, Richard Sylbert, hastily create a Chinatown location on a Los Angeles street that had a couple of Chinese restaurants.

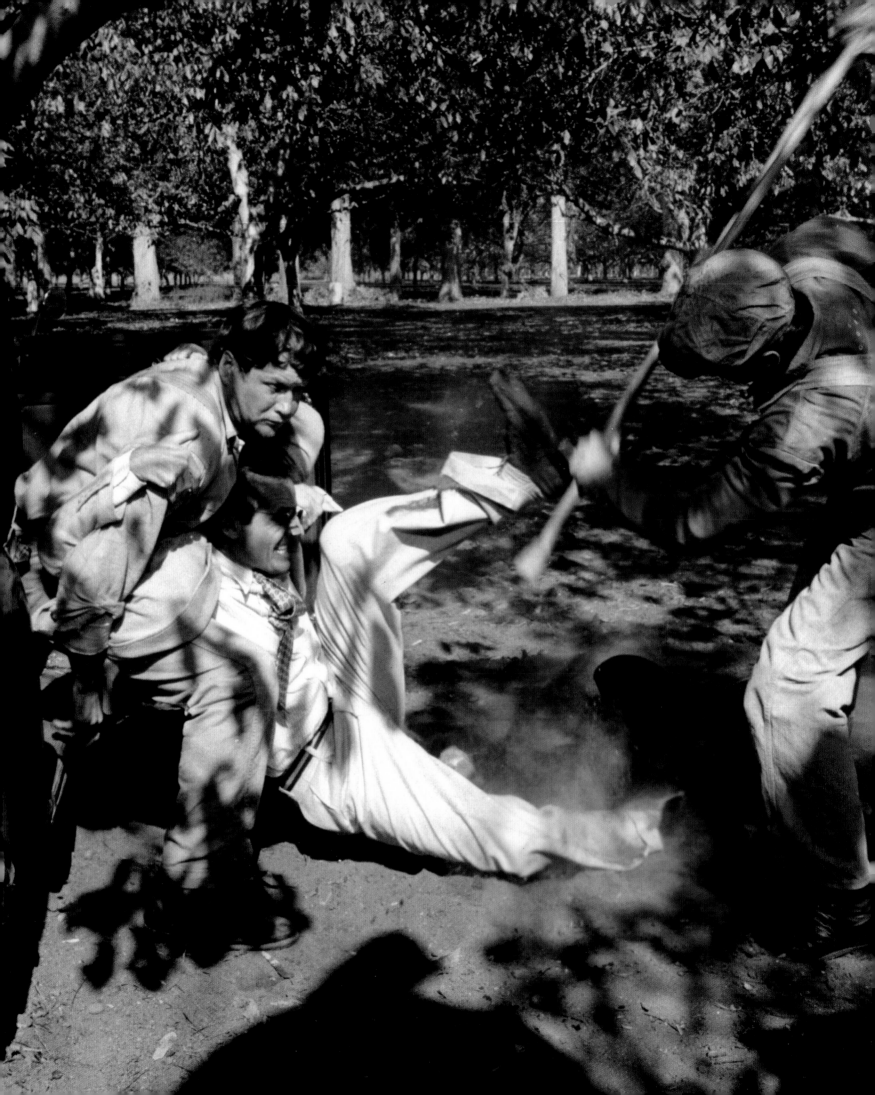

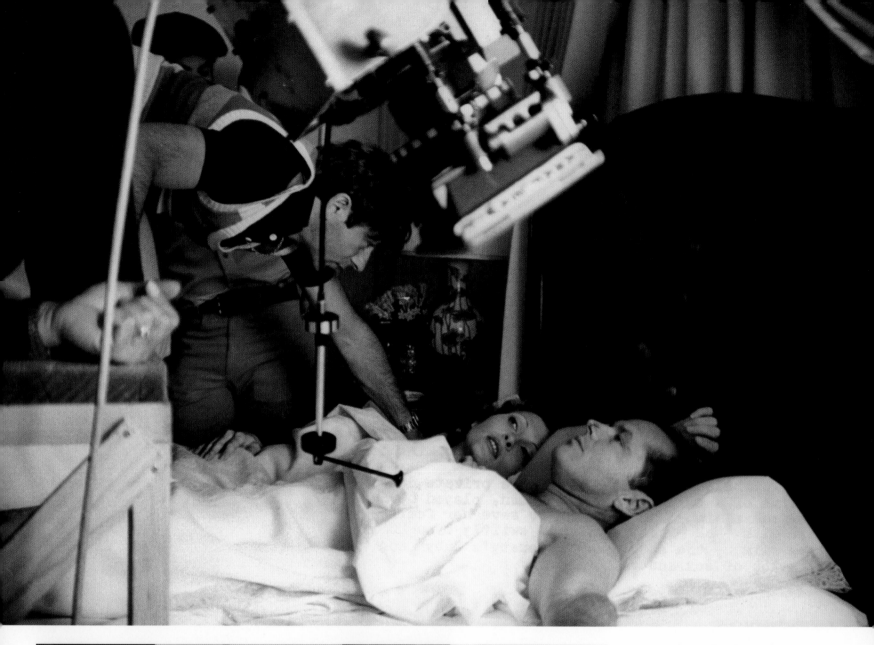

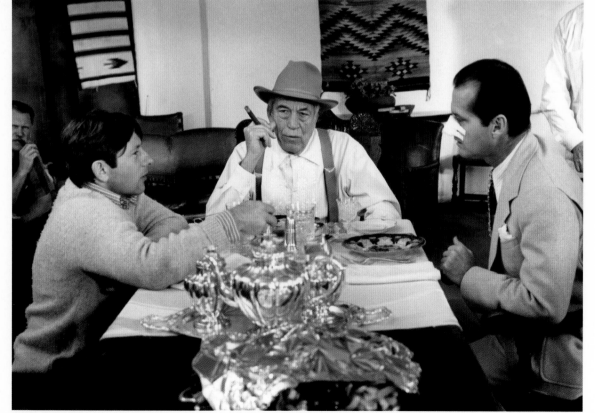

Above: Shooting Evelyn and Gittes's bed scene, one of Polanski's key additions to screenwriter Robert Towne's original story.

Left: "You may think you know what you're dealing with, but, believe me, you don't." Monstrous water tycoon Noah Cross (John Huston) pumps Gittes for information over lunch.

Opposite: It was Jack Nicholson who first brought the *Chinatown* script to Polanski's attention. He rewarded the actor by eliciting one of his best performances.

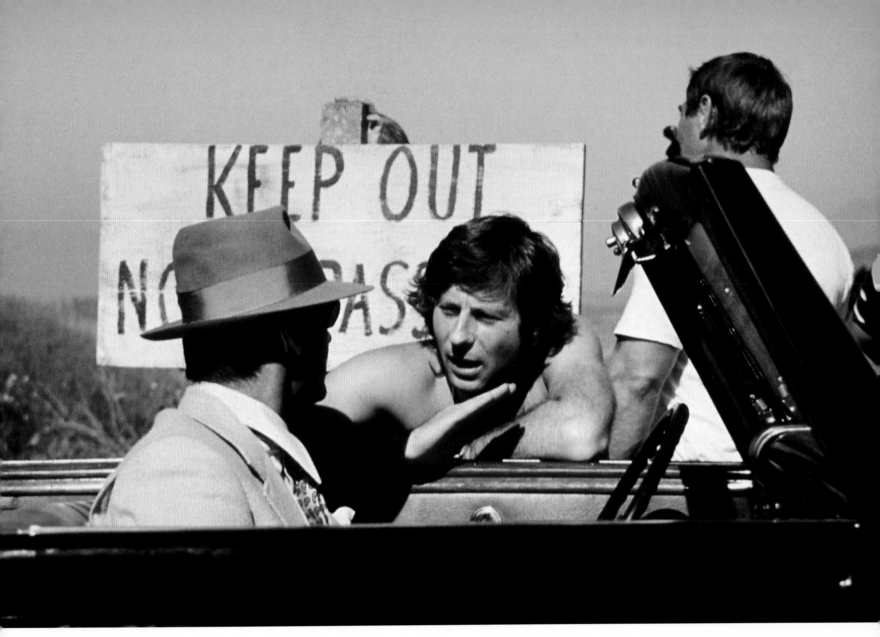

"Everyone says what a perfectionist
I am, but I'm not a perfectionist.
I just demand the minimum."

"I knew that if *Chinatown* was to be special, and not just another thriller where the good guys triumph in the final reel, Evelyn had to die."

"I wanted that ending scene to be in Chinatown," said Polanski. "So I wrote that scene and took it to Jack's trailer on the night of the shoot and asked him to revise the dialogue so it sounded like his style, and Jack adapted it and we shot it."

And at the end, the audience felt like it was shot, too. The impact is so powerful because Polanski makes you feel like you are in that world, not merely observing it. Evans had visualized the film in the sepia tones of *The Godfather* (which he had recently made at Paramount) and couldn't understand why Polanski wanted the epic scope of Panavision. But Polanski insisted on creating a film that was alive in its time, not a nostalgic period piece. *The Maltese Falcon* is fun to watch, but in the end it's just a movie. By comparison, *Chinatown* seems real. It looks like the 1930s, not a 1930s movie. "I thought the film should be completely modern in its look and what it was showing should be very authentic of the period," said Polanski.

The tone of *Chinatown* was Chandleresque, but with a twist. Gittes is no down-at-the-heels Philip Marlowe. He's a snappy dresser, successful in his métier (as he puts it) of chasing cheating husbands, but at heart Gittes is as cynical and fatalistic as Marlowe. He's a disillusioned romantic who carries the backstory of having destroyed a woman he was trying to protect when he was a beat cop in Chinatown. Now he's in over his head again.

Gittes is the eyes and ears of the audience. Polanski positions the camera behind him, so we know only what he knows as he discovers a tangled web of clues and gradually unravels the mystery. "It's very difficult to write the script this way, but it's something I've learned to do,"

Femme fatale Evelyn Mulwray (Faye Dunaway) tries to escape with her sister-daughter, Katherine (Belinda Palmer), but their getaway is foiled by a policeman's bullet.

126

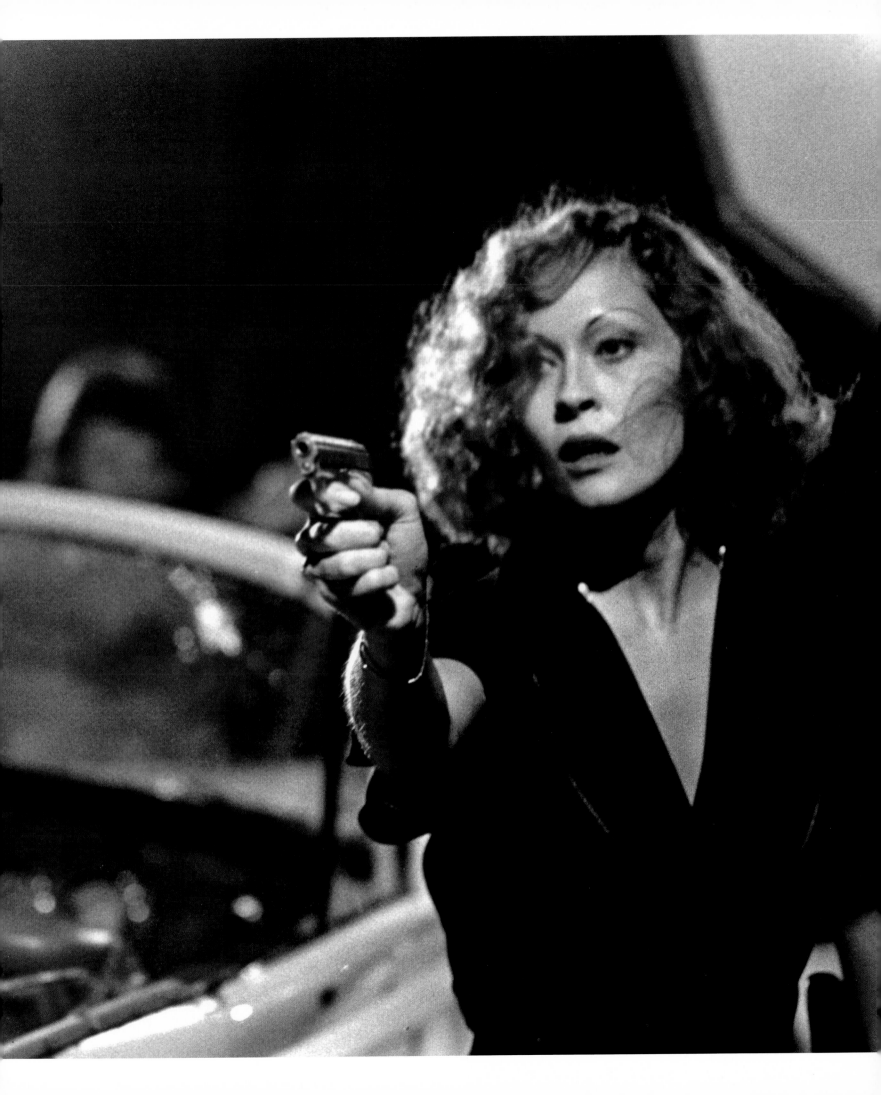

"She was neurotic and argumentative ... irritable and unprepared. Faye was the very worst to work with."

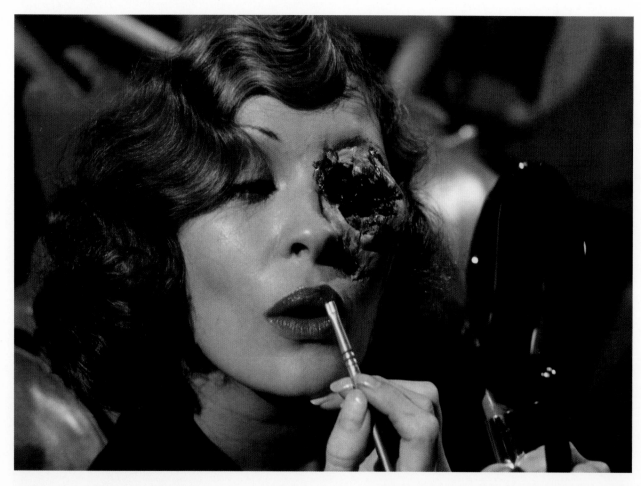

said Polanski. "In general, I hate seeing the character come into a location from the front. I want to go in with him."

The density of the story alone rewards repeated viewings like few other films, but the enormous amount of exposition presented a challenge for Polanski. Each scene had several plot points to cover, perhaps the most pivotal being when Evelyn confesses to Gittes that she bore her father's child. "It's always difficult to give the essential information without making it feel like exposition," explained Polanski. "So I thought that if she is forced to give it, you avoid that feeling."

The scene called for Nicholson to slap Dunaway around repeatedly to get the truth, but he was holding back. So Dunaway told him to do it harder. "She was encouraging him to do it," recalled Polanski. "In things like that Faye is a trooper. She may be a pain in the ass with other things, but when it comes to the action in front of the camera, she is very good."

To put it mildly, Polanski, who himself can be a terror on the set, and "dreadful Dunaway," as she came to be known, clashed almost from the word "action!"

The problem started with her look. "For the makeup of the period, I remembered my mother, when I was a child, plucking her eyebrows and putting lipstick in this cupid bow shape, which was the fashion of those times. And I told Faye that I wanted her to look like this. And she thought it was a terrific idea, to such an extent that she went completely berserk with this, and after every take she would redo that goddamn makeup and the lipstick, which took forever," said Polanski, still half amused and half annoyed.

In any case, their deteriorating relationship finally exploded when they were shooting the Brown Derby scene, where Gittes meets Evelyn for a drink and a hoped-for explanation. The shot was backlit and one of Dunaway's stray hairs kept reflecting the light and getting in the way, so an exasperated Polanski came over and plucked it out. She couldn't believe what he had done and stormed off the set until her agent and Evans brokered an uneasy truce.

And even Nicholson, who Polanski says is one of the easiest actors to work with, did not escape the director's

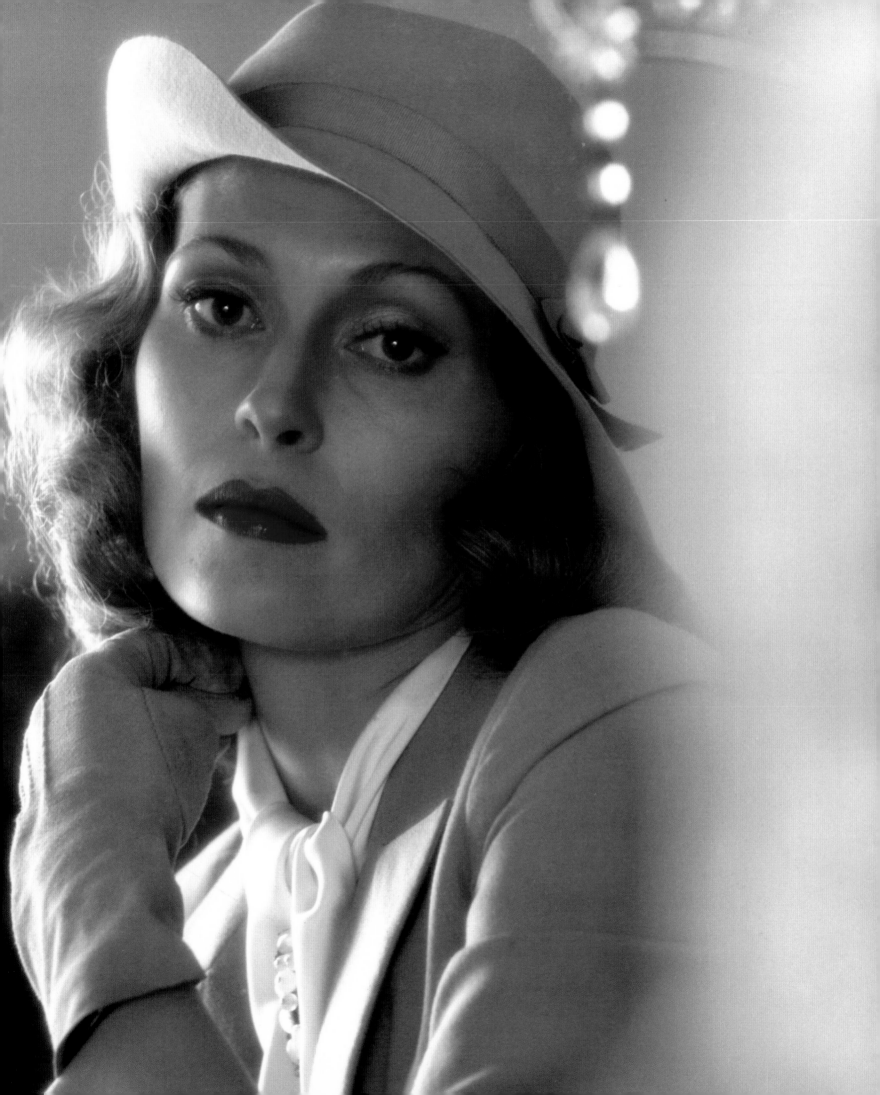

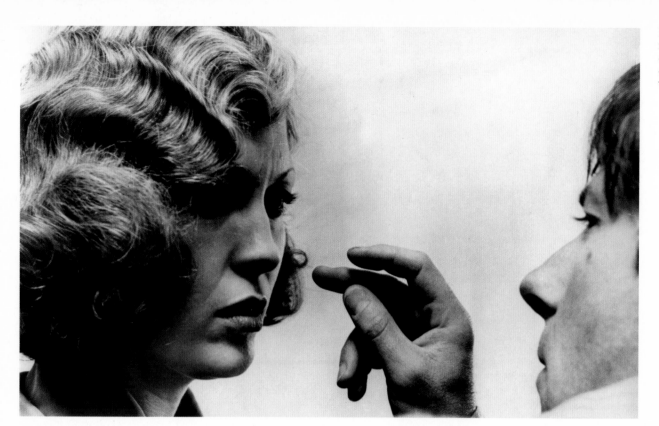

terrible temper. One night when Polanski thought Nicholson was paying more attention to a basketball broadcast of his beloved Lakers than the scene they were shooting, he charged into Nicholson's trailer swinging a mop at the TV set, and then picked up the TV and threw it out the door. Later that night, according to Polanski, the two men were stopped at a traffic light, looked over at each other, cracked up, and buried the hatchet.

Nicholson, who could be classic and modern at the same time, was a perfect fit for Gittes, but it was a demanding role in all kinds of ways. In the film's most dangerous stunt, which Polanski asked Nicholson to do himself and purposely left for the end, Gittes is investigating why water is being dumped into the ocean during a drought and he gets flooded in a torrent of water from a storm drain and is smashed into a wire fence. "I remember Jack was playing it cool, but of course doing a thing like that you have to be a little bit stressed. He had a wet suit under his usual suit and I was up on a crane just before the shot and he held up a finger. I didn't understand and I screamed, 'What?' He yelled, 'One!' I said, 'What one?' 'One take!'" Polanski chuckles. "He hit the fence so hard his shoes left a dent in it."

A moment later in the film, Gittes experiences another harrowing encounter when he gets his nose slashed and bloodied. Polanski has talked about this scene so much over the years that when I asked him how he did it, he pleaded boredom and begged to move on. For the record, it was done with a knife on a hinge that retracted imperceptibly on contact. In keeping with his demand for realism, Polanski wanted it to be done with an illusion, not an artifice.

As much as *Chinatown* is one of Nicholson's great showcases, Polanski enhanced the performance by the fullness of the world he created around him, including the pitch-perfect cast of supporting characters. Where would Gittes be if he were not able to bounce off of the put-upon Lt. Escobar (Perry Lopez), the brutish thug "Night Train" Claude Mulvihill (Roy Jenson), the smarmy Deputy Chief of Water and Power Russ Yelburton (John Hillerman), and the weasel clerk in the hall of records (Allan Warnick, who also turns up in *The Two Jakes*)? Of course these are all Towne's creations, but it was Polanski who brought them so vividly to life.

As far as I can tell, from the first strains of the sorrowful trumpet solo on Jerry Goldsmith's soundtrack over the opening credits to the God's-eye crane shot looking down at the suffering souls alone at the end, Polanski doesn't make one false move. But it's his rock-hard adherence to the darkness of his vision that makes *Chinatown* the masterpiece it is.

If you spend any time in Los Angeles, you can catch glimpses of the paradise compromised by greed, just as Towne did when he first conceived *Chinatown*. For years I have driven on Sunset Blvd. and will stop at a traffic light and look to my left to see the location of the old people's home (now a girls' school) where Gittes roared around the circular driveway, gunshots blazing. It always seems to me as much a part of the present as the past. And that's the problem with *Chinatown*—you can't forget it.

Polanski as a thug with a bowtie brandishes the knife he uses to slash Gittes's nose.

"The nose-slashing sequence
still arouses boundless curiosity.
Jack and I are both so sick
of explaining how it was done
that we sometimes say
we did it for real."

The Tenant 1976

"The picture remains a flawed but interesting experiment, admired by some students of the cinema and regarded by others as a cult film."

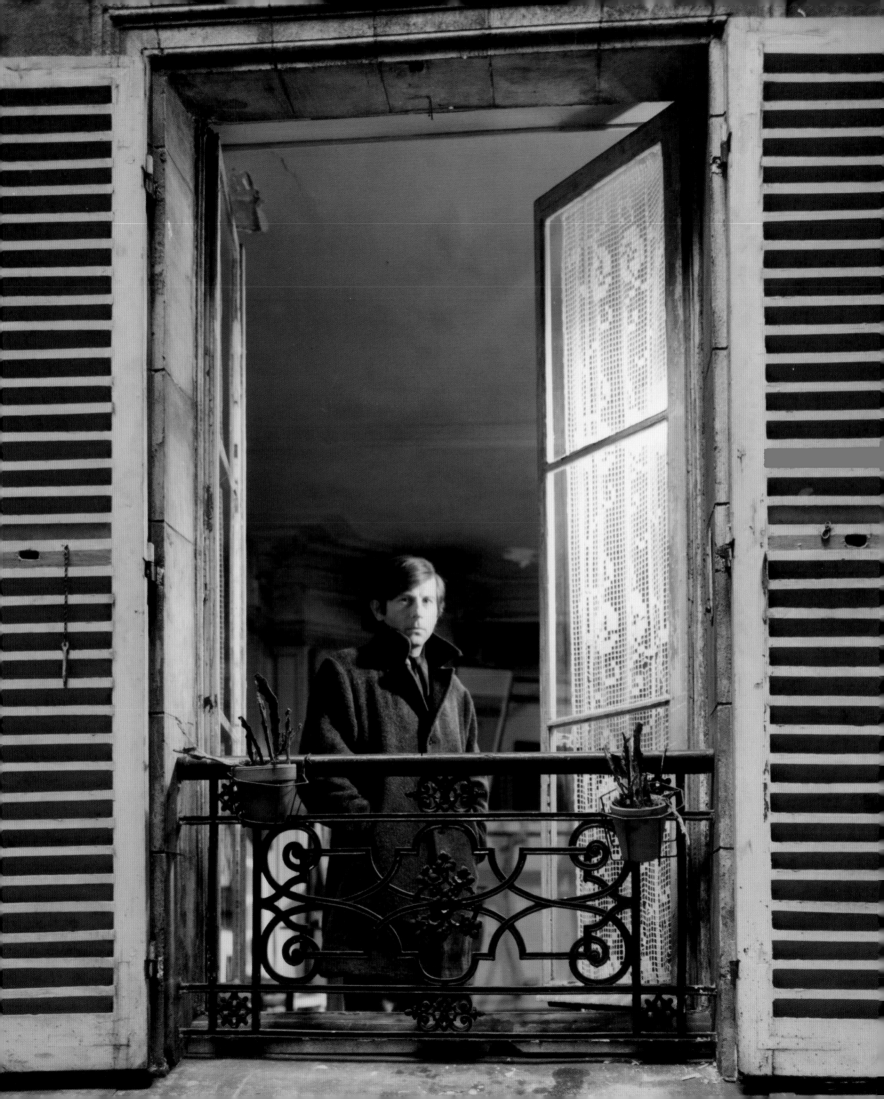

"It was hard work,
but the mere fact
of being back in Paris
galvanized me."

Nowadays, Polanski says he feels totally at home in Paris, where he's lived for almost forty years, and he is a respected and honored figure in French culture. But when he made *The Tenant* in 1976, that wasn't the case. He still felt like an outsider in the city. "In Paris, one is always reminded of being a foreigner. If you park your car wrong, it's not the fact that it's on the sidewalk that matters, but the fact that you speak with an accent," Polanski said in an interview in the New York *Daily News* at the time, cited in Christopher Sandford's *Polanski: A Biography*.

Previous page: After the wide expanses of Los Angeles and its environs, Polanski returned to one of his favorite settings: the apartment.

"Filthy little brat!" Becoming increasingly unhinged, Trelkovsky sits in the Jardin des Tuileries watching a small boy having a tantrum before walking up to the child and slapping him across the face.

Little wonder that Polanski identified with Trelkovsky, the jittery Polish-born file clerk who is the central character of the 1964 Roland Topor surrealist novel on which the film is based. Trelkovsky lives in a crappy Paris apartment with the washroom down the hall, the same kind of apartment Polanski lived in when he first came to Paris in the early 1960s. Polanski cast himself as Trelkovsky because he knew no one would understand the role as well.

From the time Trelkovsky rents the flat, the concierge (Shelley Winters) is icy, her lap dog snips his hand, and the landlord, Monsieur Zy (Melvyn Douglas), will barely look at him. "I know the atmosphere of the [French] apartment building with the twin menaces of the concierge on the ground floor and the landlord upstairs," he told the *Daily News*.

It's not exactly a warm welcome, and things get worse from there. *The Tenant* is a creepy, Kafkaesque tale in which Trelkovsky, ostracized by his neighbors and society, gradually loses his hold on reality and becomes insane, culminating in cross-dressing and suicide.

The former tenant in the apartment, Simone Choule, threw herself out the window, the concierge gleefully tells Trelkovsky, as if it were an amusing story. "You can still see where she fell," she laughs, pointing to a broken glass roof several flights below. As Trelkovsky's mental breakdown progresses, he is consumed by Simone's identity. It starts with a visit to the hospital. What he sees is the essence of Polanski—a scene both terrifying and funny.

Simone is wrapped from head to toe in bandages like a mummy. One leg is in traction and the only visible parts of her face are her eyes and mouth, frozen open in a circle

Polanski's biggest role in any of his own movies, Trelkovsky is a Polish-born functionary living in a dingy Paris apartment.

135

Trelkovsky dances with his
friend Stella (Isabelle Adjani,
in uncharacteristically
frumpy mode).

Trelkovsky dances with his
friend Stella (Isabelle Adjani,
in uncharacteristically
frumpy mode).

around her one remaining tooth. When she suddenly
screams out from the depths of her being in, what—pain,
fear, anger, acknowledgment of the absurdity of life?—
Trelkovsky looks into the hole which Polanski shoots as
if it were the deepest, darkest abyss in the world. But
Polanski can't resist the chance for some morbid fun,
so he has Trelkovsky drop a bag of oranges under the
bed and grope around on the floor to recover them.

At Simone's bedside, Trelkovsky meets her friend Stella
(Isabelle Adjani), who becomes a potential lover or
tormentor, depending on one's perspective. Polanski
allows the normally stunning Adjani to look frumpy in an
Afghan coat and frizzy hair to match. She's just another
part of the unexplained mystery.

The everyday annoyances of city life are magnified by
Trelkovsky's already fragile psyche. Taking out the garbage

becomes a minefield of comic and cosmic proportions.
Warring factions in the building draw him into a dispute
he can't win. In Monsieur Zy's hands, even a baguette
looks threatening. A visit to the police station to report
an imagined attack (Trelkovsky actually tried to strangle
himself) turns into an absurd accusation against him.

In one of the most bizarre and inexplicably spooky
scenes Polanski has ever shot, Trelkovsky excavates a tiny
hole he finds in the wall and pulls out … a tooth. Who can
say what it means, but the sight of a molar in his hand is
unaccountably disturbing. When I asked Polanski about it,
he said simply, "The hole in the wall was absolutely in the
book. That's all Topor. And the black humor comes not
only from me but mainly, I would say, from him." Which
may be true, but *The Tenant* is not the only Polanski film in
which someone pokes around in a hole in the wall.

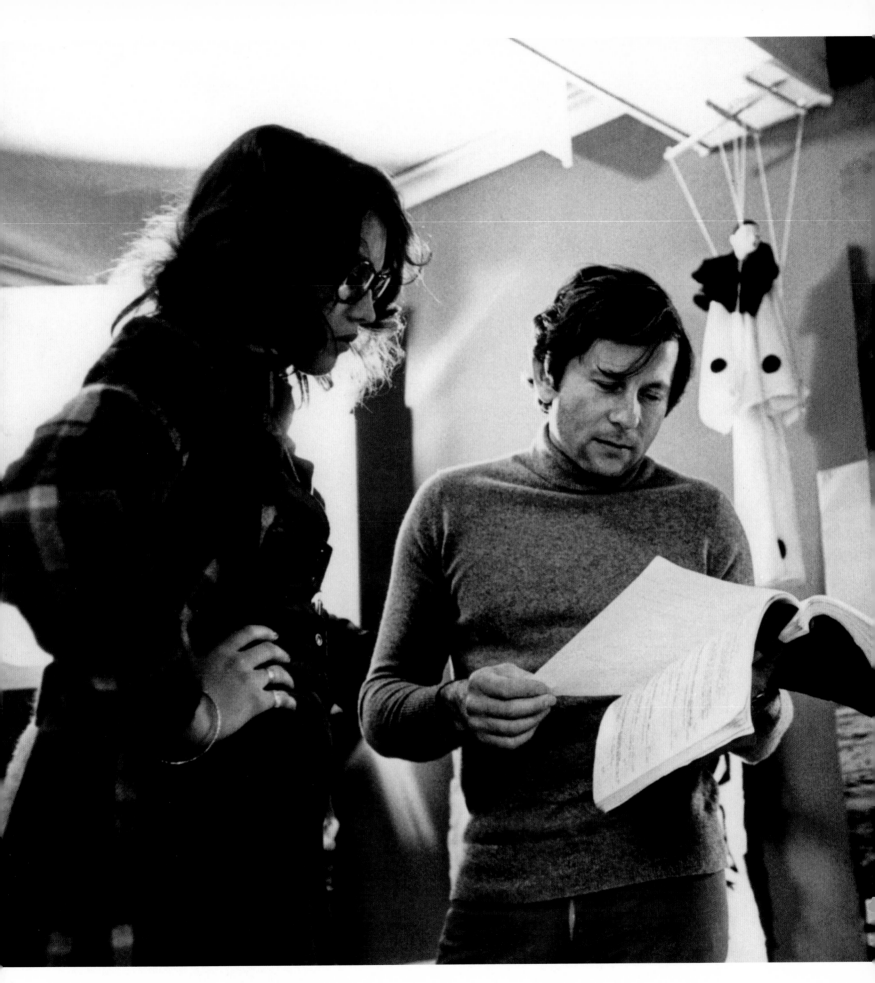

On set with Adjani. *The Tenant* is the last film to date in which Polanski has taken on the twin demands of acting and directing.

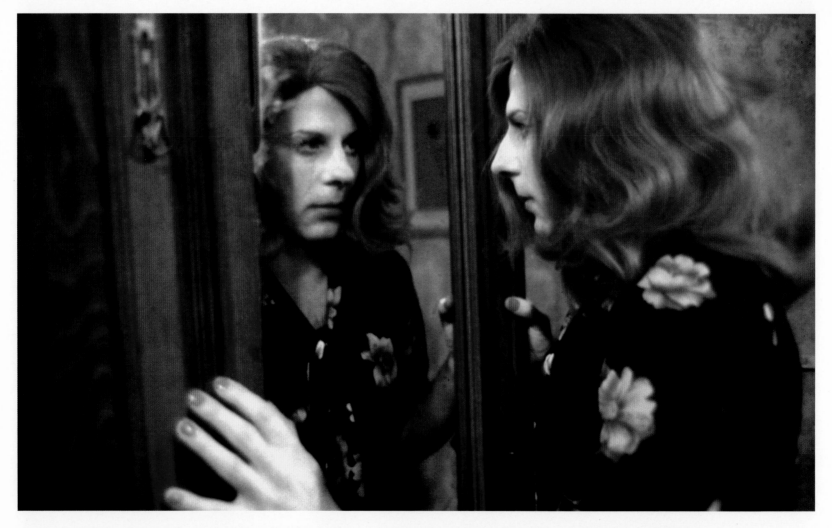

Shot by Ingmar Bergman's cinematographer, Sven Nykvist, mostly in a replica of a Paris apartment building constructed for $500,000 at the Éclair studios in Épinay outside Paris, the film manages to be claustrophobic and graceful at the same time. The opening sequence, in which Polanski used a newly invented Louma crane, pans up and around the façade of the building, peers into a series of windows, then settles down to ground level as Trelkovsky walks through the front gate into the courtyard to inquire about the apartment.

"I'm very excited when any kind of new device comes along," said Polanski, "but it was very difficult because the crane was virtually a prototype and wasn't as flexible as it is nowadays. It was a big headache and it took the whole day to get this shot. It was one of the most intricate and satisfying shots I have ever attempted."

This sequence bookends with a similar crane shot at the end of the film. By this time, Trelkovsky has become Simone, wearing a dress and makeup she left behind in the apartment. His emotional isolation has become physical. Delusional and completely cut off from the world around him, there is only one thing he can do—he jumps.

The neighbors have all come out to watch and are sitting in what are now theater boxes outside their windows

awaiting the grand performance. They are a nasty bunch of harpies delighted to watch someone else fall. Trelkovsky jumps and crashes through the glass roof in exactly the same spot as Simone did. Bloodied but not yet dead, he gets up and drags himself back up to his apartment to do it again, much to the delight of the crowd. "I think jumping for the second time is funny," Polanski chuckles. "And Shelley Winters screaming, 'he's going to jump, he's going to do it again!'"

Only Polanski could find the humor in that, but not everyone saw it that way. Despite the riveting portrait of schizophrenia, the film may have been too twisted even for critics who had previously praised Polanski's vision. The film was savaged at Cannes and never really recovered.

"They missed everything," laments Polanski. "It is black humor and when we were shooting the film we truly were having a lot of laughs. We were all expecting the film to be viewed with less fright than it gives people."

As an account of someone who is becoming mentally unglued, *The Tenant* is often compared to *Repulsion*, but Polanski dismisses that notion. "A completely different register," he says. "*Repulsion* was not [meant to be] funny."

In *Repulsion* it's clear that Catherine Deneuve has killed two men, but in *The Tenant*, how much of what we see

Opposite: Trelkovsky assumes the appearance, identity, and ultimately the fate of the previous tenant, Simone.

Above: For the film's climactic scene, in which Trelkovsky jumps to his death, the apartment building is transformed into a theater and the other residents become a ghoulish audience.

from Trelkovsky's point of view is actually happening and how much is in his head? Polanski and co-writer Gérard Brach chose not to answer that question. What matters is that this is how Trelkovsky is experiencing the world, so it's real to him—and to us. Unlike modern horror movies, it's impossible to tell what's going to happen next, which is what makes it so scary. And as an example of alienation and urban paranoia taken to an extreme, the film resonates with many of Polanski's past and future themes.

For his part, Polanski considers the film "a flawed but interesting experiment." In hindsight, he thinks Trelkovsky's insanity doesn't build gradually enough, and when he starts hallucinating it's too startling and unexpected. "The picture labors under an unacceptable change of mood halfway through," said Polanski in his autobiography. To a certain extent, he's right. But for those willing to look into the darkness, *The Tenant* is a perverse and squirmy pleasure.

"*The Tenant* was my fastest feature film ever—eight months from unadapted novel to first public screening—and I finished shooting it even before contracts were signed."

Tess ₁₉₇₉

"Until *Tess* I had never had the impression of making the film that corresponded exactly to my deepest feelings. *Tess* is that film. *Tess* is 'my' film, the film of my mature years."

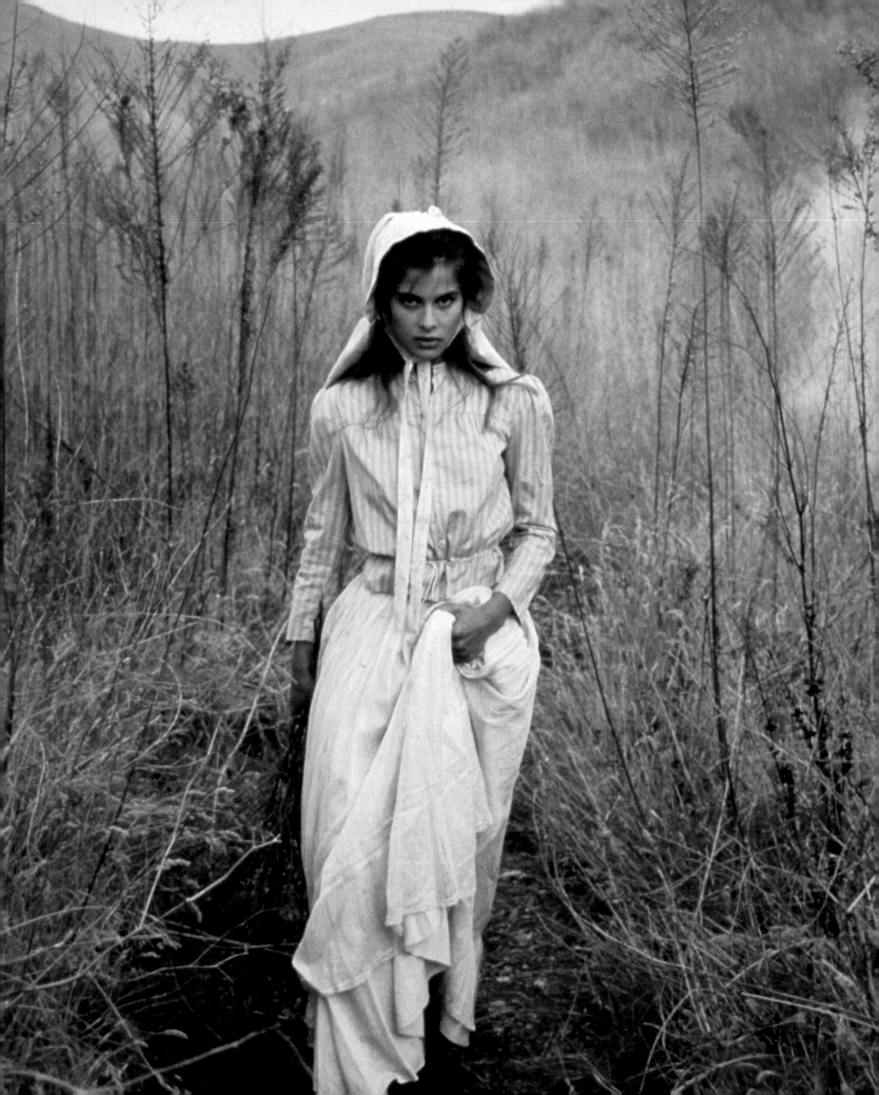

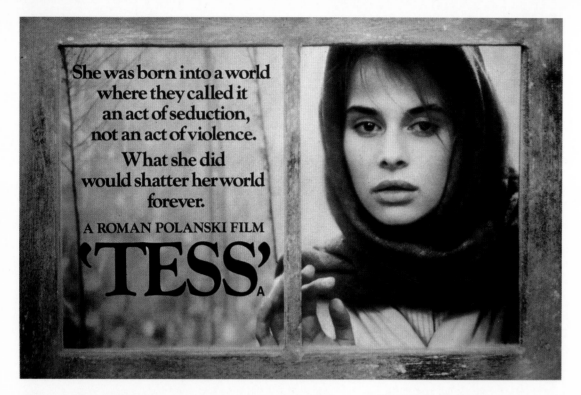

She was born into a world where they called it an act of seduction, not an act of violence. What she did would shatter her world forever.

A ROMAN POLANSKI FILM
'TESS'ₐ

When the film was announced in 1978, *Tess* seemed an unlikely picture for Polanski to be making. The sex and violence that marked his earlier work was not the stuff of Thomas Hardy's literary classic *Tess of the d'Urbervilles*, about a young woman crushed by the forces of fate and an unforgiving society. Who among Polanski's contemporaries would have dreamed of filming a nineteenth-century Victorian novel? Only two years earlier George Lucas had made *Star Wars*; Steven Spielberg made *Close Encounters of the Third Kind* also in 1976; and Francis Ford Coppola shot *Apocalypse Now* in the Philippines in 1977.

Previous page: Nastassja Kinski in the film's title role. Polanski's late wife Sharon Tate had given him a copy of Thomas Hardy's novel as a potential project for her.

But Polanski is more of a classicist than people make him out to be. *Tess* had been on his mind for years as a possible film project. In fact, his late wife Sharon Tate had given him the book to read as a potential part for her. When he picked it up later, it appealed to his deep streak of Polish romanticism. As the first film he was making in exile after his arrest and eventual flight from the United States, he wanted to touch down on familiar ground and work on emotional material. Although the parallels to his own life are undeniable, critics who interpreted his attraction to a story about a young woman seduced (or raped) by an older man as either insensitive to or a comment on his own situation were, I think, missing the point. For Polanski, who is not usually given to introspection, *Tess* probably had more to do with the malevolent fate that had befallen Tate, and the film is dedicated "to Sharon."

Polanski explained his own reasons for making *Tess* in an interview with the *New York Times* at the time of the movie's release. "The films you know me by are not necessarily the ones I wanted to do the most. Even [for] a filmmaker with integrity and guts, his films don't express exactly what he wants to express. Along with desire, you need opportunity."

The other thing that appealed to Polanski was that Hardy understood the utter capriciousness of life. If Tess's drunken, ne'er-do-well father, John Durbeyfield (John Collin), had not had a chance encounter with a local vicar who told him he was really a descendant of the ancient and noble family the d'Urbervilles, Tess would never have been thrust into the world to seek her fortune and probably would have lived and died in anonymity on a Dorset farmstead.

But sensing a way to rise in society and make a few pounds, Durbeyfield sends his naïve and beautiful daughter (Nastassja Kinski, a dead ringer for the young Ingrid Bergman) to win the favor of a wealthy scion of the family, who in reality had come by the family name the easy way—he bought it. In short order, faux cousin Alec (Leigh Lawson) seduces Tess just because he can, impregnates her, and basically ruins any chance she had for happiness. Even her great love in life, the ironically named Angel Clare (Peter Firth), can't bring himself to forgive her until it's too late. This was a world with a strictly defined hierarchy where people, especially women, had no choices and no social mobility. Trying to go against the grain is Tess's tragedy.

It's not surprising that anyone expecting the suspense and excruciating tension they had become accustomed to in a Polanski film would feel disappointed. But for those patient enough, there is plenty to admire about *Tess*. Polanski had to change his whole narrative strategy in order to be faithful to Hardy's book. Tess is essentially a passive character acted on by the forces of society, so the subjective approach of *Rosemary's Baby* or *Chinatown*, where the hero is the narrator, does not work here. To experience the world as Tess does, Polanski believed the film had to be long (186 minutes) and lyrical.

The period also had a special resonance for Polanski. The agrarian setting of Hardy's England bore an uncanny resemblance to the life he encountered as a child in the countryside of Poland when he was hiding out from the Nazis. "I really remember it well. The way the people lived in the nineteenth century in the English country was the way I lived during World War II. Very little had changed in

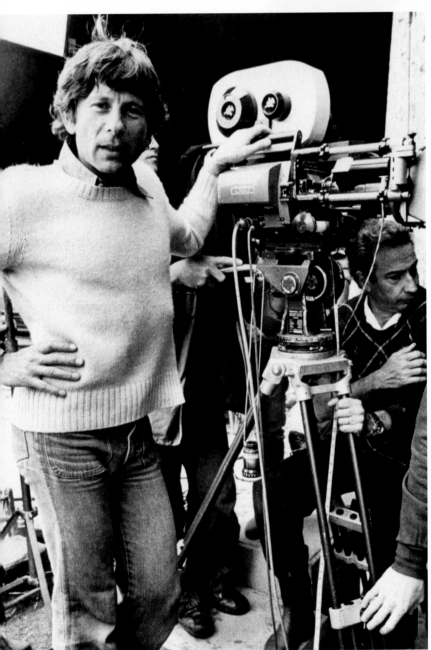

Never one to follow cinematic trends, Polanski chose to film an adaptation of a nineteenth-century novel at the height of *Star Wars* fever.

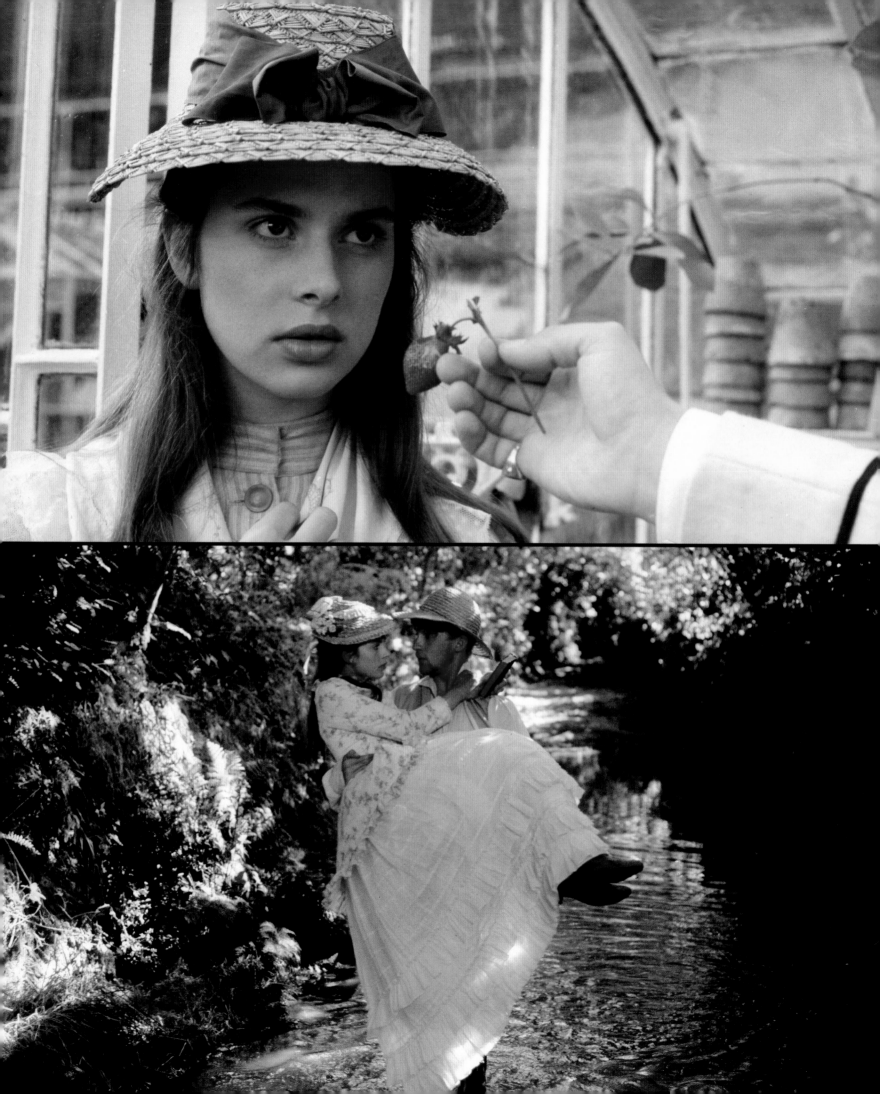

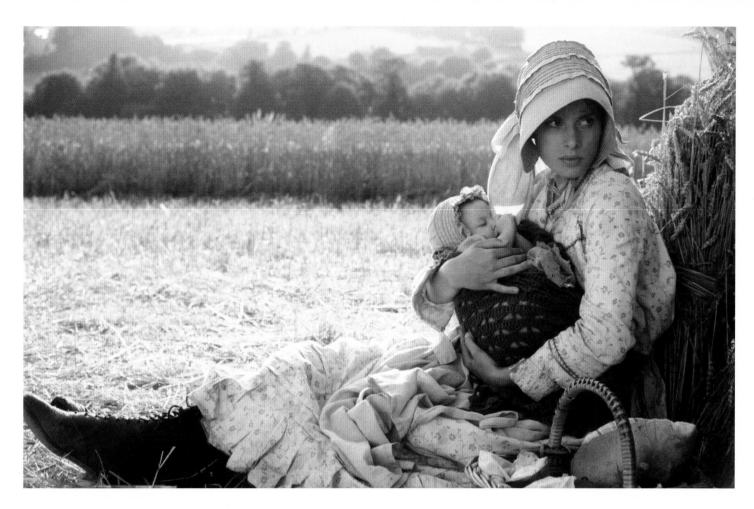

Poland and the landscape was virtually identical. So I sort of got carried away by that and I really wanted to re-create this rural life of the period as a background for our story."

At the same time, he was careful not to be too respectful and turn the film into a *Classics Illustrated* period piece. The way to get past the dusty textbook version of history was through attention to detail. "You just have to do a lot of research and try to re-create that period as honestly as you can and not just fix it to your needs," explained Polanski. "The author always writes in his reality. He's not re-creating, I am. So if you try to do everything the way it was at that time, not only the costumes but the props and elements of people's behavior, their body language, etc., it becomes real and it's not just an illustration."

Although it was impossible for Polanski to actually shoot on location in England because of the threat of extradition to the United States, there was also a practical reason to shoot in France. He maintained that the small fields bordered by hedges, once a staple of the Dorset countryside, could now be found only in Brittany and Normandy (although I know some Anglophiles and natives who question the resemblance).

In any case, it was a very ambitious shoot with the cast and crew traipsing around the French countryside like a traveling circus for nine months to capture the changing seasons required for the story. After his month-long incarceration for psychological evaluation in Chino, California, and the events in America, Polanski was relieved to be enjoying grand communal meals and the hospitality of France. "*Tess* was such an effort," he recalled. "So much energy, so much time. Yet most of the cast and crew remember the period as the happiest shoot in their lives. Something of the idyllic atmosphere may have been reflected in the film."

With unpredictable weather and striking unions, the production schedule stretched and the budget ballooned to $12 million, at the time the most expensive French production ever. Despite the problems, or perhaps because of them, the cast and crew bonded right from the start. The first day of filming—the sensuously suggestive scene where Alec meets Tess and feeds her a strawberry from his garden—was greeted by torrential rain. A canopy was hastily constructed, silk roses were "planted," but what should have been the spick-and-span greenhouse of a nouveau-riche family turned out to be a dilapidated wreck. "So I said, 'We have to paint it,'" recalled Polanski, "and I just recruited everybody who could hold a brush to paint the thing so we could shoot it the same day. Even the producers and makeup people were painting that hothouse. And the rest of it we just fixed in a very short time so we could use this location." And thanks to this movie magic, the scene plays like a luminous summer day.

Opposite top: Tess's "cousin" Alec (Leigh Lawson) offers her a strawberry to begin his seduction—and leaves her to deal with the consequences (above).

Opposite bottom: Tess is swept off her feet by Angel Clare (Peter Firth), but he can't save her.

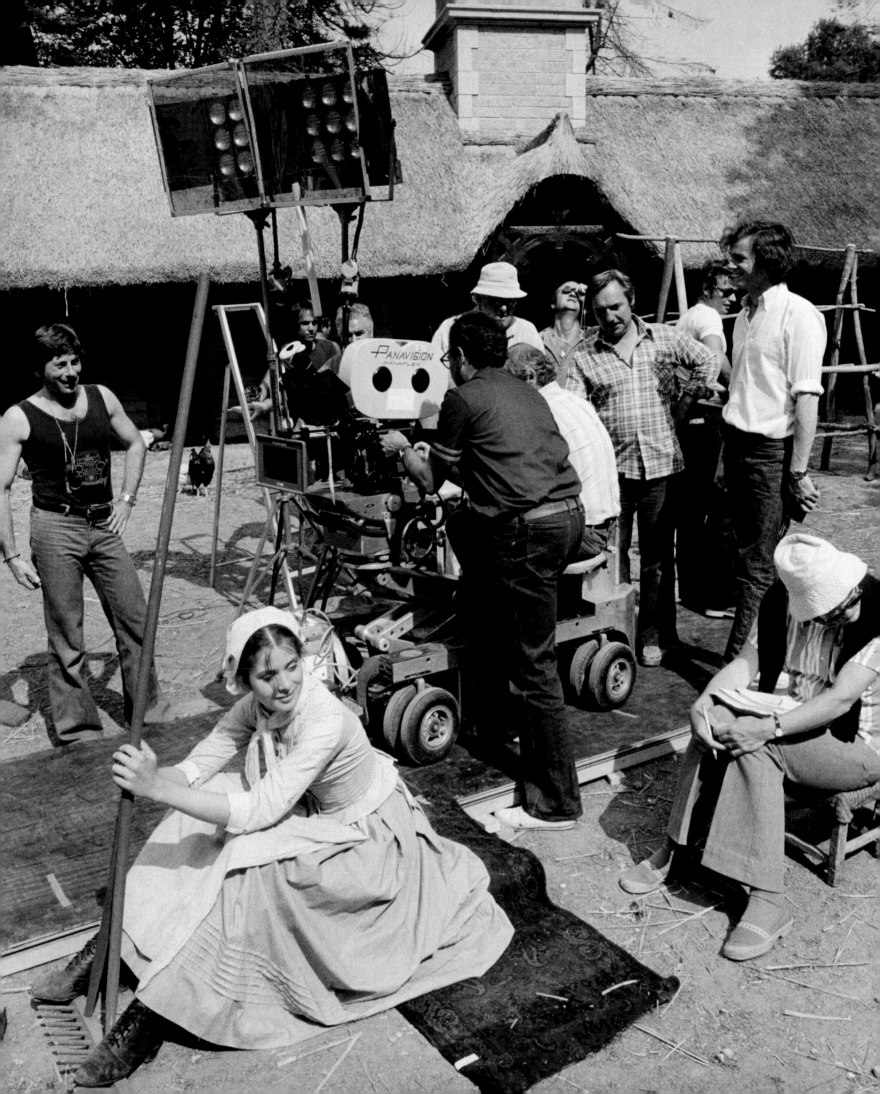

"What drew me to the character of Tess was her incredible integrity combined with her—submission? No, submissiveness—and her fatalism. She never complains. All these very ... *unfair* things happen to her, and she never complains until the end."

Polanski pulled off another clever piece of movie trickery in the barn of the dairy farm where Tess seeks refuge after her baby dies. "The farm could very easily be somewhere in Dorset from the architectural point of view," said Polanski. "The only problem was that the stable was too small. So I put a mirror on one wall so it looked twice as big with twice as many cows. Of course, in certain angles it's difficult to avoid the reflection of the crew, but with a little bit of planning you can get it all done. In those times we didn't have the help of digital cheating."

But the golden glow of the shoot faded fast and post-production was a drawn-out affair, one of the worst of Polanski's career. After sorting through forty hours of footage for a month, he employed five editing rooms racing to meet a deadline for the German release, where the film was roundly panned. The response was better in France but the film still did not have an American distributor until Columbia Pictures picked it up over a year later. *Tess* went on to receive six Academy Award nominations, including best picture and director, winning in three categories. But by that time, Polanski was so disenchanted from two years of misery, he wrote in his autobiography, "I never wanted to make a film again. I began referring to myself as a 'former' film director."

Today Polanski is proud and perhaps even more protective of *Tess* as a once-spurned child. He tends to focus on the joy of making it and the vindication of the results. In 2012, he took a restored print of *Tess* back to Cannes for a victory lap as a festival classic.

Along the way, the production transformed French provincial streets into nineteenth-century English villages.

This page and previous page: The director makes sure every gesture and nuance is exactly the way he wants it in this pivotal scene between Tess and the hypocritical Angel Clare.

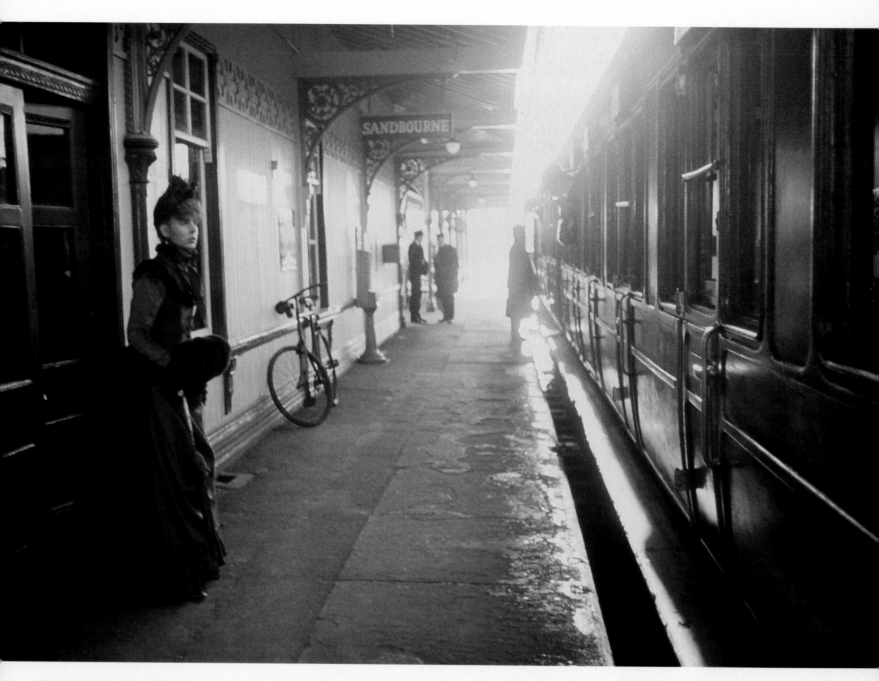

Above: Having murdered Alec,
Tess anxiously makes her escape.

Opposite: Polanski re-created
nineteenth-century Dorset in
1970s Normandy and Brittany,
including period farm equipment.

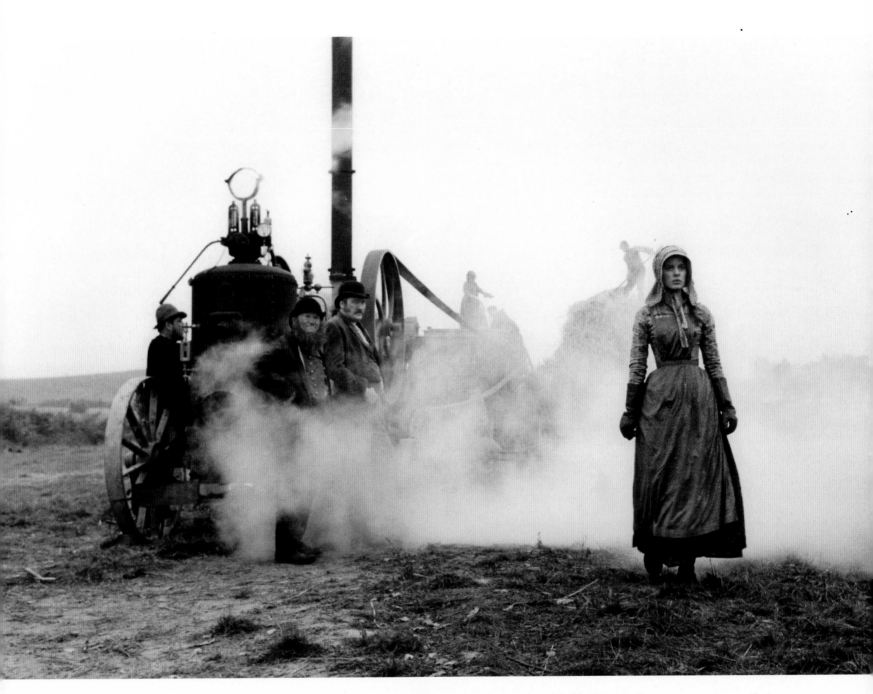

"When I was a child and ran away from the ghetto, I lived in the country exactly like the one in *Tess*. It was in the forties, but it was nineteenth-century Poland, because the peasants were virtually medieval in that part of Poland. I knew all about the country life: how you sowed, how you harvested. So I wanted to re-create this."

"I was so traumatized by the experience of *Tess*
I just didn't want to make films anymore."

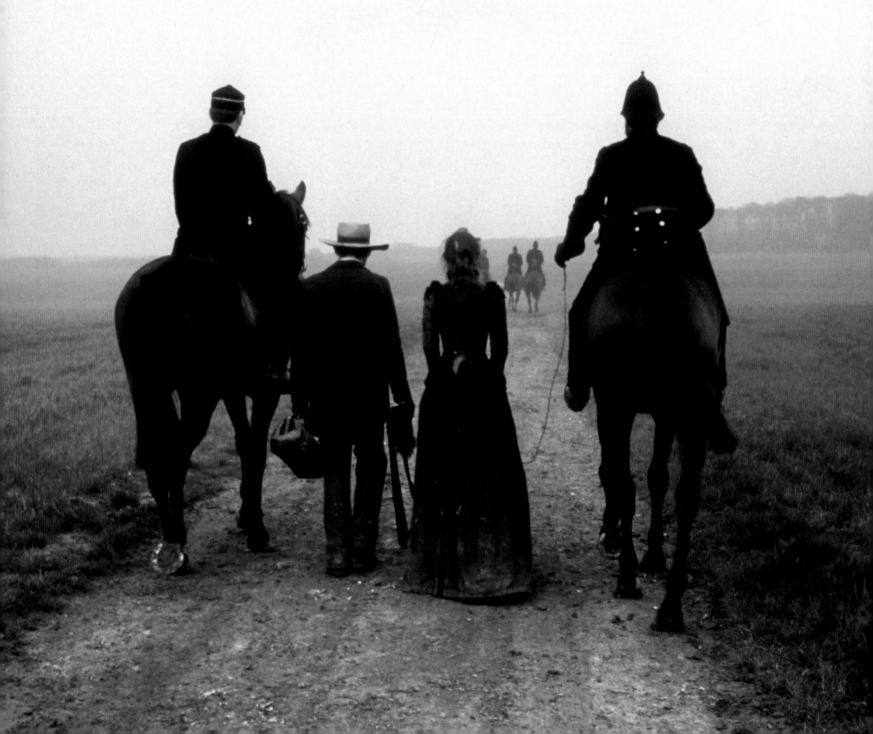

Bales of peat were ground down on asphalt roads to re-create the dirt tracks as Polanski remembered them from his childhood. Photographed by Geoffrey Unsworth (*2001: A Space Odyssey*), who died during the shoot, and Ghislain Cloquet, there are sweeping landscapes, moonlit nights, and moments of great beauty—even a glimpse of happiness—but in keeping with Hardy's novel, this is a harsh, not a picturesque world.

All the more reason Tess's extraordinary beauty shines through the dinginess. In a sympathetic performance, especially for someone with so little experience, Kinski is sensual but at the same time solemn and distant. Tess may think about being happy, but she doesn't really believe in it. She is tied to the land and never seems so much at home as when she is harvesting rye or digging for turnips in a muddy winter field, eating her meager meal by herself in a corner. In some ways she was born to suffer.

Even the love scene where Tess is seduced in the woods by her "cousin" Alec is without joy, and Polanski was careful to film it without flash. Marrying his style with the content, the director showed restraint throughout. He allowed himself one characteristic flourish where he departed from the muted palette of the film and echoed the symbolism of the novel. After Tess murders Alec, a housemaid discovers the deed when she sees drops of red blood dripping from the ceiling. And then Tess flees wearing a red dress.

But her fate is sealed. The film's biggest set piece was a re-creation of Stonehenge (built in a field fifty miles north of Paris), where the police apprehend Tess as the sun rises. Nature goes on in its indifference to the mess man has made of his existence. And the final inexorable scene at this ancient site suggests it has ever been thus. Polanski would never argue otherwise.

Opposite: Tess is led away in chains to face the consequences of her crime.

Above: By the end of shooting, all Polanski wanted was to be left alone.

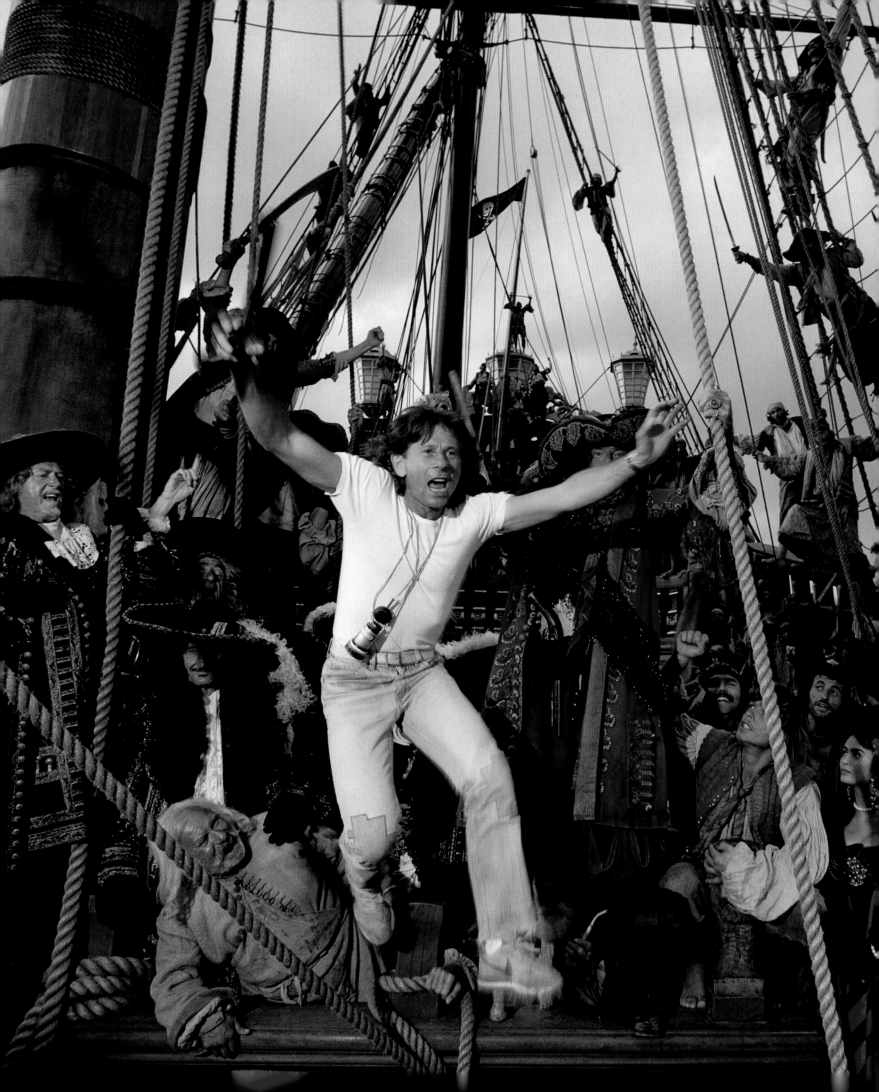

Pirates 1986

"Until now, pirate films have just been cowboy films set on water. This one will be different."

Opposite: Unable to secure his first choice, Jack Nicholson, Polanski ended up casting Walter Matthau in the movie's principal role.

The irony of *Pirates* is that after Polanski worked on the screenplay for ten years, two weeks before the start of shooting in Tunisia, the script still wasn't ready. Neither was the financing. It was a recipe for disaster, and that's indeed what happened. "*Pirates* was a textbook exercise in failure to prep, failure to develop, failure to realize. Everything about it went wrong," recalled Thom Mount, the film's executive producer.

Polanski was in love with the idea of making a pirate picture and it was the first script he and partner Gérard Brach developed after the success of *Chinatown*. As a child growing up in war-ravaged Poland, he had been transported by the rollicking action of Errol Flynn movies like *Captain Blood* and *The Adventures of Robin Hood*, and that's the kind of romance and adventure he wanted to re-create with *Pirates*. "It symbolized what the cinema was to me as a child," Polanski said.

When Polanski began working on the script in 1974, he felt the world was ripe for a rip-roaring adventure. He told his cast and crew that pirate films had become just cowboy movies on the water; this one, he promised, would be different. He wanted the tone of *Pirates* to be the same as what he had done for *The Fearless Vampire Killers*—an authentic genre piece but also an affectionate parody of the genre. "The characters are serious and the actors must be convincing, even if the situations they find themselves in are completely absurd," Polanski said in a 1986 interview in the French edition of *Premiere*.

Initially, he had envisaged Jack Nicholson as the swashbuckling hero of the film, but Nicholson was less than anxious to pick up a sword and when his asking price became too high, the project stalled. Along the way, other actors passed on the project and ultimately Polanski wound up with the unlikely choice of Walter Matthau as the swearing, boozing, peg-legged treasure hunter Captain Red. He's the kind of character who can swallow a fishhook or eat a boiled rat (which is supposed to be funny). Matthau was certainly capable of playing a crusty character, and had proven himself a skilled comic actor, but mostly in fast-talking contemporary comedies.

Previous page: Not having directed a film for seven years, Polanski relished being back at the center of things.

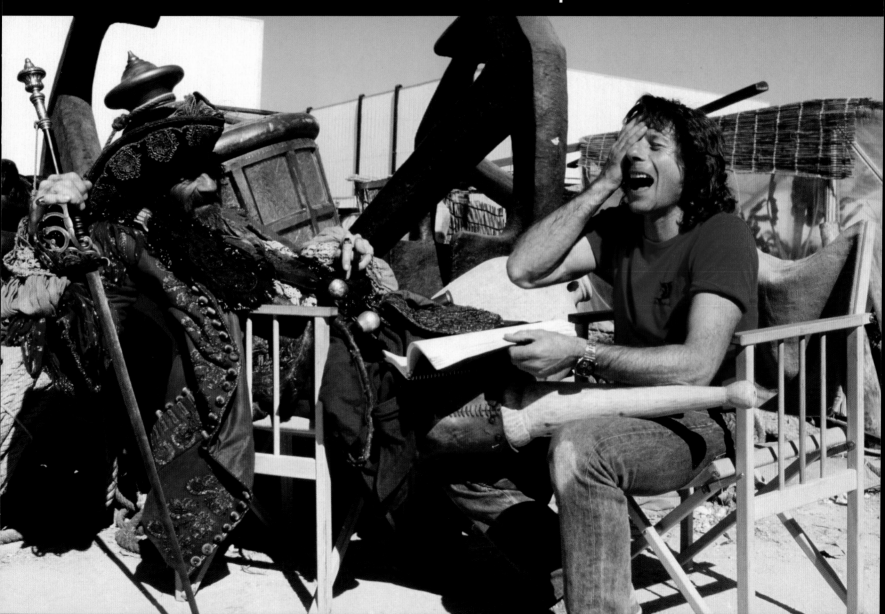

by the weather. You know that the bigger a budget is, the more problems there are."

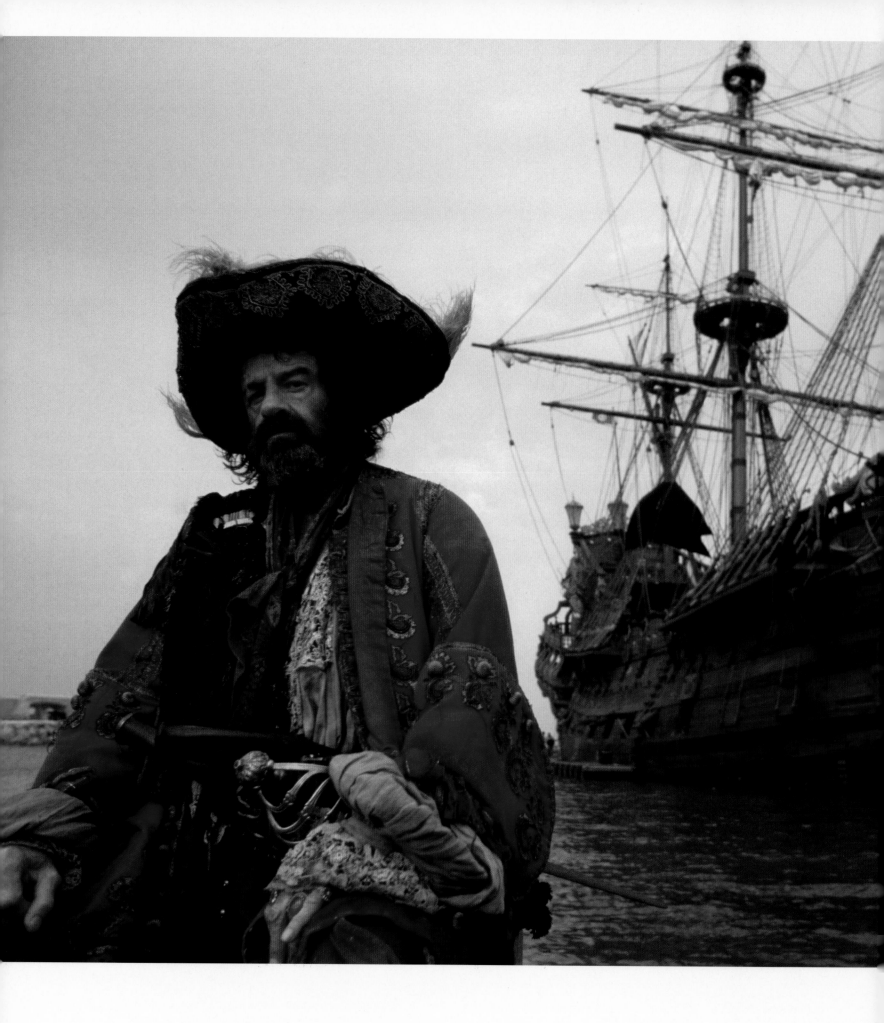

Barely recognizable behind
a scraggly beard, Matthau was
an unlikely choice for the part
of Captain Red.

"It was conceived from the outset as a grand, swashbuckling adventure comedy—a genre I hadn't tackled before."

He never seems quite at home in the pirate's frock coat, tricorn hat, and tattered silk shirt. His face is barely recognizable behind a scraggly beard and for some reason he decided on a Cockney accent that's all over the place.

The plot is the shaggiest of shaggy dog stories, with the shipwrecked Red and his accomplice, The Frog (Cris Campion), rescued by a Spanish galleon in possession of a golden Aztec throne. From one tedious mishap to another, Red, who would "rather be without my head than without gold," schemes to steal the treasure. There are detours to a tropical island, a romantic subplot between The Frog and the Spanish governor's lovely young niece (Charlotte Lewis), and finally after two hours of this, the film ends right back where it started—with Red and The Frog adrift on a raft in some kind of cosmic last laugh at the folly of human existence.

Having played all the parts in his head over and over again for years (at one time he thought about playing The Frog himself), Polanski was enthusiastic as shooting started. Each morning he would bound onto the set and run through the action for the day, including the sword fights, sometimes even climbing up the rigging of the ship to demonstrate stunts. "The biggest problem we had with Roman was to keep him from killing himself," said Mount.

Polanski wanted nothing short of an authentic rendering down to the smallest detail of what life would have looked like to someone sailing with Blackbeard himself in the eighteenth century. The great British costume designer Anthony Powell (who won an Academy Award for *Tess* and was nominated for *Pirates*) and a team of Tunisian craftsmen stitched hundreds of outfits and dozens of pairs of satin shoes. The interior of the cabins was designed by

159

> "Whether under capitalism or Communism, with a big budget or a small one, the powers that be react the same way when a director falls behind his schedule."

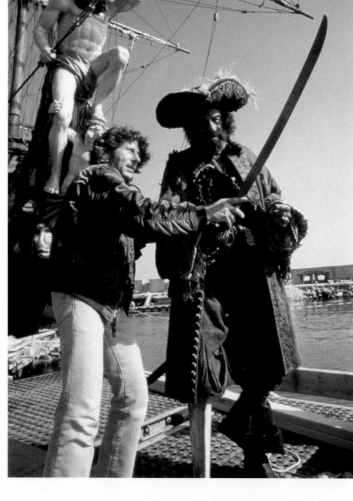

The exacting director offers swordsmanship tips to an unimpressed Walter Matthau. Polanski described every shot as being like "tearing a fish out of a shark's mouth."

Pierre Guffroy (who also won an Oscar for *Tess*) on a giant prefabricated soundstage imported from Italy. But by far Polanski's biggest toy was the *Neptune* itself, a 200-foot Spanish galleon built by a team of 600 shipwrights at the French naval shipyards in Tunisia at a cost of almost $8 million. But being a movie boat, sailing was not enough; it had to rotate 360 degrees, move sideways, back up, and change its position at any time.

This was filmmaking on a grand scale, but it wasn't quite full speed ahead. Polanski's ambitious plans were often delayed or thwarted because there wasn't enough money, despite assurances from Tunisian producer Tarak Ben Ammar. At one point, the production shut down for seventeen days—with the meter running—and on two occasions moneymen arrived from Los Angeles with suitcases of cash to keep the film afloat. In the end, the budget had soared from $13.5 million to $33.5 million.

In addition to weather problems—the *Neptune* was damaged in a storm the day it launched—and the difficulty of shooting on the Mediterranean with ever-shifting light and a constant background of speedboats, airplanes, and vacationing tourists, it became clear to Polanski after a couple of weeks that he wasn't getting the performances he wanted. Campion, a French pop star making his first film,

was an uncharismatic romantic lead; Damien Thomas, who had replaced Timothy Dalton at the last minute as the captain's main adversary, Don Alfonso de la Torré, was foppish and wooden. And Matthau, who was used to finding his own way through a part, could not fathom this little Polish guy instructing him how to hold his cup. In a later interview, Matthau would remark drily that Polanski was not his kind of director.

Polanski described it as the most agonizing work he had ever done. Eventually he would admit that under these conditions it was a mistake to fight for the film. "I had to make too many compromises," he said in a 1995 interview in *Sight and Sound*. "I had to chop the script, and to cast it in a way I didn't want to … slaving away for twenty-eight weeks in the Mediterranean and Tunisia with a multinational crew who couldn't understand one another, not enough money and all kinds of natural difficulties.… Every shot was like tearing a fish out of a shark's mouth."

By the time shooting was finished, Polanski couldn't wait to get out of Tunisia. Before the reviews came out— and they were not polite—Mount said to Polanski, "If we wait for this thing to open up before we get a new deal, neither of us will work again."

Fortunately for Polanski that wasn't the case.

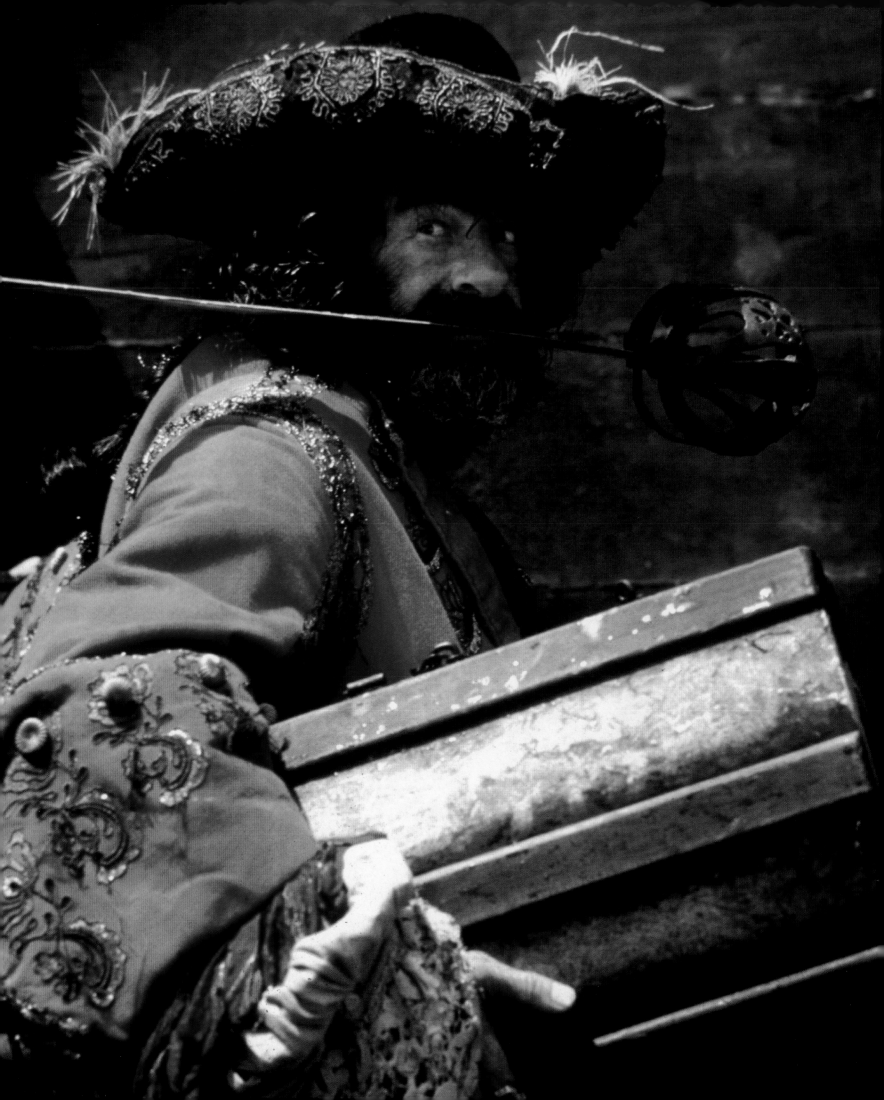

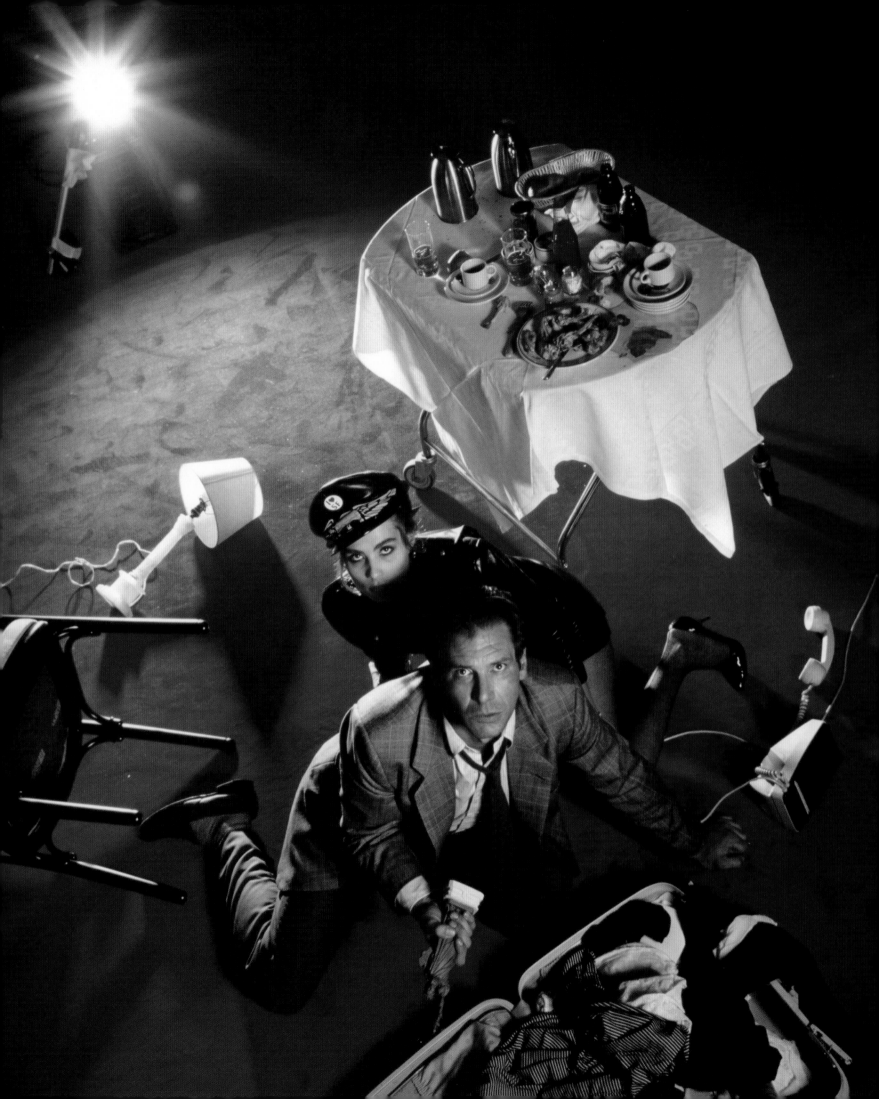

Frantic 1988

"From the start the idea was to make a film in the city where I live. I wanted to stay at home after being away for two years in Tunisia."

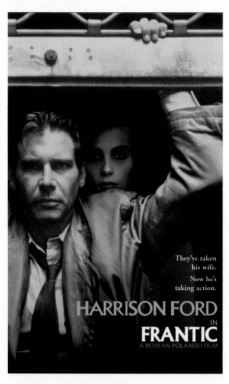

At the beginning of *Manhattan*, Woody Allen rhapsodizes in glowing black and white about "his town," New York. It's a romanticized fairy tale of the city, with elegant women, streetwise construction workers, and beautiful architecture, all punctuated by a soaring Gershwin score. In *Frantic*, Polanski shows us in murky colors the seedy nightclubs, airport parking lots, run-down apartment buildings, and back alleys of Paris. "The idea was to make a film about the things I know—to show my Paris," he said. In the process, Polanski achieved the impossible; he made Paris look unappealing. That is probably the biggest and best cinematic trick in the whole movie.

Previous page: "I thought my place was messy." The mysterious Michelle (Emmanuelle Seigner) and Dr. Richard Walker (Harrison Ford) in a stylized rendering of the Walkers' ransacked hotel room.

Polanski with his then-soon-to-be third wife, Emmanuelle Seigner, and Harrison Ford with his now-former second wife, Melissa Mathison, in front of the venerable Paris restaurant Brasserie Lipp—one of the landmarks that the Walkers may have been planning to visit on their second honeymoon.

Making Paris look unattractive was always the point of the film. Toward the end of shooting *Pirates* in Tunisia, when that ship was obviously sinking, Polanski's producer, Thom Mount, turned to him and said, "What do you want to do next?" Polanski answered, "I want to shoot someplace where you can eat the damn food and the phones work." Paris, where Polanski lived, was a logical choice. "What do you hate most about Paris?" Mount asked him. "American tourists," responded Polanski. So it was decided: He would make a thriller that would kill tourism in Paris.

Working with his longtime accomplice, Gérard Brach, with an uncredited assist from *Chinatown* scribe Robert Towne, Polanski fashioned a story about Americans in Paris, but it is not the magical Paris of unending romance. With his usual subversive and mischievous attitude, Polanski has a great time turning the tables on the city's mythical charm. The result is an effective and entertaining thriller with flourishes of Polanski's stylish suspense and bits of black humor. An ordinary cab ride from the airport to open the film creates a sense of impending doom as few directors can.

This is Polanski in Hitchcockian mode—even down to the one-word title—and to prepare for *Frantic*, he and Mount watched a dozen Hitchcock films on tape. In a twisty, sometimes incomprehensible plot, Dr. Richard Walker (Harrison Ford), a mild-mannered heart surgeon from San Francisco, and his wife Sondra (Betty Buckley) return to the scene of their honeymoon twenty years earlier for a medical convention. While he's in the shower singing "I Love Paris" and trying to wash off the jet lag, the phone rings. By the time he gets out of the shower,

his wife is missing. From that point on, everything is changed. Walker is an ordinary guy thrust into nefarious affairs he doesn't understand. His inability to speak French only heightens his frustration. And like Hitchcock, Polanski shares a distrust of authority, so a running joke in the film is the ineptitude of the American embassy officials, the hotel detective, and the police, who are supposed to be helping. With a shrug of the shoulders, they say in so many words, "It's your problem, you find her."

The MacGuffin, Hitchcock's term for the device that propels the plot, is a tiny nuclear trigger smuggled into the country at the behest of a couple of seedy Arab arms dealers by the beautiful and edgy courier Michelle (Emmanuelle Seigner). She's on the same plane as the Walkers and in the old wrong suitcase ploy, Michelle and Sondra get their bags mixed up, and before you know it, Sondra is held hostage by the bad guys. All that Walker knows is that his wife has disappeared, and as the tension builds, the audience follows him as he scrambles to put the pieces together. "We made a big effort in *Frantic* for the audience not to outsmart Harrison Ford," explained Polanski in an interview in *Positif*. "If the characters on screen know less than the audience they tend to look foolish. 'Why doesn't he see what I see?' So we tried to make his character intelligent enough so he understands things as quickly as the audience does."

Before long, Walker and Michelle, whose life is now also in danger, are hooked up night crawling the underbelly of Paris looking for the nuclear gadget, which in the film's most clever conceit has been hidden in the base of a small Statue of Liberty souvenir in her missing suitcase. "Every decision in the movie had to

Dr. Walker interrupts his ablutions to investigate the disappearance of his wife.

165

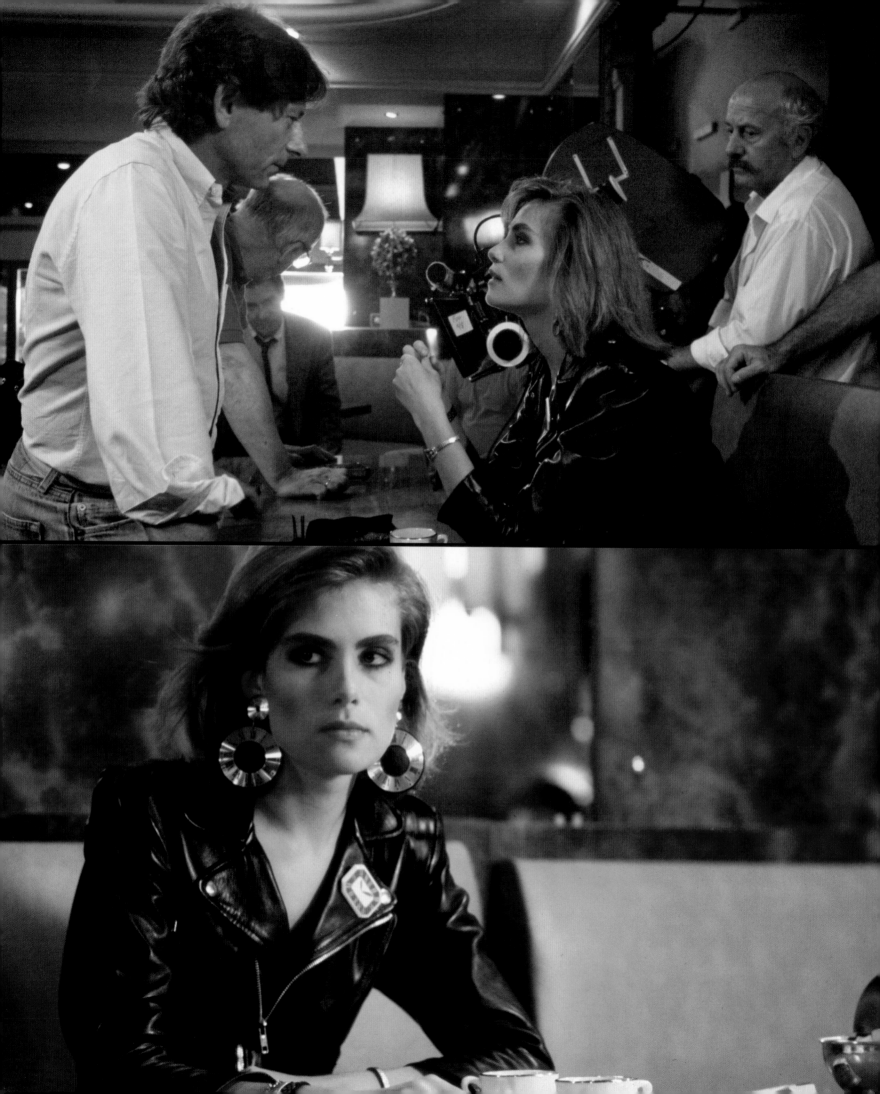

do with the culture clash between the United States and France," said Mount. "It had to do with the irony of American expectations versus European expectations, and Roman played on that in every regard."

Polanski insisted on a gray, monochromatic palette for the film, with only occasional splashes of color as the iconic Paris pokes through the haze. The hotel lobby was a drab affair, based on a real hotel that had recently been redesigned and Americanized, and was re-created on the soundstage at Boulogne-Billancourt Studios. It's an intentionally uninviting place with low ceilings and harsh lighting. Welcome to Paris, indeed.

The other big set piece built in the studio was a re-creation of Les Bains Douches nightclub, one of Polanski's favorite haunts of the period, called the Blue Parrot in the film. The late 1980s chic seems a bit dated now but the atmosphere is authentic; the extras were the real lounge lizards from the club trucked out to the studio. "[Building the set] really amused the set decorators who had to copy every nook and cranny," Polanski told *Positif*. "When the owner and clientele of the real club came to visit they were completely disoriented."

While Walker and Michelle are being chased around town, Polanski injects moments of humor in unlikely places, as they might happen in real life. The straight-arrow Ford in a bathroom stall sampling a taste of cocaine and then spilling some on his tie is delightfully incongruous. And then later, crawling across the rooftops of Paris, in an imitation of Cary Grant as the cat burglar in Hitchcock's *To Catch a Thief*, he gets tangled up in a TV antenna and spills the contents of the suitcase—including the miniature Statue of Liberty—over the ledge. (This, incidentally, was shot on a one-story model at the studio enhanced by mirrors on the bottom of the building to make it look taller.)

But the suspense and sexual attraction between Walker and Michelle can carry a thin story only so far. By the end, it has turned into a pretty routine genre piece. The villains aren't bad enough, the danger not threatening enough, and the conclusion anticlimactic. The Arab smugglers, now pursued by, I think, a couple of Israelis (it's hard to tell) are more bumbling than menacing. At one point, Walker drives a getaway car reaching over a dead body in the driver's seat. As much as Polanski might enjoy a good gag,

Opposite: Polanski directed Emmanuelle Seigner for the first time in *Frantic* and the couple married a year later. Seigner has since acted in three more of her husband's movies—including the forthcoming *Venus in Fur*.

Above: Polanski managed to find an insalubrious section of the Seine for the film's final showdown.

Polanski's desire to subvert
the typical romantic notion of
Paris took him to unglamorous

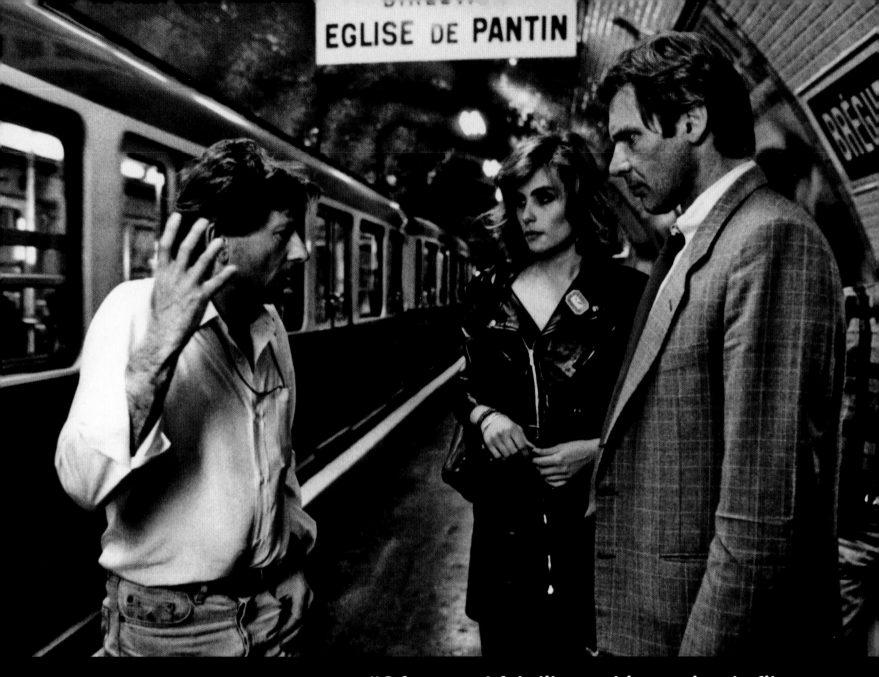

EGLISE DE PANTIN

"Of course I felt like making a simple film without complicated sets and costumes, preferably without costumes and sets at all! Anything on which I could keep a view of the entire piece and not just little moments, because *Pirates* was shot without any continuity and ... I didn't want to go through a similar experience, so I made *Frantic*."

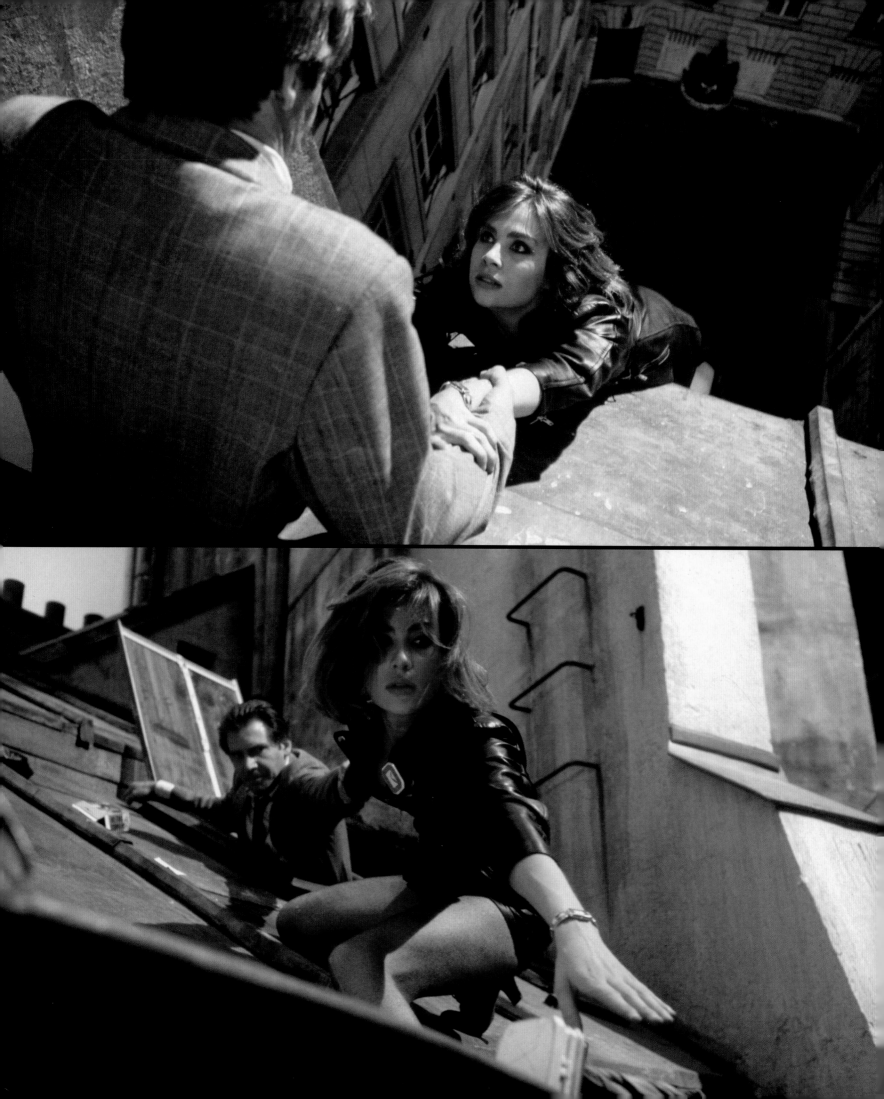

it's hard to take it all seriously or worry about what's going to happen. But on its own terms, Ford is fun to watch as he scowls his way through the film, and Seigner, wearing some of the shortest dresses this side of the sixties, captures the hard and soft sides of a late-night hipster.

It all comes to a head, fittingly, on the banks of the Seine, but not the romantic spot of so many movies and songs, but the stomping ground of drug dealers and drunks. Polanski had to use stuntmen for the scene because the villains were required to jump off a boat onto the shore, then fall backwards onto the gravel when shot. But ever the perfectionist, Polanski wasn't happy with how they were dying. So he demonstrated how to fall correctly when hit from behind by a bullet. The stuntmen, not used to getting acting lessons, stood around watching as Polanski made giant gestures with his arms extended.

If the ending in which Michelle is shot and killed and Walker throws the nuclear trigger into the river seems truncated, that's because it is. In keeping with his sense of the absurd, Polanski had filmed a different ending with Walker and his wife in traffic on their way to the airport. As the cab pulls up beside a garbage truck, he takes the device and tosses it in the back of the truck. When his wife asks him what that was, he says "nothing important." But Warner Bros. was unhappy with that ending and wanted something more concrete and dramatic. So the American release was about twelve minutes shorter and had Walker throwing the trigger into the river. As is often the case, when the studio tries to fix something, it makes things worse. I don't know if Polanski's original ending would have made *Frantic* a better movie, but at least it would have made more sense.

Opposite: Thanks to ingenious use of mirrors on the set, Seigner is not dangling from as great a height as she appears to be.

Above: The all-action director shows a bemused stuntman how you fall when you've been shot in the back.

"I wanted to get rid of everything that was too obviously quaintly Parisian and tried to show the town of today. It was the way I see it and not as Americans might imagine it to be."

Reunited with his wife, Sondra (Betty Buckley), Walker watches in horror as Michelle is shot and killed.

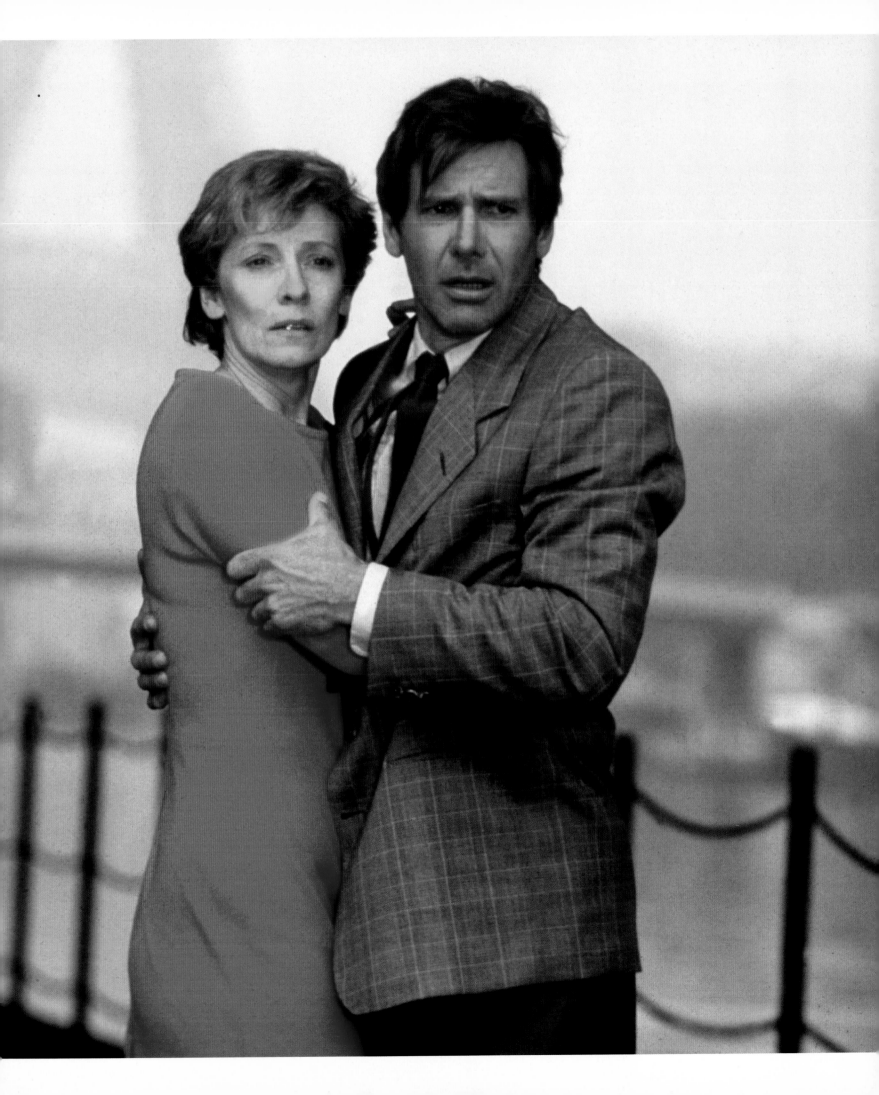

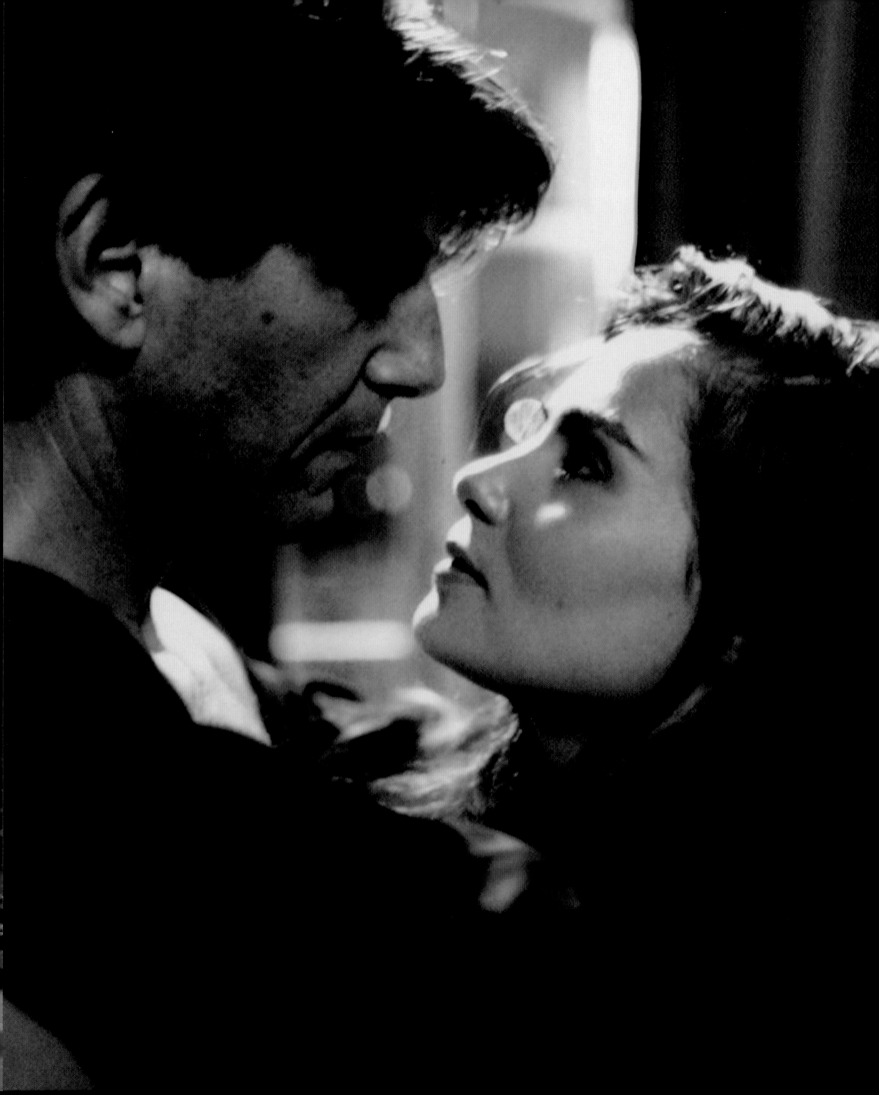

Bitter Moon 1992

"The fact that sexual attraction wanes, that's what fascinated me. That has nothing to do with love, which can actually deepen as sex declines. It's a universal issue, is it not?"

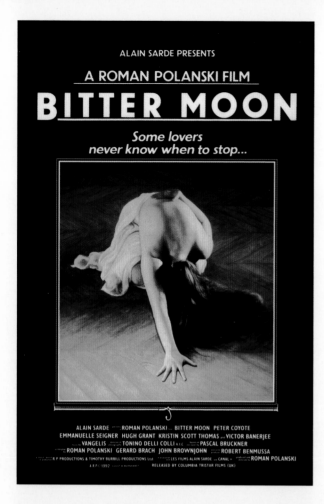

ALAIN SARDE PRESENTS

A ROMAN POLANSKI FILM

BITTER MOON

Some lovers
never know when to stop...

ALAIN SARDE ····· ROMAN POLANSKI ··· BITTER MOON · PETER COYOTE
EMMANUELLE SEIGNER · HUGH GRANT · KRISTIN SCOTT THOMAS ··· VICTOR BANERJEE
····· VANGELIS ····· TONINO DELLI COLLI A.I.C. ····· PASCAL BRUCKNER
····· ROMAN POLANSKI · GERARD BRACH · JOHN BROWNJOHN ····· ROBERT BENMUSSA
···· R P PRODUCTIONS & TIMOTHY BURRILL PRODUCTIONS Ltd ···· LES FILMS ALAIN SARDE ··· CANAL + ···· ROMAN POLANSKI
A.R.P.© 1992 ·············· RELEASED BY COLUMBIA TRISTAR FILMS (UK)

"I hadn't done a movie like this for a long time, and I felt strongly not only that *I'd* like to do it, but that people who know my work were somehow expecting and wanting me to return to this kind of material."

I once asked Polanski if he would ever consider doing a straight love story. He said sure, as long as the couple dies in the end. In *Bitter Moon* he does both. The premise of the film, he explained, is: "Love cannot last forever in its true intensity. It must bleed or end tragically. If it has peaks, it must have lows."

Previous page: A tender moment for doomed lovers Oscar (Peter Coyote) and Mimi (Emmanuelle Seigner).

That, of course, is an extreme interpretation of the throes and arrows of *amour*, but *Bitter Moon* is nothing if not extreme. Loosely based on the French novel *Lunes de Fiel* (*Poison Moons*) by Pascal Bruckner, it's about the highs of sexual attraction and the inevitable aftermath when the passion wears off. Set on a cruise ship going from Venice to Istanbul, the film conjures up a tempest of twisted love in which one couple (Peter Coyote and Emmanuelle Seigner) devours itself while drawing a staid English couple (Hugh Grant and Kristin Scott Thomas) into a storm of sex and self-destruction. By anyone's standards it's a tough piece of work, but like many bad affairs, it goes on too long.

After the formulaic genre film *Frantic*, Polanski wanted to break out in a big way and return to what he did best— explore the treachery of relationships. *Bitter Moon* was shot at the Boulogne-Billancourt Studios outside Paris and, for one week, aboard a second-rate Greek cruise ship on the Adriatic Sea. A handful of journalists, including myself, were invited to go along and watch. It was more than a little disorienting and even absurd to be traveling, not to reach a destination, but to create moments for a movie. But this was Roman Polanski's love boat. He had the ship circle to keep the sun at the desired angle, detour closer to land to avoid storms, then sail past Athens to Istanbul in order to shoot the final scene at sunrise against

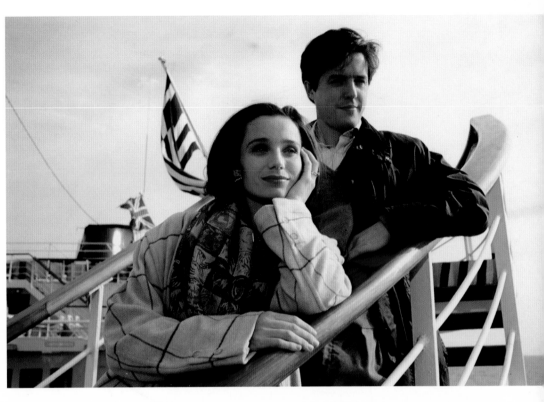

Kristin Scott Thomas and
Hugh Grant play Fiona and
Nigel, a straitlaced British
couple who become embroiled
in the death throes of Oscar
and Mimi's turbulent marriage.

a backdrop of mosques. Even the clouds were directed
by Polanski.

November on the Adriatic was no time for a pleasure
cruise, and one night, pacing on a side deck, Polanski was
trying to get a shot in before the weather turned even more
miserable. The crew was squashed into a five-foot-wide
walkway tangled with wires while soundmen hung from
the upper deck dangling a boom. This was a crucial scene
in which the wheelchair-bound Oscar (Coyote), a seedy
writer manqué, stakes out his prey, Nigel (Grant).

"Romantic isn't it?" croaks Coyote as he rolls his
wheelchair toward Grant like a tank closing in on its target.
Take after take, Polanski runs over to show what he wants,
even acting out the delivery. "Fold your legs like this,
and when you come up to him, grab his arm forcefully."
Finally, after an hour, Polanski gets the intensity he was
looking for and the scene is done. Coyote lifts himself out
of the chair. Wearing a rumpled white linen suit, the spaces
between his teeth blackened, grime under his nails, he says
with a demonic grin, "You won't see this on the Disney
Channel. Roman's going all the way."

The framework for the film, which harkens back to
Polanski's student shorts, is a lengthy flashback revealed in
sections and intercut with the seamy events in the present
on the boat. Nigel and Fiona (Scott Thomas) are on their
way to India to try to revive their passionless marriage

"I wasn't making it to shock. Maybe I had a little bit of this desire when I was young. ... I don't have any of those needs now, and even when I was beginning, the main thing for me was to tell the story, and if the story required violent images or nudity, I would use them for telling it."

This page and overleaf: Arranging Seigner's veil in a flashback to Mimi and Oscar's wedding (opposite). Polanski's decision to direct his own wife in such a sexually explicit role struck some critics as a provocative move.

after seven years. This makes Nigel a perfect foil for Oscar, who accosts him and starts telling him in explicit detail the sordid tale of his sex life with his beautiful but crazed wife Mimi (Seigner). Nigel is repelled, but can't pull himself away because of his own lust for Mimi.

In recounting his early infatuation with Mimi in Paris, in a line from the novel that Polanski might have written himself, Oscar says in a voiceover narration: "There was a freshness and innocence about her, an almost disconcerting blend of sexual maturity and childish naïveté that touched my world-weary heart and effaced the age difference between us." But after much hot and heavy lovemaking things start to cool, as they invariably do, even with the help of toys and practices you won't see on TV. Oscar becomes Mimi's tormentor instead of her lover. Then after the "accident" that leaves him paralyzed below the waist, she becomes his tormentor. It's a bleak view of relationships in which, no matter how harmonious, the seeds of tragedy and farce are always present.

I think *Bitter Moon* was meant to be a kind of sexual Grand Guignol, but for the most part the tragedy overpowers the farce. At times it seems like these people are doing things for shock value rather than dramatic purpose, more caricatures than characters. Even unrelenting sexual escapades can become monotonous. Polanski's black sense of humor is intact in scenes like the one in which Coyote roots around his apartment in a G-string and a pig's mask as Seigner chases him in black lingerie and a whip, but the tone is not always clear. The balance Polanski strikes between horror and comedy in his other films is murkier here. But the bigger problem is that the characters are not interesting or deep enough to be compelling or sympathetic.

Oscar is a kind of sexual kamikaze who wants the bliss, but isn't exceptional enough to live on the edge. "Those who live on the edge are very rare. It takes a special person. It takes a lot of courage," says Polanski. Did he do it himself? "I never went that far, but I came close. I never thought, 'I want to live on the edge.' I was just following my desires."

As the mind drifts, and there is ample time for that, one can't help wonder what *Bitter Moon* says about Polanski.

"Sex is not a pastime.
It's a force, it's a drive.
It changes your way of thinking."

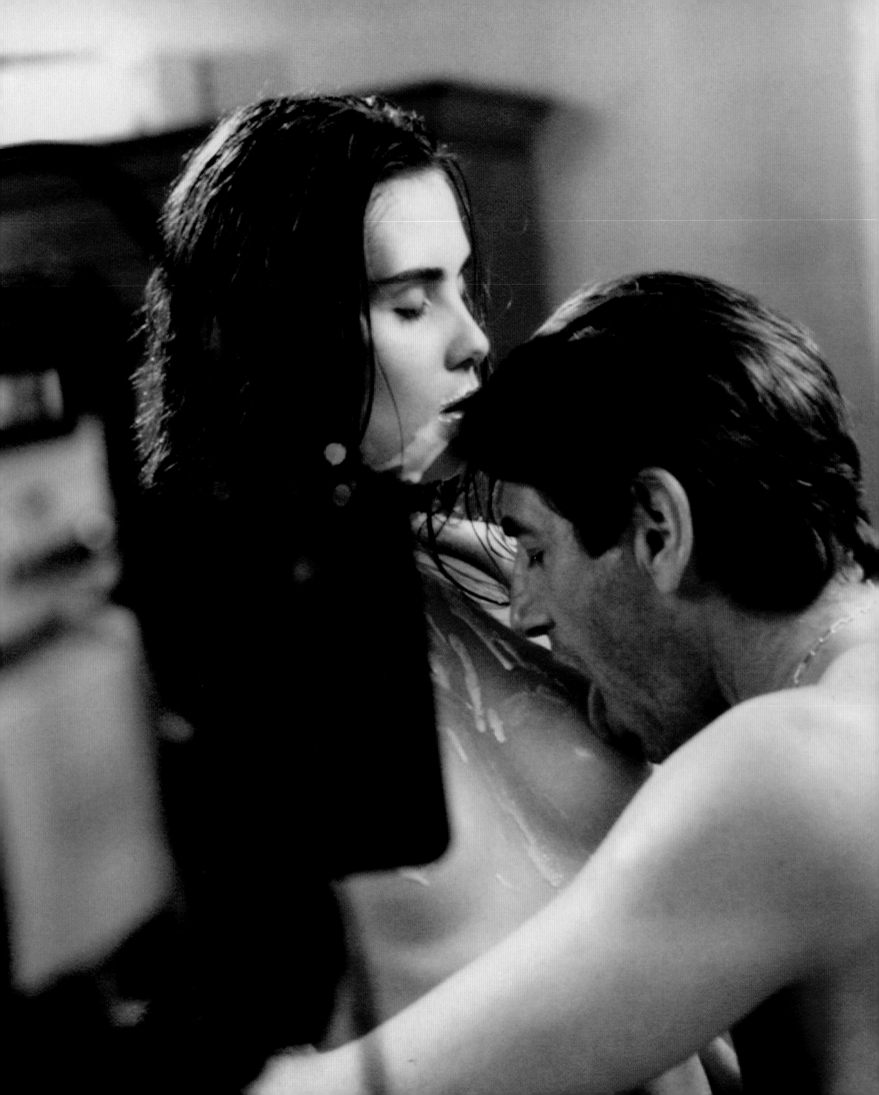

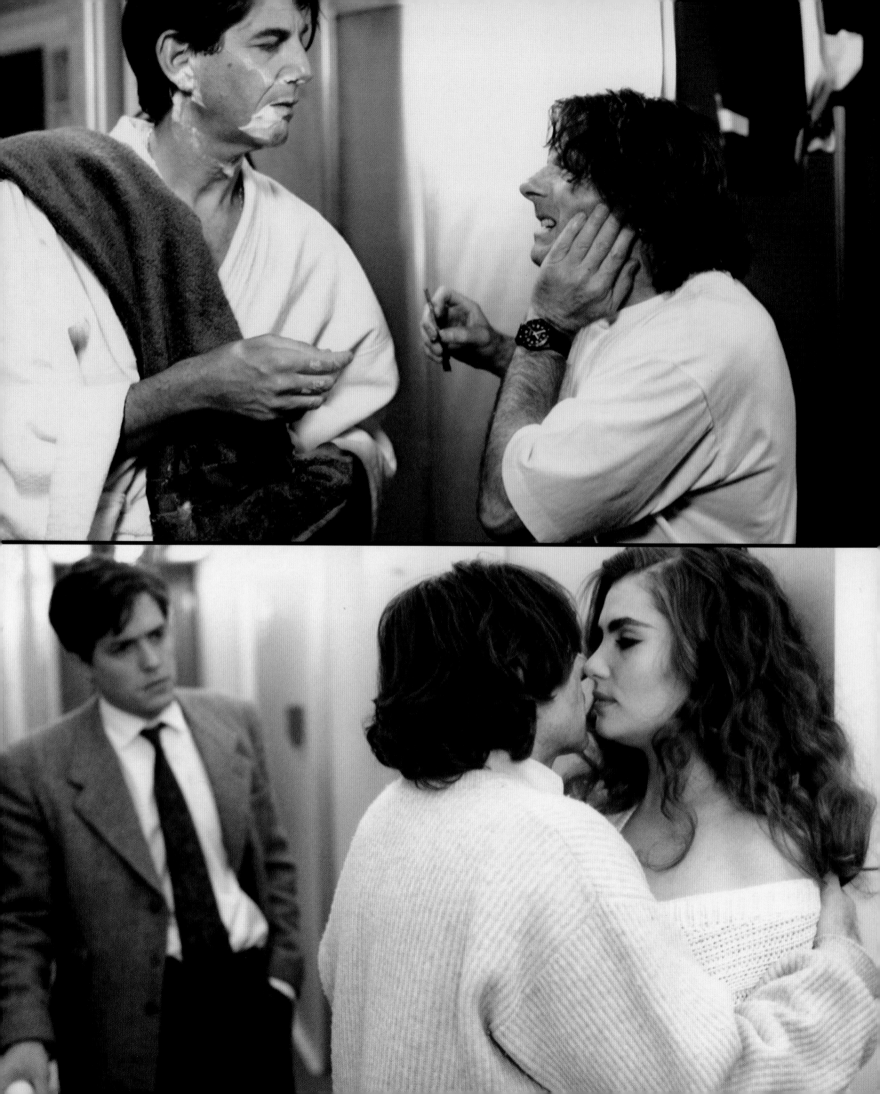

"I didn't have much money, so we worked hard and were under tremendous pressure, but I did what I wanted and nobody interfered with the result."

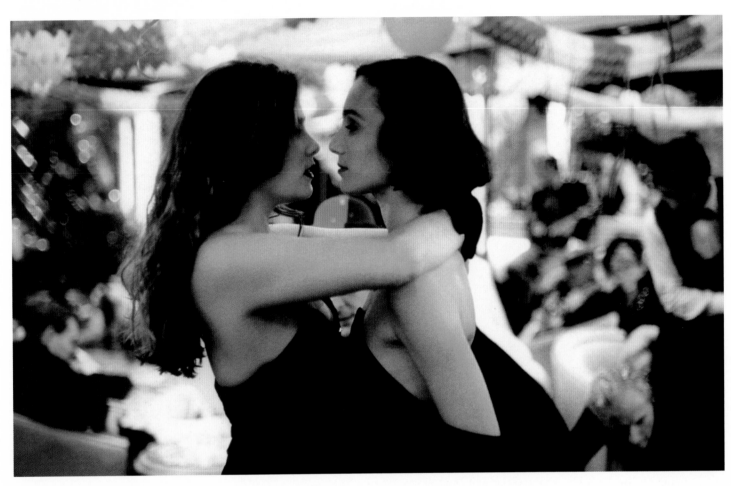

The casting of his wife as "a walking mantrap" and having her parade around in provocative outfits, only adds to the curiosity. Polanski says he dislikes the attention he gets in the media, but here it almost seems like he's courting sensation and playing off his reputation. Polanski, who was fifty-eight when he made *Bitter Moon*, dismissed the idea that the film was representative of his relationship with his new wife, who was then twenty-five, or in any way autobiographical. "It had some resonance for me," admitted Polanski, "but you have to be careful here because it only goes so far. It doesn't mean that I practice some of the excesses that the people in this film do. In the same way that I don't practice black magic because I did *Rosemary's Baby*."

Looking at what happens when love fades isn't in itself a novel idea for a director to tackle, and normally no one cares about a director's personal connection to the material. But this was Polanski, one of the great libertines of our time, so the assumption of many was that this was a firsthand report from a war zone most of them would never visit. *Bitter Moon* may not be one of his better films, but it is ambitious. How many filmmakers at his age would dare go where he went?

A Polanski film can never be dull exactly; the craft is immaculate and the staging first-rate. There are always interesting things to watch. But if *Bitter Moon* was a transitional film for Polanski about aging and coming to terms with the excesses of youth, his conclusions about love and obsession are surprisingly tame.

At the end, as Nigel and Fiona face their infidelities, both imagined and real, and an uncertain future, an Indian gentleman aboard ship tells them that children are a better form of marital therapy than a trip to India. This may not be a traditional happy ending, but in Polanski's world it's the best you can do. And Nigel and Fiona are a lot better off than Oscar and Mimi—at least they're alive.

Opposite: As an accomplished actor himself, Polanski demonstrates to Peter Coyote (top) and Hugh Grant (bottom) exactly what he wants from them.

Above: Slaves to love—to the strains of Bryan Ferry, Mimi and Fiona embrace in the middle of the ship's ballroom on New Year's Eve.

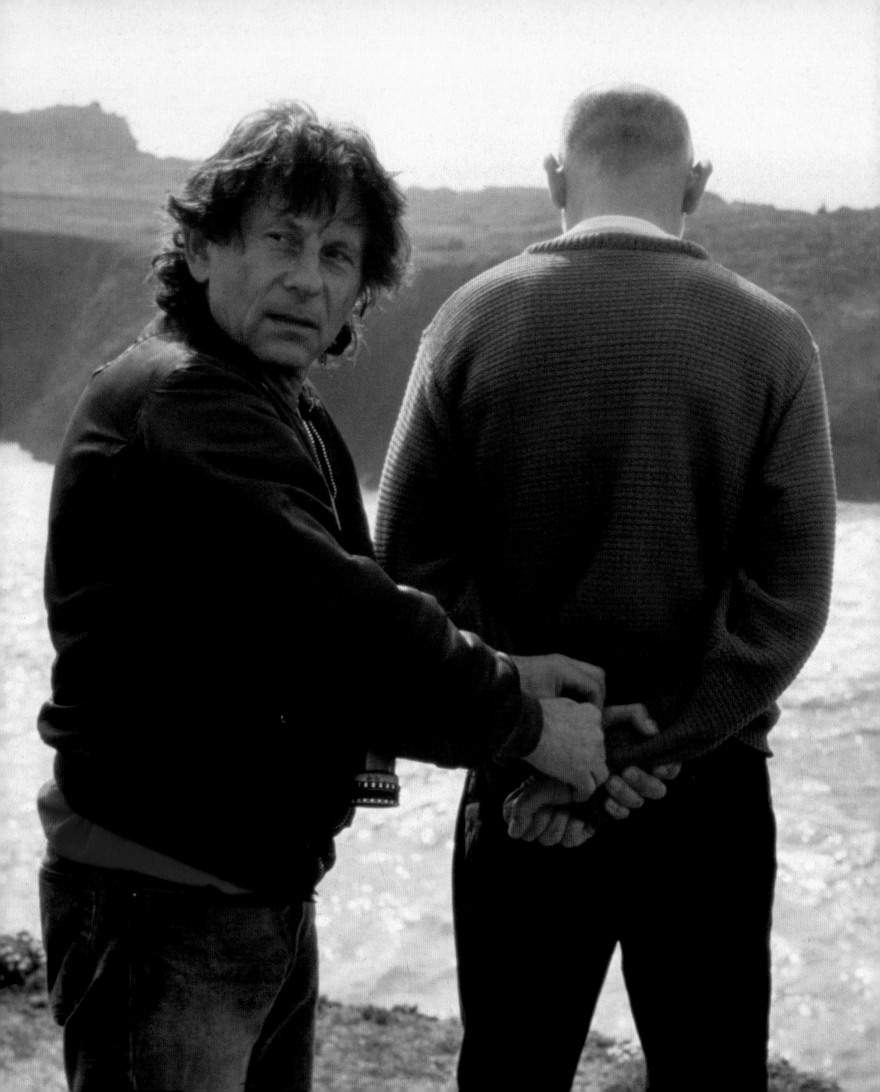

Death and
the Maiden 1994

"To have the same story told, or the same event related by various people, or various parties, these different points of view that don't concord, that always fascinated me. And this is as close to it as I could get."

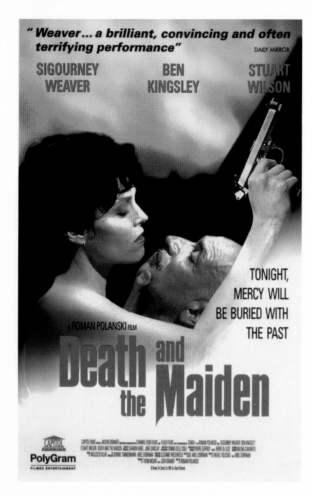

"In the play, he's definitely guilty, I think. It gives an answer, but then somehow it doesn't manage to give an answer. It's ambiguous, and it seems to me to a certain extent to be a cop-out. But I think we managed to make it more satisfying."

Death and the Maiden was enjoying a successful run on the London and New York stage, when the playwright Ariel Dorfman was approached by a number of directors who wanted to turn it into a film. He chose Polanski. "I knew that in Polanski I had a director who would understand what the story was about without me having to explain it," Dorfman said at the time. "He has lived these situations of repression over and over again in his life.... I needed a director who would understand, and interpret, from the very depths of his own experience, what *Death and the Maiden* was about."

This page and previous page: Filming the climactic clifftop scene in which Dr. Roberto Miranda (Ben Kingsley) finally confesses to having repeatedly raped and tortured Paulina Escobar (Sigourney Weaver).

Set in an unnamed South American country (clearly Chile) shortly after the fall of a totalitarian regime, the film is a three-character play about guilt, retribution, and forgiveness for horrendous acts—conditions Polanski did indeed know something about. His early life in a Poland stained by the Nazis followed by the Communists, his encounter with the American legal system, and his subsequent exile in France have, temperamentally, made Polanski seem like an outsider fighting the system. As a result his films feel vaguely political even when they're not. But he's never been an overtly political artist, preferring instead to bury his politics in personal terms. *Death and the Maiden* may be the only movie in which he marries the personal with the political, and the result is a film crackling with the contradictions of oppression, sex, and violence.

The film opens on a dark and stormy night and has some of the trappings of a horror movie, but the real horror here is human. Home alone in a remote cliffside beach house, Paulina (Sigourney Weaver) is getting tenser by the minute. She has just heard on the radio—before the power blacks out—that her lawyer husband Gerardo (Stuart Wilson) has taken a position heading the new president's committee investigating the rampant human rights violations during the dictatorship. She was one of the victims, having been tortured and raped for her political activism. Paulina doesn't think the committee will go far enough and she does not give Gerardo a warm welcome when he returns home. Even less welcome is the stranger who comes in for a drink after helping him fix a flat tire. From the sound of his voice, Paulina is convinced that this man, Dr. Roberto Miranda (Ben Kingsley), is the doctor who tortured her, and she spends the rest of the film trying to get him to confess his sins while she holds him captive, strapped to a chair with tape and wire.

That's the setup for the play. One would think not ideal for a movie, but Polanski loved the challenge. For one thing, it offered an opportunity for his trademark claustrophobia—in spades. But the problem was how to move what is basically a one-room play to the screen. "Most film directors don't understand the essentials of adapting a stage play," Polanski once said. "They try to render it more like a movie simply by opening things up. It appears like a sneeze, you know? Completely artificial. Suddenly these people are going out into some new location, preferably one as open and large as possible— and for what? To ventilate? They don't get it. It's not the fact that it happens in a single room that makes it theatrical. You can have an extremely eventful night in a broom cupboard and it could still be profoundly cinematic—if it's filmed right."

Most of the movie takes place in the Escobars' house, the set of which was constructed in such a way as to allow the camera to travel into every recess, making the audience feel like an intruder.

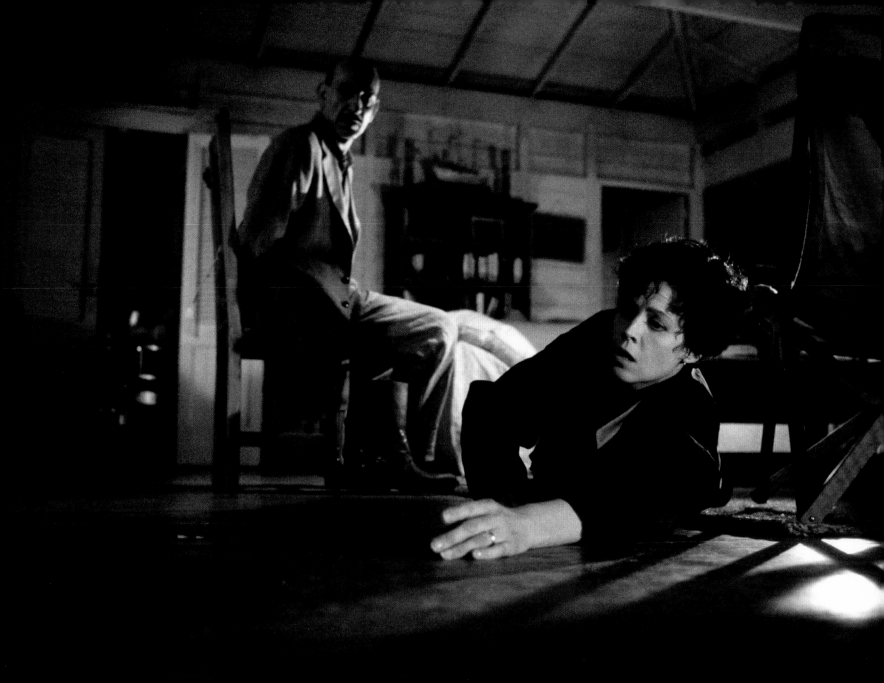

"In *Death and the Maiden* I never mention any political leader or a concrete dictatorship that's fallen. I'm talking about an unspecified country in South America. And it's more universal than that, because this sort of situation occurs all around the globe, where former victims are faced with their former oppressors or torturers. They have to live through these kinds of encounters and deal with them."

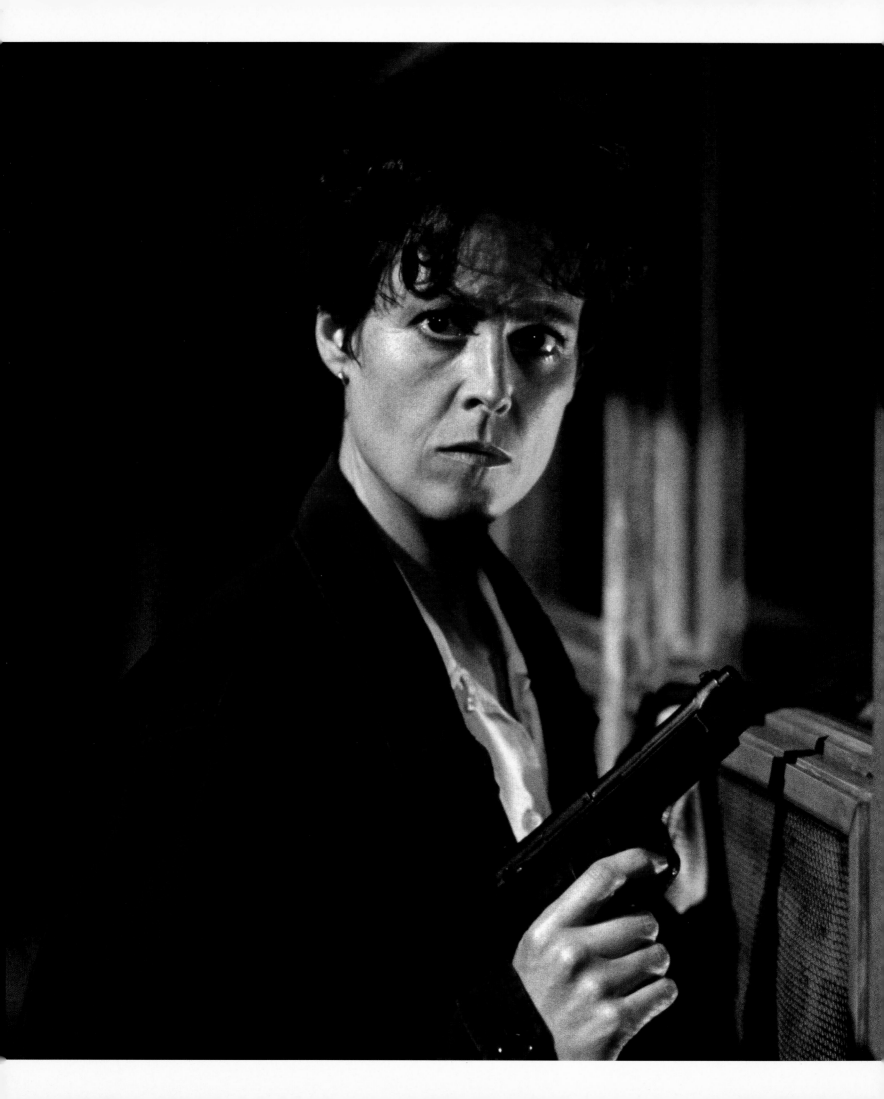

Paulina is amazed when, in her own home, she hears a voice she believes to be that of her former tormentor. "It's a miracle. He's delivered himself. Like a fantastic surprise Christmas present, left at the door."

For Polanski, who much prefers the precision of shooting on a soundstage, that meant having complete control of the set to do what he wanted to with the camera. Working at the Boulogne-Billancourt Studios outside Paris with production designer Pierre Guffroy, Polanski built a house that was all moving parts with retractable walls and sliding pieces. "It was like a child's jigsaw puzzle," said the film's producer Thom Mount. It was tight quarters, but from a shooting perspective the camera could go anywhere. Every door and window had a split so the camera and crew could come up to it and push through on a dolly. Right from the opening scene, the camera slides up to the house, past Paulina at the kitchen window, past the sink and into the living room. It feels a little like breaking and entering and establishes a sense of trespassing on private lives we're not supposed to be seeing. Polanski's camera is utterly fluid, keeping a story confined to a small space from feeling static.

The temptation with this kind of material is to go right for the jugular with close-ups. But Polanski understood that once he did that there was nowhere for the story to go. So he pulled back and allowed the stew to simmer, using the kind of deep focus photography he probably first saw in *Citizen Kane*. In one scene Roberto might be tied to a chair in the living room in the foreground, Paulina a little further back, and the horrified husband in the bedroom in the background. This kind of shifting perspective keeps the audience guessing as the characters bounce off of each other. It's almost a *Rashomon* approach to storytelling

191

in which truth is relative and everyone has his or her reasons. Is Roberto really the dreaded doctor, or is Paulina a paranoid, crazed victim?

The other thing Polanski avoided in translating the play from stage to screen was showing the characters' backstory. "Here, the obvious thing would be to introduce flashbacks," he explained. "Scenes of Paulina's torture, of the days when she was a student activist. But I didn't do that. It would conflict with the style of the picture, which is about the three unities and the gradual building of tension."

Outwardly the film bears a close resemblance to the play (Dorfman wrote the first draft of the screenplay, later revised and improved by Rafael Yglesias). But where the stage version may have been somewhat wooden and humorless, Polanski's film is ironic and sexually charged. When Paulina gags Roberto with her panties, she hovers over him like a tormentor and a lover. With Weaver in the central role, the character is strong and steely right from the beginning when she virtually rips a cooked chicken apart with her hands. She is angry as hell and no pushover. Kingsley, whom Polanski cast because he wanted someone who didn't look like a torturer, matches Weaver blow for blow. He's the kind of actor who can go from sympathetic to smarmy in a heartbeat. Wilson's role as a professional liberal and the fulcrum between the two warring parties

is by necessity the blandest, and he seems a bit stiff, as if he were still stuck on stage.

Polanski was not above manipulating the actors to get the desired results. When getting close to shooting a scene that would require hostility, he would say something annoying to provoke them. One morning he came in and saw the actors in their makeup chairs and cheerfully said to Kingsley, "Oh, I see the animals are in the zoo this morning." The next morning, the same thing. "And how are the animals this morning?" he asked. Kingsley stood up and said, "We are here to entertain you, sir," and started throwing bananas at Polanski. And that's how the director got what he wanted for the scene.

Polanski insisted on shooting the film in chronological order to enhance the emotional progression of the actors. He felt if he was going to get the kind of intensity he wanted from Weaver at the end, where it was impossible to tell if she was righteous or crazy, he would have to lead up to it this way. But shooting chronologically can be a scheduling nightmare, so to make this work a huge soundstage was excavated and the house was built with a porch and all the surrounding landscaping. When cars drove into the driveway one could hear the gravel crunch. "Roman built this huge wonderland on the soundstage where you could shoot much the same way *Casablanca* was shot," said Mount. "It was completely convincing."

Polanski, with his finger on the trigger, in conversation with Stuart Wilson, who played Paulina's husband Gerardo (opposite bottom); showing Weaver how to get into Miranda's face in an electrifying moment (above).

193

"The final shot looking over the cliff came to me at the location. It was actually a shot to be used somewhere else, when Gerardo was holding him over the edge. In the editing, I felt it would be better at the end."

The production did leave the friendly confines of Boulogne-Billancourt for a week to shoot the film's climax and some exteriors on the northwest coast of Spain. It is here that Polanski made his most radical departure from the play. On stage, Roberto offers a perfunctory confession to save his life that doesn't really confirm his guilt; it's equivocal. That wasn't enough for Polanski, who regarded the story as a whodunit in need of a climactic third act. So on the edge of the cliff, with his life in the balance, Roberto confesses for the second time, this time for real. "I had all the power," he says of his experience as a torturer. "I was very sorry it ended."

But it doesn't end there. Neither Paulina nor Gerardo is constitutionally capable of killing Miranda in cold blood. In a final scene that Polanski revised and made more powerful, they meet again. A string quartet is playing Schubert's *Death and the Maiden* in a concert hall. A crane shot rises over the audience and we see Paulina and Gerardo. The camera follows as Paulina looks up and sees Roberto in a box sitting with his wife and sons. Their eyes lock. In the real world, Paulina must share her beloved Schubert with this monster. She has gotten a measure of revenge, but has justice been served?

That is the question Polanski leaves open for debate. Roberto has to live with his secret, but now he is not the only one who knows. Paulina and Roberto coexist in a world where there are bad people, and as in *Chinatown*, sometimes bad deeds go unpunished. There she is; there he is; there we are. Life goes on.

The production moved to a location near Ferrol in Galicia, northwestern Spain, for a week to shoot the climax of the film.

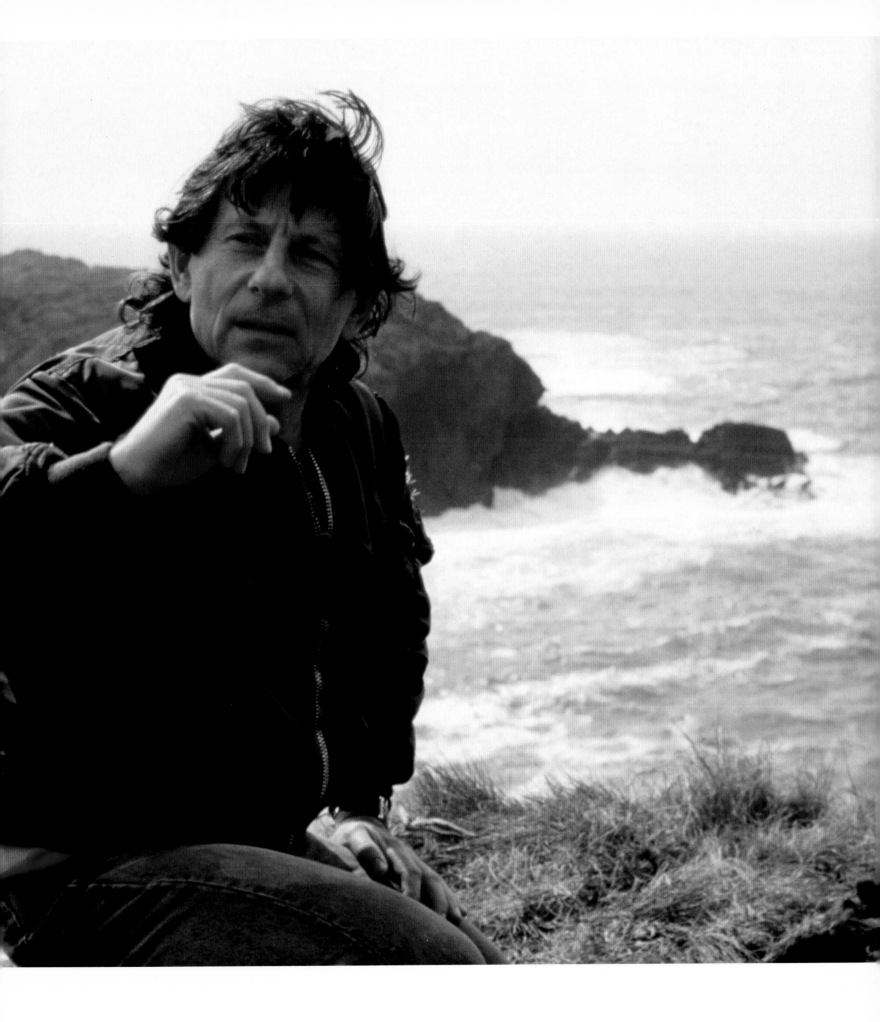

The Ninth Gate 1999

"I don't have a relationship to evil.
I've never believed in occultism
or the devil. I'm not at all religious.
I'd rather read science books than
something like that."

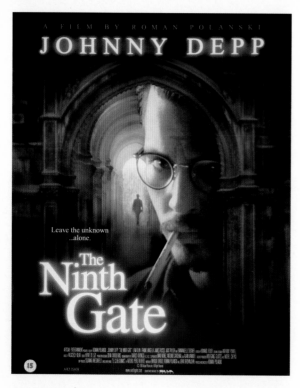

A FILM BY ROMAN POLANSKI

JOHNNY DEPP

Leave the unknown
...alone.

The
Ninth
Gate

The perception that Polanski is the second cousin of the devil started with the murder of his wife, Sharon Tate, by the satanic Manson Family in 1969. It was a case of guilt by association fanned by the more sensational elements of the media. The fact that he had directed *Rosemary's Baby* the year before was the evidence. And then when he made *The Ninth Gate* in 1999, that was the proof.

Polanski finds it quite ridiculous. "I'm not interested at all in witchcraft and the occult as a philosophy. To an atheist like myself it's exotic. The devil makes me laugh."

Evil with horns and a tail is simply another form of entertainment, a cinematic tool for him to play with. "Making a film about the devil is the same for me as a director making a film about any religious event. Catholic, Jewish, Protestant. It's just a subject. But people get bent out of shape, they think it's about the devil."

When Polanski came across Spanish writer Arturo Pérez-Reverte's supernatural novel *The Club Dumas*, about a mercenary bookseller in pursuit of two ancient volumes supposedly based on satanic teachings, he immediately saw the cinematic potential. Fires blazing, a flying woman, secret rituals. It was custom made for an excursion into the expanding and improving realm of computer-generated imagery. Polanski used four companies to render the film's more than 200 special-effects shots, some of which, it must be said, are more convincing than others.

Johnny Depp, with slashes of gray at the temples, stars as Dean Corso, a bookseller with a chip on his shoulder, but he shares the billing with a seventeenth-century book. Actually it's three volumes, entitled *The Nine Gates of the Kingdom of Shadows*, which when taken together constitute something like the complete works of Satan. Some of the etchings in each of the editions, as Corso discovers, are perhaps copies of those made by Lucifer himself and when assembled in the right order with the right incantations they can supposedly conjure up the devil himself—or herself, but more about that later.

Previous page: With *The Ninth Gate*, Polanski returned to the devil-worshipping theme he had first tackled three decades earlier in *Rosemary's Baby*.

Polanski loved the idea of a book being the hero of the film and considered it a main character in the story. He designed the size and shape of the book and the pentacle on its cover as carefully as he would cast an actor. And as we see in the film's splendid pre-credit sequence, a book is the way into unlocking the mysteries of the film. At first we hear only the scratching of a pen on paper, then see an older, well-heeled gentleman in his library writing a note. The camera pans slowly to a footstool and above it a noose hanging from a chandelier. Once the deed is done, the camera retraces its steps, searching the bookcases until it finds the place from which a volume is missing, and plunges into the black hole where it had been. Then moving through a succession of animated doorways, the credits appear, until with the last one, there's a flash of blinding light—illumination. Immediately we're hooked and want to know the answers.

The film starts out as a first-rate mystery with Corso ill-equipped to be a private eye. In fact, he is told—just as Jake Gittes was in *Chinatown*—"You don't know what you're getting yourself into, Mr. Corso. Get out before it's too late."

Corso is hired by the fabulously wealthy but slippery publishing mogul Boris Balkan (Frank Langella), whom Polanski imagined as a charming and disturbing character like Sydney Greenstreet in *The Maltese Falcon*. Balkan, who owns one of the copies of the satanic book, wants Corso to fly to Lisbon and Paris, all expenses paid, to verify the authenticity of the other two extant editions. At the start, Corso is in it just for the money, then gradually becomes drawn in by the supernatural. His first temptation is Liana Telfer (Lena Olin), the wife

of the man who killed himself at the beginning. She sleeps with Corso but really just wants Balkan's book, and is a lot less friendly when Corso won't give it to her.

Polanski and his writing partner John Brownjohn shaved a lot off the novel (and the original screenplay by Enrique Urbizu) but the plot is still tangled in countless twists and turns. Everywhere Corso goes, someone linked to the book seems to be getting killed in a gruesome fashion—one man drowns in a fountain; a baroness burns in her library—and he starts fearing for his life. Fortunately for Corso, or not, he has an enigmatic guardian angel (Emmanuelle Seigner) who keeps turning up.

By the time the film gets to the end after at least two premature climaxes, it has pretty much flamed out—literally. In her enormous château, Liana and a bunch of her fellow devil worshippers try to summon their maker when Balkan busts in and breaks up the party, and breaks Liana's neck. Next Polanski gets to stage the finale at one of his favorite locations—a castle (see *Macbeth*, *Cul-de-Sac*, *The Fearless Vampire Killers*). First Balkan incinerates himself trying to commune with Satan.

"There are masses of special effects in this film. I was trying to make them discreet, so you wouldn't notice them. I like all this stuff, what I like the most is making movies, the process of manufacturing them. It's probably why I'm really in this profession."

Above: Mysterious guardian "angel" (Emmanuelle Seigner) flies, this time in a plane, with Corso.

Opposite and overleaf: Corso finds his friend and fellow bookseller Bernie (James Russo) hanging upside down in the pose of one of the engravings in *The Nine Gates*. This discovery leads him deeper into the mystery.

And then, after escaping that fire, Corso winds up in the mother of all infernos.

In most of Polanski's films the woman is the victim; here the tables are turned and the woman is empowered. For those who have not guessed, the mystery girl is Satan incarnate, and for whatever reason, she is hot for Corso. After some very explosive sex, his conversion to the dark side is complete.

As the castle goes up in smoke, the conclusion is so spectacular it verges on the comical, which is apparently what Polanski had in mind. "I wanted the film to be more of a comedy, more of a parody of the genre," he said. "In fact, I imagined it completely as a parody. But it seems like nobody really got it."

There are some humorous moments, things like Corso dropping ashes from a cigarette on the priceless book, or identical twin booksellers (one actor digitally doubled) finishing each other's sentences, but for the most part the film appears to be playing it straight, like a handsomely mounted thriller. In an era when people regard comic book movies as important social commentary and James Bond pictures have become solemn, it's easy to see how audiences might take this story seriously. It's almost as if Polanski and his collaborators—the great production designer Dean Tavoularis and cinematographer Darius Khondji—with their obsession for detail, have made this world seem too real. "There was no footnote in the script that said you were supposed to laugh at a scene," said Polanski, "but that's how I saw it. Maybe people would have had more fun if I'd played it broader."

Polanski accepts some of the blame for people not getting the joke and admits that Depp's performance was a bit off the mark. "I think Johnny did not quite catch that humorous side of the character. He's a very good actor and his performance in the film is admirable," said Polanski, "but it's not actually the line that I wanted."

Rosemary's Baby was so effective because it balanced both horror and humor, but it was also a stronger story with a sympathetic heroine. There are some wonderful individual scenes in *The Ninth Gate* but as a whole it's not something you care deeply about. Polanski would probably be the first to admit it doesn't add up to much, but then it wasn't supposed to. It was just meant to be good devilish fun.

Above: Polanski and Depp with Frank Langella, who played publisher Boris Balkan with sinister charm, before sending himself up in flames (opposite) in an attempt to commune with Satan.

The Pianist 2002

"The Pianist was a film that
I could make with my eyes closed
because I had lived it and
everything was still alive in me."

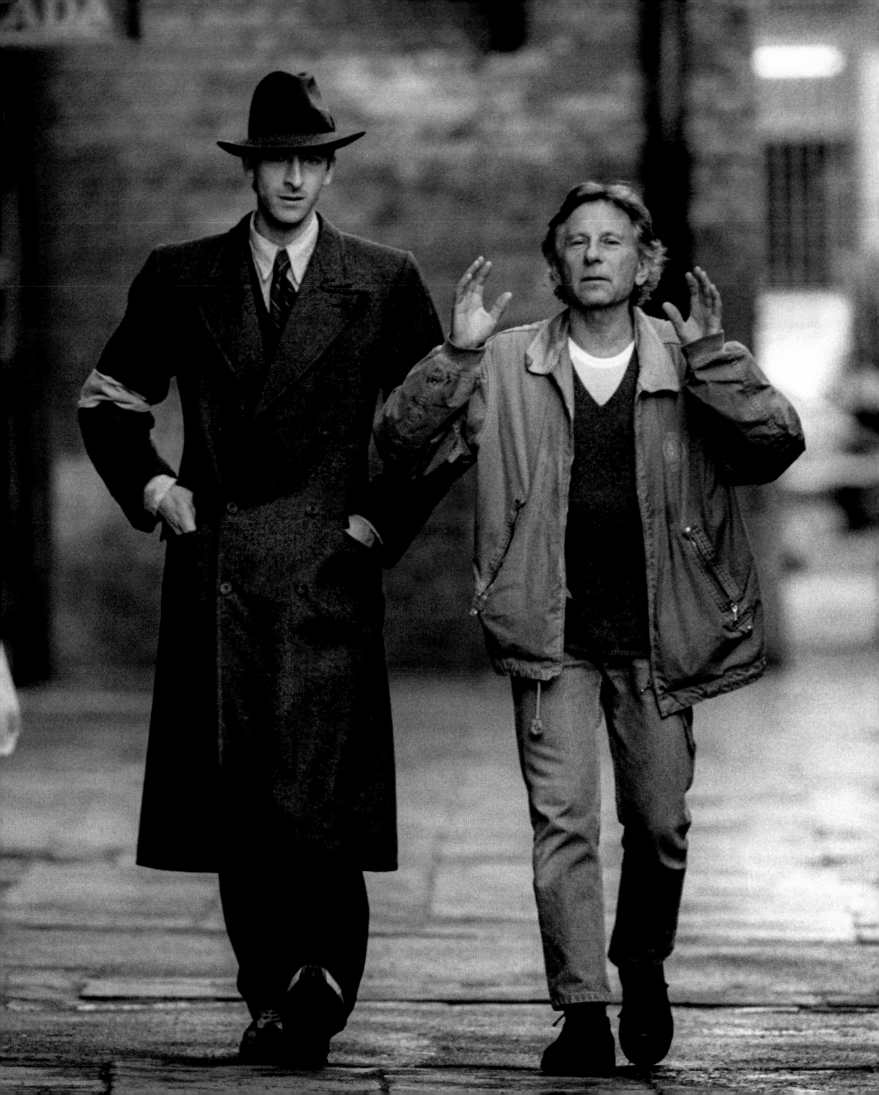

There was never any doubt that Polanski would eventually get around to telling a Holocaust story. It was only a question of finding the right material. Steven Spielberg had offered him *Schindler's List* to direct, and he turned it down. That story took place in the Kraków ghetto, which Polanski himself had survived, and he felt it was too close to home. "It was [about] people I knew personally. I could not deal with it," he said.

Previous page: Polanski gives direction to Adrien Brody as Wladyslaw Szpilman, the eponymous pianist whose memoir was the source for the film.

When Polanski came across a reissue of Polish pianist Wladyslaw Szpilman's memoir of surviving the Holocaust, he knew he had found what he was looking for. Szpilman's book, originally published in Poland in 1945, was a dispassionate account of escaping the ghetto and hiding in various flats in Warsaw for the duration of the war. Polanski knew instinctively, "this is the time. If I don't do it now, stories like this one don't come along that often."

It was, in fact, ideal material for Polanski and played to many of his strengths as a director. His best films have always dramatized the push and pull between a dark view of the world and a superhuman will to survive in it. And what could be more claustrophobic—physically and psychologically—than living within the confines of the Warsaw ghetto and hiding in tiny rooms locked from the outside? Tying all these elements together, and in some ways the key to survival, is Polanski's dark sense of humor. The intermingling of the comic and the tragic is a staple of his work. He remembers people telling Jewish jokes in the ghetto. "Even at the funeral of someone very dear to you, seeing a priest slipping on the mud and falling on his face will make you laugh," Polanski explained to me in his inimitable fashion.

The other thing *The Pianist* had going for it, in a stroke of genius or luck, or both, was the casting of Adrien Brody as Szpilman. Polanski found him at the right time in his career, and Brody bought into the director's demanding methods. He gave up his apartment and car so he would feel rootless like Szpilman, and in a move reminiscent of Robert De Niro in *Raging Bull*, only in reverse, he lost over twenty-five pounds. For his trouble, Brody won the Oscar for best actor, and Polanski won for best director, in large

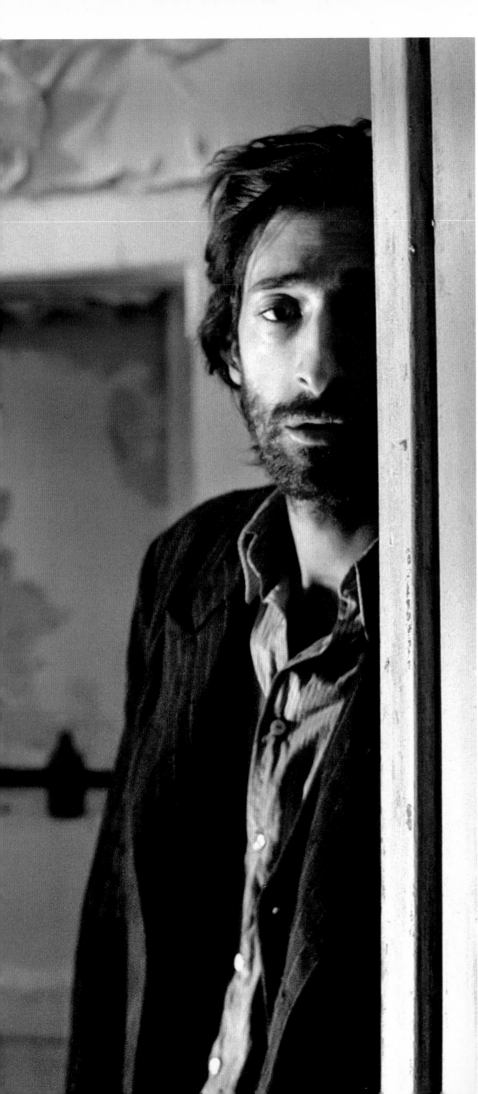

"When I watched a few films with Adrien Brody, I did not hesitate for a moment: He was the pianist."

measure for eliciting that performance. It is a powerfully controlled feat with great range and nuance, that takes Szpilman from a prewar dandy in Warsaw to a ravaged man clutching a can of pickles as if his life depended on it—and it did. In his *New York Times* review, A.O. Scott likened Szpilman to "one of Samuel Beckett's gaunt existential clowns, shambling through a barren, bombed-out landscape … He is like a walking punch line to a cosmic jest of unfathomable cruelty."

The quality Polanski had responded to in Szpilman's memoir was what he had called "the precision and distance that the survivor often carries with him." *The Pianist* wasn't an epic tale; it was one man's story as a looking glass into the absurd. This gave Polanski the opportunity to create a world he knew intimately with his usual painstaking attention to detail. The triumph of the film, and what makes it so devastating, is the restraint with which Polanski tells Szpilman's story. There is none of the sentimentality and sanctimoniousness that often accompanies Holocaust films. As Polanski had seen first hand, there were good Germans and bad Germans, good Jews and bad Jews. When the film was criticized in France for its objectivity, Polanski was delighted; objectivity was exactly what he had been trying to achieve.

He understood that Szpilman's extraordinary journey from a respected and somewhat self-satisfied artist, to watching his family perish, near starvation and surviving thanks to a mix of sheer coincidence and basic intelligence, needed no embellishment. After his family was gone and all was lost, Szpilman's commitment to his music kept him going, much as the imagination of the young Polanski must have enabled him to survive.

Adrien Brody's pitch-perfect performance in the title role was rewarded with an Oscar for best actor—at twenty-nine, he was the youngest man to receive this accolade.

209

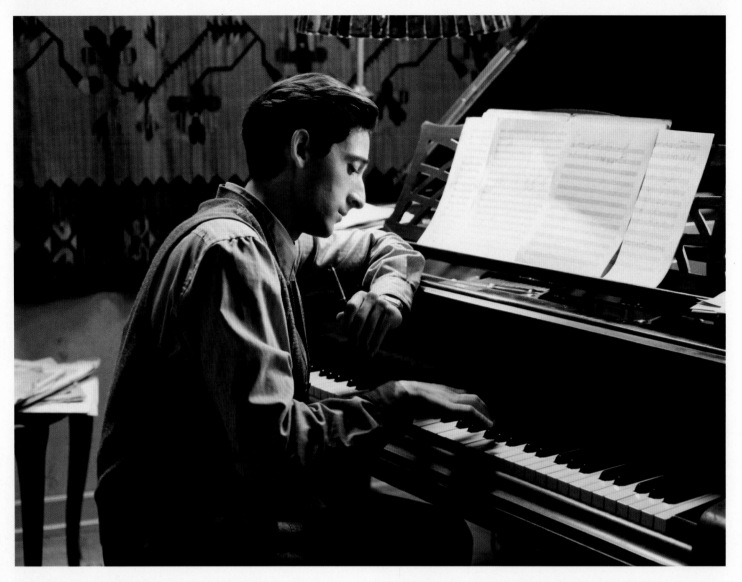

Polanski thought it would be "indecent" to use filmmaking tricks to tell the story. He had many pre-production conversations with cinematographer Pawel Edelman to explain the look he wanted. Unlike the subjective, over-the-shoulder camera setups for *Chinatown*, this storytelling had to be more detached. Obviously there is great artistry here, and a director working at the height of his creative powers, but the craft was meant to be invisible, employed in service of the material. "You don't want [the audience] to feel that suddenly this is a movie when they're in the middle of it; that the director is showing you beautiful camera movements," said Polanski. "What you're showing is important, and not how you show it."

Starting with black-and-white archival footage of the bustling streets of Warsaw in 1939, Polanski eases into the muted colors of the film as Szpilman's performance of Chopin's *Nocturne in C-sharp Minor* in a Polish radio studio is interrupted by German bombs. The events in *The Pianist* have the authority and authenticity of a documentary with the emotional complexity of a great

feature film. "You should have the feeling that you get from watching documentaries of the period," says Polanski, "but not stylized like a documentary."

One might wonder how Polanski could not be overwhelmed by the emotion of the moment having lived through so much of what he was putting on the screen. The tone and dramatic core of numerous scenes, if not the actual action, are extrapolated from his own life. "I did not ever want to do any kind of autobiographical film about my childhood during the war," he explained. "But I did want to use that experience in a motion picture on that subject. So throughout the film I use bits and pieces of what I remember."

Early in the film, before the Jews were moved to the ghetto, there is a scene of Szpilman's father (Frank Finlay) passing a pair of Nazi soldiers and getting cuffed in the head because he wasn't walking in the gutter with the other animals. This comes from a memory Polanski had of his father coming home with a bloody ear, as the character does in the film. "He told us that there was a German officer who stopped him and said, 'Why didn't

Above: Szpilman continues to earn a living playing the piano until Nazi restrictions tighten.

Opposite: German troops put down the Warsaw Uprising.

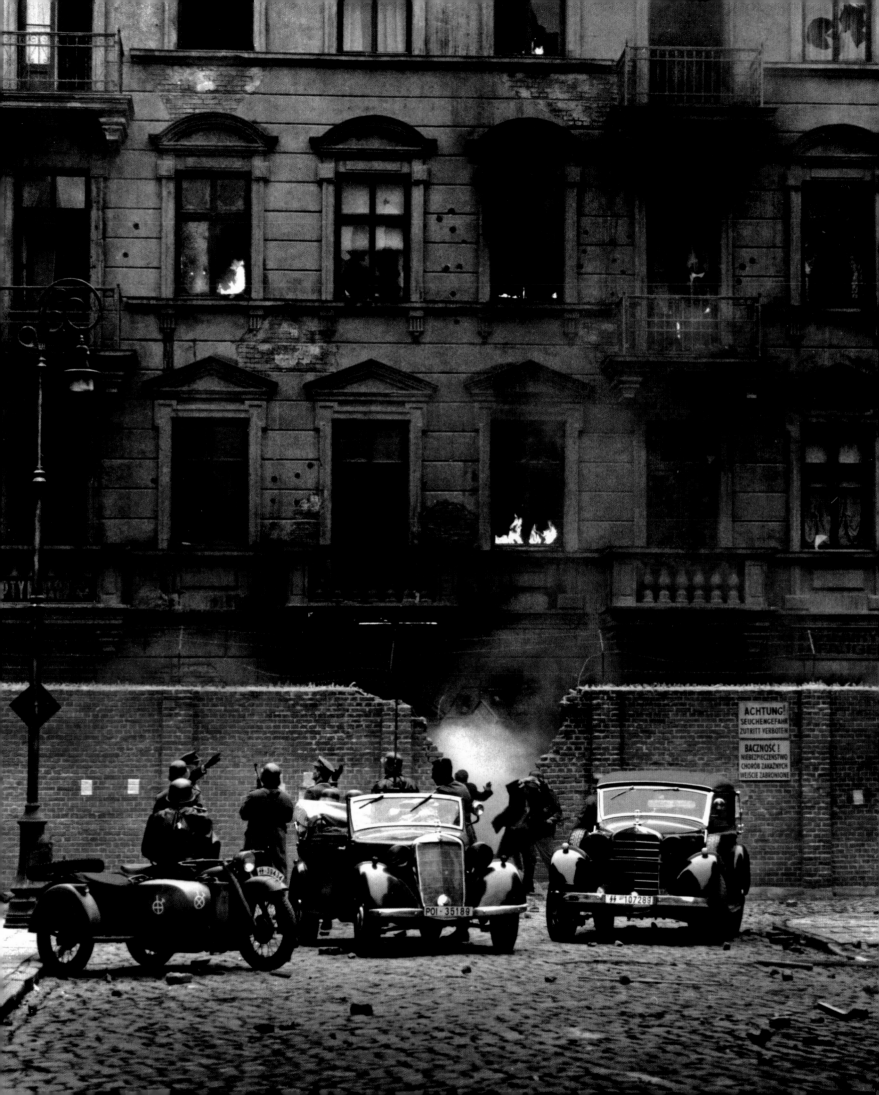

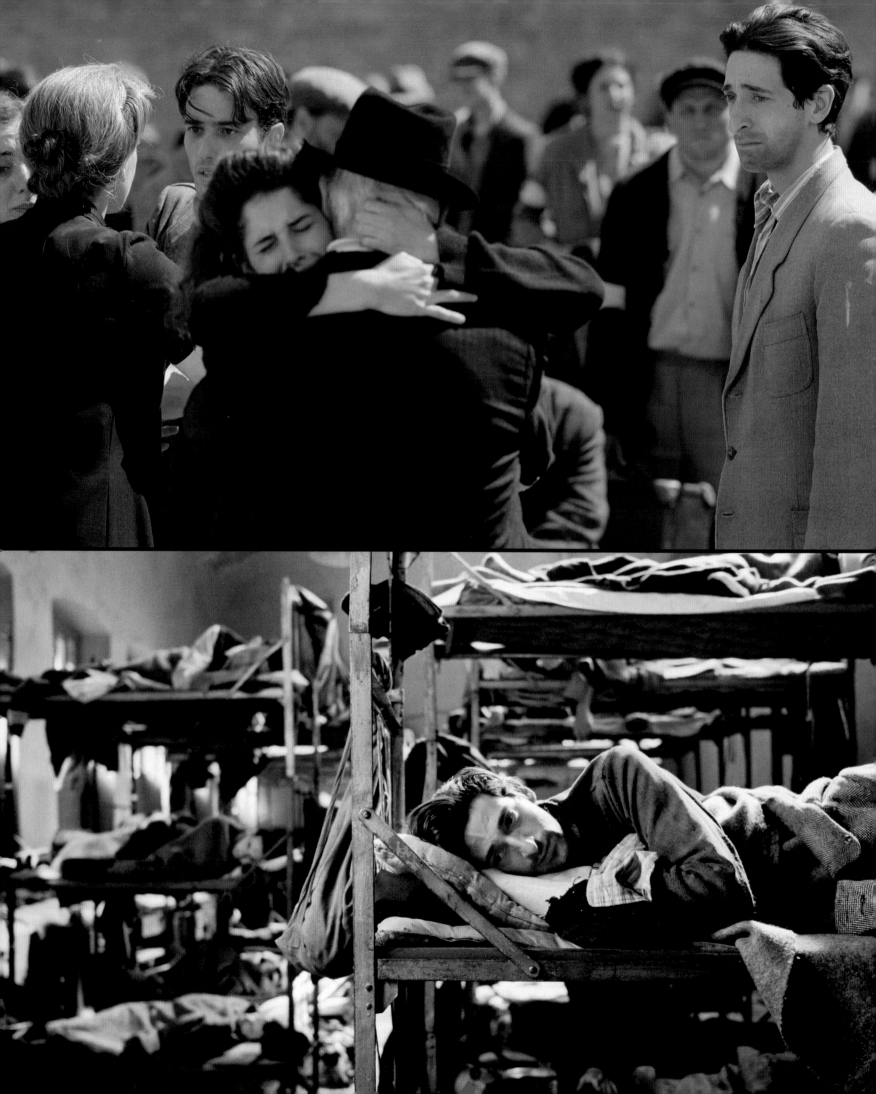

"It's probably my most personal film for the simple reason that I was able to use my own recollections of the period. It was actually more painful to go through the research preparations than it was shooting. However, during the six months of production there were moments that so vividly reminded me of events that I felt very taken aback."

you bow?' and hit my father in the head. And that's how I re-created this scene."

There is a cumulative effect to the atrocities witnessed, but Polanski takes his time, allowing the horror to build almost matter-of-factly, as it did in real life. *The Pianist* is a long film (150 minutes), but it doesn't feel that way. "Some silly people say, 'Why didn't Jews rebel?' Well, they did rebel, but it doesn't happen like it happens in the movies. It happens gradually," said Polanski, shaking his head.

Because Polanski had witnessed so much of this in person and still carries it in his head, none of the action seems stagy. I also think his decision for the most part not to use computer-generated imagery (CGI) works to the advantage of the film. A good example of this is the last section of the movie when Russian bombs are within earshot and Szpilman emerges from where he's been hiding. He looks over a fence, and for as far as the eye can see there is nothing but the ruins and rubble of the city. Coming out of the darkness after so long and seeing this is like opening the window on a nightmare. Again, this was something Polanski had experienced. After the war he was working as a child actor in a Soviet propaganda play that traveled to Warsaw. "The city was flattened out. It was endless ruins. That's what I saw. And from the beginning of the work on the film I said I must have this scene in the film. But I realized that if I did it with CGI, it would never be that way because you can't just re-create it."

So the production team found an abandoned Soviet army base in the former East Germany and blew it up to order. "Allan Starski, the production designer, just went from house to house and destroyed it the way he saw it. And that gave us that main street and also gave us plenty of other angles and positions for the rest of the movie," recalled Polanski.

Since most of Warsaw and the ghetto had been destroyed during the war, the production had to shoot exteriors at an outlying section of the city where some streets were still intact. And it is here that one of the most painful scenes takes place as a mass of humanity waits in the Umschlagplatz for the train to carry them unknowingly to the Treblinka death camp. The production design of the yard and the threadbare but proud clothing the people are wearing, supervised by Polanski right down to the size of the Jewish star on the armbands, feel utterly authentic. As these people wait, their suffering is unique and specific: A woman moans endlessly over the infant she unwittingly suffocated; a young girl wanders in a daze carrying her pet bird in a cage; Szpilman's father slices a piece of caramel candy into six tiny slivers to share with his family as a last meal together. It's so absurd as to be almost comical, like a macabre carnival. And after everyone is carted off by train for the Final Solution, Polanski sums up the tragedy with one brief, devastating shot of the abandoned suitcases scattered in the empty square. No need to say more.

Polanski had seen his own family taken away like this, but his focus was by necessity on his job and not the heartache of it all. For him this wasn't real, it was just the artifacts of filmmaking. In a particularly vicious scene, Szpilman's work brigade is marching back to the ghetto and eight men are summarily called out of the line. A hysterical Nazi officer orders them to kneel on the ground and executes them one by one, even pausing to reload his gun as the last man awaits his fate. But for Polanski it was more about the logistics than the emotion.

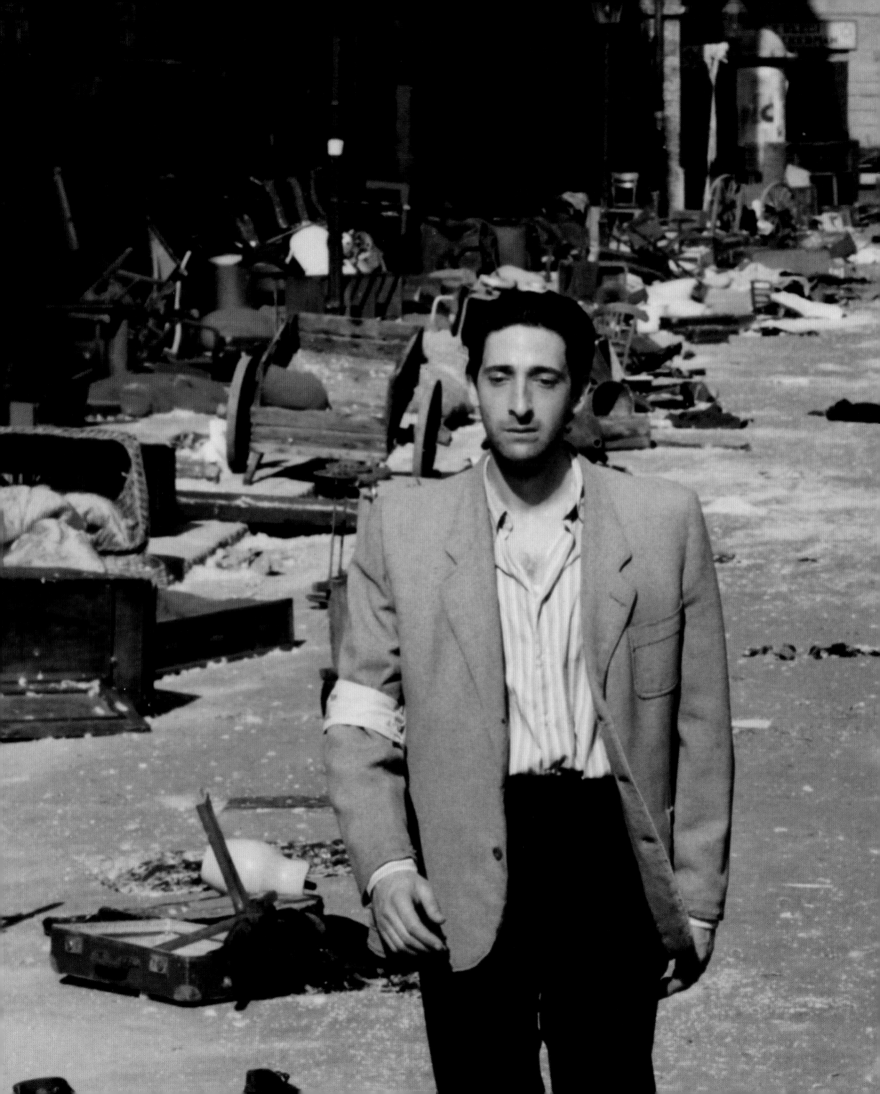

"[As a director] you don't see at all the drama or the horror of it," Polanski reflected. "You see that the actor managed to reload, he had to pull out the chamber and smoothly change it for the new one. It's an operation close in front of the camera. If the guy is awkward with it, it doesn't work. So when the actor does it well, when all the special-effects people and prop man and the actors do it well, the fact that it functions is enjoyable."

There were, however, a few times when the sorrow hit home for Polanski and was nearly overwhelming. What may have triggered it the most was the commitment and dedication of his army of extras. It was as if the spirit of the film had infected everyone, and despite long, cold hours at night, no one ever complained. "Observing these extras was extremely moving for us," said Polanski. "They weren't doing it for the money. They were doing it for something else. Most of them remembered the Holocaust, others were told by their parents. And they were absolutely fantastic. Each of them acted in such a way that I had hardly anything to improve. It was astonishing. I did not anticipate it."

And even some of Polanski's veteran crewmembers could not keep a dry eye while shooting the movie's climactic scene. As the war moves into its final days, a depleted, disoriented Szpilman is discovered hiding in the bombed-out remains of a once grand house. The Nazi commander (Thomas Kretschmann) warily asks him what he did before the war, and when Szpilman says he was a pianist, the officer asks him to play. All the tension that has been building comes down to this one moment.

Captain Hosenfeld (Thomas Kretschmann) is moved by the beauty of Szpilman's performance of Chopin's *Ballade No. 1 in G Minor*.

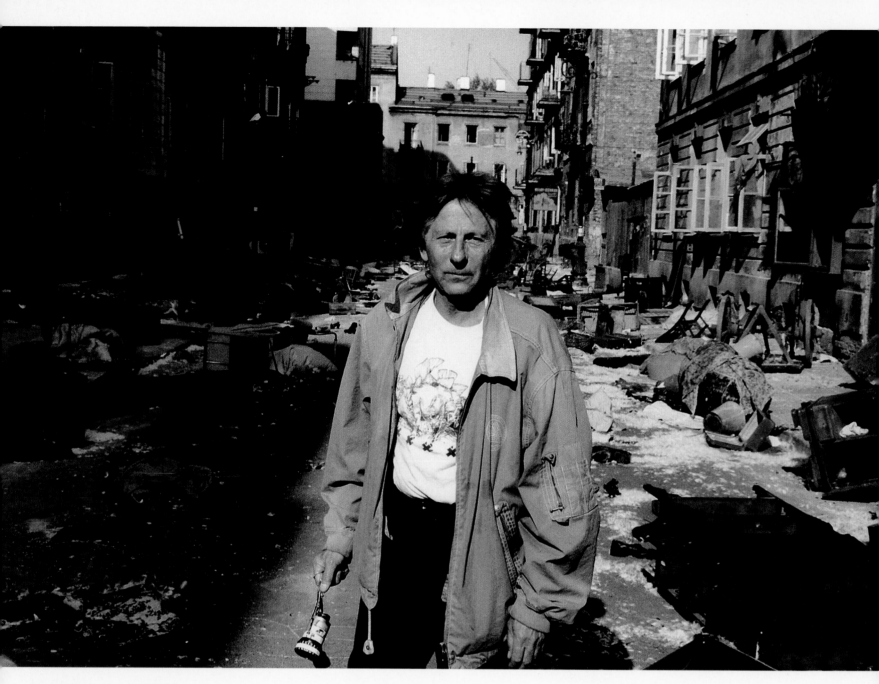

Eschewing CGI technology,
Polanski insisted on re-creating
the ruins of bombed-out Warsaw
for real.

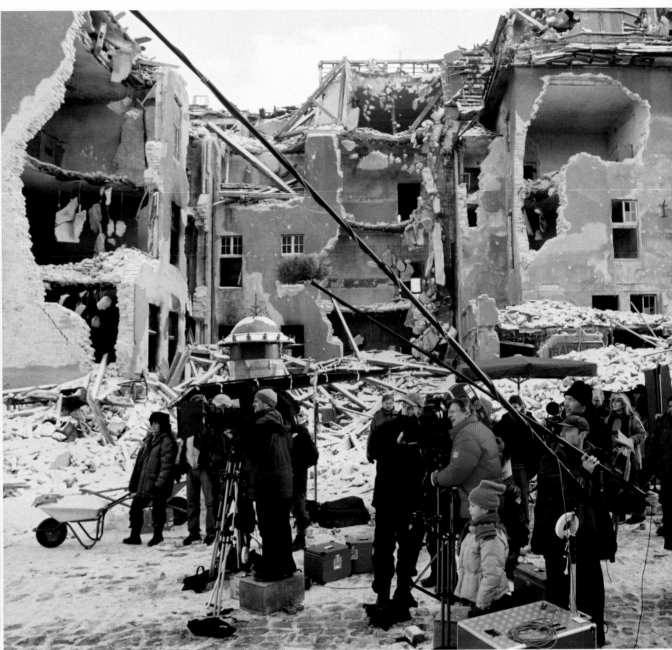

"You know, many times I read things that could more or less make a movie on that subject, but they were usually too close to my own personal experiences of the war. I didn't want that. Here, however, we are dealing with the Warsaw ghetto—I was in the Kraków ghetto. I could use my own experiences in the script without making it an autobiography."

> "It's amazing how short the human memory is, how it doesn't penetrate the new generation. I'm glad I'm doing *The Pianist* now, it seems timely."

After all that's happened, can he still play? Is there any decency left in the world?

But in keeping with the simple style of the film, Polanski again holds back and doesn't go for the cheap shots. As Szpilman launches into an exquisite version of Chopin's *Ballade No. 1 in G Minor*, there are no extended close-ups to milk emotion. We listen, we watch, we think about what we've seen. Polanski allows the performance to go on for nearly four minutes. The complexity of feelings, the contradictory impulses, the stain the war has left on the human soul, is laid bare on these faces without editorializing. It is what it is.

Polanski backlit the scene, and Szpilman is so emaciated that the light literally shines through his nose. If there is such a thing still possible in this insane world, he is illuminated and saved by his art—and the humanity of this Nazi officer. "I never had this type of experience where people, the factory on the other side of the camera, would be so moved on the set," recalled Polanski. "A few of them were crying during that scene."

Polanski believes *The Pianist* is the best work he has ever done—and he could be right. Some years ago he said he hadn't yet made the film that he wanted on his tombstone. When I asked him if he still felt that way, he said, "Well, I think I did it now. I think that *The Pianist* is it." He thought that earlier in his career he didn't have the maturity or experience to do it. "Truly, when I was shooting it everything I'd done before felt like a rehearsal for making this one." It took some time, but it was clearly the story he was born to tell.

Making *The Pianist* unearthed painful memories for the many participants in the film who had lived through the Holocaust—not least the director himself.

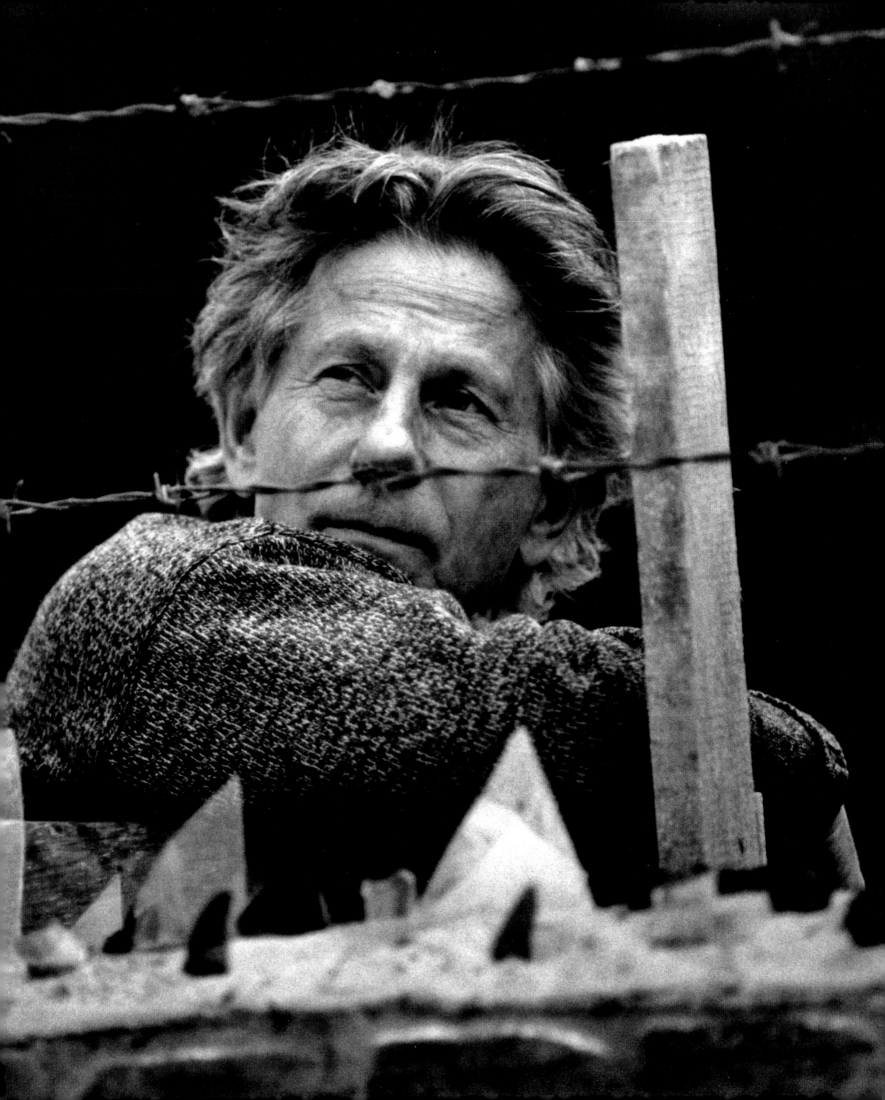

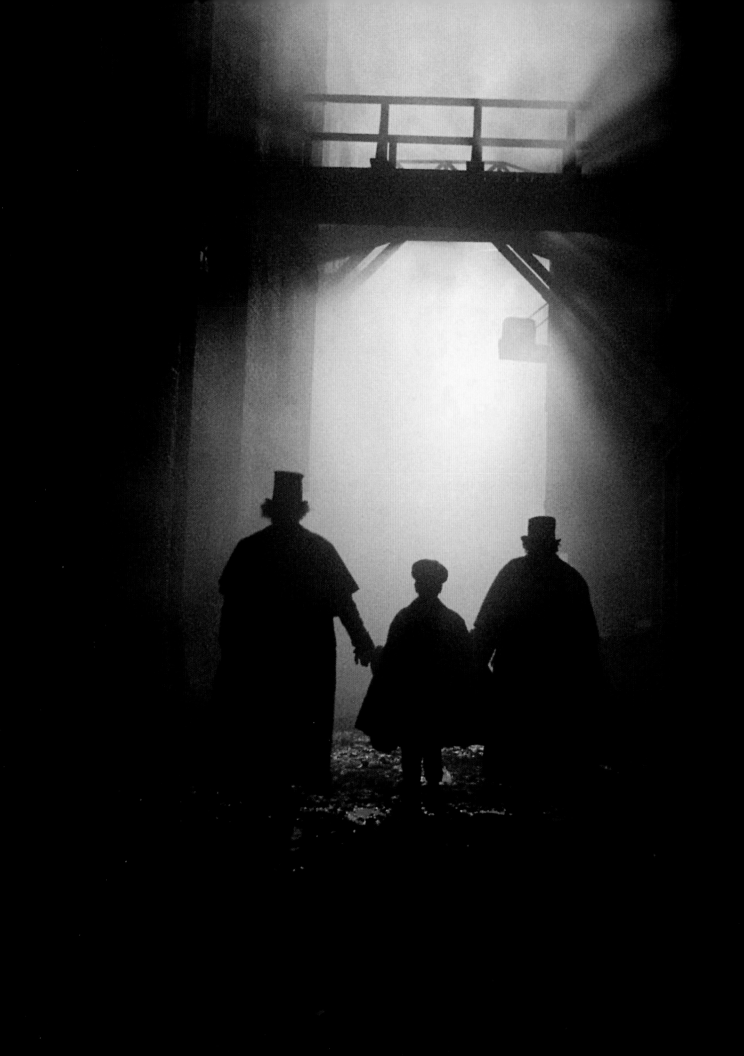

Oliver Twist 2005

"I would never think of doing a movie for children if I didn't have any. I relate to all the sufferings much more now that I have kids. Children have this capacity for resistance, and they accept things as they are, maybe because they have no other reference."

With a face suggesting goodness, intelligence, and melancholy, eleven-year-old Barney Clark was perfect for the title role.

Overleaf: This meticulously crafted evocation of Victorian London was actually filmed at Prague's Barrandov Studios.

Never one for false modesty, Polanski told his cast when he started work on *Oliver Twist* that he wanted to make *the Oliver Twist*. He may not have succeeded in making a *Twist* for the ages, but he did manage to dust it off and make it come alive again for a new generation. The generation he specifically had in mind was his children's, who were then eleven and six. "My children like coming to the set of my movies," said Polanski. "They know what I do but the result of my work escapes them. So I started looking for a subject that would be suited to them and which they could identify with."

Previous page: Polanski's *Oliver Twist* vividly re-created the menacing underbelly of Charles Dickens' London.

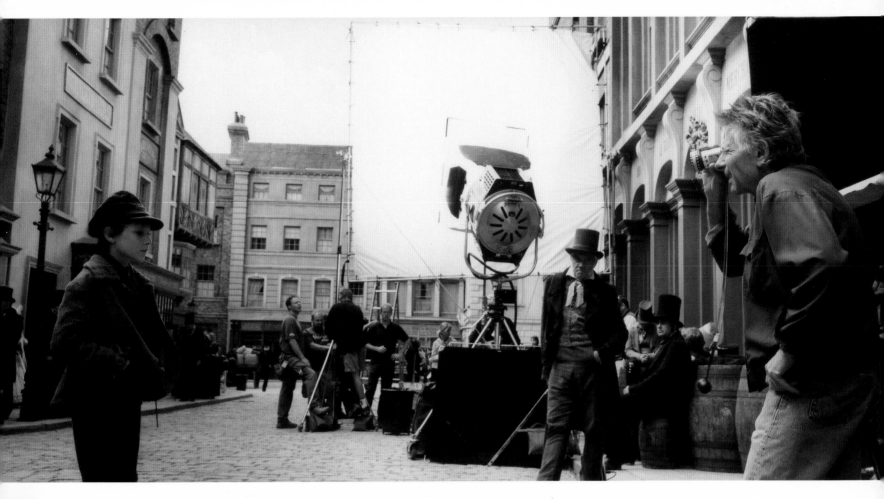

Polanski had always been enchanted by *Oliver!*, Carol Reed's 1968 musical film version of Dickens' classic tale of an impoverished orphan boy blown by the winds of fate into a world of crime in Victorian London. So when his wife, actress Emmanuelle Seigner, pointed out that *Oliver!* was almost forty years old, he thought it might be time for a new *Twist*.

"I reread the book and it was a joy—the humor, the constant irony and sarcasm is overwhelming," Polanski said. "The characters are beautifully described. It was a thrill, really, and I thought, 'My God, what a good story, good bank of ideas and situations, different atmospheres, a good pretext for re-creating a world that is gone.' All those elements were very exciting. To build the London of the nineteenth century on the back lot, this is already a great fit for a director."

When I asked Polanski if he identified with Oliver Twist he was evasive, as he usually is with such autobiographical questions. As someone who had to survive by his wits in a hostile environment as a child on his own in wartime Poland, Polanski reluctantly acknowledged that he might have something in common with Oliver. It makes sense that he would use this experience, as would any director, but not wanting the film to be seen through that lens, he quickly added, "I wasn't conscious of it when I was making the picture."

Nonetheless, a section in Polanski's autobiography about his postwar experience in Kraków sounds like it could be a passage from *Oliver Twist*. He wrote: "I came closer to starving then than at any other time in the war.... I became a specialist scavenger. Primarily interested in anything that went off with a bang. I joined a gang of local children who collected and bartered anything."

Polanski will concede that there was one thing about the story that did resonate for him. The turning point in Oliver's life, when fate pushed him to walk seventy miles to London, resembled Polanski's own trek out of Kraków. "After I escaped from the ghetto, I went to live with peasants in the country and the conditions were virtually medieval. The way of life there, the landscape, and how they worked the fields hadn't changed in centuries. And me, a town boy, suddenly living in it. It was a discovery and a combination of enchantment and suffering. So, yes, sometimes I would come back mentally to those times."

What distinguishes Polanski's version of *Oliver Twist* is his understanding and empathy for all the characters, no matter how loathsome, even Fagin. One of the great anti-Semitic creations in all of literature, along with Shakespeare's Shylock from *The Merchant of Venice*, Fagin is the miserly keeper of a pack of child pickpockets where Oliver finds himself after being "recruited" by the most adept of the thieves, the Artful Dodger (Harry Eden).

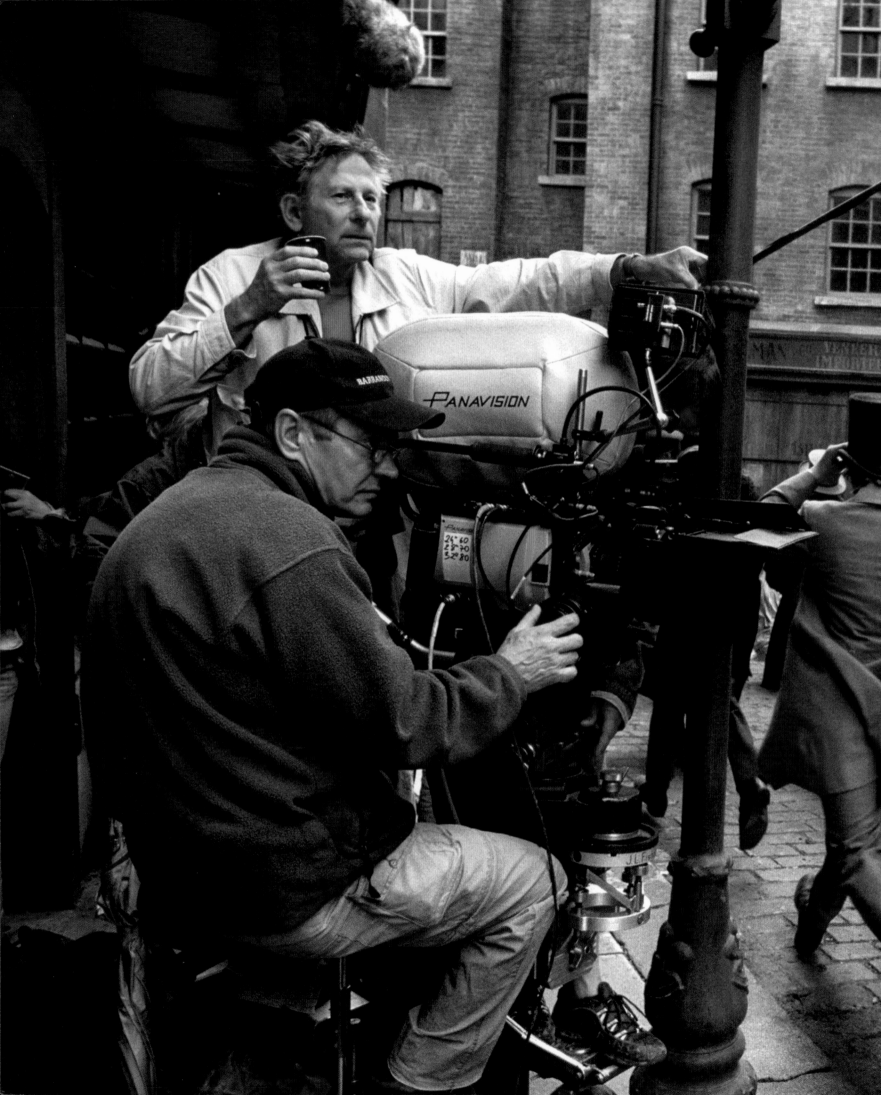

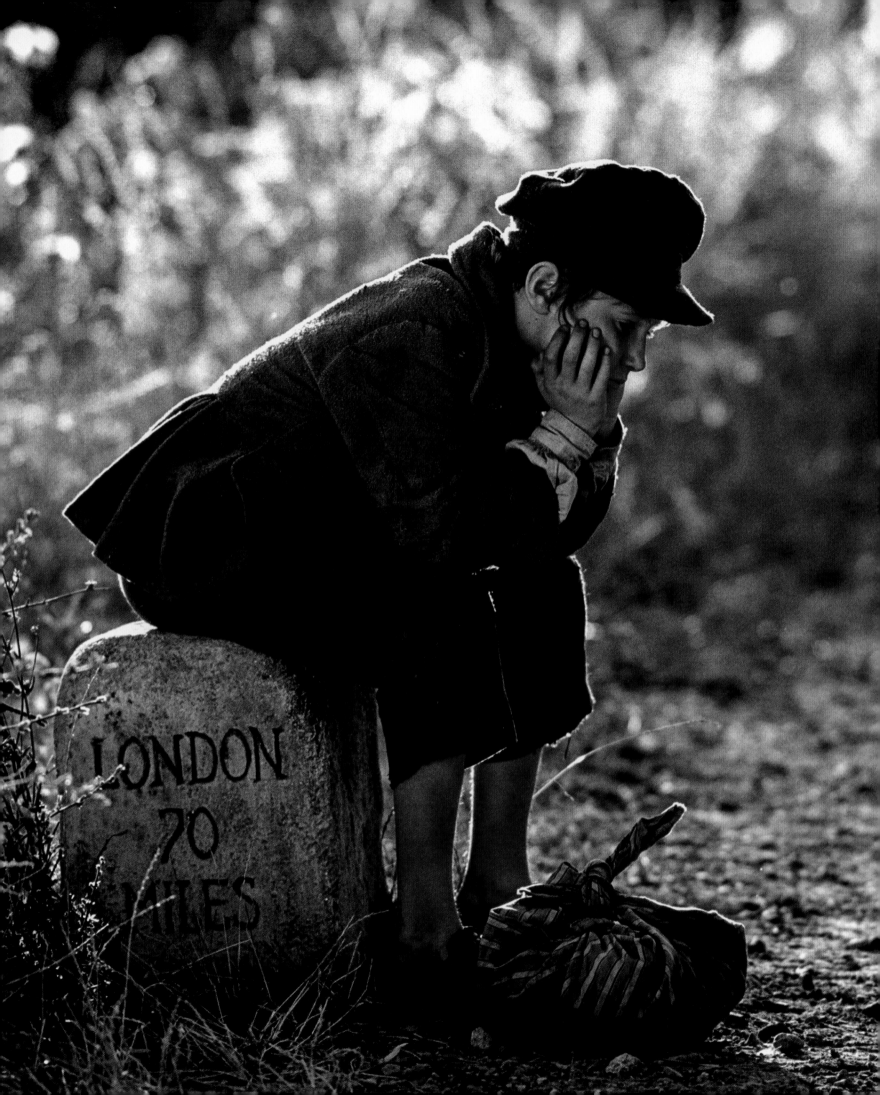

"You know Oliver's long walk to London? I went through it at exactly the same age that the boy did."

As played with a scraggy beard, filthy jacket, and stooped posture by Ben Kingsley, Fagin is not just the children's shameless exploiter, he is also their provider. In a system where the professional do-gooders have abandoned Oliver, while patting themselves on the back for all they've done, Fagin takes better care of Oliver than the system ever did. When it comes to the ills of society, Polanski is a filmmaker who gets it. As we watch the poor starving people of Dickens' London scrambling to survive without a safety net, the resonance of the story has never seemed more contemporary. And London was the biggest and richest city in the world at the time.

Polanski, who admits he met a few Fagins in his travels, reveals his own feelings about the character in the last scene of the film. Fagin is awaiting execution for his evil deeds and Oliver, who has been rescued by his too-good-to-be-true benefactor Mr. Brownlow (Edward Hardwicke), visits him in his cell and tells him, "You were kind." This is a scene that even some critics in Dickens' day found mawkish, but Polanski and his co-scenarist Ronald Harwood (*The Pianist*) realized the film needed this cathartic moment for closure and allowed it to play out. As Polanski sees him, Fagin was bad, but he was still human. It was not, incidentally, a scene David Lean included in his celebrated 1948 *Oliver Twist*, which Polanski had somehow never seen before, and when he did, he didn't like it. He found the film's expressionistic style dated, and he especially didn't think much of Alec Guinness's performance as Fagin.

"Guinness as Fagin is already a bad idea," Polanski opined. "He was a big star at that time and must have been quite bankable. Other than that, I don't see why you should glue a gigantic nose on him and make him speak with an accent that is neither real nor consistent. I think it's grotesque."

Perhaps a sensitive point for a director who is a survivor of the Holocaust, Polanski could see no reason to emphasize the fact that Fagin was Jewish. "Well, he's obviously Jewish," said Polanski. "He speaks with a Cockney Jewish accent. He looks like a Jew. What else do you need?"

It's true that many characters in Dickens are archetypes, but what makes them real is the extraordinary amount of description and detail he related about them, providing a perfect canvas for a miniaturist like Polanski. Dickens is cinematic not only because of his intricate plots, but also because he's so attuned to faces, and Polanski found some great ones. The jowly chins, unpleasant countenances, and self-satisfied expressions of the workhouse keepers where Oliver is dumped, accurately reflect this barbaric society without saying a word.

The most important of all the faces is, of course, that of Oliver Twist himself. Polanski insisted on using an English actor (as he did for all the characters), and threw out the usual wide net of casting calls. He wanted a boy whose face would suggest an innate goodness, intelligence, and an air of melancholy. The winner was Barney Clark, an eleven-year-old Londoner, and he certainly looks the part. The basic problem with Oliver, by necessity, is that he's a bit bland, and on that count Clark does not disappoint. Oliver is an innocent reacting to the incredible goings-on around him. All he has to do is be a likable presence and absorb the blows, which this Oliver does well enough.

A disconsolate Oliver contemplates the miles still to be traveled. Polanski recognized echoes of his own childhood in *Oliver Twist*.

Overleaf: The runaway orphan finds fellowship as a member of Fagin's colorful gang of petty criminals.

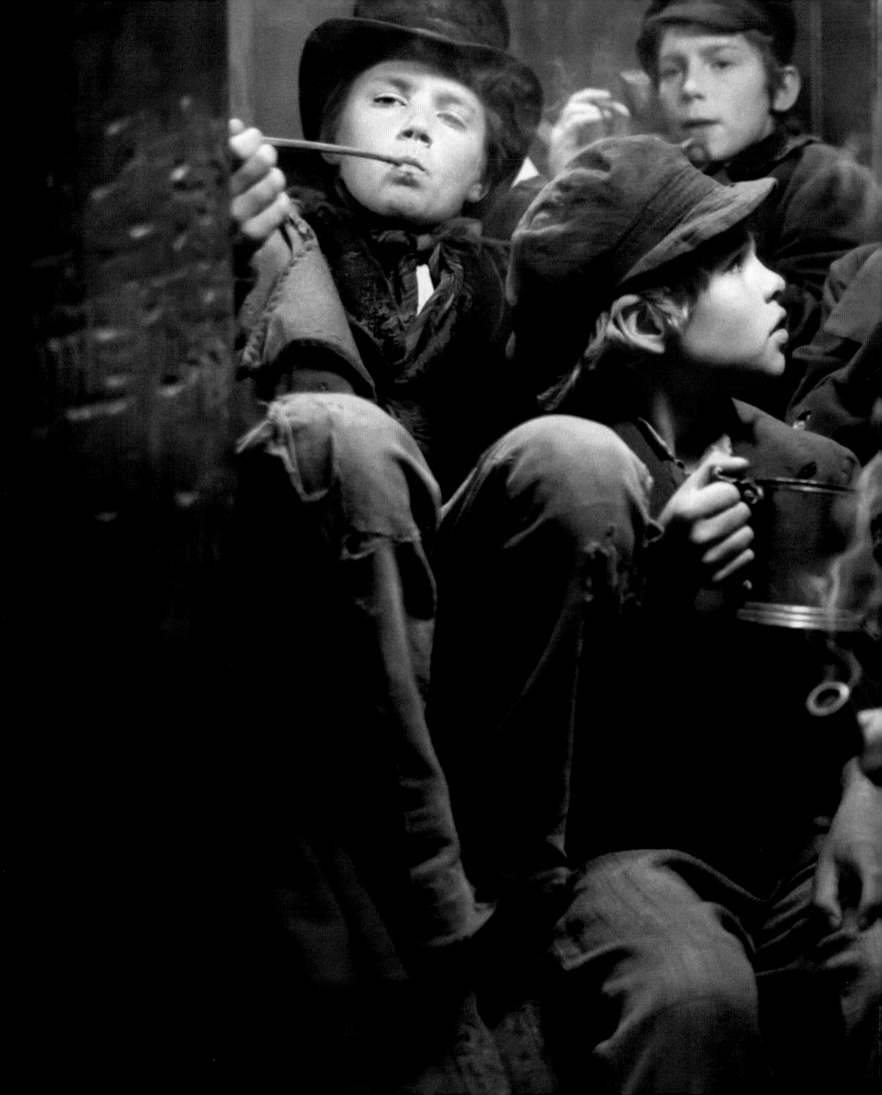

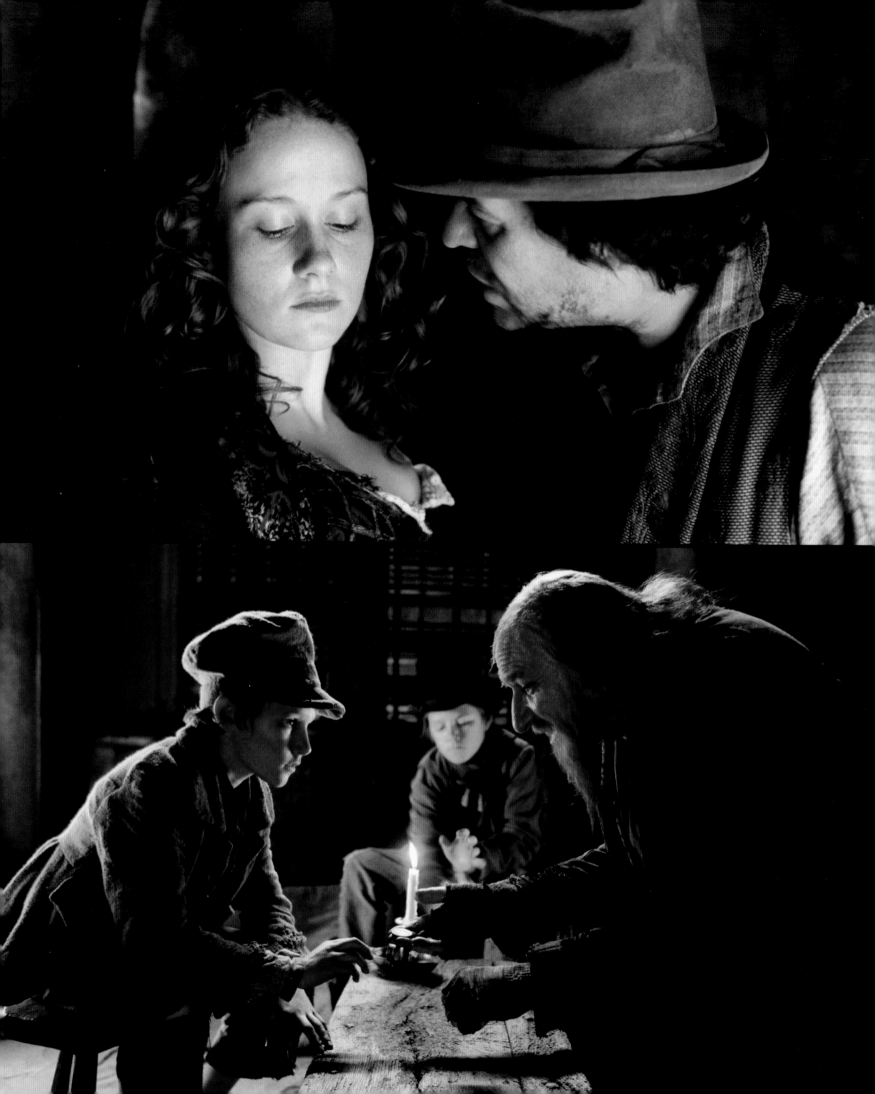

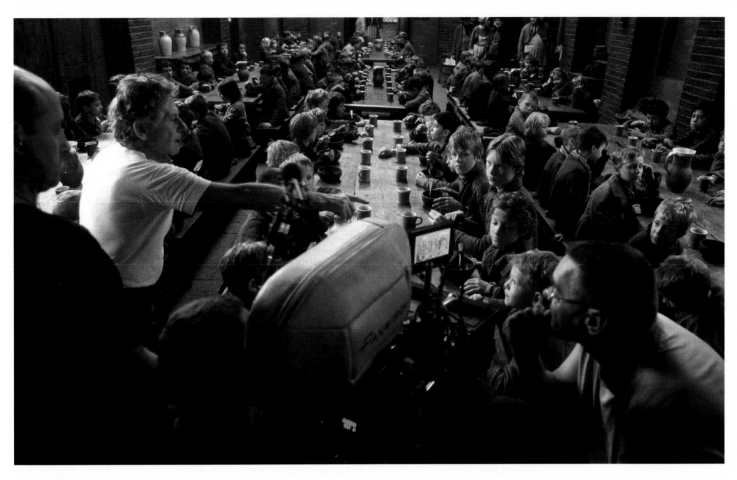

As a group, the boys who have ended up as petty criminals—the Dodger, the clownish Charley Bates (Lewis Chase), and the rest of the gang—are not surprisingly more interesting. Polanski said the key to working with children was to treat them like grown-ups and not talk down to them. So he held tea parties for the kids, served them ice cream and generally had a grand time acting out the story for them. "I can tell you that, as far as *Oliver Twist* is concerned, working with children was virtually easier than with the adults. They were so much into this groove, and it was so rewarding."

The crew was basically the same group Polanski had worked with on *The Pianist*. To re-create this bustling metropolis, the director and his team set out for Prague's Barrandov Studios, where the production's $60-million budget—Polanski's largest ever—could buy more and literally build a city. The set took three months to construct and included five full-scale streets with some twenty storefronts, period houses, and a labyrinth of back roads and alleyways paved with real cobblestones from the 1830s. For the market scene, 800 extras were dressed in custom-made period costumes and twenty actual carriages from the era were pulled down the street by dozens of

horses. It was the biggest *Twist* ever made and the scope of it delighted a detail-obsessed director like Polanski.

He'd go through dozens of hats and then the moment before shooting make a slight adjustment to get the exact look he had in mind for a character. "I was relying a lot on the costumes because that changes the way people walk, their whole body language. And if the costume is right, not only superficially but in the detail—if the coats are sewn the right way, if the hats have the right shape and weight—after wearing it for a while the people look exactly as in the photographs or paintings of the time."

When it was all put together, Polanski's re-creation of Victorian London was bigger than life, more colorful, more exaggerated, and shot with wider lenses just to take in all the information. In the end, was it really the children's story he set out to make for his kids? Like many of his films, this is unquestionably a dark and scary place full of ugliness and cruelty. But *Oliver Twist* is not a film Polanski would have made as a younger man, and there is also an appreciation for human kindness. It's Polanski's unique ability to encompass both the ugliness and the decency that makes the film so rich and rewarding— for children and adults.

Opposite top: The brutal Bill Sikes (Jamie Foreman) bullies his lover Nancy (Leanne Rowe).

Opposite bottom: Fagin (Ben Kingsley) looks after Oliver.

Above: Hard at it in the workhouse. Polanski couldn't have asked for more from his cast of child actors.

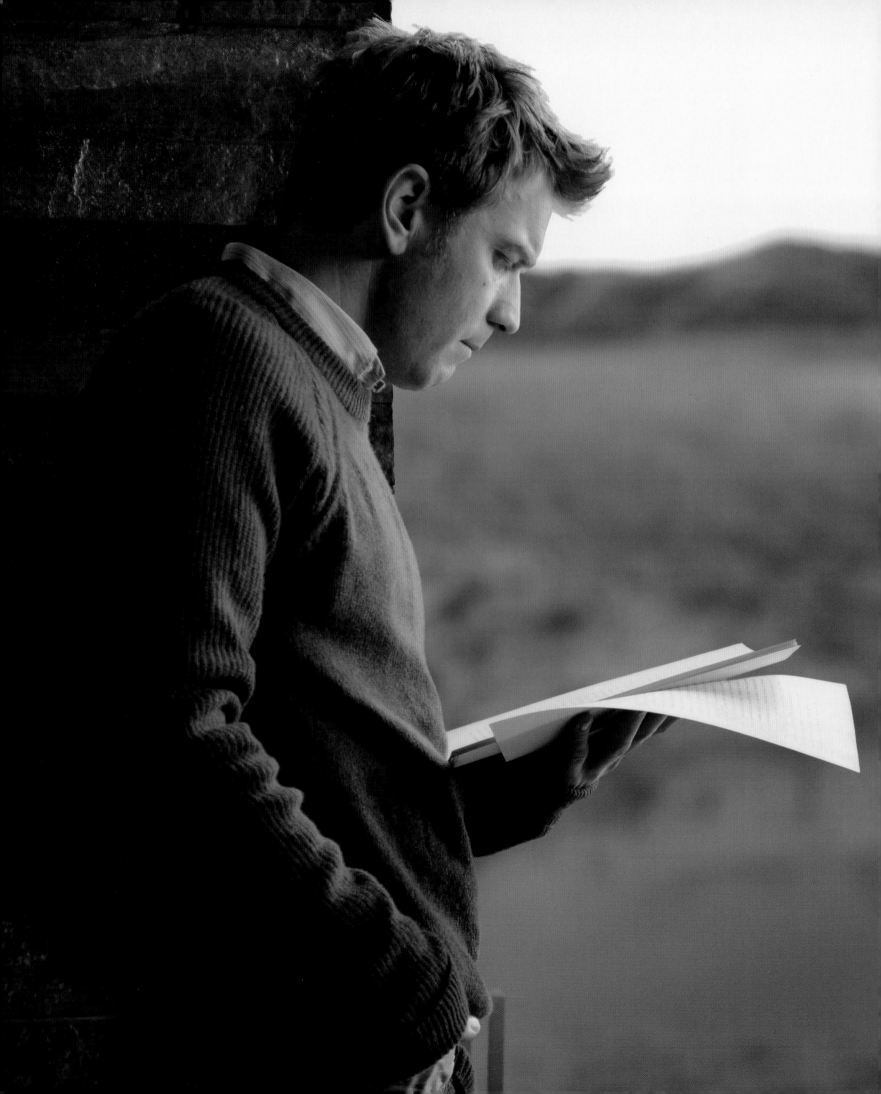

The Ghost Writer 2010

"I read the galleys of the book which Robert Harris sent me and I thought 'that's a good story.' It felt very much like one of Chandler's books."

In September 2009, while in post-production on *The Ghost Writer*, Polanski was arrested in Switzerland for his 1977 conviction of having sex with a thirteen-year-old girl in Los Angeles. He was on his way to receive a lifetime achievement award at the Zurich Film Festival and instead spent two months in jail and eight months under house arrest before the Swiss government refused the extradition request from the United States.

Previous page: Hired to complete the memoir of a former British prime minister, the unnamed ghost writer (Ewan McGregor) immerses himself in the half-finished manuscript he has inherited from his mysteriously drowned predecessor.

Legal issues aside, it was terrible timing for the movie. "There were a huge number of people still working on the film and if it had not been delivered on time, it would have been a total catastrophe," said Polanski. "Not only for our production but for the investors, the distributors, the producers, without even mentioning the people who would have lost their jobs. I mean, everybody was just panicked," said Polanski.

So Polanski continued working to finish the film from jail. His longtime editor, Hervé de Luze, would send him the latest version on a disc, which Polanski would watch on his laptop making notes in longhand. He would then give the notes to his lawyer to pass on to prison officials for a perfunctory review, and finally back to de Luze. It was a time consuming and inefficient way to work. So Polanski went to the warden of the prison ("actually a terrific guy"). "I said, 'I don't think I'm going to finish the film this way. Couldn't my editor come here and bring the equipment and finish it in prison?' And he said, 'Of course, why didn't you ask before? No problem.'"

Polanski and de Luze set up the equipment in a room on a table where prisoners normally worked peeling onions for extra money. They completed the editing in four days. And once he was allowed to go to his chalet in Gstaad, Polanski finished the film under constant scrutiny by hundreds of paparazzi parked outside the gates of his house. "There were television cameras permanently set looking into the windows. So I had to have drawn curtains throughout my time there."

One of the principal characters of *The Ghost Writer*, adapted from the novel *The Ghost* by Robert Harris, is a Tony Blair–like former prime minister of Great Britain

"I'm not interested in
what the audience thinks,
because the audience is
usually wrong."

A Roman Polanski film set can
be an intense place to work,
particularly when the number
of takes mounts up, but here he
shares a lighter moment with
Ewan McGregor.

Like Polanski in real life, Pierce Brosnan's character is restricted in his geographical movements because of the fallout from a scandal in his past.

"Everyone voted for him. He wasn't a politician, he was a craze." Disgraced former prime minister of Great Britain Adam Lang (Pierce Brosnan) and his wife, Ruth (Olivia Williams), leave Downing Street for the last time.

who can't leave the United States because of a scandal at home and is hounded by the media. Polanski can't go to the United States because of a scandal and is hounded by the media. It can be a mistake to equate the personal life of an artist too closely with his work, but in this case the meta-connection to the material makes the film even more tantalizing and was not lost on Polanski. "It coincided with what was happening to me," he acknowledged. "So I had a lot of sympathy for my characters."

Harris's book reminded Polanski of a Raymond Chandler mystery, and after *The Pianist* and *Oliver Twist* he was anxious to get back to a good, old-fashioned pulp thriller. It's the story of an ordinary guy (we never find out his name), a ghost writer (Ewan McGregor) who is hired to punch up the memoirs of the former head of state, Adam Lang (Pierce Brosnan), whose previous ghost turned up dead under questionable circumstances. The ghost goes off to Martha's Vineyard, where Lang is hiding out after the World Court has accused him of war crimes in Iraq. Lang is an old-school smarmy politician with an electric smile, and in spite of what he may or may not have done, Polanski wisely keeps his charm intact.

It's not really the politics that interests Polanski, although current events do give the film some sparks. He is more concerned with creating the atmosphere for his characters. This starts at the script stage, which for

Polanski is the blueprint for everything. He has often said that when he is adapting a novel he prefers to leave it intact as much as possible. He usually takes a screenwriting credit, but not since very early in his career has he actually sat down to write. What he tends to focus on is the construction of the screenplay. "In most of the work I've done with my co-writers—with Gérard Brach or [Jerzy] Skolimowski in my first film, *Knife in the Water*, and lately with Robert [Harris]—my job is building the skeleton of the piece. In a thriller it shows as the buildup of suspense."

The architecture of the screenplay was especially important for *The Ghost Writer* as most of the action takes place in the modernist beach house where Lang is living in the dead of winter. The palette, created by Polanski's regular cinematographer Pawel Edelman, is shades of gray, almost monochromatic. The ocean is the color of lead, and the sand, porch, and pavement blend together in their dullness. The sky is so low and the tone so oppressive, it feels like the characters are in an enclosed space even when they're outside. Polanski immerses the viewer in the experience.

Within minutes, with the necessary exposition out of the way, the ghost is ensconced in the house, where secrets seem to lurk around every sharp corner, including in the manuscript itself, which is kept under lock and key. Lang's wife, Ruth (Olivia Williams), is intelligent and combative, not least because Lang is having an affair with his assistant (Kim Cattrall) and does little to hide it. A maid and groundskeeper round out the unhappy household.

The ghost quickly picks up the vibe of the place and makes some disturbing discoveries. He's a curious sort and doesn't like being played for the fool. When he finds a clue ingeniously left by his dead predecessor, he becomes increasingly suspicious. Of what, he's not sure, but what's certain is that he's in over his head. In Polanski's films, he's got a lot of company.

Polanski isn't shooting for the instant gratification of rapid-fire editing to stun the audience. He's in no rush, and having too much fun. He prefers to creep around the house and up staircases to build tension with interesting angles, staging, and camera movement. For instance, if a character is walking across the room to pick up a glass, Polanski makes sure there is an obstacle to walk around. It's a small detail, but the effect is cumulative.

"The geography [of the house] follows the action as designed in the screenplay," explains Polanski. "So we knew exactly how much time it would take to go from the ground floor to the first floor, and from room to room. Because the picture virtually has a unity of time, it required great precision with these things. Otherwise you could not keep this same pace and would have many more ellipses [between cuts]."

Opposite: In conversation with Kim Cattrall, who played Lang's P.A. and lover Amelia Bly.

Left: Viewfinding rather than sightseeing on the picturesque north German coast, standing in for Martha's Vineyard.

Overleaf: The modernist beach house where the Langs are staying was coveted by numerous viewers of *The Ghost Writer*, yet it was all an illusion—confected at the Babelsberg Studio in Germany.

241

"People will definitely find there is some kind of message in this film. Every film I make I hope has some meaning besides being only an entertainment piece."

Polanski is able to suggest hidden meanings and create excruciating suspense through little things like lighting, sound effects, and a witty score by Alexandre Desplat. In one scene, looking out from the bay window of the house, the gardener is sweeping the gray wood porch on a windy day. There is not much happening, but the menacing undertone of suspense is deafening. When I asked Polanski how he did it, he pleaded ignorance. "I just don't know," he said. "I know how certain things work and others don't. But I should not dwell on it too much because it's not necessary. It's like someone who can sing; he sings, right, while others sing out of tune."

It's such a tangible moment, yet what's even more remarkable is that it's not even a real house. "Many people have asked me, 'Where is that house? We want to buy it,'" laughs Polanski. "To find a real house like this, it's practically impossible. Can you imagine the nightmare when you start a scene by the bay window and, by the time you rehearsed it, the light has already changed?"

An entirely convincing interior house was built at the Babelsberg Studio in Germany, which allowed Polanski to follow the structure of the script as it was written. For some exterior shots, the façade of the house was built in northern Germany, where the beach scenes were also filmed. Shooting in February by the North Sea should have been miserable, which is what was needed, but Polanski was once again sabotaged by the weather, as it was the warmest winter in years. Consequently, showing the view from the bay window proved a real challenge because the actual footage shot on location was too sunny. So most of the stormy skies in the film were created in the lab using composite shots from Germany and the Atlantic coast of France. In fact, *The Ghost Writer* has the most computer-generated imagery of any Polanski film.

Beneath the gray skies things aren't always as they appear, and layers of truth are eventually revealed—which could be a description of almost any Polanski film. But at this point in his career, Polanski seems more amused than outraged by the story. It's almost as if he's delighting in his craft and his ability to hold an audience captive.

The Ghost Writer doesn't have the seriousness of *Chinatown*, but it does traffic in a similar corruption,

deceit, and duplicity. In fact, as with *Chinatown*, right up until the last days of shooting Polanski was searching for a suitably dramatic ending that would reflect the true darkness of the material. "The thing is, we didn't know exactly how to finish the film," recalled Polanski. "I kept telling everyone, 'Don't worry, we'll get something.'"

He had always envisioned following the manuscript as a kind of a character throughout the film and came up with a way to pay that off in one of his great endings. After the ghost thinks he's got to the bottom of the mystery, identifying Lang as a CIA pawn, the former prime minister is assassinated. He becomes a slain hero and the book is rushed to press as his final testament. At the book release party, the ghost has a revelation and finds the final piece of the puzzle, realizing it's Lang's wife who is the real villain. In a bravado piece of staging, the ghost passes a note from the back of a crowded reception room to Ruth at the podium making a speech, letting her know that he knows. Polanski tracks the note as it goes from hand to hand to hand, the music swelling and the suspense mounting. "This was a great achievement by our focus puller because it was very difficult to stay on the note throughout the shot," said Polanski. "We had to do quite a few takes."

The ugly truth uncovered, the ghost slinks into the damp London night. But Polanski has one more card to play. A car, presumably dispatched by the bad guys, comes roaring down the street and off camera runs into the ghost with a dull and deadly thud. In the last shot, the pages of the manuscript—the evidence—go flying. It's a poetic ending, but it's not poetic justice. In this kind of story, there is no justice.

Carnage 2011

"I like to tackle challenges. On this film, it was telling a story that takes place in real time and in a confined space."

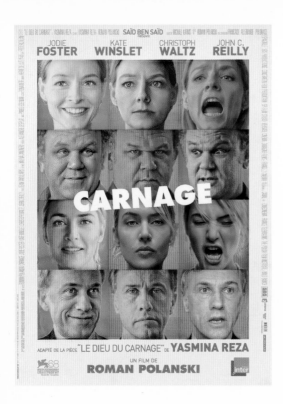

Making sure everything—and everybody—is in just the right place, including, from left to right, John C. Reilly (Michael Longstreet), Jodie Foster (Penelope Longstreet), Christoph Waltz (Alan Cowan), and Kate Winslet (Nancy Cowan).

Having lived in Communist Poland where political correctness was a matter of State policy with serious consequences, Polanski was highly attuned to the dangers of the thought police. This made him the ideal director to adapt Yasmina Reza's bourgeois comedy of bad manners, *God of Carnage*, for the screen. Moved to Brooklyn from its original Paris setting and the title shortened to *Carnage*, the film is a brief (eighty minutes) and biting dissection of middle-class piety in the twenty-first century.

This page and previous page: Aided by Kate Winslet, Polanski gets to grips with some of the unique challenges presented by shooting a film that runs in real time.

Polanski has never been that interested in big-picture politics but has focused instead on the dynamics of interpersonal relationships. He usually wraps his observations about the baser human instincts in genre pieces, but in *Carnage* the subject itself is a battle of raging ids. It starts with a playground scuffle, glimpsed in the distance over the opening credits, in which an eleven-year-old boy whacks another kid with a stick, cracking a few teeth. The parents are left to work it out in the confines of the victim's family apartment. In just a few hours, the niceties of polite society are deconstructed.

"I was thinking of how political correctness takes over people's lives and the great hypocrisy of those two words," said Polanski. "It's not *correct*; it's just politically correct. It means if you don't act in a particular way, it may cause you problems. It's just such an awful concept."

Polanski thought this was a typical New York situation and the script by Reza and Polanski (written while Polanski was under house arrest in Switzerland) wastes no time in abandoning the pleasantries. In one corner is the brittle, liberal do-gooder Penelope (Jodie Foster) and her conciliatory husband Michael (John C. Reilly), and in the other corner the supercilious businesswoman Nancy (Kate Winslet) and her blunt attorney husband Alan (Christoph Waltz), who spends much of the time on his cell phone defending a morally questionable drug company. At first, there is the strained cordiality of an awkward situation, with Penelope self-righteously pleased to believe that "luckily some of us still have a sense of community." But the assumptions this community is built on are soon exposed as a sham, and by the end of the day, Nancy is screaming at her hosts, "I'm glad my son kicked the shit out of your son and I wipe my ass with your human rights."

Beneath the surface, these are angry people frustrated with their own lives. In the course of the film, temporary allegiances form: the men against the women; one couple against the other; opposite partners together. It's like a tag team wrestling match with the sides constantly changing. The challenge for the director was to juggle the four characters as they bounce off of each other and change emotions in a flash from comedy, to drama, to satire. Characters that loom this large invariably become even bigger on screen, and Polanski doesn't flinch. The camera never pulls back for a broader perspective; the audience is trapped in the apartment with them. These people are in your face, and they're not pleasant.

"The difficulty is that with four people in this situation, even if there is something particularly tense between two of them, you have to film the other two, either in the same shot or separate shots, because later in the editing you'll need to see what the others are doing," said Polanski. "So you have to film the four virtually throughout the piece."

"I have two children aged eighteen and thirteen and I've found myself in the same position as the protagonists of the film. I know what it's like to get word from a school or other parents and then trying to alleviate the situation"

Alan to Penelope: "I saw your friend Jane Fonda on TV the other day. Made me want to run out and buy a Ku Klux Klan poster." The Cowans and the Longstreets try to maintain a veneer of civility, but the impulse to fire off jibes at each other becomes impossible to suppress.

Left: Michael and Penelope ply their guests with homemade pear and apple cobbler, which makes a dramatic reappearance soon after.

Opposite and overleaf: Relations both between and within the couples break down, sending handbags, cell phones, fists, and tulips flying.

The process started with a fortnight of intense rehearsals at the Bry-sur-Marne Studio outside Paris. Polanski, of course, couldn't shoot in New York but wanted the film to feel like it really was taking place in Brooklyn. So he hired the great production designer Dean Tavoularis (*The Godfather, Apocalypse Now*), who meticulously built a contemporary apartment filled with books, primitive art, and other objects in such detail that if a character were to open a drawer, it would be filled with real household items. Polanski insisted his cast memorize the whole script as they would a stage play. "We rehearsed on the set with all the props in place, basically the way it was going to look when we shot," said Polanski.

The staging was mostly done in rehearsals so the actors would know what was required by the time shooting started and Polanski could concentrate on camera movement and angles. "Roman puts the marks down and he sets the camera," recalled Foster in the production notes, "and he's there with his little viewfinder, which I haven't seen anyone use in about twenty years. It's all scratched, it's like from when he made *Knife in the Water*."

With the film taking place in a single afternoon, it was necessary for the action to be continuous without cutting for transitions between scenes. Polanski had used this technique a bit in his previous picture, *The Ghost Writer*, but had never done an entire film that happens essentially in real time. "I've made films before set in an enclosed space, but not as rigorously self-contained, so this was a new experience." Consequently, continuity became a major issue. "Because there were no ellipses, you couldn't put something in a different place from one shot to another," explained Polanski. "If someone put a glass on the table it had to be there throughout the picture unless we see it being moved in the action."

Then there was the matter of showing the very gradual change in light as afternoon becomes twilight. Since there is physically nowhere for the story to go, Polanski had to devise a visual strategy that allowed him to show the situation deteriorating as the day progresses and the mood grows darker. The idea was to make the apartment seem even more claustrophobic, so later in the film the camera becomes more mobile and the cuts are quicker.

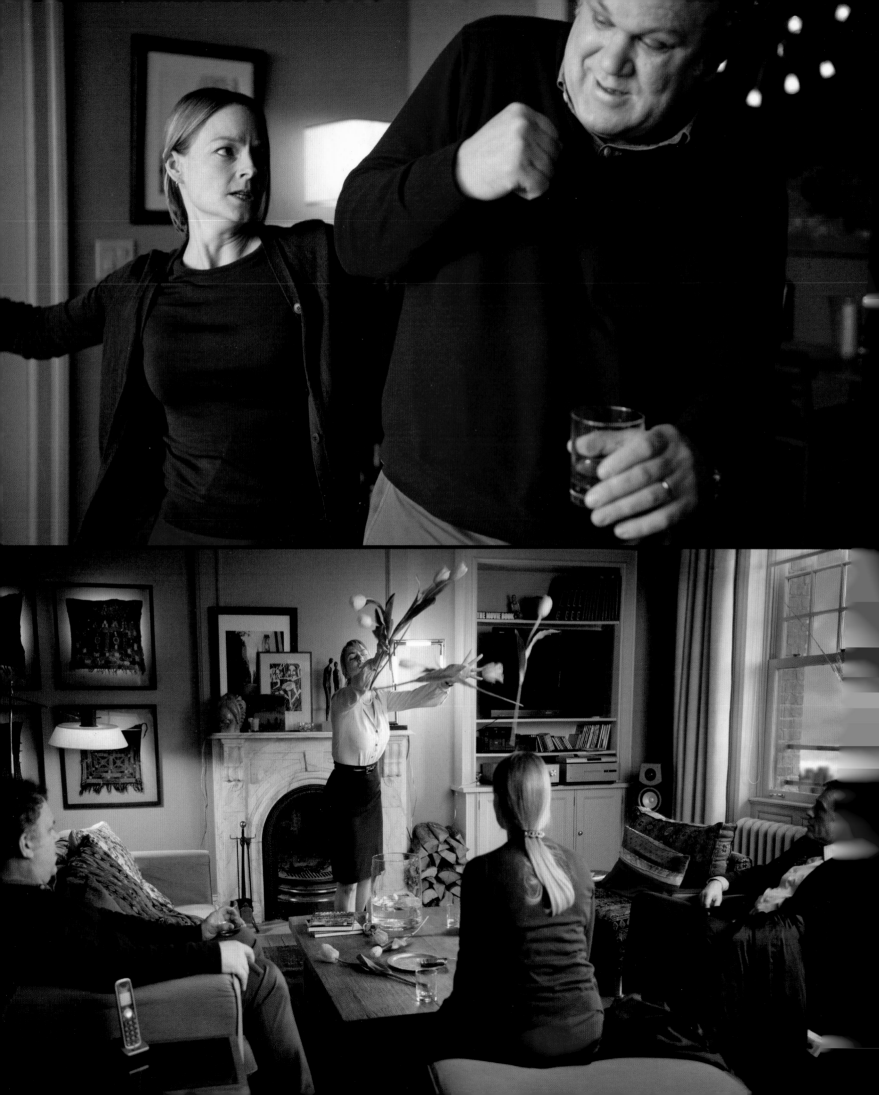

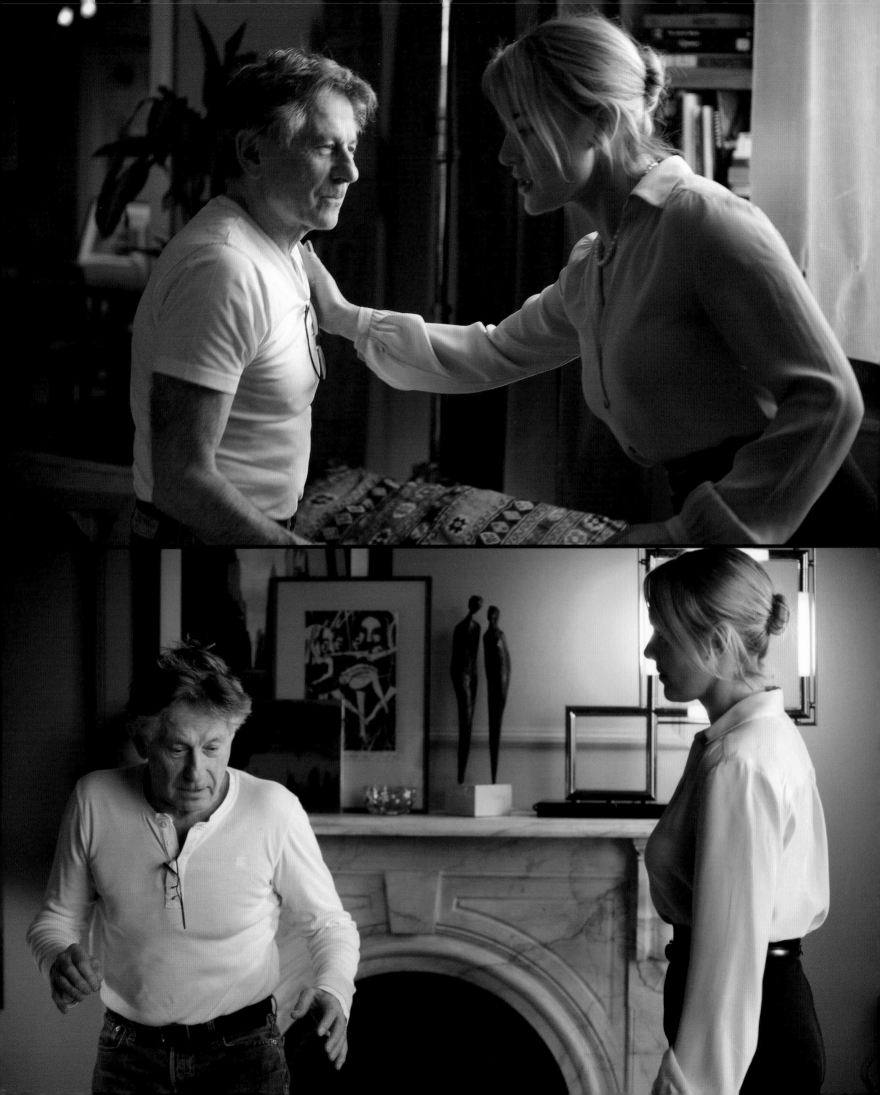

"Everything is different," said Polanski. "Framing is different, and the use of lenses and the lighting is different. We used slightly wider angles and we went slightly closer."

As the façade of civility is eroded, the characters' true feelings come pouring out. Alan takes nothing seriously except his job. He isn't really concerned about his son's violent behavior and has showed up to discuss it simply as a social convention. He thinks boys will be boys, and believes only in "the god of carnage, whose rule has been unchallenged since time immemorial."

Penelope is outraged at such callous disregard for the ills of the world, especially her own son's misfortune. Her shrill hectoring is enough to make anyone vomit, and after having a few drinks, Nancy does—all over Penelope's precious coffee table art books (her rare Kokoschka catalogue is ruined). Puking on the canon of western civilization is an obvious image, but one that delighted Polanski. Ever eager to get a reaction, he would go around the set tasting the concoction of movie vomit. The scene was digitally composed, putting the projectile together with another shot of Winslet in the correct position. "It was gross but people like this type of joke," laughed Polanski.

It's an eventful day. By the end, the strains in both marriages are exposed, perhaps irreparably, and the name-calling makes them sound much like the children they're supposed to be disciplining. The screaming achieves nothing. When it's over, these people (except the kids, who seem to have patched things up back in the playground) are spent and miserable. The need to milk the most out of a simple situation makes the film feel a bit forced and stagy at times, and even for a metaphorical farce, some of the action is far-fetched. But as exhausting as it may be, what's most disturbing is how familiar these people look.

Polanski staged the whole film before shooting. "So when we got onto the set we all knew exactly what our positions were," said Winslet.

The Actor

"I only use me because I'm
cheap and give no trouble.
I'm so nice to work with, you know?
I always do what I tell me to."

"Hold it there, kitty cat," says the man with a knife (Roman Polanski) approaching J.J. Gittes (Jack Nicholson) in *Chinatown*. "You're a pretty nosy fella, kitty cat. You know what happens to nosy fellas? They lose their noses." With that he slits Gittes' nose and warns him, "Next time you lose the whole thing. Cut it off and feed it to my goldfish, understand?" he says with a menacing glance into the camera. And that's how most people think of Polanski when they think of him as an actor. It's certainly a part that makes an impression, but in fact, Polanski was an actor long before he was a director.

Capitalizing on his youthful ability to entertain his friends and mimic performances from movies, he started as a child actor in radio, graduating to bit parts in the theater and a fateful leading role in a Soviet propaganda play, *Son of the Regiment*. "He was marvelous and so expressive that I remembered him for a long time," said Polish director Andrzej Wajda, who cast Polanski at age twenty-one in his first significant film role as a World War II resistance fighter in *A Generation* (1955).

Despite having no formal training, from an early age Polanski was able to project both naturalness and intensity on screen. Over the years, he has appeared most prominently in several films he directed, as well as taking on a few starring and cameo roles for other directors, and he has also delivered some memorable performances on the stage.

The first big part Polanski gave himself was in *The Fearless Vampire Killers*, as Alfred, the cheerfully innocent vampire hunter who tries to rescue the innkeeper's daughter (Sharon Tate) from the clutches of the undead. As a parody of vampire pictures, it's one of the films he made just for the joy of it and his infectiously good-natured and goofy performance helps set the tone. It's a role he wanted to play as much for practicality as the chance to act. He didn't mind portraying a character that was a bit ridiculous and he could easily handle the skiing and other strenuous aspects of the part. "Some routines required a lot of stamina and physical strength," Polanski said in a 1969 *Cahiers du Cinéma* interview. "I was aware that things like this would pose certain problems and take time. What's more, the character looked a lot like me, so why not play the part?"

Polanski took a less prominent turn in probably his least-seen film, *What?* Shot in 1972 when he was living in Rome, the absurdist farce featured a bunch of Polanski's international jet-setting friends, so it's no wonder he wanted to get in on the fun in a small supporting part as a resident of a villa full of sex-crazed eccentrics. Playfully toying with his own reputation, the character's name is Mosquito because he "stings with his big stinger," and he's about as pleasant as an insect.

After playing the vicious thug in *Chinatown*, Polanski took on his most challenging assignment in the title role of *The Tenant*, a Kafkaesque story about the gradual mental deterioration of a Polish immigrant in Paris. Polanski shows surprising range and sympathy exploring the drama and black humor of a character going from a mild-mannered bureaucrat to a transvestite leaping out of the window of his apartment. On screen for every scene, Polanski got an advanced lesson in the hazards of acting and directing at the same time.

"When I'm ready for a take," he explained, "and I feel completely relaxed and indeed concentrated on my

This page and previous page: *Chinatown* is one of several movies in which Polanski has divided his time behind and in front of the camera.

Finding an opening as Alfred in *The Fearless Vampire Killers*. Polanski decided to cast himself because he looked like the character and he had the required skiing skills and physical stamina.

character, and ready to be carried by the progress of the shot, the clapper comes and the guy says, 'scene 89, take 42.' Clap. And then my concentration is lost and I start worrying about the number of takes I have wasted. Or I see that my partner did not hit the mark and is not in the right light. These are things I should not be concerned with. Once you're in the groove, you should be carried by it as though you were on a railroad track taking you somewhere."

That may or may not explain why Polanski hasn't tried to direct himself since making *The Tenant*, but he has worked successfully for other directors. He was intrigued to play a criminal kingpin eager to exploit emerging capitalism just before the fall of the Soviet Union in Deran Sarafian's underrated thriller *Back in the U.S.S.R.* in 1992. The character is a dangerous guy but Polanski gives him depth by adding a dose of charm and magnetism.

"I wanted to do it just because the idea of me playing in an American film made in Moscow seemed totally surreal to me," said Polanski with a laugh. "When I was going to film school, if I said to one of my friends, one day I would act in an American film in the Soviet Union, even the remotest possibility of it happening would be inconceivable. So it was worth it."

Working in the legendary Mosfilms Studios, however, was a big disappointment. "What I saw was a decrepit,

falling-apart ruin of a studio with broken windows, dirty walls, and literally holes in the floor. Nothing functioned. You couldn't even get a bottle of mineral water."

Conditions weren't a lot better working on Giuseppe Tornatore's thriller *A Pure Formality* in 1994. The film is basically a two-hander featuring riveting performances by Gérard Depardieu as a famous reclusive writer who may have committed a murder on a stormy night in the French provinces and Polanski as a cagey detective investigating the crime. Swimming in a dark suit half a size too big and with his hair slicked back, Polanski is like a French Columbo searching for answers in a leaky police station while the power is out. "I remember the set was cold and dank, water everywhere and candles strewn all over the floor," said Polanski. "It was a very depressing atmosphere. The only plus was Depardieu, who cheered me up no end."

Reuniting with Wajda in 2002 for the nineteenth-century farce *The Revenge* (*Zemsta*) was a happier experience. Polanski had made a triumphant return to Poland in 1981 to direct and star in a production of Peter Shaffer's *Amadeus* (later doing the same in Paris), and since the fall of the Soviet Union he has occasionally visited his homeland where he is proudly welcomed as a respected artist. So the lead role of Papkin in *The Revenge*, a staple of the Polish theater, was a perfect fit. Sporting a small

In 2002, Polanski returned to Poland to act in *The Revenge*, a nineteenth-century farce directed by his early champion Andrzej Wajda.

"Sometimes it's very handy to be an actor, rather than look for somebody who could do what you want him to do exactly the way you want it. It's just simpler to do it yourself."

upturned mustache and a three-cornered hat, he plays an affable braggart and liar who seems to have stepped out of a Molière play to act as a mediator between two warring neighbors living side-by-side in a seventeenth-century castle. Affecting a high-pitched, whiney voice and a loose-limbed dandyish manner, this is Polanski in a comic mode as he's never been seen before. He seems to be having a grand time chewing the scenery, but one undoubtedly has to be Polish to fully appreciate the performance and the film. In any case, Wajda was delighted to be working with his friend almost five decades after their first film together.

"I was amazed at the astounding patience and calmness with which Roman accepted all the technical difficulties that accompany the making of a film," said Wajda in remarks for an exhibit of Polanski memorabilia at the Lodz Film Museum. "His readiness to surmount each difficulty reminded me of our first shared film set, as if those forty-eight years had passed in a single day."

Patience is not normally a virtue associated with Polanski, and although he sometimes regrets not having done more acting, he much prefers to be the man of action on the set. "What I don't like is all this hurry-and-wait business," said Polanski. "It's a drag to get up at 4:30 in the morning and get into makeup, and wait forever until they call you onto the set. As a director, it's different; it's excitement all the time."

Opposite: Polanski directed and starred in a 1981 production of Peter Shaffer's play *Amadeus* that opened in Warsaw and then toured to Paris.

Above: Acting opposite Gérard Depardieu in Giuseppe Tornatore's 1994 thriller *A Pure Formality*.

The Writer

"The script is essential.
Filmmaking is too complicated
to leave things for improvisation.
That's just for amateurs."

Polanski is not a writer in the traditional sense. He doesn't sit down at a desk and struggle with the material. "I used to do that but not anymore," he said. Even when he wrote the screenplay for *Rosemary's Baby* in a two-week fit of creativity, he paced around the room while dictating it to his assistant. Polanski does, however, work closely with his writing partners to ensure that the architecture of a script accurately represents his artistic vision and can, in practical terms, be executed. "I have to have a script worked on really well so there is no time wasted when you're on the set," said Polanski. "It has to be what I consider a model of the movie, which is more or less settled before I start filming."

This approach to the screenplay has been consistent throughout Polanski's career in various configurations. For most of his films he has worked with co-writers and taken a credit for his contribution. In a few instances he has served the same role without a credit. Early on, he also collaborated on a few forgettable scripts he didn't direct—*A Taste for Women* (1964), *The Girl Opposite* (1965), and *The Girl Across the Way* (1968)—and he wrote the screenplay on his own for, but did not direct, another oddity, the rarely seen *A Day at the Beach* (1972).

It is difficult to draw generalizations about a Polanski script given the different working arrangements and sources he's used. Sometimes when asked to explain a peculiar plot twist, he'll say, "It was in the book." However, aside from common themes and his distinctive sensibility running through the work, there are certain characteristics in the structure. Stories tend to be layered with each scene addressing more than one element of the plot with a logical, almost scientific precision.

Visually there is usually a lot of information within the frame, but the richness of Polanski's storytelling always starts with the screenplay.

Facing the blank page, even with a writing partner, is agony for Polanski. "Unfortunately, you have to invent things," he said. "And that's why screenwriting is so painful, because you have to force yourself, discipline yourself to invent characters, scenes, events, dialogues that don't exist." Once the process is underway and he's able to put the script together piece by piece, sometimes drawing on events or bits of dialogue from real life, he feels more confident.

Polanski's first real collaboration on a script was for his debut feature, *Knife in the Water*. He started working with his film school friend Kuba Goldberg, but the screenplay wasn't going anywhere until Jerzy Skolimowski came onboard as a co-writer. Skolimowski, who would later become a well-known director in his own right, had a strong enough personality to go head to head with Polanski. Skolimowski insisted that the events of the film take place in a single day and observe the Aristotelian unities of time, place, and action, a lesson Polanski would keep in mind for the rest of his career. He gave Skolimowski a co-writing and dialogue credit and has always acknowledged what he brought to the film.

"I saw in the dialogue that the *ans, buts, wells,* all of this is really crap," Polanski said in a 1966 *Cahiers du Cinéma* interview. "Good dialogue does without this kind of clutter. Skolimowski compelled me to organize myself very strictly for the construction, ... compelled me to give up some ideas that appeared interesting, brilliant, wildly funny, in favor of perfecting that construction."

Going back to the source with Mia Farrow on the set of *Rosemary's Baby*, 1968. Polanski's adaptation of Ira Levin's novel earned him his first Oscar nomination.

"I love clichés. Practically every
film I make starts with one. I just
try to update them, give them
an acceptable shape."

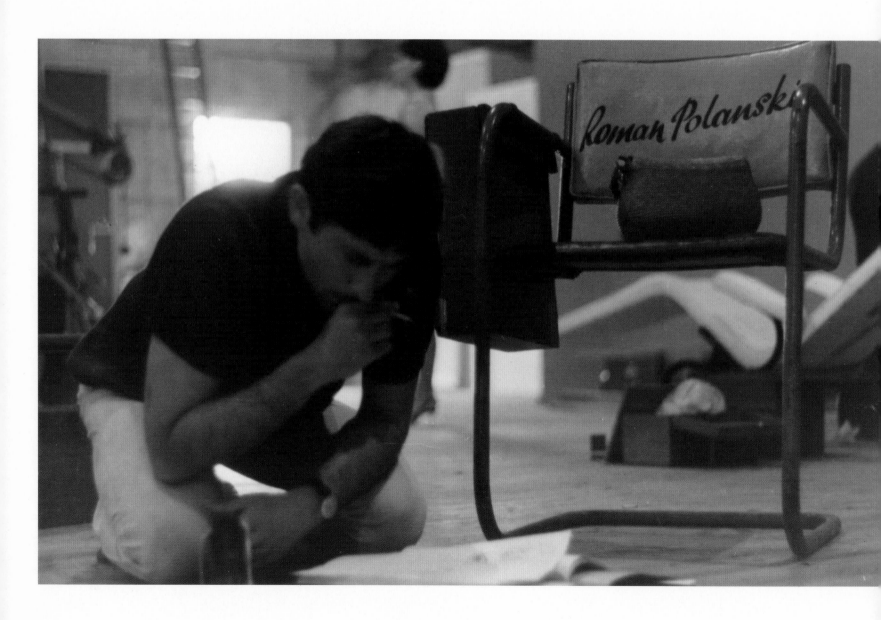

Polanski's longest and most productive writing collaboration was with Gérard Brach. They worked together on nine Polanski features until Brach's death in 2006, but they couldn't have been more different physically or temperamentally. Polanski was athletic and sociable; Brach was squat and agoraphobic, and for many years rarely left his apartment. But artistically they complemented each other perfectly. Polanski could see the large strokes of a screenplay and the mechanics of the plot; Brach was skilled at dialogue. They shared a dark, fatalistic worldview and appreciated the cosmic joke of the universe.

There was no real method to how they worked together, Polanski said in a 1988 interview in *Positif*, reprinted in *Roman Polanski Interviews*. "It's more that we developed a kind of routine. I explain the theme and we discuss it together, and then steadily improve on things. Little by little a sequence is created that seems worth putting to paper, and that's when Gérard starts to write. He reads me what he's written and we discuss it again. I often play out the parts, miming the situations and moving around a lot."

The first screenplay they wrote, inspired in equal parts by American gangster films and Samuel Beckett, was *When Katelbach Comes*, which would get made two years later, as *Cul-de-Sac*. In the meantime, to bring in some money they wrote *Repulsion*, based on a woman they knew in Saint-Germain-des-Prés who was attracted and repelled by sex. Over the years they would write such classics as *The Fearless Vampire Killers*, *The Tenant*, and *Tess* (with John Brownjohn), and the not-so-classic *Pirates* and *What?* Polanski and Brach also did the script for *The Boat on the Grass*, a rich man–poor man triangular love story, which Brach directed and premiered at Cannes in 1971.

Robert Harris, who wrote *The Ghost Writer* with Polanski based on his novel *The Ghost*, said Polanski was the most respectful of source material of any director he had ever worked with. At the same time, in adapting a book, Polanski understands the necessities of the medium. So even a writer as sacred as Shakespeare was not exempt from the screen treatment when Polanski and drama critic Kenneth Tynan rearranged scenes into chronological order and internalized monologues for their version of *Macbeth*.

Perhaps Polanski's best-known collaboration was on *Chinatown*. He did not receive a screenplay credit, although he holed up with writer Robert Towne for eight weeks, combining characters, compressing scenes, and structuring the story so it would work as a film. In the end, they disagreed on the conclusion so Polanski wrote it himself in keeping with his view of the material.

Some of Polanski's best writing experiences have come when he's been involved with a script from the outset without receiving a credit. Such was the case working with Ronald Harwood on *The Pianist* (and later on *Oliver Twist*). "We'd get up very early and discuss what he'd written the day before and I'd suggest possible changes," said Polanski in an interview in *El País Semanal*. "Then we'd go for a walk, review the story, and go through the next sequences."

Once the writing is completed and Polanski has to deal with the realities of shooting, he knows the film will never be one hundred percent as he imagined it while working on the script. But he believes the closer he adheres to his original idea, the better. "I look on the screenplay as an instruction manual on how to tell the story," said Polanski. "I can't imagine being on location without having collaborated on writing those instructions."

Fast Forward

"From time to time I think about the audience, but I'm not very concerned with it. You can't cater to an imaginary group of people. You have to satisfy your own taste."

Early in his career, Polanski was in Italy talking to Stanley Kubrick on the phone. Kubrick was going on about how he hated the time in between projects when you don't know what you're going to do next. "To be honest, I didn't know what the hell he was talking about," said Polanski, "because in those days I did one film after the other. Now I know exactly what he meant. With the years and with experience, and with some kind of reputation to defend or sustain, you think twice before you actually dive."

So as he looks ahead, after directing *A Therapy*, an ironic and witty short for Prada in 2012, Polanski is pleased that he already has his next two films lined up. First is a screen adaptation of *Venus in Fur*, David Ives' kinky comedy that was a hit on Broadway in late 2011, followed by *D*, a long-gestating account of the turn-of-the-century spy scandal, the Dreyfus affair. "It's good to do two films back to back," said Polanski. "I always dream of doing that and then something happens. Like I was thinking of doing *Carnage* immediately after *Ghost Writer* and I was stopped in my tracks."

Venus in Fur was not even on the radar when it became obvious that the screenplay for *D* and the logistics of a large-scale period piece would take more time to prep. "I wasn't planning *Venus in Fur* at all, but *D* is very complex and a long job, so I thought I'd do something quickly in between."

Polanski recognized *Venus* as perfect material for him, and started shooting in late December 2012. It's the story of a theater director trying to cast an actress for his play based on the nineteenth-century novel *Venus in Furs* written by Leopold von Sacher-Masoch, the man who gave masochism its name. In the course of the audition,

the sexual upper hand shifts from the director to the actress, who may be more than he bargained for. Along with the scathing humor, there is an element of suspense and eeriness as the identity of the actress reveals itself.

Ives' play is a two-hander. After having directed three characters in *Knife in the Water* and four characters in *Carnage*, Polanski said he was eager to try a film with two characters, and he knew exactly who to cast in the female role—his wife, Emmanuelle Seigner. They hadn't worked together since *The Ninth Gate* almost fifteen years ago. "We haven't done anything together for years so it's good to find ourselves doing this and see how we've both evolved," said Polanski.

The art-imitating-life aspect of the film—a well-known director directing his wife in a film about a director with a complicated relationship with his actress—was, Polanski admits, "a good subject for us," but it was, as usual, the dramatic quality of the material along with the humor that attracted him. Joining Polanski and Seigner in the love triangle is French actor Mathieu Amalric, who had previously worked with Seigner in *The Diving Bell and the Butterfly* (2007).

Unlike *Carnage*, which Polanski transposed from Paris to New York, he and Ives have moved the setting of *Venus* from a second-rate casting room in New York to a run-down theater in Paris. Because most real theaters would be in use, the one-room set was built in a facility right in the center of town. "It's a big set and has various angles [to shoot], and an empty theater in the evening is a bit spooky," said Polanski.

While *Venus in Fur* was filming, Polanski's other obsession was getting the script for *D* ready to go with

Left: Vanda (Emmanuelle Seigner) gains the upper hand over Thomas (Mathieu Amalric) in *Venus in Fur*, 2013.

Opposite: Putting his faithful viewfinder to good use during the shooting of *Venus in Fur*.

co-writer Robert Harris (*The Ghost Writer*). This is a project Polanski started thinking about five or six years ago and returned to more recently. "It's a great subject because what I went through made me think about it," said Polanski, equating the media circus that has followed him much of his life, and especially after his arrest in Switzerland in 2009, with the persecution of the Jewish-French artillery officer Alfred Dreyfus. Dreyfus was accused of passing government secrets to the Germans and was imprisoned in 1894 for five years before being pardoned and later exonerated.

"It was a tragic mistake and when [military officials] discovered that it wasn't Dreyfus, they didn't want to admit the error and started falsifying documents to sustain their version," explained Polanski. "It's very much like it is with justice [today] and very much as it is with institutions like the media, newspapers, and magazines. They will never admit they made a fucking mistake, which would stop everything." Polanski was thinking specifically of a libel case he won against *Vanity Fair* in 2005 after the magazine alleged he had tried to seduce a Scandinavian model on his way to the funeral of his murdered wife Sharon Tate in 1969.

Clearly *D* is a personal project for Polanski and one that he believes has contemporary resonance. If it gets made, it will undoubtedly stir up debate yet again about his long history with the American legal system, and *Venus in Fur* will get attention because of his notorious reputation. The fact that at this stage of his career Polanski can still generate this kind of controversy is part of his genius.

While *Venus* will be his first feature in French, *D* will be a large-scale international picture in English. Interestingly, the films represent two poles of Polanski's career. One is a dark comedy about the nature of sexual desire, and the other an attack on the injustices of society, built around one of the most sensational stories of the last century.

And after that? Polanski doesn't have any immediate plans, but not because he's slowing down, or thinking about retiring. Choosing a film, he says, is "very much as it is with food. You don't know what you're going to eat next. What determines your choice? Have you had too much pasta or not enough pasta? What do you feel like eating now?"

This book, of course, is a retrospective, which by its very nature looks at what Polanski has digested already. But despite what's he's accomplished and the indelible mark he's left on film history, Polanski does not by nature look back. He once said, "Satisfaction is a most unpleasant feeling." Like any great artist, he's looking toward the next work. At eighty, Polanski has not lost his appetite. Not even close.

"*Venus in Fur* was one of those projects that just happened. Everything is going so smoothly I suspect some kind of catastrophe will happen any moment because it's hard to believe how lucky we've been with everything."

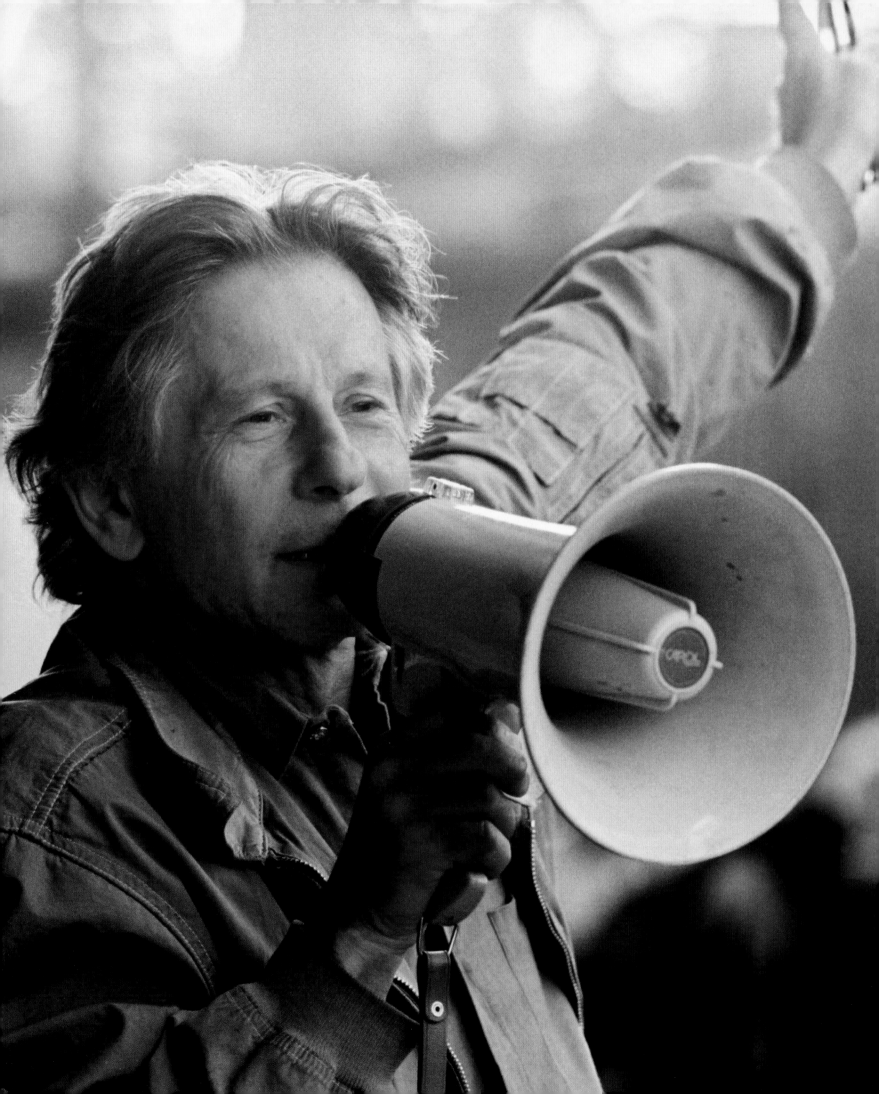

Filmography

As Director

Opening dates are for the United States (general release) unless stated.

Amateur/Short Films

The Bicycle
Rower (original title)
Unfinished
Screenplay: Roman Polanski
Cinematography: Nikola Todorow
Cast: Adam Fiut, Roman Polanski
1955 (Poland)

Murder
Morderstwo (original title)
2 minutes
Screenplay: Roman Polanski
Cinematography: Nikola Todorow
1957 (Poland)

Teeth Smile
Usmiech zebiczny (original title)
2 minutes
Screenplay: Roman Polanski
Cinematography: Henryk Kucharski
Cast: Nikola Todorow
1957 (Poland)

Breaking Up the Party
Rozbijemy zabawe (original title)
8 minutes
Screenplay: Roman Polanski
Cinematography: Marek Nowicki, Andrzej Galinski
1957 (Poland)

Two Men and a Wardrobe
Dwaj ludzie z szafa (original title)
14 minutes
Screenplay: Roman Polanski
Cinematography: Maciej Kijowski
Cast: Kuba Goldberg, Henryk Kluba, Andrzej Kondratiuk, Barbara Kwiatkowska, Stanislav Michalski
1958 (Poland)

The Lamp
Lampa (original title)
(Panstwowa Wyzsza Szkola Filmowa/Telewizyjna i Teatralna)
8 minutes
Screenplay: Roman Polanski
Cinematography: Krzysztof Romanowski
Cast: Roman Polanski
1959 (Poland)

When Angels Fall
Gdy spadaja anioly (original title)
(Panstwowa Wyzsza Szkola Filmowa/Telewizyjna i Teatralna)
21 minutes
Screenplay: Roman Polanski
Cinematography: Henryk Kucharski
Cast: Barbara Kwiatkowska, Roman Polanski, Henryk Kluba, Andrzej Kondratiuk
1959 (Poland)

The Fat and the Lean
Le gros et le maigre (original title)
(APEC)
15 minutes
Screenplay: Roman Polanski
Cinematography: Jean-Michel Boussaguet
Cast: Andrzej Katelbach, Roman Polanski
1961 (France)

Mammals
Ssaki (original title)
(Film Polski Film Agency/Studio Filmowe Se-Ma-For)
10 minutes
Screenplay: Andrzej Kondratiuk, Roman Polanski
Cinematography: Andrzej Kostenko
Cast: Henryk Kluba, Michal Zolnierkiewicz
1962 (Poland)

Feature Films

Knife in the Water
Nóz w wodzie (original title)
(Zespol Filmowy "Kamera")
94 minutes
Screenplay: Kuba Goldberg, Roman Polanski, Jerzy Skolimowski
Cinematography: Jerzy Lipman
Cast: Leon Niemczyk (Andrzej), Jolanta Umecka (Krystyna), Zygmunt Malanowicz (Young Boy)
Opened March 9, 1962 (Poland), October 28, 1963 (USA)

The World's Most Beautiful Swindlers
Les plus belles escroqueries du monde (original title)
(anthology film with segments directed by Claude Chabrol, Jean-Luc Godard, Ugo Gregoretti, Hiromichi Horikawa, and Polanski)
(Ulysse Productions/Primex Films/Lux Compagnie Cinématographique de France/Toho Film (Eiga)/Vides Cinematografica/Cesar Film Productie)
108 minutes
Polanski segment: "River of Diamonds" ("La rivière des diamants")
Screenplay: Gérard Brach, Roman Polanski
Cinematography: Jerzy Lipman
Cast: Arnold Gelderman (Jeweler), Nicole Karen (Swindler), Jan Teulings (Dutch Man)
Opened August 14, 1964 (France), September 12, 1967 (USA)

Repulsion
(Compton Films/Tekli British Productions)
105 minutes
Screenplay: Gérard Brach, Roman Polanski
Cinematography: Gilbert Taylor
Cast: Catherine Deneuve (Carole), Ian Hendry (Michael), John Fraser (Colin), Yvonne Furneaux (Helen),

Patrick Wymark (Landlord)
Opened July 7, 1965
(West Germany), October 3,
1965 (USA)

Cul-de-Sac
(Compton Films/Tekli British
Productions)
113 minutes
Screenplay: Gérard Brach,
Roman Polanski
Cinematography: Gilbert
Taylor
Cast: Donald Pleasence
(George), Françoise Dorléac
(Teresa), Lionel Stander
(Dickie), Jack MacGowran
(Albie), Iain Quarrier
(Christopher), Geoffrey
Sumner (Christopher's
Father), Renée Houston
(Christopher's Mother),
Jacqueline Bisset (Jacqueline)
Opened June 30, 1966
(West Germany), November 7,
1966 (USA)

**The Fearless Vampire
Killers or: Pardon Me,
But Your Teeth Are in
My Neck**
**Dance of the Vampires
(original title)**
(Filmways Pictures/
Cadre Films)
108 minutes
Screenplay: Gérard Brach,
Roman Polanski
Cinematography: Douglas
Slocombe
Cast: Jack MacGowran
(Professor Abronsius),
Roman Polanski (Alfred),

Alfie Bass (Shagal, the
Innkeeper), Jessie Robins
(Rebecca Shagal), Sharon Tate
(Sarah Shagal), Ferdy Mayne
(Count von Krolock)
Opened November 13, 1967

Rosemary's Baby
(William Castle Productions)
136 minutes
Screenplay: Roman Polanski
Cinematography: William
Fraker
Cast: Mia Farrow (Rosemary
Woodhouse), John Cassavetes
(Guy Woodhouse), Ruth
Gordon (Minnie Castevet),
Sidney Blackmer (Roman
Castevet), Maurice Evans
(Hutch)
Opened June 12, 1968

Macbeth
(Caliban Films/Playboy
Productions)
140 minutes
Screenplay: Roman Polanski,
Kenneth Tynan
Cinematography: Gilbert
Taylor
Cast: Jon Finch (Macbeth),
Francesca Annis (Lady
Macbeth), Martin Shaw
(Banquo), Terence Bayler
(Macduff), John Stride (Ross),
Nicholas Selby (Duncan),
Stephan Chase (Malcolm)
Opened October 13, 1971

What?
Che? **(original title)**
(Compagnia Cinematografica
Champion/Les Films

Concordia/Dieter Geissler)
114 minutes
Screenplay: Gérard Brach,
Roman Polanski
Cinematography: Marcello
Gatti, Giuseppe Ruzzolini
Cast: Marcello Mastroianni
(Alex), Sydne Rome (Nancy),
Hugh Griffith (Joseph Noblart),
Guido Alberti (Priest),
Gianfranco Piacentini (Tony)
Opened December 8, 1972
(Italy), October 3, 1973 (USA)

Chinatown
(Paramount/Penthouse)
130 minutes
Screenplay: Robert Towne
Cinematography: John A.
Alonzo
Cast: Jack Nicholson (J.J.
Gittes), Faye Dunaway (Evelyn
Mulwray), John Huston (Noah
Cross), Perry Lopez (Escobar),
John Hillerman (Yelburton)
Opened June 20, 1974

The Tenant
Le locataire **(original title)**
(Marianne Productions)
126 minutes
Screenplay: Gérard Brach,
Roman Polanski
Cinematography: Sven
Nykvist
Cast: Roman Polanski
(Trelkovsky), Isabelle Adjani
(Stella), Melvyn Douglas
(Monsieur Zy), Jo Van Fleet
(Madame Dioz), Bernard
Fresson (Scope)
Opened May 26, 1976 (France),
June 11, 1976 (USA)

Tess
(Renn Productions/Timothy
Burrill Productions/Société
Française de Production)
186 minutes
Screenplay: Gérard Brach,
Roman Polanski, John
Brownjohn
Cinematography: Ghislain
Cloquet, Geoffrey Unsworth
Cast: Nastassja Kinski (Tess),
Peter Firth (Angel Clare),
Leigh Lawson (Alec
d'Urberville), John Collin (John
Durbeyfield), Tony Church
(Parson Tringham), Arielle
Dombasle (Mercy Chant)
Opened October 25, 1979
(West Germany), December
12, 1980 (USA)

Pirates
(Carthago Films/Accent-
Cominco)
121 minutes
Screenplay: Gérard Brach,
Roman Polanski, John
Brownjohn
Cinematography: Witold
Sobocinski
Cast: Walter Matthau (Captain
Thomas Bartholomew Red),
Cris Campion (The Frog),
Damien Thomas (Don Alfonso
de la Torré), Olu Jacobs
(Boomako), Ferdy Mayne
(Captain Linares)
Opened May 8, 1986 (France),
July 18, 1986 (USA)

Frantic
(Warner Bros. Pictures/
The Mount Company)

120 minutes
Screenplay: Gérard Brach,
Roman Polanski
Cinematography: Witold
Sobocinski
Cast: Harrison Ford (Dr.
Richard Walker), Emmanuelle
Seigner (Michelle), Betty
Buckley (Sondra Walker),
John Mahoney (Williams)
Opened February 26, 1988

Bitter Moon
(R.P. Productions/Timothy
Burrill Productions/Columbia
Pictures/Les Films Alain
Sarde/Canal+)
139 minutes
Screenplay: Gérard Brach,
Roman Polanski, John
Brownjohn
Cinematography: Tonino
Delli Colli
Cast: Peter Coyote (Oscar),
Emmanuelle Seigner (Mimi),
Hugh Grant (Nigel), Kristin
Scott Thomas (Fiona), Victor
Banerjee (Mr. Singh)
Opened September 23, 1992
(France), March 11, 1994 (USA)

Death and the Maiden
(Fine Line Features/Capitol
Films/TF1 Films/Channel
Four Films/Flach Film/
Canal+/Les Films de l'Astre)
103 minutes
Screenplay: Rafael Yglesias,
Ariel Dorfman
Cinematography: Tonino
Delli Colli
Cast: Sigourney Weaver
(Paulina Escobar),

Ben Kingsley (Dr. Roberto
Miranda), Stuart Wilson
(Gerardo Escobar)
Opened December 23, 1994
(USA limited release)

The Ninth Gate
(Artisan Entertainment/
R.P. Productions/Orly Films/
TF1 Films/Bac Films/
Canal+/Kino Vision/Origen/
Vía Digital)
133 minutes
Screenplay: John Brownjohn,
Enrique Urbizu, Roman
Polanski
Cinematography: Darius
Khondji
Cast: Johnny Depp (Dean
Corso), Frank Langella (Boris
Balkan), Lena Olin (Liana
Telfer), Emmanuelle Seigner
(The Girl), Barbara Jefford
(Baroness Kessler), Jack Taylor
(Victor Fargas)
Opened August 27, 1999
(Spain), March 10, 2000 (USA)

The Pianist
(R.P. Productions/Heritage
Films/Babelsberg/Runteam/
Bac Films/Focus Features/
FFA/Canal+/Telewizja
Polska/FilmFernsehFonds
Bayern/Agencja Produkcji
Filmowej/Filmboard Berlin-
Brandenburg)
150 minutes
Screenplay: Ronald Harwood
Cinematography: Pawel
Edelman
Cast: Adrien Brody
(Wladyslaw Szpilman),

Thomas Kretschmann
(Captain Wilm Hosenfeld),
Emilia Fox (Dorota), Ed
Stoppard (Henryk), Maureen
Lipman (Mother), Frank Finlay
(Father), Julia Rayner (Regina)
Opened September 25, 2002
(Belgium), March 28, 2003
(USA)

Oliver Twist
(R.P. Productions/ETIC
Films/Runteam II)
130 minutes
Screenplay: Ronald Harwood
Cinematography: Pawel
Edelman
Cast: Barney Clark (Oliver
Twist), Harry Eden (Artful
Dodger), Ben Kingsley (Fagin),
Leanne Rowe (Nancy), Jamie
Foreman (Bill Sikes)
Opened September 30, 2005

To Each His Own Cinema
*Chacun son cinéma ou Ce petit
coup au coeur quand la
lumière s'étient et que le film
commence* (original title)
(anthology film to celebrate the
60th anniversary of the Cannes
Film Festival with 33 segments
by leading directors)
(Cannes Film Festival/
Elzévir Films)
100 minutes
Polanski segment: "Cinéma
Erotique"
Cast: Jean-Claude Dreyfus,
Sara Forestier, Sylvia Kristel,
Édith Le Merdy
Opened May 20, 2007 (Cannes
Film Festival, France)

The Ghost Writer
(R.P. Productions/France 2
Cinéma/Elfte Babelsberg
Film/Runteam III)
128 minutes
Screenplay: Robert Harris,
Roman Polanski
Cinematography: Pawel
Edelman
Cast: Ewan McGregor
(The Ghost), Pierce Brosnan
(Adam Lang), Kim Cattrall
(Amelia Bly), Olivia Williams
(Ruth Lang)
Opened March 19, 2010

Carnage
(SBS Productions/SPI Film
Studio/Versátil/France 2
Cinéma/Constantin Film/
Zanagar/Wild Bunch/
Canal+/CinéCinéma/
The Polish Film Institute/
France Télévisions)
80 minutes
Screenplay: Yasmina Reza,
Roman Polanski, Michael
Katims (translation)
Cinematography: Pawel
Edelman
Cast: Jodie Foster (Penelope
Longstreet), Kate Winslet
(Nancy Cowan), Christoph
Waltz (Alan Cowan), John C.
Reilly (Michael Longstreet)
Opened September 16, 2011
(Italy), December 16, 2011
(USA limited release)

Venus in Fur
La Vénus à la fourrure
(original title)
(R.P. Productions)

Screenplay: David Ives,
Roman Polanski
Cinematography: Pawel
Edelman
Cast: Emmanuelle Seigner
(Vanda), Mathieu Amalric
(Thomas)
Opening 2013

Commercials/
Promotional Shorts

**GREED, a New Fragrance
by Francesco Vezzoli**
1 minute
Cast: Natalie Portman,
Michelle Williams
2009

A Therapy
(Prada/R.P. Productions/
Hi! Production)
4 minutes
Screenplay: Ronald Harwood,
Roman Polanski
Cinematography: Eduardo
Serra
Cast: Helena Bonham Carter
(Patient), Ben Kingsley
(Therapist)
First shown May 22, 2012
(Cannes Film Festival, France)

As Producer

For films that Polanski
directed and produced, only
producer details are listed
here. See also pages 277–279.

Short Films

The Fat and the Lean
Producers: Roman Polanski,
Jean-Pierre Rousseau

G.G. Passion
(Cadre Films)
30 minutes
Director: David Bailey
Screenplay: David Bailey,
Gérard Brach
Cinematography: Stanley A.
Long
Producer: Gene Gutowski
Co-producer: Roman Polanski
Associate producer: Arnold
Miller
Cast: Eric Swayne, Rory
Davies, Janice Haye, Greta
Rantwick, Chrissie Shrimpton
Opened November 1966 (UK)

Feature Films

A Day at the Beach
(ASA Filmudlejning/Cadre
Films/Cinema Group/
Paramount British Pictures)
93 minutes
Director: Simon Hesera
Screenplay: Roman Polanski
Cinematography: Gilbert
Taylor

Producers: Gene Gutowski,
Roman Polanski
Cast: Mark Burns (Bernie),
Beatie Edney (Winnie),
Maurice Roeves (Nicholas),
Jack MacGowran (The
Collector), Peter Sellers
(The Salesman, A. Queen)
Opened April 17, 1972
(Denmark)

Bitter Moon
Producer: Roman Polanski
Co-producers: Alain Sarde,
Timothy Burrill (uncredited)
Executive producer: Robert
Benmussa

Castelnuovo
(Castelnuovo Corporation/
Diamante Films/Medusa
Produzione/TF1)
Director: Stefano Salvati
Screenplay: Michael Di
Jiacomo
Producer: Roman Polanski
1999 (Italy)

The Ninth Gate
Producer: Roman Polanski
Co-producers: Mark Allan,
Antonio Cardenal, Iñaki
Núñez, Alain Vannier
Executive producers: Michel
Cheyko, Wolfgang Glattes
Associate producer: Adam
Kempton
Line producer: Suzanne
Wiesenfeld

The Pianist
Producers: Robert Benmussa,
Roman Polanski, Alain Sarde

Co-producer: Gene Gutowski
Executive producers: Timothy
Burrill, Henning Molfenter,
Lew Rywin
Associate producer: Rainer
Schaper
Line producer: Daniel
Champagnon

Oliver Twist
Producers: Robert Benmussa,
Roman Polanski, Alain Sarde
Executive producers: Timothy
Burrill, Petr Moravec
Line producer: Michael
Schwarz

To Each His Own Cinema
"Cinéma Erotique" segment
Producers: Robert Benmussa,
Roman Polanski, Alain Sarde

The Ghost Writer
Producers: Robert Benmussa,
Roman Polanski, Alain Sarde
Co-producers: Timothy
Burrill, Christoph Fisser,
Carl L. Woebcken
Executive producer: Henning
Molfenter
Line producers: Oliver Lüer,
Christian von Tippelskirch

Documentaries

Afternoon of a Champion
(Anglo-EMI)
80 minutes
Director: Frank Simon
Screenplay: Frank Simon
Cinematography: William
Brayne

Producer: Roman Polanski
Cast: Roman Polanski, Helen
Stewart, Jackie Stewart
First shown June 1972 (Berlin
International Film Festival)

As Actor

For films that Polanski
directed and acted in,
only acting details are listed
here. See also pages 277–279.

Three Stories
Trzy opowiesci **(original title)**
(anthology film with segments
by Konrad Nalecki, Ewa
Petelska, and Czeslaw Petelski)
(Panstwowa Wyzsza Szkola
Filmowa/Telewizyjna i
Teatralna/Wytwórnia Filmów
Fabularnych)
"Jacek" segment
Director: Konrad Nalecki
Screenplay: Bohdan Czeszko,
Ewa Petelska, Czeslaw
Petelski, Andrzej Wajda
Cinematography: Jerzy
Lipman, Stefan
Matyjaszkiewicz
Polanski as Genek
Opened April 24, 1953 (Poland)

The Bicycle
**Polanski as Boy Who Wants
to Buy a Bicycle**

Hour Without Sun
Godzina bez slonca
(original title)

(Panstwowa Wyzsza Szkola
Filmowa)
16 minutes
Director: Pawel Komorowski
Screenplay: Pawel
Komorowski
**Polanski as unnamed
character**
1955 (Poland)

A Generation
Pokolenie **(original title)**
(Zespól Filmowy "Kadr")
83 minutes
Director: Andrzej Wajda
Screenplay: Bohdan Czeszko
Cinematography: Jerzy
Lipman
Polanski as Mundek
Opened January 26, 1955
(Poland)

The Enchanted Bicycle
Zaczarowany rower
(original title)
(Wytwórnia Filmów
Fabularnych)
71 minutes
Director: Silik Sternfeld
Screenplay: Jerzy Suszko,
Bohdan Tomaszewski
Cinematography: Tadeusz
Korecki
Polanski as Adas
Opened December 25, 1955
(Poland)

Nikodem Dyzma
(Film Polski/Zespol Autorow
Fimowych)
107 minutes
Director: Jan Rybkowski
Screenplay: Ludwik Starski

Cinematography: Wladyslaw
Forbert
**Polanski as Boy at Hotel
(uncredited)**
Opened October 29, 1956
(Poland)

The Wrecks
Wraki **(original title)**
(Film Polski)
89 minutes
Directors: Ewa Petelska,
Czeslaw Petelski
Screenplay: Janusz Meissner,
Ewa Petelska, Czeslaw
Petelski
Cinematography: Karol
Chodura
**Polanski as unnamed
character**
Opened September 2, 1957
(Poland)

End of the Night
Koniec nocy
(original title)
(Panstwowa Wyzsza Szkola
Filmowa)
90 minutes
Directors: Julian Dziedzina,
Pawel Komorowski,
Walentyna Uszycka
Screenplay: Antoni
Bohdziewicz, Bohdan
Drozdowski, Julian Dziedzina,
Marek Hlasko, Pawel
Komorowski, Jerzy Wójcik
Cinematography: Henryk
Depczyk, Krzysztof
Winiewicz, Jerzy Wójcik
Polanski as Little One
Opened December 21, 1957
(Poland)

Two Men and a Wardrobe
**Polanski as Bad Boy
(uncredited)**

**What Will My Wife Say
to This?**
Co rekne zena?
(original title)
(Ceskoslovenský Státní Film/
Filmové Studio Barrandov/
Film Polski)
93 minutes
Director: Jaroslav Mach
Screenplay: Jan Fethke,
Václav Jelínek, Jaroslav Mach,
Zdzislaw Skowronski
Cinematography: Boguslaw
Lambach
Polanski as Dancer
Opened September 26, 1958
(Czechoslovakia)

The Lamp
**Polanski as Passer-by
(uncredited)**

When Angels Fall
Polanski as Old Woman

Speed
Lotna **(original title)**
(Kadr Cinematographic
Unit)
90 minutes
Director: Andrzej
Wajda
Screenplay: Wojciech
Zukrowski
Cinematography: Jerzy
Lipman
Polanski as Musician
Opened September 27, 1959
(Poland)

Bad Luck
Zezowate szczescie
(original title)
(Polski State Film/ZRF
"Kamera")
92 minutes
Director: Andrzej Munk
Screenplay: Jerzy Stefan
Stawinski
Cinematography: Jerzy
Lipman, Krzysztof Winiewicz
**Polanski as Jola's Tutor
(uncredited)**
Opened April 4, 1960 (Poland)

Good Bye, Till Tomorrow
Do widzenia, do jutra
(original title)
(Film Polski)
88 minutes
Director: Janusz Morgenstern
Screenplay: Zbigniew
Cybulski, Bogumil Kobiela,
Wilhelm Mach
Cinematography: Jan
Laskowski
Polanski as Romek
Opened May 25, 1960 (Poland)

Innocent Sorcerers
Niewinni czarodzieje
(original title)
(Film Polski)
87 minutes
Director: Andrzej Wajda
Screenplay: Jerzy
Andrzejewski, Jerzy
Skolimowski
Cinematography: Krzysztof
Winiewicz
Polanski as Dudzio
Opened December 17, 1960
(Poland)

Beware of the Yeti!
Ostroznie, Yeti!
(original title)
(Zespol Filmowy "Syrena")
77 minutes
Director: Andrzej Czekalski
Screenplay: Andrzej
Brzozowski, Andrzej
Czekalski
Cinematography: Henryk
Depczyk, Jan Janczewski
Polanski as Driver
Opened January 20, 1961
(Poland)

Samson
(Zespól Filmowy "Kadr"/
Zespól Filmowy "Droga")
117 minutes
Director: Andrzej Wajda
Screenplay: Kazimierz
Brandys, Andrzej Wajda
Cinematography: Jerzy
Wójcik
**Polanski as unnamed
character**
Opened September 11, 1961
(Poland)

**The Fat and the Lean
Polanski as The Lean
(uncredited)**

**Knife in the Water
Polanski as Young Boy (voice)
(uncredited)**

**Repulsion
Polanski as Spoon Player
(uncredited)**

**The Fearless Vampire Killers
Polanski as Alfred**

The Magic Christian
(Grand Films/Commonwealth
United Entertainment)
92 minutes
Director: Joseph McGrath
Screenplay: Terry Southern,
Joseph McGrath
Cinematography: Geoffrey
Unsworth
**Polanski as Solitary
Drinker**
Opened December 12, 1969
(UK)

**What?
Polanski as Mosquito
(uncredited)**

Blood for Dracula
(Compagnia Cinematografica
Champion/Yanne et Rassam/
Andy Warhol Presentation)
103 minutes
Director: Paul Morrissey
Screenplay: Paul Morrissey
Cinematography: Luigi
Kuveiller
**Polanski as Man in Tavern
(uncredited)**
Opened March 1, 1974 (West
Germany), November 27, 1974
(USA)

**Chinatown
Polanski as Man with Knife**

**The Tenant
Polanski as Trelkovsky**

Chassé-croisé
(Film et Vidéo Compagnie)
80 minutes
Director: Arielle Dombasle

Screenplay: Arielle Dombasle
Cinematography: Jacques
Robin
**Polanski as unnamed
character**
Opened March 24, 1982
(France)

**Frantic
Polanski as Taxi Driver Who
Hands Over Matches to Dr.
Walker**

En attendant Godot (TV play)
(La Sept)
Director: Walter D. Asmus
Screenplay: Samuel Beckett
(play)
Polanski as Lucky
First broadcast June 3, 1989
(France)

Back in the U.S.S.R.
(JVC Entertainment
Networks/Largo
International)
87 minutes
Director: Deran Sarafian
Screenplay: Lindsay Smith
Cinematography: Yuri
Neyman
Polanski as Kurilov
Opened February 7, 1992

A Pure Formality
Una pura formalità
(original title)
(Orly Films/Sidonie/
Cecchi Gori Group
Tiger Cinematografica/
D.D. Productions/
Film Par Film/TF1)
108 minutes

Director: Giuseppe Tornatore
Screenplay: Giuseppe
Tornatore
Cinematography: Blasco
Giurato
Polanski as Inspector
Opened May 15, 1994 (Italy),
May 26, 1995 (USA)

Tribute to Alfred Lepetit
Hommage à Alfred Lepetit
(original title)
(Les Films du Jeudi)
9 minutes
Director: Jean Rousselot
Screenplay: Jean Rousselot
Cinematography: Pierre
Barougier
Polanski as himself
First shown February 16,
2000 (Berlin International
Film Festival)

The Revenge
Zemsta **(original title)**
(Vision Film Production/
Telewizja Polska/Arkafilm)
100 minutes
Director: Andrzej Wajda
Screenplay: Andrzej Wajda
Cinematography: Pawel
Edelman
Polanski as Józef Papkin
Opened October 4, 2002
(Poland)

Rush Hour 3
(New Line Cinema/Roger
Birnbaum Productions/Arthur
Sarkissian Productions/Unlike
Film Productions)
91 minutes
Director: Brett Ratner

Screenplay: Jeff Nathanson
Cinematography: J. Michael
Muro
**Polanski as Detective Revi
(uncredited)**
Opened August 10, 2007

Quiet Chaos
Caos calmo **(original title)**
(Fandango/Portobello
Pictures/Phoenix Film/
Rai Cinema/Ministero per i
Beni e le Attività Culturali)
105 minutes
Director: Antonello Grimaldi
Screenplay: Nanni Moretti,
Laura Paolucci, Francesco
Piccolo
Cinematography: Alessandro
Pesci
Polanski as Steiner
Opened February 8, 2008
(Italy), June 26, 2009 (USA)

As Writer

See pages 277–280 for details
of films that Polanski wrote
and directed/produced.

Feature Films

A Taste for Women
Aimez-vous les femmes?
(original title)
(Les Films Number One/
Federiz/Francoriz
Productions)
100 minutes
Director: Jean Léon

Screenplay: Roman Polanski
Cast: Sophie Daumier
(Violette/Marguerite),
Guy Bedos (Jérôme Fenwick),
Grégoire Aslan (Inspecteur
Rossi), Edwige Feuillère
(Tante Flo), Gérard Séty
(Léon Palmer)
Opened May 13, 1964 (France)

The Girl Across the Way
La fille d'en face
(original title)
(Société Nouvelle Pathé
Cinéma)
90 minutes
Director: Jean-Daniel
Simon
Screenplay: Gérard Brach,
Roman Polanski
Cinematography: Patrice
Pouget
Cast: Bernard Verley (Marek),
Joël Barbouth (Roger), Marika
Green (La fille d'en face/The
Girl Opposite), Albane Navizet
(Nicole), Dany Graule
(Martine)
Opened January 14, 1968
(France)

The Boat on the Grass
Le bateau sur l'herbe
(original title)
(Cinétel/Sinar Films/
Vicco Films)
90 minutes
Director: Gérard Brach
Screenplay: Gérard Brach,
Roman Polanski, Suzanne
Schiffman
Cinematography: Étienne
Becker

Cast: Claude Jade (Eleonore),
Jean-Pierre Cassel (David),
John McEnery (Oliver),
Valentina Cortese (Christine),
Paul Préboist (Leon)
Opened April 16, 1971 (France)

TV Series

Love Story
"The Girl Opposite"
(Associated Television)
60 minutes
Director: Lionel Harris
Screenplay: Roman Polanski
Cast: Dudley Moore (Kuba),
Joanna Wake (The Girl),
Geoffrey Whitehead (Marek)
First broadcast November 1,
1965 (UK)

Acknowledgments

James Greenberg is indebted to Richard Schickel for getting this started and for his advice along the way. Big thanks to Thom Mount for moving it forward; Beth Atkin for her early counsel; Carley Johnson for her expert edit; Janet Jones and friends for their hospitality in Paris. At Palazzo Editions, I'm grateful to James Hodgson and Judy Barratt for their editorial acumen, and Emma O'Neill for the not inconsiderable task of collecting all the images. At R.P. Productions, to Françoise Piraud, who was kind enough to help me in August in Paris and throughout, and Malgosia Abramowska for her assistance this time and the time before that. Barry and Jennifer Greenberg, who, in a sense, were there at the start of this project many years ago. Of course, to Roman Polanski for agreeing to do this and his graciousness with my endless questions. And most of all to Gloria Norris, who was patient and supportive while I disappeared for months, and, well, for just being herself.

Select Bibliography

Cronin Paul, ed. *Roman Polanski: Interviews.* Jackson: University Press of Mississippi, 2005.
Feeney, F.X. *Roman Polanski.* Edited by Paul Duncan. Cologne: Taschen, 2006.
Kiernan, Thomas. *Repulsion: The Life and Times of Roman Polanski.* London: NEL, 1980.
Kurowska, Barbara, ed. *Roman Polanski: Actor. Director.* Düsseldorf: Lodz Film Museum/ Düsseldorf Film Museum/Polish Institute, 2010.
Meikle, Denis. *Roman Polanski: Odd Man Out.* Surrey: Reynolds & Hearn, 2006.
Parker, John. *Polanski.* London: Gollancz, 1993.
Polanski, Roman. *Roman* (autobiography). London: Heinemann, 1984.
Sandford, Christopher. *Polanski.* London: Century, 2007.
Wright Wexman, Virginia. *Columbus Filmmakers: Roman Polanski.* London: 1985.

Interviews
Amis, Martin. "Interview: Roman Polanski." *Observer*, December 6, 2009. http://www. guardian.co.uk/film/2009/dec/06/roman-polanski-martin-amis-interview. Previously published in *Tatler*, 1979.
Combs, Jacob, trans. "Roman Polanski Interview by *Le Figaro*: Misses Hollywood and Nicholson, Wants to Do Film About Aging." *Thompson on Hollywood* (blog), December 1, 2011. http://blogs.indiewire.com/ thompsononhollywood/frances-le-figaro-interviews-roman-polanski
Fuchs, Cynthia. "Interview with Roman Polanski: *The Ninth Gate.*" *Pop Matters*, March 10, 2000. http://www.popmatters.com/pm/ feature/polanski-roman/
Greenberg, James. "A Life in Pictures." *DGA Quarterly*, Winter 2009.
Summers, Sue. "Roman à clef." *Observer*, October 2, 2005.
Thompson, David. "I Make Films for Adults." *Sight and Sound*, April 1995.
Vezzoli, Francesco and Christopher Bollen. "Roman Polanski." *Interview*, January 22, 2009. http://www.interviewmagazine.com/film/ roman-polanski-/#_
"Roman Polanski: Death and the Maiden Interview." http://minadream.com/ romanpolanski/DeathAndTheMaiden.htm
"Roman Polanski Interview, The Ghost Writer." YouTube video, 8:40. Posted November 10, 2010. http://www.youtube.com/ watch?v=XSS9AR5BI-g

Picture Credits

Every effort has been made to trace and acknowledge the copyright holders. We apologize in advance for any unintentional omissions and would be pleased, if any such case should arise, to add appropriate acknowledgment in any future edition of the book.

T: top; B: bottom; R: right; L: left

Guy Ferrandis: Endpapers, 32–33, 207, 209, 211, 220–221, 272, 286–287 (R.P. Productions/Focus Features/Studio Canal); 6, 9, 234, 238–239, 240, 242–243, 244, 246–247, 274, 275 (R.P. Productions); 222, 226–227, 228, 230–231, 233 (R.P. Productions/Runteam Ltd.); 248, 252–253 (SBS Productions); **The Roman Polanski Archive:** 1, 12, 13 L & R, 15, 16 T, 18, 20 R (Roman Polanski); 20 L, 23, 24, 25 (Panstwowa Wyzsza Szkola Filmowa); 21 (Zespol Filmowy "Kadr"); 28 (APEC); 35, 37, 39, 40 B, 42, 43, 46 (Zespol Filmowy "Kamera"); 51 T, 64, 69 (Compton Films); 61 (Laurie Turner/Compton Films); 70, 79 (MGM); 82, 83 T, 133 (Paramount); 101 (Columbia Pictures/Playboy Productions); 109, 111 T, 113, 114 (Compagnia Cinematografica Champion); 171 (Warner Bros./François Duhamel); 196 (R.P. Productions/Kino Vision); **Camera Press, London:** 2–3 (Photograph by Bryan Campbell); 63 B (Compton Films/Botti/Stills/Gamma); **Film Museum in Lodz:** 10, 16 B, 19 T (Panstwowa Wyzsza Szkola Filmowa); 30 (Se-Ma-For/PWSFTviT); 36, 278 L (Zespol Filmowy "Kamera"); 208 (R.P. Productions/Focus Features/Studio Canal); 278 R, 279 R (Compton Films); 280 L (MGM); 281 L (Paramount); 283 R (R.P. Productions/Artisan); **Ronald Grant:** 19 B (Zespol Filmowy "Kadr"); 50, 57 T, 68, 77 T (Compton Films); 134–135 (Paramount); 161 (Cannon); **Andrzej Kostenko Archive:** 22, 26 (Panstwowa Wyzsza Szkola Filmowa); 31; **The Kobal Collection:** 27 (Film Polski); 40 T (Zespol Filmowy "Kamera"/Film Polski); 49, 52–53, 56, 59 (Compton-Tekli/Royal); 76 T, 77 B (MGM); 98, 100 B, 102, 103, 107 (Columbia/Playboy Productions); 112, 115 (Compagnia Cinematografica Champion); 118, 119 T, 120–121, 124 T, 125, 128 (Paramount); 144 T & B, 148–149 (Columbia/Renn Productions/Burrill/SFP); 167, 172–173 (Warner Bros.); 184, 194–195 (Capitol/Mount/Kramer/Channel 4/Canal+); 199 B, 201, 202–203, 204, 205 (R.P. Productions/Artisan); 210, 218–219,

276 (R.P. Productions/Focus Features/Studio Canal/Guy Ferrandis); 224 B, 232 B (R.P. Productions/Runteam Ltd./Guy Ferrandis); 245 (R.P. Productions); 254 T, 255, 259 (SBS Productions/Guy Ferrandis); 262, 268 (Paramount); **Mary Evans Picture Library:** 29 T (Rue des Archives/AGIP); 151 (Columbia/Renn Productions/Epic); 162 (Warner Bros./Rue des Archives/DILTZ); 164 B (Warner Bros./Rue des Archives/Collection CSFF); 271 (Elizabeth Brach/Rue des Archives); **TopFoto:** 29 B (Roger-Viollet); 130 (Paramount/Keystone Archives/Heritage-Images); **British Film Institute Stills, Posters and Designs, London:** 38, 41, 44 (Zespol Filmowy "Kamera"); 52 L, 65, 270 (Compton Films); 72 T (MGM); 104, 104–105, 106 T & B (Columbia/Playboy Productions); 122, 138 (Paramount); 142, 143 T, 145, 147 T & B, 150, 152, 153 (Columbia/Renn Productions); 192 T (Fine Features/François Duhamel); 216 L, 219 (R.P. Productions/Focus Features/Studio Canal/Guy Ferrandis); **Rex Features:** 45 (Zespol Filmowy "Kamera"/Everett Collection); 66 B (Compton Films/Moviestore Collection); 67 (Compton Films/Everett Collection); 84 (Paramount/Everett Collection); 96 (Paramount/Moviestore Collection); 186 T (Fine Features/Moviestore Collection); 212 T (R.P. Productions/Focus Features/Studio Canal/Guy Ferrandis); 225 (R.P. Productions/Runteam Ltd./Guy Ferrandis); 241 (Action Press); 254 B (SBS Productions/Guy Ferrandis/Moviestore Collection); **mptvimages.com:** 54 (Compton Films), 81, 83 B, 86, 87, 92, 97 (Paramount/© 1978 Bob Willoughby); 117, 129, 260–261 (Paramount); 141 (Columbia/Renn Productions); 178 (R.P. Productions/Columbia/Burrill); **Photofest:** 57 B (Compton Films/Columbia); 73 (MGM); 85, 88, 89, 94–95 (Paramount/Photographer: Robert Willoughby); 123, 124 B, 126–127, 134 T, 135 T (Paramount); 166 B, 170 B (Warner Bros./François Duhamel); 267 (Sony Pictures Classics); **Alamy:** 62 (Compton Films/Pictorial Press); 136 (Paramount/AF Archive); 160 (Cannon/AF Archive); 176 (R.P. Productions/Columbia/Burrill/Moviestore Collection); 198, 200 (R.P. Productions/Kino Vision); 212 B (R.P. Productions/Focus Features/Studio Canal/Guy Ferrandis/AF Archive); 239 R (R.P. Productions/Guy Ferrandis/AF Archive); **Photo12.com:** 63 T, 66 T (Compton Films/Archives du 7e Art/DR); 76 B (MGM/Archives du 7e Art/DR); 110 (Compagnia Cinematografica Champion/

Archives du 7e Art/DR); 137 (Paramount/Archives du 7e Art/DR); 156 (Cannon/Archives du 7e Art/DR); 168 (Warner Bros./Archives du 7e Art/DR); 177 T, 183 (R.P. Productions/Columbia/Burrill/Archives du 7e Art/DR); 199 T (R.P. Productions/Kino Vision/Archives du 7e Art/DR); 214–215 (R.P. Productions/Focus Features/Studio Canal/Guy Ferrandis/Archives du 7e Art/DR); 232 T (R.P. Productions/Runteam Ltd./Guy Ferrandis/Archives du 7e Art/DR); 237 (R.P. Productions/Guy Ferrandis/Archives du 7e Art/DR); 250 T & B, 251, 256 T & B, 257 T & B, 258 T & B (SBS Productions/Guy Ferrandis/Archives du 7e Art/DR); **Press Association:** 72 B, 75, 288 (MGM/Scanpix/Bjorn Larsson); **Getty Images:** 74, 264 (MGM/Michael Ochs Archives); **Corbis:** 51 B (Compton Films/Sunset Boulevard); 90 (Paramount/Sunset Boulevard); 119 B, 131 (Paramount/Steve Schapiro); 139 (Paramount/Sunset Boulevard); 146 (Columbia/Renn Productions/Christian Simonpietri/Sygma); 154 (Cannon/Douglas Kirkland); 157, 158–159 (Cannon/JP Laffont); 165 (BDV); 166 T, 170 T (Warner Bros./François Duhamel/Sygma); 174 (R.P. Productions/Columbia/Burrill/Frédéric de Lafosse/Sygma); 177 B (R.P. Productions/Columbia/Burrill/François Duhamel/Sygma); 179, 180, 181, 182 T & B (R.P. Productions/Columbia/Burrill/Étienne George/Sygma); 186 B, 187, 188, 189, 190–191, 192 B, 193 (Fine Line Features/François Duhamel/Sygma); 266 (BDV); **akg-images:** 91 (Paramount/Album); 100 T (Columbia/Playboy Productions/Album); 169 (Warner Bros./Album); 236 (France 2 Cinéma/Album); **Photoshot:** 111 B (Compagnia Cinematografica Champion); 143 B (Columbia/Renn Productions/Entertainment Pictures); 164 T (Warner Bros./The Mount Company); 216–217 (R.P. Productions/Focus Features/Studio Canal/Guy Ferrandis); 224 T (R.P. Productions/Sony Pictures Entertainment); **Piotr Bujnowicz/TrailerAndMore.pl:** 265; **www.cinemaposter.com:** 279 L (Compton Films); 280 R, 281 R, 282 (Paramount); 283 L (Warner Bros.).

We would like to give special thanks to Magda Bladowska, Piotr Kulesza, Mieczyslaw Kuzmicki, and Krystyna Zamyslowska at the Film Museum in Lodz, for the supply of photographs from their archives, and for their invaluable help with our picture research.

Overleaf: Not just another face in the crowd, *The Pianist*, 2002.

Page 288: Away from his post, *The Fearless Vampire Killers*, 1967.

"Don't ask me why I make these films.
I am just a director."